1986

1986

The Art of Brazil

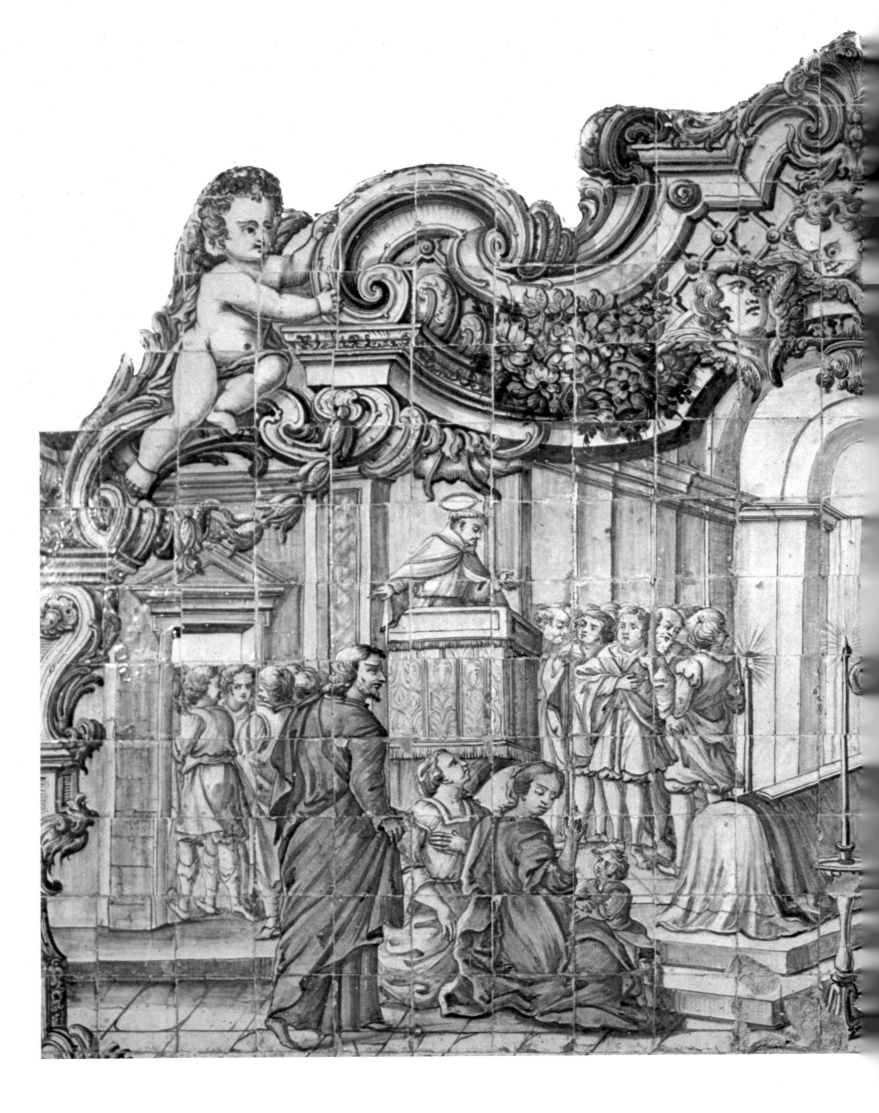

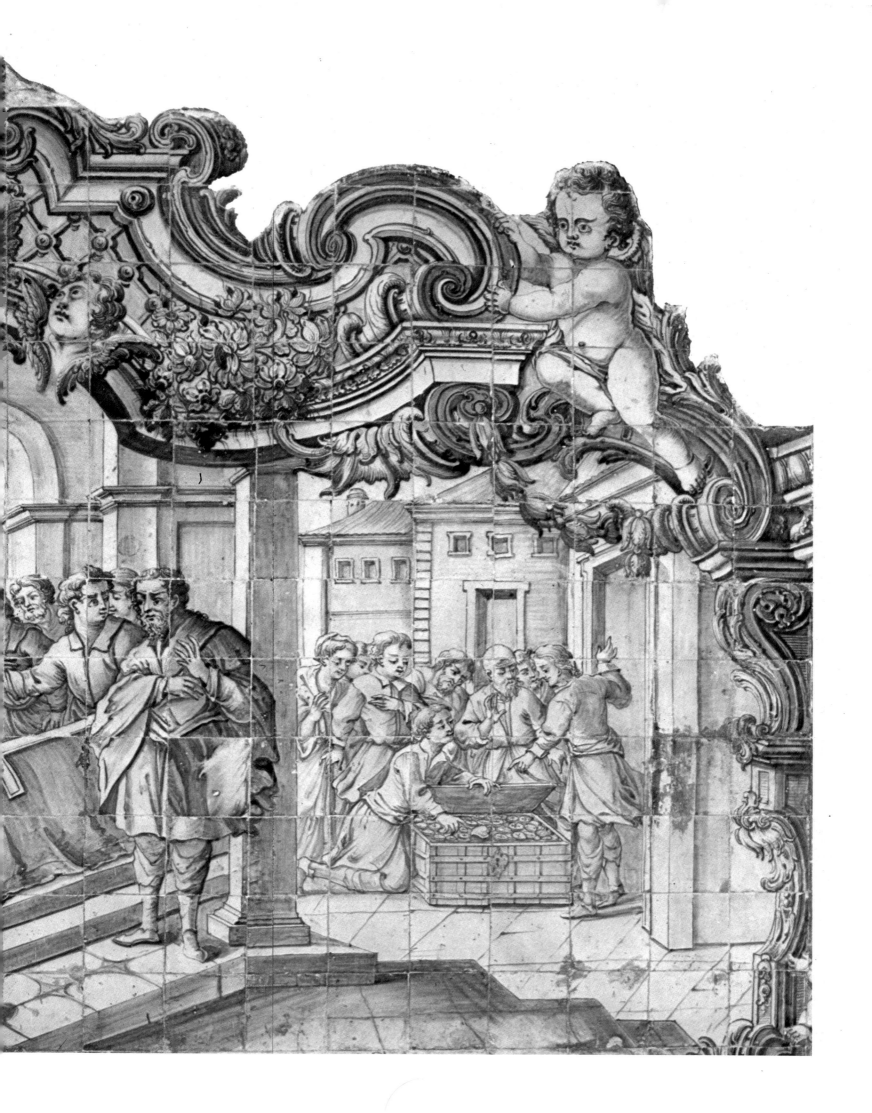

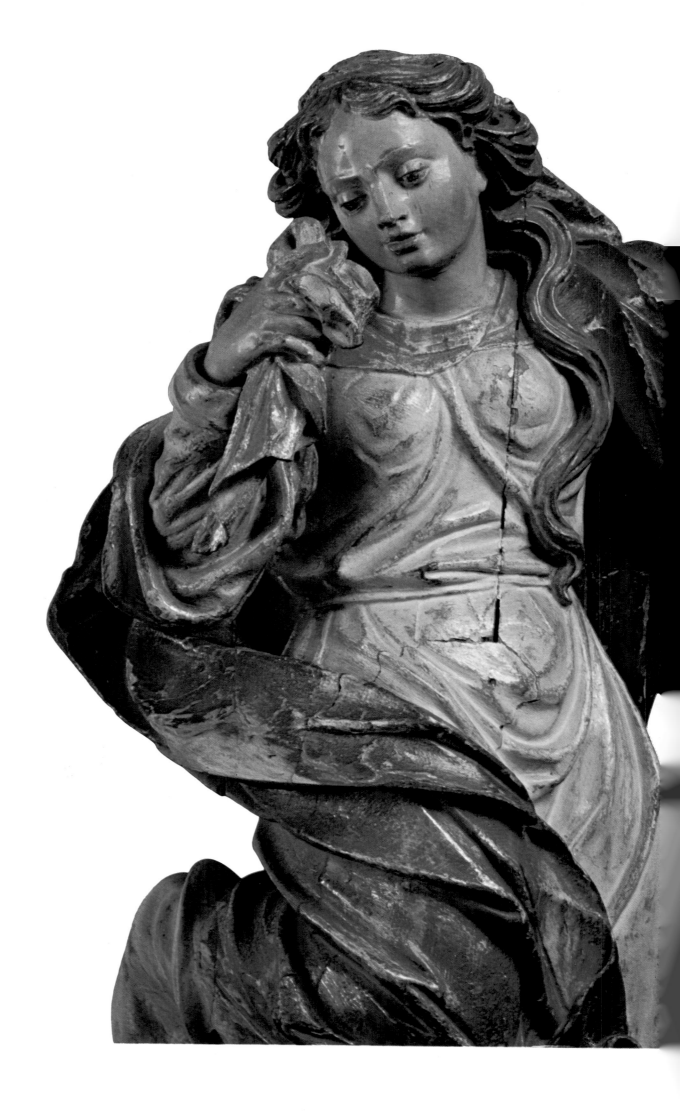

The Art
of Brazil

By Carlos Lemos, José Roberto Teixeira Leite
and Pedro Manuel Gismonti

With an introduction by Pietro Maria Bardi
and an essay by Oscar Niemeyer

Icon Editions

1817

HARPER & ROW, PUBLISHERS, New York

Cambridge, Philadelphia, San Francisco,
London, Mexico City, São Paulo, Sydney

Above Marcelo Grassman (born 1925),
Incubus Sucubus, 1953 (detail). Xylograph.
Museu de Arte Contemporanea, São
Paulo.

THE ART OF BRAZIL

Copyright © 1979 Abril S.A. Cultural e Industrial, São Paulo
Copyright © 1982 Arnoldo Mondadori Editore S.p.A., Milan
for the international edition
English language translation copyright © 1983
Arnoldo Mondadori Editore S.p.A., Milan

Translated by Jennifer Clay

FIRST U.S. EDITION

ISBN 0-06-435289-7

LIBRARY OF CONGRESS CATALOG CARD NUMBER: 83-47557

Printed and bound in Italy by
Arnoldo Mondadori Editore, Verona

Contents

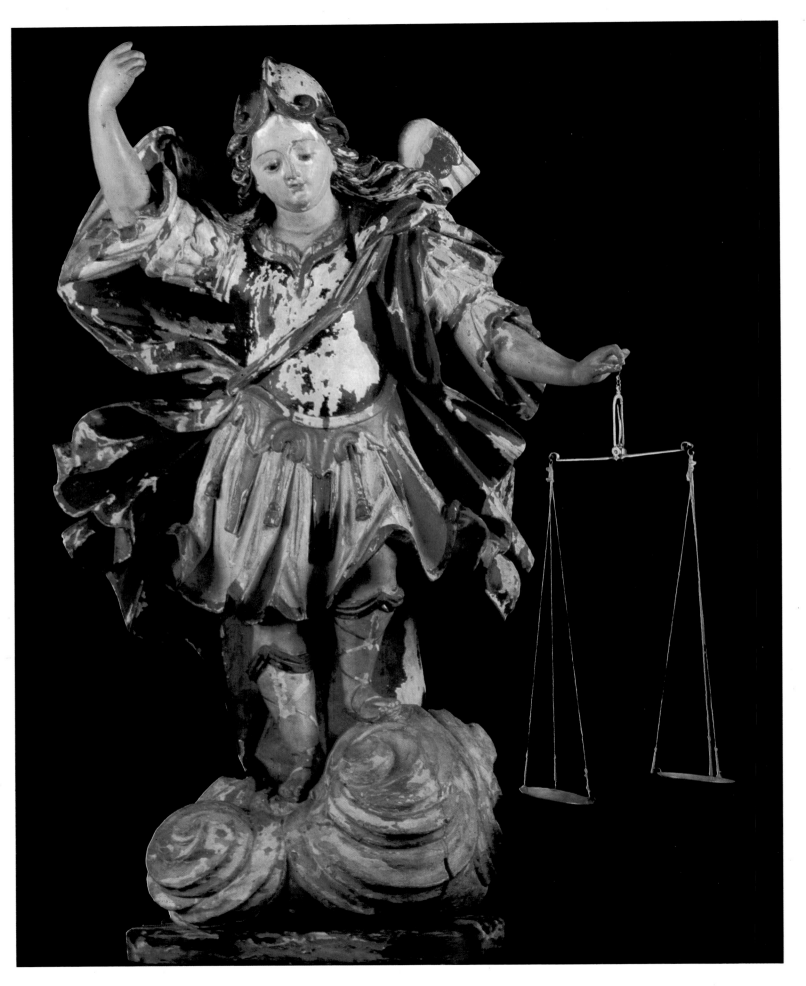

Introduction

by Pietro Maria Bardi

We could begin our journey into Brazilian history with Montaigne's comment of surprise: "Our world has found another ... so new and childlike that it must be taught the alphabet." In 1500, the "adults" of Pedro Álvares Cabral's caravels met the Indians on an Atlantic Coast beach that became known as Vera Cruz. The cross was raised, a mass celebrated and thus the king of Portugal claimed another colony.

The new arrivals were given a splendid welcome and danced with the celebrating natives. This forerunner of a forced brotherly affection is considered to be the precursor of the now famous Brazilian carnival, which, however, did not originate from that first meeting but from a subsequent one with the Africans. Two sailors of the expedition deserted and joined the tribe of the "good savages" in pursuit of the myths that were then astonishing Europe: El Dorado, the Valley of Youth, the Amazons and many more.

From that time onward for almost four centuries, the history of Brazil depended on Portugal, which dominated the vast territory. In the nineteenth century, the monarchy took refuge in Rio de Janeiro as a result of the Napoleonic invasions. The monarchy then proclaimed the empire, which, toward the end of the century, crumbled due to circumstances unconnected with revolution, opening the way for the republic.

The Portuguese began their occupation by sending out soldiers, "new Christians," those considered undesirable at home, eager gold prospectors and chaplains. These were the so-called pioneers who took it upon themselves to convince the natives, assumed to be savages, to adopt white civilization.

These new arrivals formed the first settlements. The commemorated cross and the hut were the first faint glimmers of art. After building the roof a sketch of some popular sacred image was made, there was singing and then it was down to work. The most difficult thing was securing the help of the land owners, by fair or foul means, thus giving rise, unfortunately, to the system of slavery.

Everything had to be made from scratch, harquebuses and work tools being the most precious objects. Ploughs and canoes were made and redwood trees were cut down. The wood, called the *pau-brasil*, gives its name to the colony. The Portuguese were already importing this tree from the Indies since it was of great value in Europe for dyeing cloth. The idea of gold did not even exist and so the economy depended upon rearing cattle and cultivating sugarcane. Much later, the coffee plant was imported. This was and would continue to be one of the main sources of wealth.

As regards Brazil's origins, it is necessary to consult the *Chronicle* of her discovery compiled by Cabral's scribe, Pero Vaz de Caminha, and the reports by the German, Hans Staden and the Frenchmen, André Thevet and Jean de Léry, companions of Nicolas Durand de Villegaignon, the Calvinist who tried to create an "Antarctic France" in the bay of Rio de Janeiro. The pages of these men tell of the Indians. For the conquerors, clad in hats and boots, the novelty lay in the art of the Indians, who painted themselves from top to toe in an early form of "body art."

When the Jesuit missionaries arrived, the Indian style of adornment was the first anomaly to be wiped out. The naked had to be clothed, and it had to be explained that polygamy was not right, nor was cooking and devouring the bodies of enemies. The missionaries protected the Indians from adventurers who subjected them to slavery and took on the task of converting them using a new style of the catechism—celebrations and "frightening spectacles" to convey the most simple idea of the existence of God and Satan, heaven and hell.

In the nineteenth century, the conquerors, heading ever increasing heterogeneous and unstable groups, became firmly encamped along the Atlantic Coast in Recife (formerly Pernambuco), Salvador (formerly Bahia) and São Vicente, defending these places from pirates and intruders and

Left, José Joaquim da Veiga Vale (1806–1874), *The Archangel St. Michael.* Polychromed wood.

starting off the multiplication of family trees in which African slave families would soon take part.

The poet Camões condemned the "glory of power," advising against expeditions that were not crusades to free the Holy Sepulcher. No one, neither the king nor the Christian population, took any notice of the poet, since their thoughts were set on gold. Those who had been "transferred" to Brazil feverishly searched for it, penetrating the forests with great difficulty.

A makeshift form of architecture was created. In order to create a shelter with four walls, tamped earth was used which was rammed down thoroughly and soaked in whale fat to make a *taipa*, a wall reinforced internally with laths of wood. The same technique was used to reinforce trenching and to shape terra-cotta wares drying in the sun, following the experience of the natives. Later on, stone was used to build walls. Lime was obtained by grinding shells collected by the Indians in *sambaqui*. They used rough wooden crushers, whose rudimentary design gave rise to the *engenho de acucar*, the sugarcane cutter which, in that era of hallucinations and mysticism, claimed the favor of "a small portion of the Divine, so as to show itself admirable in its method of operation," according to a chronicler.

The sugarcane cutter soon became the symbol of the vast properties governed according to a feudal system. The division of land into large estates was to continue until the nineteenth century, causing reactions in the North, from which emerged strange figures such as the *cangaceiros*, assailants and executioners, plus cases of fanaticism among followers of witch doctors. Such events caused the government to dispatch military expeditions.

In Brazil, art cannot be separated from reality which is checkered with social events. There are a great number of popular festivals. We have already referred to the carnival, an artistic event of unquestionable importance since it represents the ethnic reawakening of the Africans who arrived in Brazil on the slave ships in which even Voltaire had an interest. He wrote to the slave trader of the *Congo* saying, "I know that the slaves who embark upon your ship are treated kindly and humanely, and for this reason I am delighted with this good business, participating at the same time in a worthy act."

It took half a century for the Africans to find a public form in which they could express their inherent sense of race, which had never waned. By being christened they could benefit from Sunday and dedicate that free time to tribal dances. After the abolition of slavery, this outlet slowly developed into the merrymaking and infernal din of the parades of *samba* dancers. In 1982, speaking of the carnival, the cardinal and archbishop of Rio de Janeiro, recalling the *pulvis et umbra sumus*, said, "I observe these tumultuous days realistically. We must have the courage to assess what is happening, which on occasion assumes the proportions of a real group orgy, with a growing degradation of moral behavior and aggression toward human dignity." Times have changed. The most popular *marchinha* is by Lamartine Babo: "Who discovered Brazil?/Who discovered Brazil?/It was Senhor Cabral, Senhor Cabral/on the twenty-first day of April/three months after the carnival."

To return to history: While those who were seeking to strengthen the colony strove to give stability to their estates, the major preoccupation was to build fortifications. Various military architects arrived from Italy by way of Portugal. Among them was Baccio da Filicaia, agent of the grand duke of Tuscany, who was in search of gold mines but, failing to find any, took on the task of building churches and fortresses. The Indians and Africans assisted in the construction work. Father Antônio Vieira, considered one of the apostles of Brazil, wrote, "Together with the Indians we have built churches with walls made of earth, columns made of tree trunks and vaults of palm leaves, becoming the masters of this form of architecture. With the plumb line, hoe, saw and other tools that we gave them, they served God and themselves, but not us."

Hans Staden, *Tupinambás Chieftains*, from *Descrição Verdadeira de um País de Selvagens . . .*, (1957). Private collection, São Paulo.

He was not referring to the arts. In old letters and writings by religious men, the word "art" is found to mean practices of life. Father Manuel da Nóbrega, for example, mentions the "art of the wind," meaning navigation. In the *Dietário* (*Chronicle*) of the Benedictine monastery in Rio de Janeiro, the word "direction" is used to mean art. The sculptor Agostinho de Jesus was said to have "special grace and direction."

The architecture of the wealthy, as can be seen in the ruins of the fortified house of Garcia d'Avila in Salvador, was defensive. The landowners formed an ignorant pyramid, interested solely in profit. There were many feudalistic skirmishes, described by the slaves as "white men's" quarrels. The clergy were less reactionary but were still interested in making a profit. The following description of an abbey near Rio de Janeiro, visited by Prince Maximilian of Wied Neuweid will give an idea of how this class lived: [There is] "a huge building with a beautiful church, two patios and an inner garden, plots bordered with stones and planted with balsams and tuberoses. . . . There are many activities at the monastery: it has horses and oxen, sugar refineries, various stables and farms; from the surrounding farms it receives heavy taxes. It has fifty slaves whose huts are situated in a courtyard around a large cross."

This traveler was in Brazil between 1815 and 1817. Only in 1888, after numerous escapes and conflicts, were the slaves freed. It was only natural that, in these unusual circumstances, the religious authorities should think of themselves, ignoring the moral strictures of religious teachings, expropriating property and arranging for prebends and profits. There were plenty of severe critics. In 1549, Father da Nóbrega wrote, "I have heard bad things about the priests." Concerning the arrival of a bishop he exhorted, "Come to work, not to earn money." All decisions were made within clerical circles, and social and economic problems were discussed and resolved by the churches. Almost all the orders were present. In addition to the Jesuits, there were Franciscans, Benedictines and Carmelites. The utmost attention was given to the sumptuousness of the sees. Craftsmen were attracted from Portugal and made to compete with each other from center to center, thus inducing them to travel about the country. As regards style, the dominant trend, to use a very broad historiographic label, was a form of mannerism related to eclecticism. There was some noteworthy and unwitting originality of style, since Brazil is far from Europe and its values emerged from improvisation. After initial adaptations, the trend was toward grandeur which, almost always, emphasized the lack of proportion between the buildings and the meager population that inhabited them. Wherever the conquerors settled the first building was the chapel, but there was immediately a desire to replace it with a church.

Many of the profiteers, powerful men, officials and high-ranking military officers were not satisfied solely with a roof over their heads. They sought to distinguish themselves with more comfortable houses and refined tastes than those in other neighborhoods. Agricultural farms were constantly springing up, on which the owners lived in a large house and the slaves in a *senzala*.

The regime was colonial and there was little feeling of humaneness. Public education and printing were prohibited. The first printing house in Brazil was established in 1808, and the first university in 1827. Despite the crime of massacres, the Spanish were less oppressive than the Portugese. In 1551 they opened the university of Lima, and the first printing house in Mexico dates from 1535.

The clerics continued to remain detached from secular development, intensifying the construction of convents and churches and encouraging the proliferation of the *irmandades*, confraternities formed according to ethnic groups, income and trade.

In architecture, the Jesuits were outstanding. With surprising tenacity, this order, obeying the rule of the justification of the means and "discernment," in

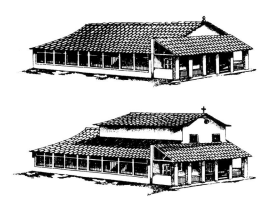

Luís Gonçalves, drawings of the Chapel of São Miguel in São Paulo before (*above*) and after (*below*) its restoration in 1738.

1554 miraculously founded their center in the Planalto, where the metropolis of São Paulo was to strike root, celebrating "the first mass in a very lowly, cramped and wretched house," as Father da Nóbrega tells us.

The Jesuit Society gradually saw to the establishment of centers of worship in the various distant regions. Important men, the *mestres de pedrarias*, arrived in Salvador: Luís Dias and a pupil of Italy's Filippo Terzi, the Jesuit Francisco Dias, who introduced the mannerist styles of Serlio and Vignola. Luís Dias was entrusted by the first governor of Brazil, Tomé de Souza, with the task of constructing fortresses, but he ended up building the capital. Lisbon sent other architects, including Friar Francisco dos Santos, who designed the Franciscan monastery at Olinda. Others went to Paraíba. A class of architects rapidly formed. The style continued to be mannerist in the form of superficial imitation. New contributions depended on chance circumstances and the nationality of the artists. Architects also came from Spain. The monastery of the Barefoot Carmelites of Santa Theresa, today the headquarters of the Museu de Arte Sacra in Salvador, is attributed to the Spaniard Friar Macário de São João.

At the beginning of the seventeenth century, Portugal and Spain, at that time united in a pseudo-alliance, fought in northern Brazil against the Dutch. The Dutch had seized vast sugar-producing regions, setting up the West India Companies, under the command of count Maurice of Nassau. The Dutch occupation lasted twenty-four years, leaving behind a fairly strong cultural mark. Nassau landed with a court of scholars, including the cosmographer Michel de Ruyter, the doctors and naturalists Piso and Georg Marcgraf, the architect Pieter Post, who was to lay out the plan for the town of Recife, and the painters Frans Post, Albert Eckhout and Zacharias Wagener. These were the painters who were to introduce Brazil to Europe, however inaccurately. The Gobelin workshops, using Eckhout's drawings, prepared a Brazilian series of tapestries which, among other animals, included an elephant. Moreover, camels were believed to exist in Peru.

After the Calvinist period, under the artistic patronage of the orders, the seventeenth century witnessed the decline of a mannerism that was predominantly Vignolesque, in favor of the baroque style that characterizes the colony's two most exuberant centuries. Its expression is not so discernible in facades but is exaggerated in interior decoration. The amazing "golden chapel" is unique, a contribution to the idea of rhetoric underlying this style. From the pulpit, the panegyrist emphasizes the words, not to demonstrate but rather to persuade. In the same way, the decorative artist, placing emphasis on sculpture, does not want to demonstrate but to focus the attention on a labyrinth of forms, sterilizing thought and reasoning. Rhetoric is concerned with obtaining an audience, decoration demands wonder. The walls and ceilings of these obsessive buildings are intricate forests, thick with crowds of angels, doves and varied representations of nature, an illusion of infinite space, a breath-taking communication, the only color being gold.

Running parallel with the somewhat daring work of the artists was popular craft work. Both in practical areas of life and in the spiritual areas of religion, crafts developed into an intense production to be attributed to those arts that have no masters. There is no lack of opportunity to admire the results of creativity. Popular inventiveness is very prolific. Suffice it to mention the common names of plants or the labels for bottles of aqua vitae which in Salvador alone number more than two hundred, from "smoking serpent" to "tamed lion." Consider the titles of the first newspapers, such as *Soft Mouth* or *Stone Calf*, not to mention the so-called *cordel* literature (so named because it was exhibited dangling from a piece of string, *cordel*), a daily comment in the town square by poets who set their thoughts to music. Everything is an ironic, disordered riot of the imagination that imitates the *aljofre barroco* of the

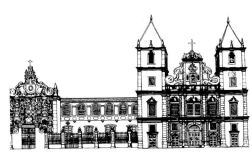

Luis Gonçalves, drawing of the group of buildings (including the Church of São Francisco, the convent and the Church of the Tertiary Order of São Francisco) erected in Salvador in the eighteenth century.

Portuguese, irregularity being significant since it seemed to govern everything in the colony, beginning with the mixture of races.

Reading the chronicles brings to mind the baroque formula of "the theater within a theater." The Church adapted that formula, the result of which was the procession, a choreography of the policy of consensus which still endures in part, even if in a less exciting form. The traveler Daniel P. Kidder in 1839 gave a very good description of a procession: "It left the cathedral and wound through the main streets to a constant ringing of bells. The entire town turned out to take part; windows and balconies were overflowing with spectators; there was a display of fine damask hangings at the houses of the wealthy.... Two confraternities, one made up of Africans, the other of whites, marched on either side, each brother wearing a white, red or yellow cloak, depending on their orders, and holding a long candle in their hand...." To this studied order came the explosive reaction of the carnival.

In 1924, when the modernists launched their nationalist manifestos to rid the country from the yoke of foreign culture, Oswald de Andrade invoked the carnival: "Poetry exists in reality. The saffron and ocher colored dwellings, among the green of the *favelas* ... are aesthetic realities. The Rio carnival is the religious festival of the Pau-Brasil race. Wagner submerged by the Botafogo parades. Barbarous and ours. The ethical formation remains. A vegetal wealth. The mines. Cooking. *Vatapá*, gold and dancing." Saffron and ocher alongside green are the colors of the Brazilian flag, Botafogo is a district in Rio and *vatapá* is a choice dish of Salvador.

Brought over from the Iberian Peninsula, baroque began to gain in popularity. It became enriched by naturalist myths and did not reject pagan traits, which were inserted into the Catholic liturgy; by the passion that the tropic expected from its guests. Scholars have expressed a diversity of opinions. There has even been a claim that South American baroque does not exist as a style since it is an extension of an uncontrolled European style. When we go and discover what remains of the ruins, which are sometimes incorporated into the ground plans of subsequent towns, it is certainly not possible to refer to one of the many interpretations that blur the distinctiveness of a style very dear to frontier art. It must be remembered that the Brazilian style flowered like a fantastic plant grown in an unsuitable nursery, a pruned plant, crudely grafted with rejected branches or, where they are accepted, are accepted with bad grace by unenlightened experts. This peripheral baroque blossomed, however, and has its own vitality.

The Portuguese, apart from the wars against the dissidents who were denounced by the Council of Trent and who tried to expropriate territory, had to look to contributing to the safety of their colonial beginnings, justifying and making them acceptable, which was almost an exercise in ideological policing. The monumentality of the churches represented power. The Jesuits asked for projects from the mother house. Other orders built as the occasion demanded but always obtained permission from the Council of Conscience and Orders, which issued building licenses from Lisbon.

Builders, carvers, painters, sculptors, their Indian, black and mulatto helpers all contributed as best they could. With a little imagination the spirit of adventure of the navigators can be discerned in the methods of building. Similarly, the navigators introduced to Portugal the then-curious shapes of the Orient, which implies a degree of cultural and racial harmony, the overcoming of fideistic prescriptions, a pact of friendship. The style was pompous, like the Spanish one in Mexico, where it was more monumental, being intended for the survivors of a people originating from grandiose civilizations.

The baroque spread easily. Its sumptuousness, which began with architecture, was in keeping with the dramatic processions and solemn catechizing, used to reinforce a fear of the hereafter, instilling faith in those who

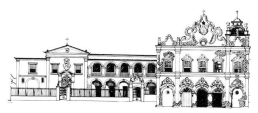

Luís Gonçalves, drawing of the Carmelite Foundation in Cachoeira. The right-hand side of the drawing shows the facade of the Church of the Tertiary Order of Carmelites, the construction of which was begun around 1702.

administered the divine will. The centers of nonreligious popular gathering were the large trading fairs, similar in some ways to the carnival, where the necessity for reform was discussed in secret, giving birth to a barely adumbrated hope for freedom. It was difficult to discard the insistent and all-important *concursus Dei*, but there was an increasing desire to find a way to organize the country, which was realized only after independence.

Theatrical performances were not only religious but also political. In one play, a character called Despotism appears with three shepherdesses, War, Peace and Union, and, as a finale, Authoritarian falls to his knees at Union's feet singing: "Always hold in your breast/A firm love for Union/All should remember this maxim/And keep it in the depths of their hearts." The theater was important because it represented, and continues to represent, a readily accepted art form.

The Church excelled in maintaining harmony among the mixed population, especially between the Indians and Africans, by tolerating the remembrance of their traditional idols. The consequence of this tolerance was a spread of spiritualism and numerous superstitions colored with paganism.

Sculpture, painting and gilding became progressively more gaudy in church decoration. There was not a ceiling, vault or wall that failed to be decorated with a wealth of moldings: volutes guessed at rather than measured with accuracy, painted episodes enclosed in large over-ornate frames, pulpits with baldachins that were decorated with historical scenes, and a profusion of angels everywhere. Winckelmann is said to have come out of one of these "golden chapels" perturbed by the lack of a sense of nature and taste and by the disproportion and the disproportionate, saying that, as a fervent classicist, he would have set fire to such an artistic transgression.

Painting, which generally prevailed only on ceilings, was without exception carried out by copyists rather than by professionals, the subjects being taken unashamedly from prints and missals. This was very different from what occurred in the Spanish colonies where artistic schools flourished with iconographic freedom and a rich, imaginative style. In some chapels in Brazil, the painter charms the onlooker with the emotion that inspired him to sketch a head encircled with a halo. As can be seen in the following pages, there were some very remarkable painters. They came to the missions already trained, and their works are remarkable for their technical skill, reflecting the schools the artists attended in Europe. If some paintings portray secular themes, it is to underline events of a religious life, as occurs in the evocation of the battles against the Dutch, illustrations that were prompted by the Counter-Reformation. Deviations from these kinds of subjects were not recorded, except for some oversights, such as in a convent at Salvador where ceramic mural panels from Portugal were put up, portraying sacred and also profane scenes, the latter taken from Horace.

Nonreligious themes were rare and almost exclusively concern scenes from life as shown in ex-voto pictures, tales of miraculous events that occurred through divine intervention. Not even Frans Post devoted himself to truly secular themes, absorbed as he was in the portrayal of a well-groomed nature in the Dutch style. Those painters who stand out almost always belong to the orders, the Jesuit and particularly the Benedictine ones. It is interesting to note the artificial and, at times, odd perspective of the faces, which look as if they are focused with a "fish-eye" photographic lens. Scene painting was governed by the rules of orthodoxy and is devoid of suggestions and surprises.

Sculptors abound, some important, such as Agostinho de Jesus and his pupil, Agostinho da Piedade, from the Benedictine order, who both operated outside the exaggerated baroque style and were capable of a direct mystical fervor. Their figures are spectacular, and for speed, many statues were clothed trunks with only the head, hands and feet sculpted. Sculptors often doubled as

Armand Julien Pallière, *Rua e Hospício dos Bárbaros*, 1818. Lithograph; 6.29" × 9.05" (16 cm × 23 cm). F. Marques dos Santos collection.

carvers, many being the descendants of the Indians and Africans, both races accustomed to sculpting, the Indians as makers of anthropomorphic vases and the Africans as surrealists and makers of enigmatic fetishes. As helpers, the sculptors interpreted the assignments they were given in their own way and, for example, instead of a symbolic bunch of grapes they would portray a pineapple. They gave space to the Madonna, St. Anthony and St. George, identifying them with their Oxalá, Ogum and Iemanjá. The latter are still celebrated today in a fantastic ceremony consisting of a riotous procession to the sea, where gifts are thrown to the Mother of the Waters, a goddess who, after committing incest with her son, is said to have given birth to countless deities. During the course of time, this goddess has been assimilated into the legend of the Holy Conception by Afro-Catholic syncretism.

These characteristics, this simplistic manipulation and naivety, make a work of art a curiosity so that it can by no means be judged according to current aesthetic standards. Art, as an attempt to propagate and strengthen faith, had to amaze, divert and entertain. In the rush to produce, no thought was given to critical considerations. There were some cases of positive evaluation, however, among the young Brazilians whom Portugal received for instruction in colonial administration. One such Brazilian in the seventeenth century was Manoel Botelho de Oliveira, who distinguished himself as a writer and dramatist and took stock of the arts. "In this America, in an ancient uncultured habitation of barbarous Indians, there was no hope that the muses would become naturalized as Brazilian; but in spite of everything, they still wanted to visit this emporium."

Intellectualism had its "emporium" in Salvador, the capital where the decisions received from Lisbon were centralized and transmitted. These were times of discussion with political undertones. Finally, two personalities became restless. They were the Matos brothers, Eusébio, a Jesuit, the musician and poet called "the father of painting in Bahia," and the liberal Gregório, a bohemian poet considered to be "our Camões." Gregório was a commentator on colonial life, from the conquest to civil and religious disagreements and controversies, who was guilty of spreading the idea of ending slavery, the most daring revolt against the regime. Like Quevedo, for the conformists Gregório "exceeded the limits of decency and sometimes failed to be a gentleman," for which he ended up exiled in Angola.

Civil unrest did not lead to events that could shake the system. The vigilant Inquisition, the close agreement between the government and the Church, the indifference of the landowners, whom the chronicler Fernão Cardim described as "very coarse people, possessing forty, fifty or eighty thousand *cruzados* and seeking to enjoy their fortune," were all factors that maintained the regime. Wealth counted more than anything else and manifested itself primarily in the houses. The gentleman's home, the *solar*, the spacious "large house" and its appearance contrasted with the municipal buildings, which included the prison in front of which was a *pelourinho*, a column to which disobedient slaves were tied and whipped.

The frivolity of the middle classes took hold. Cardim writes, "They dress their wives and daughters in as much velvet, damask and silk as possible, and they do so to excess. The women are very sophisticated and not very devout.... The men are very fond of merrymaking, given to banqueting and they drink wine from Portugal." As regards women's devotion, in the seventeenth century which overflowed with convents, only one was allowed in Salvador, dedicated to St. Clare in Exile, a luxurious place where the worldly revelry of the nuns was a scandal.

In Recife, after the expulsion of the Dutch, life was the same. One person commented, "There is more vanity here than in Lisbon." This vanity, hailing from Portugal, prompted the desire for self exhibition, a dandyism that

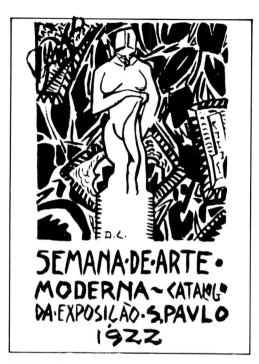

Di Cavalcanti, cover of the catalogue for the exhibition held in São Paulo's Teatro Municipal in 1922 for the Semana de Arte Moderna.

exemplified the spirit of the baroque. Gold and silver objects were imported to decorate houses and horse harnesses. This was the start of pomp and exaggeration.

Finally, it was the great discovery of gold that threw the colony into confusion and encouraged the greed of the Crown. Gold, as the discoverer of America had said, is a very excellent, cherished thing, and its power is capable of uprooting souls from Purgatory. Indeed, in Lisbon people lost their heads and, for fear of smuggling, tripled surveillance. A frenzied excitement reigned.

Adventurous men from São Paulo struck gold in Minas Gerais. In a few years the region became the "land of milk and honey" to which, once the news had spread, there flocked vast numbers of greedy men with, as always, masses of slaves who received no benefit except for the legendary one who, a former sovereign in Africa, became king of the mines in Minas Gerais.

The Jesuits attempted to give the Indians social status and took a stand against colonies that persisted in subjugating them. Father Vieira had already tried to create better conditions for Indians in Maranhão, without success, and finished by being accused of heresy and having to account for his actions to the Inquisition.

The most complicated experiment occurred in the *reduções*, in the region of Guarany, on the border between Brazil and Paraguay. The Jesuit order organized agricultural and craft work, which was run according to a very methodical and strict regime; the villages were arranged and laid out like the *castrum* of the Roman legions; catechumens were instructed making suitable allowances where necessary. *Autos*, religious plays, notably enacting the lives of St. Laurence and St. Sebastian, were used in opposition to the Indian demons. In the small-scale missions the Jesuits erected the monumental church of São Miguel at Santo Angelo, its architect being the Italian, Giovanni Battista Primoli, an advocate of Palladianism. In 1767, the marquis of Pombal, the prime minister of Portugal, expelled the Society of Jesus from Brazil.

Meanwhile, Europe began to pay more attention to the Americas. Naturalists delighted in making comparisons between the Old World and the New World. Count Buffon discovered in the New World "something conflicting with the aggrandizement of living nature." That statement actually contradicts reality, because in Brazil nature becomes more exuberant.

Interest in Brazil continued, more for its gold than its vegetation. Jealous of this fortune, Portugal built more fortresses, one even in Guaporé on the border with Bolivia, which was the work of an Italian engineer, Domenico Sambuceti, and was later abandoned and swallowed up by the forest. Two hundred strategic ports along the coast were armed to guard against pirates. The obsession was such that the Crown buried its head in the sand. For example, it prohibited the spread of a book by the Jesuit Giovanni Antonio Andreoni, whose Portuguese pen name was the anagram André João Antonil, *Cultura e Opulência do Brasil por suas Drogas e Minas*, fearing that other countries would be aquainted with what was by then common knowledge: the abundance of sugar, tobacco, mines and cattle. The book is of great interest for the advice it gives to the *senhores de engenho* (sugar manufacturers) concerning the treatment of slaves.

The discovery of gold gave new impetus to the arts and provoked unexpected concessions from the rulers. A decree allowed small theaters called "opera houses" to be opened in some towns, with the aim, however, of teaching the people "sound principles concerning politics, morals, love of the homeland, valor, zeal and the loyalty with which they must serve their sovereigns." Along with the theaters, pastoral plays were written in imitation of the European ones. Among the learned men was a philosopher, Matias Aires Ramos da Silva d'Eça, who criticized vanity and was author of an important book on the problems of civil architecture. He was the son of a very rich man

Ismael Nery (1900–1934), *Death and Ascension*. Drawing; 15.74″ × 7.87″ (40 cm × 20 cm). Private collection.

who gave enormous sums of money to build churches, calling in artists from Portugal.

With the resources that were available, the orders busied themselves building more churches and convents. The greatest development occurred at Vila Rica, the present-day Ouro Prêto, which UNESCO has recently recognized as the most important historical city in Brazil.

There were three styles that alternated and interbred in seventeenth-century architecture with the most surprising unions, builders' interpretations and clients' interventions: mannerism, baroque and rococo. The long periods of construction, which sometimes dragged on for many years, produced modifications and additions that reshaped the initial designs. Another more restrained style, neoclassicism, then joined the pseudo-styles.

After its degradation into the novelty of rococo, imported from Portugal, which had received it belatedly from France, the baroque, originally a result of free expression, could not tolerate any other styles. The reaction against over-decoration favored, to a certain extent, the establishment of neoclassicism. This came to the fore in the north at Belém, capital of Pará, through the activities of Antonio Giuseppe Landi, whose unorthodox style resulted in a tasteful composition of simplified elements which can be seen in the facades of the religious and civil buildings commissioned from this Italian architect.

How could this rather melancholy style, also called Pombalesque, thrive in the tropics after a thirdhand transplant? The case of Belém remains an isolated one. Attempts to introduce neoclassicism in Rio de Janeiro made during the following century met with a similar lack of success.

In the region where gold was discovered and extravagantly spent, there is a revised style of baroque that, however, is not as imposing in the churches and administrative buildings. The houses, on the other hand, conform to a neat functionality, which gives the cities a face characterized by an elegant autonomy of style.

Furniture was very refined. In the sacristies and large houses the most precious wood, *jacarandá*, was used, and the styles reflect Portuguese taste imported from England. The "Chippendale" that derives from it receives markedly baroque alterations, typical, after all, of this style with its many historical references.

Artisans were very active, despite the flood of prohibitions which led to the closure of shops suspected of smuggling. Cabinetmakers, potters, silversmiths and goldsmiths made what was required for the extravagant life-style of the wealthy. Dress tended to be eccentric, as did carriages, horses' harnesses and, as was the custom, liturgical ornaments and vestments. The processions formed a spectacle of theatrical display, confirming the fanatic religiousness that was truly felt and practiced. Among such gaudiness there emerged an artist who was to exalt and conclude that period of prosperity.

The illegitimate son of a Portuguese master architect, Antonio Francisco Lisboa was a mulatto nicknamed Aleijadinho ("Little Cripple") because of serious deformities of his hands and feet. He was well taught and knew a great deal about the Vila Rica school, which kept up to date with what was happening on the other side of the ocean. The small town buzzed with a certain amount of culture and boasted the presence of poets, artists and musicians. According to reports, manuscripts were being handed around because of the pressure of the Inquisition. A comic actor, Antonio José da Silva, having dared to criticize the ruling class, was burned at an *auto-da-fe* in Lisbon.

Aleijadinho worked in a difficult environment but, as far as we know, was accepted by the servants of God. His style was typically Catholic and popular in spirit. Perhaps, although it is not known for certain, he shared the sentiments of the intellectuals of Minas who wanted to free Brazil from the Portuguese yoke. It is thought that the prophets that he sculptured from blocks

J. Borges, *The Woodcutter*. Woodcut.

of soapstone in front of the Sanctuary of the Bom Jesus de Matosinhos in Congonhas do Campo represent the martyrs of the conspiracy led by Tiradentes, the champion of Brazilian independence, who was arrested and cruelly hung, drawn and quartered.

The visitor to Ouro Prêto, São João del Rei, Sabará, Mariana, Congonhas and Diamantina in Minas will find architecture of high quality. Some of the buildings are said to show the influence of the master who was hailed as the "new Praxiteles" during his lifetime, and, in the twentieth century, as "the mulatto El Greco" by André Maurois and "Brazil's Michelangelo" by Germain Bazin.

The personality of Aleijadinho is complex and is based on the influence of various cultures. His work is distinguished by its composure of forms, whether in a simple wooden figure or an elaborate building. We shall leave to more meticulous researchers the task of tracing, in his work, the influence of Borromini, neoclassicism and the still powerful baroque tradition. A terse gothic expressionism, achieved through a deep knowledge of modeling, shines through his sculptures in the way he captures insights and emotions, always from a popular starting point.

We should mention here Manuel da Costa, the most important painter of Minas, who worked alongside Aleijadinho together with other talented colleagues like Leandro Joaquim and Manuel Dias de Oliveira.

Meanwhile, Europe was overturned and reshaped by the French Revolution and Napoleon. The Portuguese royal household quickly set sail and took refuge in Rio de Janeiro. The first undertaking of Dom João VI was to Europeanize the capital—its churches, convents, the temporary residences of landowners, the barracks and the headquarters of colonial bureaucracy—against a backdrop of the wretched life of the slaves.

The prince regent embarked upon an ambitious plan of reform and building. As far as the arts were concerned, in 1816, on the advice of his accredited ambassador to Paris, where an attempt was being made to return to the times of the monarchy, he invited to Brazil a mission of Napoleonic artists headed by Joaquim Lebreton, the former head of the École des Beaux-Arts. Among them were eminent people like Sigismund von Neukomm, a pupil of Haydn, and the painters Nicolas-Antoine Taunay and Jean-Baptiste Debret.

The Portuguese court artists and those in charge of sacred art were shocked by the change in their situation and gave them a frosty reception. The instigator of this killjoy attitude was Manuel da Costa, an "architect, painter, carver, musician and authority on all the arts," as he described himself. We mention him as an example of the difficulties that await all those who are called upon to become involved in the problems of the arts in a foreign land. From these disagreements the Escola Real das Ciências, Artes e Ofícios was formed, later shortened to Academia Imperial de Belas-Artes.

The attempts to transplant the novelty of neoclassicism to the detriment of baroque showed no sign of success. Public opinion no longer expressed wild enthusiasm for taking part in a religious procession; they were excited about a mythological figure that had been prepared for the marriage of Dom Pedro I, an allegorical chariot that portrayed America inside an enormous shell drawn by sea horses driven by Neptune. The chariot was surrounded by golden dolphins and the new America stood with bow and arrows in one hand and the royal arms in the other, surrounded by crowds of Indians. The carnival was fast approaching. To the usual cry of independence or death, Dom Pedro I signed the constitution and a liberal atmosphere began to filter through, without, however, shaking the attitude of the ruling classes. Slavery continued.

The first few neoclassical buildings seemed eccentric. The architect of the French Mission, Grandjean de Montigny, was famous in Europe and was a stout supporter of Greek and Roman archaeology. He failed to introduce

Italo Cencini (born 1925), *The God of Wheat*,
1957. Drawing; 13.38" × 14.56"
(34 cm × 37 cm). Private collection.

American elements into his style, unlike Latrobe who, in Washington, inserted a tobacco leaf in column capitals. It would have been a good idea to put the splendid "parrot-beak" plant in the capitals in Rio. But architecture and the rest of the arts were moving into second place. The new political setup in Brazil, which had finally opened its doors to all nations, favored the commercial sector. Dockyards, customhouses, hospitals, slaughterhouses, markets, prisons and a mint were built, all of which did not exist before, or existed only in primitive forms.

Painters were ordered to contribute to the glorification of the regime. So as not to set aside the Catholic tradition, the theme of the first canvas was, *Our Lady of Mount Carmel, as the queen of heaven, blesses Dom João VI, the queen and the princes Dom Pedro and Dom Miguel, the latter led by the hand by angels.* Secular culture awoke from its slumber, and there were disturbances that were increasingly anticolonial in flavor. The middle classes did not take time to reflect on the slow change that was taking place; people tried to forget the past. A minister had the unfortunate idea of burning all the records he held on slavery. Masonic lodges were formed, one of which was called "Commerce and Art," the first word meaning "dialogue", the second referring to the "architecture of the universe." Everything came from Europe, from political beliefs to fashion, and emigrants flooded in, among them artists, learned men and industrialists.

Brazil took part, although with meager exhibits, in the Great Exhibition held at the Crystal Palace in London in 1851. Gone were the times about which, a century before, the shrewd Antonil wrote, "These are callow people whose conversation is limited to horses and cattle." Political discussions were popular and people took part in the general reorganisation, which received great impetus under the reign of Dom Pedro II, a person of progressive ideas and deeds. Brazil settled down among clashes between the conservatives and other parties, uprisings, reactions from the landowners and the noble campaigns of the abolitionists. The Braganza empire fell and the idea of a republic made headway, though dogged with serious problems.

The advent of the republic coincided with a profound change in the people's mentality, which was inextricably linked with agriculture. This same link was also strong in the emigrants who originally came from the countryside and in their masters who came from the same rural background. This was an important turning point which meant changing from one way of life to another and venturing into the preindustrial era, replacing familiar trappings with increasingly important new ones, accepting foreign entrepreneurs and adapting to innovations and to a new culture.

Amid all this fervor, the arts were caught up in the whirl of modernization, but at a slower, more irregular pace. The academy founded by the French introduced the concept of official art and produced artists of an acceptable standard of professionalism who, however, were not to try to take part in the breakthroughs that shook Europe. Some painters were sent to Paris and returned without having been aware of impressionism.

The poets in the Café d'Europe became involved in romanticism, which was dying out in Europe, and formed a group that published the magazine entitled *Nichteroy*. They returned to the origins—the heavenly Garden of Eden mingled with a cannibalistic hell—all translated into affected poetic terms. In spite of the romantics, a talented poet emerged without Brazil realizing it. He was Joaquim Souza de Andrade, called Souzândrade, a forerunner of the use of imagery characteristic of the *Cantos* of Ezra Pound, ironic and concerned about the political development of the country, as was Pound himself.

Eclecticism, the strength of the academy and the succession of trends and fashions that spread from Paris had repercussions involving some key centers and giving rise to timid, isolated avant-garde groups.

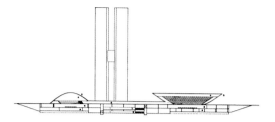

Part of the National Congress buildings of Brasilia, designed by Oscar Niemeyer, 1958.

Positive contributions came from a few foreigners, such as the architects Victor Dubugras and Carlos Ekman, who managed to build art nouveau houses in provincial São Paulo.

Not until 1922 did something new suddenly happen. The Semana de Arte Moderna was organized by a small group of literati, painters, sculptors and musicians who had decided to take a stand against continued adherence to ideas that were behind the times. This took place in São Paulo and was anticipated by two events: the exhibitions of Lasar Segall and Anita Malfatti, in 1913 and 1917 respectively, which showed expressionist paintings. Segall was a Russian who had come from Berlin and Malfatti was a young Brazilian woman who had studied with Lovis Corinth. The two artists broke the academic monopoly and were met with a stream of hostile sarcasm. The Semana was also received badly; suffice it to recall the scenes at the futuristic evenings held by Marinetti, who spent a brief time in Brazil.

The environment was not ready and could not even appreciate Vítor Brecheret who, returning from Paris, tried, in terms of art deco, to redefine sculpture, which had lapsed into academic formulas. The same occurred with the music of Heitor Villa-Lobos. But the group that promoted the Semana, with the writers Menotti del Picchia, Oswald and Mario de Andrade at its head, pursued the dispute tenaciously. The spirit of the exhibitions was nationalistic. The writer Sérgio Milliet said, "In our language, love, society, tradition and art, we will fulfill ourselves as Brazilians. The sacrifice for this ideal is good and will not be in vain. We will stop being governmental so as finally to be Brazilian. We will stop being Frenchified, Portuguesified, Germanized and I don't know what else, so as to become truly Brazilianized." Once again, as occurred with the romantics, the seductive theme was that of the noble savage, now assuming the role of a devourer; Oswald's poster is entitled *Anthropophagy*.

Meanwhile, another Russian, Gregori Warchavchik, took the first steps towards rational architecture. Le Corbusier who, in 1929, had tried to obtain a project in São Paulo, returned in 1936 for a series of his propaganda conferences, firing a group of young people with enthusiasm. They later constructed the Ministry of Education and Health building in Rio de Janeiro according to one of his drawings. The murals of this building are by Cândido Portinari, the talented illustrator of contemporary daily Brazilian life. Oscar Niemeyer, one of the architects on the Le Corbusier project, was to have the task of building the new capital, a unique and much-discussed project, which, in any case, is a testament to its creator's originality. Niemeyer used the town plan of Lúcio Costa and the calculations for the unusual structures of Joaquim Cardozo. Perhaps Niemeyer's greatest achievement was to have overcome the complacency of modernist experiments with buildings that are identical in form, and those of the international style, anticipating the post-modern controversy.

In the postwar period, thanks to the initiative of Assis Chateaubriand, the first museum planned according to current criteria was opened. For the first time in Latin America an extensive gallery of Western art was formed, from Daddi and Raphael to Velazquez, from Manet to Van Gogh, Modigliani and Max Ernst, promoting large exhibitions of a didactic nature. At the same time, the museum opened schools of the plastic arts, including industrial design, cinema, music and theater, prompting useful discussions that have led to the emergence of other museums favoring the modernization of the arts.

Modern Brazilian Architecture
by Oscar Niemeyer

...chiaroscuro, the third dimension...

In order to discuss Brazilian architecture I must comment on the mis-understanding that, in my opinion, has distorted contemporary architecture. By architecture I am, of course, referring to that with reinforced concrete structures and not to that based on metal structures which prevails in the United States. These materials have such different characteristics that normally they should constitute opposing styles, or, at least, dissimilar ones. The technique using reinforced concrete suggests to the architect the most unexpected shapes, plastic freedom and free and creative curves which the other, linear and restricting, rejects. The metal structure technique, a simpler and colder form of architecture, is far from the roads of imagination and fantasy.

Unfortunately, the difference between the two techniques has not been well analyzed and those responsible for contemporary architecture have accepted a common plastic vocabulary that is poor, rigid and incapable of expressing the possibilities and spirit of reinforced concrete. Then the rules arrived, the eternal "experts" on architecture, the purists of the time, and so on, and with them functionalism became an unquestionable watchword.

The first rough plans to appear, full of vigor and boldness, were put to one side, and fantasy was repressed as superfluous and unnecessary. "Any perfect structural solution is beautiful," said one of the great masters of reinforced concrete, as though beauty were not composed of research, creation and poetry. "Less is more," others would say, a correct phrase if applied to the exemplary architecture of Mies Van der Rohe, but completely contradicting the spirit of reinforced concrete.

The only one to understand the problem and address himself to it was the old master Le Corbusier, the great artist of contemporary architecture. As Amédée Ozenfant, a friend of Le Corbusier, wrote in his diary, "Le Corbusier, after having for a long time shown purist discipline and loyalty to the respectable right angle, sensing the beginnings of a new baroque from different sources, seems to have decided to abandon it, still believing he had special rights over it. At the end of the day the born baroque artist took the law into his own hands and, as always, showed immense talent."

Rationalist architecture, having no definite direction and serving both techniques at the same time, continued to maintain its privileges. The architectural contrast of the past, chiaroscuro, the third dimension and beauty that was so sought after, was replaced by an architecture of glass cubes, threatening, cold and ostentatious, on the pavements. International architecture had arrived, so simple to produce and repeated so often that in a few years it spread from the United States to Japan.

It was not only architects who were guilty of this deplorable mistake. The Bauhaus itself took an active part in it with its implicit proposal to study a model project for each type of building. "But the Bauhaus is the paradise of mediocrity!" Le Corbusier once said to me.

In the effort to defend international rationalist architecture many things were written. Contradictions abound. In his book *Space, Time and Architecture*, Siegfried Gedion, after having strongly defended architectural rationalism, contradicts himself by saying that the curved facade of the nineteenth century was one of the great monuments of architecture.

I was aware of all this when I was designing the Pampulha project, the first real challenge to rationalist architecture. I could feel a new type of architecture coming to the fore, a different, lighter architecture, full of grace and creativity. Today, now that so many years have passed, the truth that Pampulha proclaimed has proved indisputable, with architects all over the world suffering and searching for the architectural transformation it heralded forty years ago. But the misunderstanding had lasted for such a long time and jeopardized so much that the clear, indisputable change for which the technique of reinforced

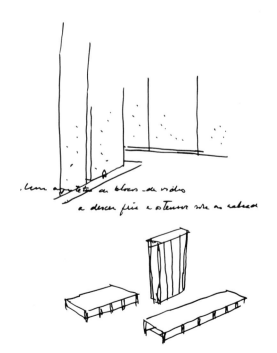

An architecture of blocks of glass, which looms up, cold and ostentatious, on the pavements.

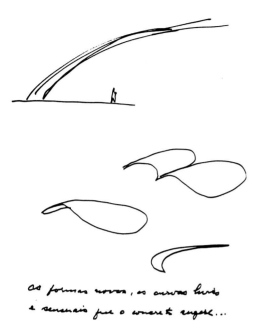

as formas novas, as curvas livres e sensuais que o concreto engole...

The new forms and the free and sensual curves that concrete suggests.

nas colunatas paralelas, os egípcios reduzindo as seções das colunas mais próximas dos edifícios procuravam, visualmente, o vão maior que hoje o concreto tão generosamente oferece.

In rows of parallel columns, by reducing the sections of the columns nearest the buildings, the Egyptians achieved, visually, a greater sense of empty space, a sense so liberally afforded today by concrete.

concrete cried out was indefinitely postponed. Then post-modernism emerged, accompanied by the most inappropriate architectural works. Even traditionalism was courted in an attempt to perpetuate the melancholy march of international rationalist architecture.

Modern Brazilian architecture developed within this tortuous and contradictory framework. Some adapted themselves to international architecture and were completely absorbed by it. Others returned to the more liberated architecture we prefer. The latter, a great many very talented architects, are without doubt the true representatives of our architecture. They are to be found all over Brazil, designing government buildings, universities, schools, office buildings, apartment buildings, clubs, theaters, cinemas and so on.

I am not able to quote names. I would risk making inexcusable omissions. But I can mention some completed works and advise those who are interested in architecture to travel a little. Go to Salvador in Bahia, for instance, and see the works of João Filgueiras Lima, the magnificent buildings he designed for the government administrative center with enormous empty spaces and spectacular structures. Go to São Paulo and admire the work of Vilanova Artigas in the city's university, the Guaimbé building by Paulo Mendes da Rocha, the CESP building by Jorge Wilheim, the Emplasa by Rui Ohtake, Eduardo Noronha's History Faculty, Lina Bo Bardi's Museu de Arte Popular and many more.

I would further recommend visits to João Pessoa in Paraíba to see Sérgio Bernardes' hotel; to Rio to visit the ABI (the Brazilian Press Association), the Resseguro and Academia de Letras buildings by the Roberto brothers, the Museum of Modern Art and the Pedregulho complex by Afonso Reidy, Lúcio Costa's Parque Guinle apartments and the subway stations by Sabino Barroso, Jayme Zetel and José Leal. Then one should go to Brasília, the city that Lúcio Costa created in the middle of the desert, the fruit of so much enthusiasm and sacrifice. Take time and look over it. Try to feel its urban and architectonic qualities by visiting the hospitals of Filgueiras Lima, the works of Milton Ramos, Nauro Esteves, Hermano Montenegro and many others, including the beautiful Sarah Kubitschek Center by Glauco Campelo. If your curiosity in architecture leads you to other continents, it would be useful to see what is being built by Brazilian architects abroad: the Universities of Constantine and Algiers in Algeria, the headquarters of Mondadori in Milan and of Fata in Turin, Italy, the headquarters of the French Communist Party in Paris, the Labor Exchange by Bobigni and the Le Havre Cultural Center in France. You would wonder at how our architecture is accepted and praised in the old world that is full of tradition and pride.

Many have asked for a more critical comment on our architecture and in order to satisfy them I shall devote a little time to recalling its main aspects and trying to justify them with irrefutable examples from the past. One of the most distinctive features of our architecture is the search for an up-to-date technology, the creation of vast, empty spaces that concrete favors. Long ago, when the limited technology of the time held them back, the Egyptians, when designing two parallel rows of columns, reduced the sections of the columns nearest the building. In this way they visually broadened the empty space between the two rows of columns. Then, with the same objective—greater space—arches, vaults, huge domes, and so on, were used. Why forsake this old preoccupation when, now, reinforced concrete allows everything, and its technicians eagerly accept the challenge? When I planned the Fata headquarters in Turin, the structure I designed was so advanced that the Italian engineer who made the calculations for it was bursting with enthusiasm. "For the first time I have been able to make use of everything I know about reinforced concrete," he said. Another feature of Brazilian architecture is its lightness, and to justify it I would bring to mind how builders throughout

O palacio dos Doges nos ensina e prova que toda forma capaz de criar beleza, tem na beleza sua principal função.

The Doge's Palace proves that every form capable of creating beauty finds its main function in its own beauty.

history have pursued this characteristic. In two of his buildings, Palladio grouped the external supports into groups of three columns each. His aim was to avoid the excessive volume that one single column would have created. Contemporary advocates of "architectural purity" would scoff at this, but not the old, ingenious Palladio.

All the different sectors of building technology evolved towards the much sought-after quality of architectural lightness. This is a matter of technical improvement, which can be seen in every field. It has even spread to industry, the electronics industry in particular, as if miniaturization were the inevitable goal. In the past, connections in metal bridges were so fine and delicate that in many cases they could only be assembled by touch.

Regarding freedom of form in architecture, the best example that I know is the beautiful Doge's Palace in Venice. With its highly-ornamented columns, contrasting with the smooth walls they support, the palace teaches us and proves that "every form capable of creating beauty finds its main function in its own beauty."

It remains for me to comment on the social aspect of Brazilian architecture and to repeat that architecture will always express the technical and social progress of the country in which it appears. On the drawing board we architects can do nothing in this regard; all we can do is protest against poverty and oppression and fight for a better, fairer world. Brazilian architecture, like all others, however, responds to varied themes and this justifies its different aspects. There are common, everyday buildings that call for a simple and economical form of architecture. These are industrial and proletarian complexes requiring prefabrication and designs that can be repeated and are easy to produce. There are also as they say, prestige buildings, in which economy is a secondary consideration and architecture enables the imagination to flourish. Obviously, within this framework, the projects are not always well thought out. They are very often ill-suited for their desired purposes. But there is a worthy minority that is spontaneous and creative. One can also sense that architecturally autonomous groups are forming, united solely by the problem of plastic freedom and technical improvement, with no inevitable common denominators.

Integrated into its time, respecting the past without being paralyzed or intimidated by it, Brazilian architecture is a significant presence in the world of architecture. In the words of the French town planner and architect, Marc Emery: "Brazilian architecture is the only independent branch of contemporary architecture."*

Paris, May 5th, 1982

* Marc Emery, town planner and architect, editor of the magazines *L'architecture d'aujourd'hui* and *Métropolis*.

The Art
of Brazil

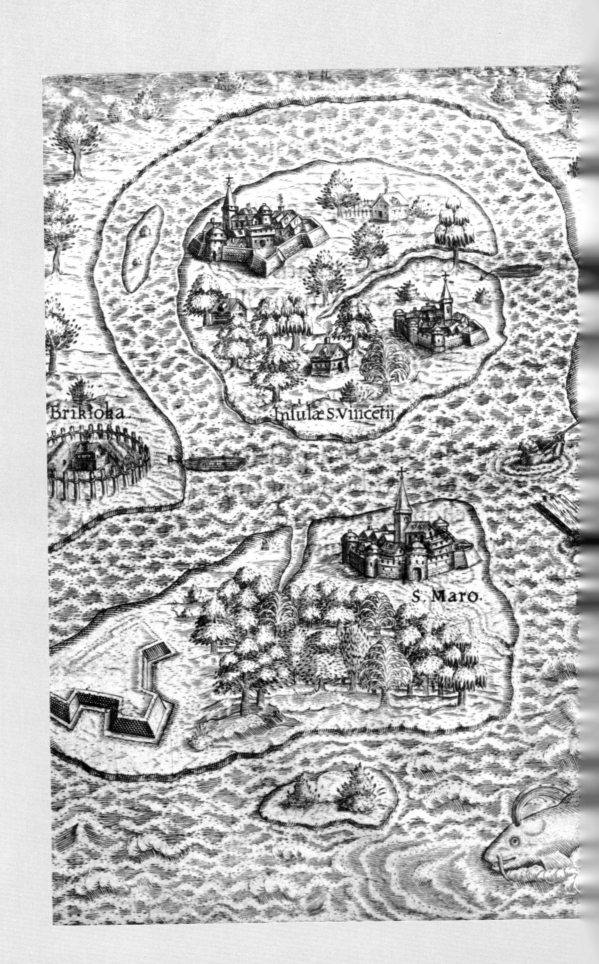

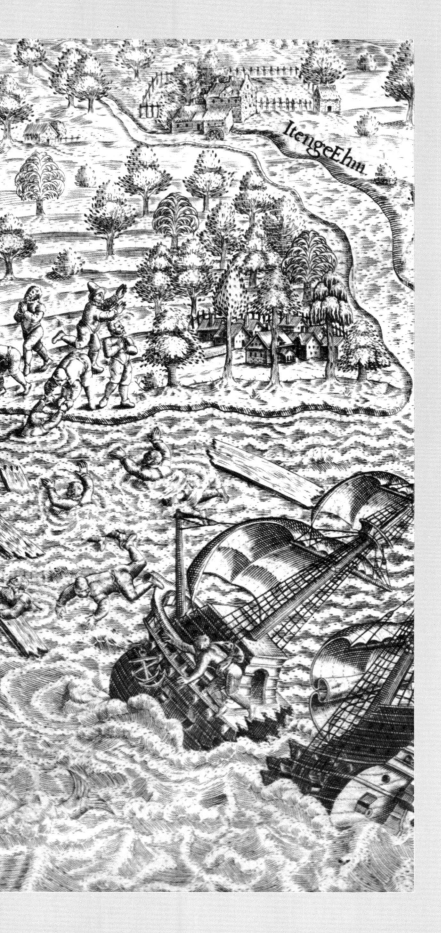

Early
Colonial Art

Early Colonial Art

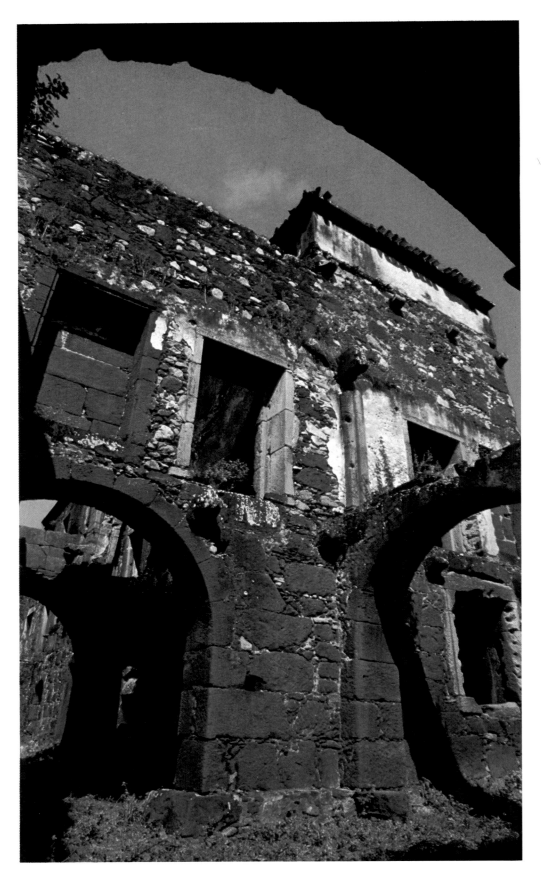

The Arrival of the Portuguese

The Portuguese discovered Brazil in 1500 and, over the following years, established themselves along the coast in makeshift outposts that became centers of trade in slaves and in brazilwood and other valuable tropical products. Pictures of that period, such as Théodore de Bry's engraving, *Americae Tertia Pars...*, reveal that the early settlements were precarious structures surrounded by stake fences (page 28) to repel attacks by the natives and groups of mercenaries, particularly French, who were vying with the Portuguese for trade with Europe.

It is not possible to say exactly how many settlements there were, but from contemporary records it appears that the most important settlements were the farm fortresses of Arraial do Cabo, founded in 1503 by Amerigo Vespucci, the one at Salvador (Bahia), founded by Diogo Álvares in 1510, and the one at Rio de Janeiro, built before 1519 and founded by João Braga.

In 1530, a new period began in the colonization of Brazil. The king of Portugal, João III, sent an expedition led by Martim Affonso de Sousa, who succeeded in driving out the French settled in Recife (Pernambuco), strengthening the garrisons and setting up the first administrations. In addition, de Sousa founded São Vicente in 1532 and, close by, Santo André, both of which served as bases for the exploration of Brazil's inland southern territories. As a result of the failure of the division of Brazil into twelve hereditary captaincies, in 1548 the government of the colony passed under the direct control of the Crown and a governor general was appointed, Tomé de Souza, who arrived a year later in

Bahia, which was declared the capital by Portugal. (The city bore the name Bahia for a long time, and it is still used by many foreigners, although the city is now called Salvador). With the establishment of civil and religious powers (the Jesuits arrived in Brazil in 1549, the Benedictines in 1581 and the Franciscans in 1584) came the first artistic expressions of the colonizers in Recife in the Bahia region, São Vicente in Paraíba and Espírito Santo in Rio de Janeiro.

The Portuguese had at their disposal many architects, builders, masons, stonecutters, carpenters, cabinetmakers and other craftsmen from Europe. By contrast, painters and sculptors were a rarity. There are records of Jesuit painters like Manuel Álvares, active in Salvador in 1560; Manuel Sanches, who came to Brazil in 1574; Paulo Belchior, active before 1600 in Salvador, Espírito Santo and Pernambuco. The first sculptor to work in Brazil was probably João Gonçalves Viana who, toward the middle of the century, made some religious figures in terra-cotta, like the statue, *Our Lady of the Immaculate Conception* (page 29) for the mother church of São Vicente, in 1560. Architecture was characterized by adapting Portuguese models to the climatic conditions and the materials available on site. The buildings usually had a rectangular plan with sloping roofs (for better drainage of rain water) comprising cylindrical stakes that supported straw and leaves of coconut palm or *sapé*, a type of gramineae. The walls were made from traditional Portuguese *taipa*—earth mixed with shredded straw, or walls in stone and lime obtained from *sambaquis*, a petrified mass of shells found deposited along the coast.

From Outposts to Urban Centers

After the arrival of Tomé de Souza, in a few years, due to the drive of the civil authorities the early settlements turned into established urban centers. In the case of the capital, for example, the defense system and town plan were designed by the same governor who commissioned Luís Dias, a Portuguese architect who worked in Brazil from 1549 to 1553, to build the administrative buildings. Around 1580 the population of Salvador already numbered 15,000 (a quarter of the urban population of the colony). The center was a large square

29

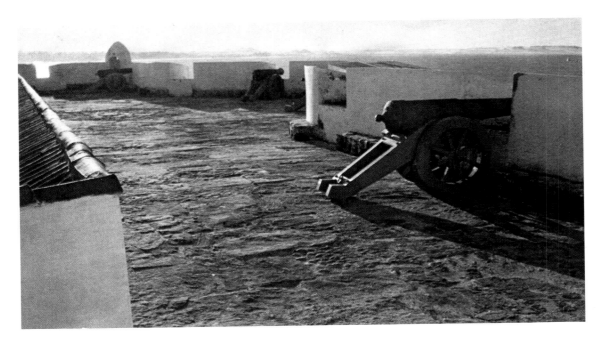

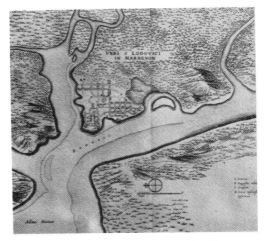

Barlaeus, *São Luís do Maranhão* (detail).
Engraving from *Rerum per Octennium in
Brasilia...*, 1648.

overlooked by the government buildings
and had numerous streets and a fair
number of stone and lime dwellings.
Other Brazilian towns, however, de-
veloped around the early Portuguese
fortifications. In 1565, Estácio de Sá
founded the village of São Sebastião do
Rio on the isthmus that connects the
Cara de Cão hill to Pão de Açúcar by
moving the pre-existing military en-
campment to a nearby hill. Almost all of
the buildings were in *taipa*, but some
administrative buildings, like the custom-
house, courthouse and prisons, had tiled
roofs and verandas. Toward the end of
the century, new stone and lime build-
ings, such as the convent of Nossa
Senhora do Carmo and the Santa Casa de
Misericórdia, were erected in coastal
areas.

Usually these towns were established
without preliminary planning and they
grew in a disorderly fashion dictated

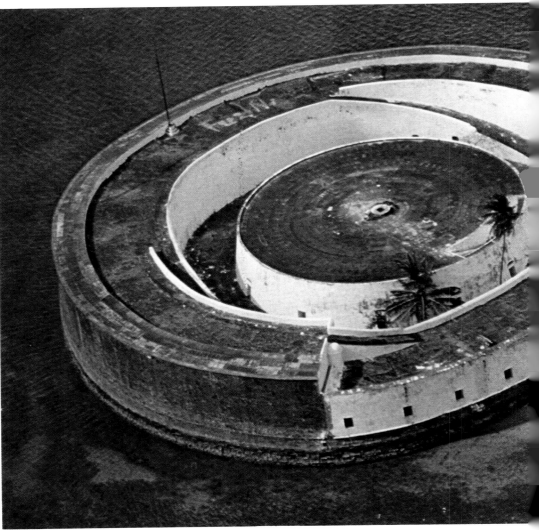

Forte de São Marcelo (or Forte do Mar),
Salvador. The work of Francisco Frias de
Mesquita (1587–1645), begun in 1623.

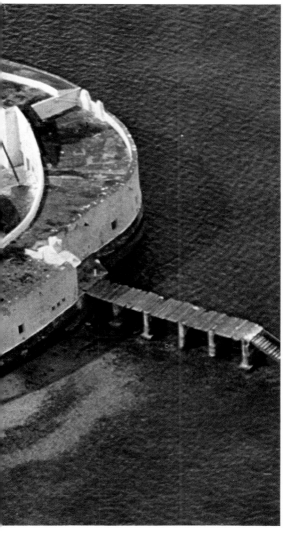

Fortaleza dos Reis Magos, Natal, Rio Grande do Norte. Built by Francisco Frias de Mesquita in 1614.
Far left, The fortress bastions; *left*, the chapel, positioned in the middle of the inner courtyard of the fortress.

by the convenience of the inhabitants and the topography of the land. For military needs, however, they followed the Portuguese tradition of the acropolis-style town built in an elevated position. Salvador and Rio de Janeiro exemplify this plan. Olinda and São Paulo were also built on high ground in defensive positions to repel possible attacks by the natives.

Olinda, founded in 1537 by Duarte Coelho, was one of the main centers of Recife at the end of the seventeenth century and had a population of two thousand whites. By contrast, São Paulo developed around the monastery of the Society of Jesus and at the beginning of the seventeenth century it was already a center of fifteen hundred inhabitants with more than a hundred houses and four churches—those of Carmo and of Jesus, São Francisco and São Bento.

Most Brazilian towns, however, sprang up on coastal plains, close to natural ports and on the banks of rivers, which offered a means of communication with the interior of the country. They were mostly spontaneous settlements, but there were many attempts by government representatives at town planning following regular, Renaissance-style plans.

Brazil's civil and religious buildings of the sixteenth century were usually mannerist in style, although simplified and adapted to local materials, since the engineers and architects, even if they belonged to religious orders, modeled themselves on Serlio and Vignola. Today, very little sixteenth-century architecture survives, since it has been destroyed either through the perishability of some of the materials such as wood, or by the Dutch at the beginning of the seventeenth century, or by the continuous reconstructive work carried out on the buildings over the years.

In the state of Pernambuco, the Church of São Cosme e São Damião in Igaraçu still has its original sixteenth-century structure with an aisleless plan and a facade surmounted by a triangular pediment. In Olinda, also in Pernambuco, mannerist elements are still identifiable in the Church of the Savior, founded in 1540, and in the Church of Nossa Senhora das Graças, begun in 1580 based on the design of a Portuguese architect, the Jesuit Francisco Dias (1538–1633), who was later to work also in Salvador.

In Tatuapara, in the state of Bahia, there are the remains of the Casa da Torre (page 28), a group of buildings forming the center of a fief that belonged to Garcia d'Ávila, a Portuguese nobleman who came to Brazil in the retinue of Tomé de Souza. Today, the best-preserved building is the chapel, with a hexagonal plan, a brick-work dome and a pyramid-shaped roof, imitating a structure that was very widespread in Portugal.

Colonial Brazil in the Seventeenth Century

In the first half of the seventeenth century the economic situation of colonial Brazil was already established. While regions south of the state of Bahia and the northern coast were still at a level of pure subsistence, the colonized areas in the interior (along the São Francisco river) had been given over to cattle rearing. Nordeste (from the mouth of the Garupi river to that of the São Francisco) was growing rich on the cultivation of sugarcane and on the sugar industry, in addition to trading in precious woods, despite repeated attempts by the French to settle south of the Amazon river.

Brazil's chief artistic expression was architecture—military, civil and religious. Its most important exponent was Francisco Frias (1587–1645), nicknamed Mesquita, a pupil in Portugal of Nicolau de Frias, who was probably his father. Appointed as "the first architect of Brazil" by the king, he reached Nordeste in 1603 and did not return home until 1634. In the course of thirty years, for the defense of the coastal towns against French incursions, he fortified Guaxenduba and other centers in Maranhão and designed numerous forts: Fortaleza da Lage (1608) in Recife; Forte de São Diogo (1609–1612) in Salvador; Forte de São Mateus (1617) in Cabo Frio and Forte de Santa Catarina do Cabedelo in Paraíba, on a pre-existing construction by Cristóvão Lins. He then regularized the town plan of the growing city of São Luís (page 30) and designed a few religious buildings, such as the monastery of São Bento (1617) in Rio de Janeiro. His name is connected above all with the construction of the Fortaleza dos Reis Magos (pages 30–31) in Natal. Erected in 1614 in brick on a pre-existing *taipa* construction destroyed by the sea, it is built on a typically Portuguese plan

Church of Nossa Senhora das Neves and the
convent of São Francisco in Olinda.
Designed by Friar Francisco dos Santos.

This Franciscan foundation in Olinda is the
oldest one in Brazil. Work to erect the
church and convent began in 1585.

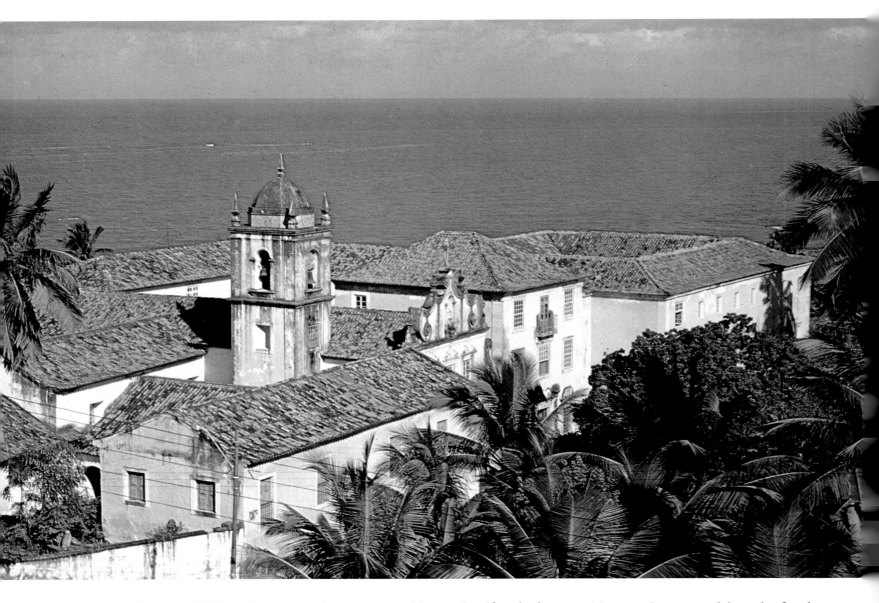

in the shape of a star with five points. In
addition, Francisco Frias designed the
Forte de São Marcelo, or Forte do Mar
(page 30), in Salvador. It has a circular
plan and is built on a rocky platform at
sea level in the port of the town. The
fortress, begun in 1623, was still under
construction the following year when the
town was invaded by the Dutch, who
completed the work, introducing a few
changes in the design.

At the beginning of the seventeenth
century, a new type of architecture
developed, still characterized by adap-
tation to the country's climatic condi-
tions, in Nordeste and the São Paulo
region. In the large estates in the north,
as far as one can tell from a few
contemporary paintings by Frans Post,

there was no architectural uniformity but
a series of variations on Portuguese
models of rural houses. It is not known
whether, on the plantations, a precise
spatial arrangement was adopted for the
buildings intended for sugar manufac-
ture, the slave dwellings and the master's
house. The only common element seems
to have been the portico of the main
facade, which sometimes had overlooking
balconies and could have been modeled
on Indian bungalows or, as some scholars
believe, could have been modified ver-
sions of the country chapels of the
Iberian Peninsula. In the farms on the
São Paulo plateau, however, a more
distinctive type of architectural grouping
became widespread. It comprised the
master's house (on a rectangular plan

with a portico recessed into the facade,
the family chapel on one side and guest
accommodations on the other), the grain
store, the mill, the kitchens, the stables
and the quarters for the *negros* or en-
slaved, indigenous inhabitants. This ar-
rangement, which was to remain un-
changed for two centuries due to the
virtual isolation of the population
confined to the area between the
Paranapiacaba mountain range and the
meandering Tietê River, was also present
in the regions colonized by the Spanish,
such as Colombia and Ecuador, and its
use was probably due to the strong
Spanish presence among the people of
São Paulo.

Buildings with porticos were also built
by the Jesuits, who created a network

Carved, painted ceiling of the Chapel of the
Tertiary Order of the Franciscan foundation
in Olinda.

Below, Statue of St. Francis in the Chapter-House Chapel. *Top right*, Cloister. *Bottom right*, The sacristy with a carved chest, in the Franciscan foundation in Olinda.

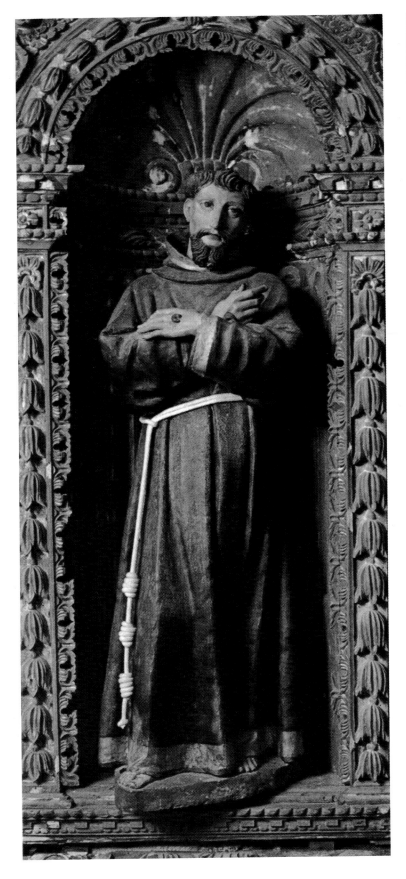

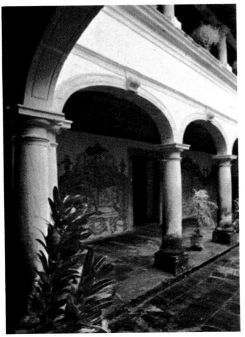

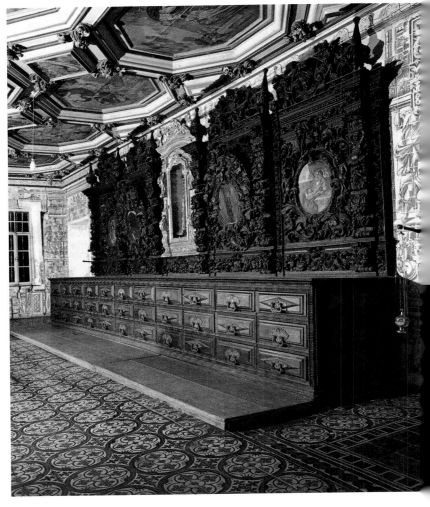

Triumphal arch, covered with gilt carvings, in the Chapel of the Tertiary Order in the Franciscan foundation, Olinda.

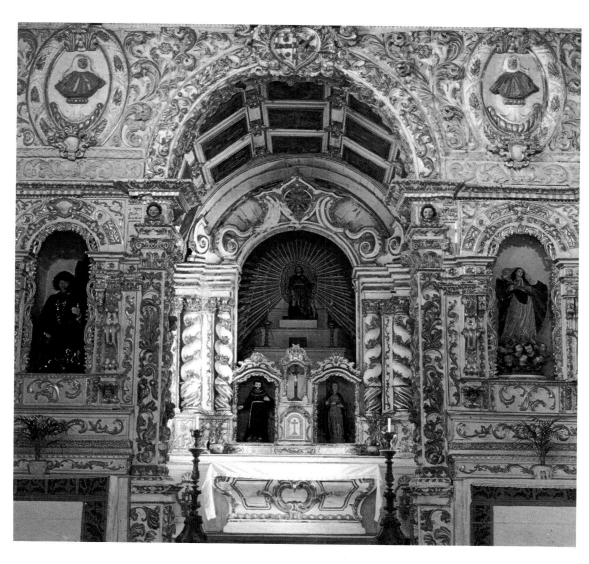

Triumphal arch, covered with gilt carvings, in the Chapel of the Tertiary Order in the Franciscan foundation, Olinda.

of villages along the northern coast, in the south and in the interior of the country in order to carry out their missionary activities. In the poorest areas, which had no specialized work force, the fathers of the Society of Jesus came up with differing solutions appropriate to the availability of local materials. Most of the mission churches are buildings that reflect an attempt at a refined architectural composition of mannerist derivation, freely interpreted and simplified by the builders, usually Mamluks (that is, children of European men and indigenous women), as in the case of the Chapel of São Miguel, near São Paulo, founded in 1622 (page 13). Mannerist influence can be seen most clearly in the interior, in the decorations of the pulpits and altars (like the retable of the high altar in the Church of São Lourenço dos Indios in Niterói, page 37)

and in the altar and ceiling paintings. Other religious orders built their churches and convents in the more densely populated coastal towns. In 1585 (a year after their arrival in Brazil), the Franciscans began the construction in Olinda of the Church of Nossa Senhora das Neves with the convent of São Francisco attached (pages 32–33). The buildings, mannerist in style and decorated inside (pages 34–35) with gilt work, painted panels and *azulejos* (ceramic tiles depicting allegorical figures and religious scenes in white and blue), were designed by Friar Francisco dos Santos (who died around 1650), the first Franciscan architect to have worked in Brazil. After serious damage during the Dutch invasion, the convent was extensively reconstructed from 1660 on.

In Salvador, which already had numerous churches, one of which was the

Jesuit one designed in 1604 by Friar Francisco Dias, the Benedictines built the monastery of Nossa Senhora do Monte Serrate. Its design is attributed to a Florentine nobleman, Baccio da Filicaia, who came to Brazil in 1591 in the retinue of Francisco de Sousa, sent to the colony to organize mining operations. The elegant simplicity of the monastery's church (recently restored), its double-slope facade decorated with pilaster strips, and its portico opposite, lead one to suppose that the influence of Baccio di Filicaia on Brazilian architecture of the day was quite strong.

The Dutch Period

From 1580, with the union of the Portuguese and Spanish Crowns (which was to last until 1640), the Brazilian colonies were practically left to their own

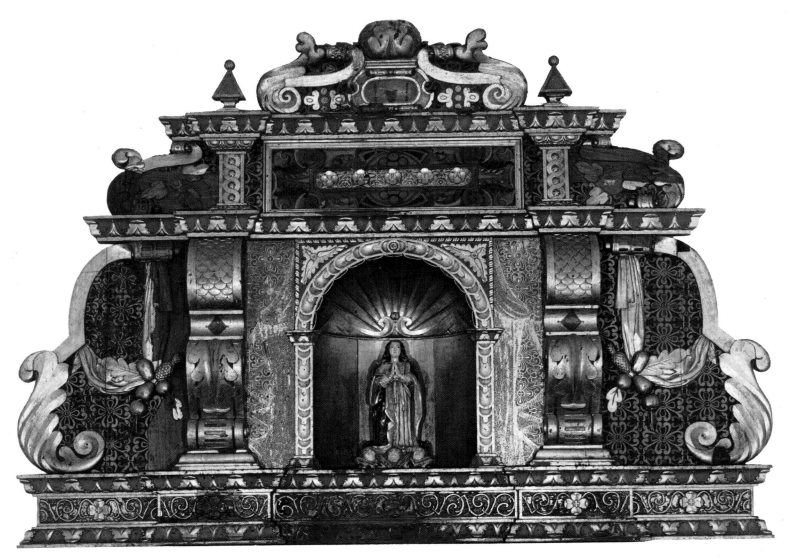

devices and had to resist repeated attacks from the English, French and Dutch. Between 1630 and 1654, however, virtually all of Nordeste passed under the control of the Dutch East India Company. The years during which count Maurice of Nassau ruled (1637–1644) were, due to his direct intervention, particularly fertile for the art and culture of Brazil. In the capital, Recife (renamed Mauritsstad), the governor personally supervised the extension and urban reorganization of the town, using the plans of the Dutch architect Pieter Post (1608–1669), who was one of the main exponents of Dutch classicism.

To meet the requirements of an ever increasing population, in the old town (built in 1526 by the Portuguese) the public administration buildings, commercial offices, storehouses and workshops were centralized. A huge residen-

tial area, which included woods, gardens, and the Fribourg Palace (the governor's residence), was built from scratch on the island of Antônio Vaz, which was connected to the mainland by a series of bridges. When Maurice of Nassau left for the Netherlands, Recife had almost two thousand buildings that were built entirely of stone and brick and had narrow facades, were two or more stories high and were topped by pointed roofs. Building materials were imported directly from Europe, like the specialized work force, or obtained by plundering existing Portuguese buildings. Almost all the churches in Olinda, for example, were demolished for their stones, bricks, tiles and timber. The Dutch capital was short-lived, however, since during the Portuguese reconquest of the Nordeste region it was almost completely destroyed.

The Nassau period was also of particular importance in the history of Brazilian culture because of the intense activity of a group of painters connected with the governor. Other painters who had already worked in the Portuguese colony included Jean Gardien, a portrait painter who arrived in 1555 in the retinue of Jean de Léry. Hierônimo de Mendonça from Portugal was in Olinda in 1595 and the painter Rita Joana de Souza, who died in 1618 at the age of twenty-three, was born and lived all her life in Olinda. In addition, as tradition would have it, during the Dutch period there were many Flemish, Dutch and German artists in Pernambuco. The "Nassau painters," however, were the first, not only in Brazil but in all of the American colonies, to tackle nonreligious subjects such as local landscapes, still-life paintings depicting the flowers and fruits of the New

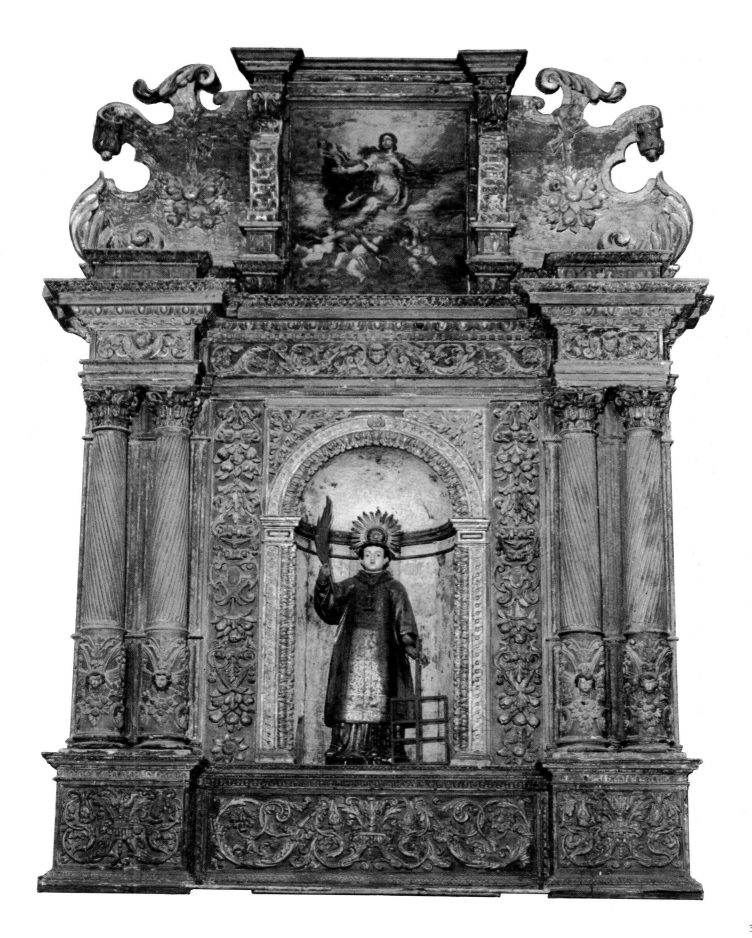

Retable of the high altar of the Church of
São Lourenço dos Indios, in Niterói, Rio de
Janeiro. Early seventeenth century.

1680), younger brother of Pieter, came to Brazil in the retinue of Maurice of Nassau in 1637 and left before 1644. The paintings known to be by Post, numbering almost 150 and, for the most part, dated and signed, all depict Brazilian landscapes, even though many of them were painted after his return to Europe. Although fond of a style that was already old-fashioned in relation to Dutch innovations in landscape painting, Post knew how to tackle the portrayal of the picturesque tropical country and its inhabitants without ever being guilty of an excess of detail or the easy game of color effects. In his European paintings, he tended to replace direct excitement, roused by contact with the sumptuous and novel spectacle of Brazil (*The Island of Itamaracá*, 1637; Mauritshuis, The Hague; *The São Francisco River*, 1638; Louvre, Paris; page 41) with an affected application of tried and tested formulas (*Olinda*, 1650–1654; Museu Nacional de Belas-Artes, Rio de Janeiro; page 43). In some works, however, like the huge *Brazilian View* (1625; Rijksmuseum, Amsterdam; page 42), Post exalts the richness and majesty of the tropical landscape in a harmonious idealization. Apart from being a landscape painter, Post also carried on a lot of work for Maurice of Nassau. It is highly probable, in fact, that he had a hand in the decoration of the Fribourg Palace in Recife. After his return to Europe in 1645, he made a few drawings for some of the carvings showing the *Rerum per Octennium in Brasilia . . .*, *História* (1648; Amsterdam), commissioned by the governor from the poet Caspar van Baerle (or Barlaeus), a work on which Georg Marcgraf, the cartographer, also collaborated.

Paintings protraying the natives of Brazil (*Mamluk Woman*, 1641; and *Dance of the Tapuias*; National Museum of Denmark, Copenhagen; page 44) and still-life paintings with tropical flowers and fruits were, however, the speciality of the Dutchman Albert Eckhout (1610–1665), who was in Brazil from 1637 to 1644. A group of his paintings was included in the "gifts from Brazil" sent by Maurice of Nassau to Louis XIV in 1678 and was used as a model for a series of eight tapestries (known as *Grandes Indes* and *Petites Indes* depending on their size) reproduced several times by the Gobelin Works between 1687 and 1730. A new series, *Nouvelles*

World and documentary images of natives and exotic animals.

In a letter accompanying the "gifts from Brazil" sent in 1678 to Louis XIV, king of France, Maurice of Nassau said that he had no fewer than six painters under his orders in Recife. The list began with the two most talented artists, Frans Post and Albert Eckhout, and continued with the German artist Zacharias Wagener (1614–1668), a soldier in the East India Company and author of the *Book on Animals* (kept at the Kupferstichkabinett, Dresden), comprising 110

water colors; the German cartographer, Georg Marcgraf, creator of the maps and about 100 drawings of plants and animals for *História Naturalis Brasiliae* (1648); Gaspar Schmalkalden, another German soldier of fortune who in his *Diary* (kept in Gotha in the Thuringia Library) describes with the help of maps, water colors and drawings, the flora and fauna of Brazil; and lastly another cartographer, who may have been either Cornelis Goliath or Jan Vingboons.

The Dutchman, Frans Post (1612–

Left, Frans Post (1612–1680), *Gentleman's House Under Construction* (detail). Oil on wood panel; 18.11″ × 18.89″ (46 cm × 70 cm). Private collection. *Bottom,* Frans Post, *Church with Portico.* Oil on wood panel; 14.17″ × 18.89″ (36 cm × 48 cm). Private collection.

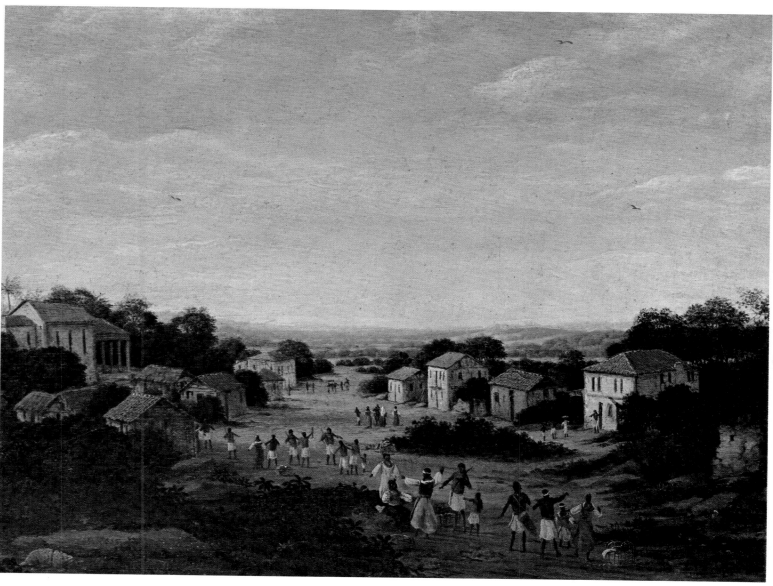

Frans Post, *The Arrival of Nassau*, 1657. Oil
on wood panel; 18.11″ × 32.28″
(46 cm × 83 cm). Américo Ribeiro dos Santos
Collection, São Paulo.

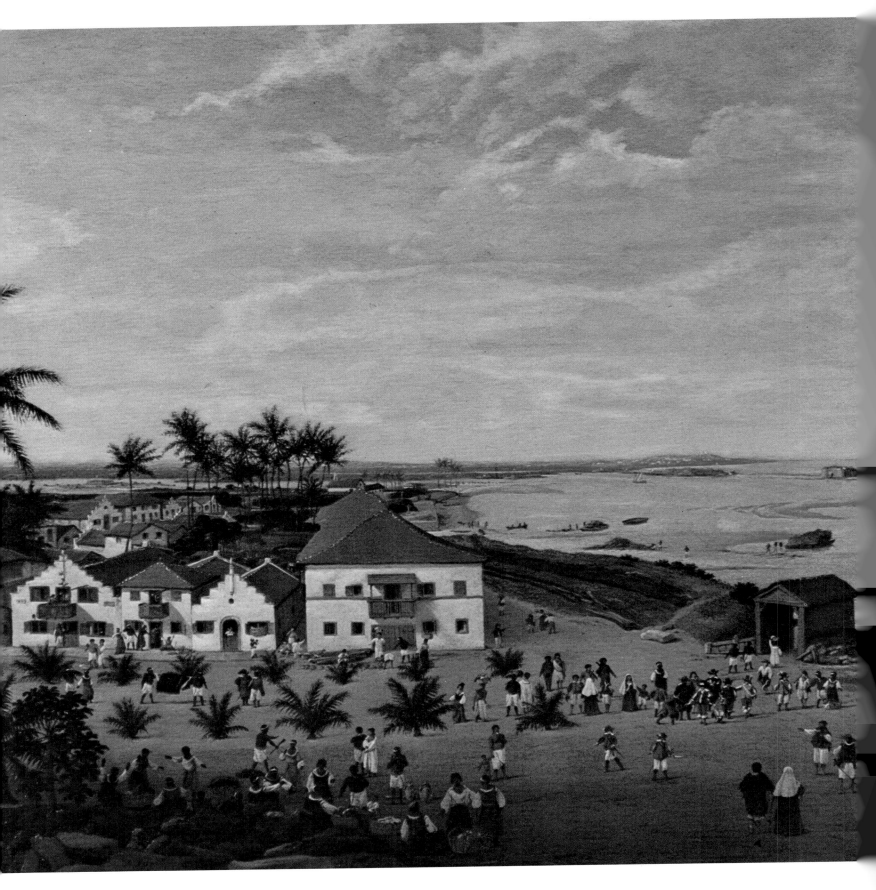

Frans Post, *The São Francisco River*, 1638.
Oil on canvas; 23.62″ × 34.64″
(60 cm × 88 cm). Musée du Louvre, Paris.

Indes (page 45), was reproduced between 1740 and 1802, after a few variations had been introduced by the painter François Desportes between 1735 and 1740.

The Style of Transition

After the Dutch were ousted in 1654, Nordeste, the only region in Brazil to have any economic importance, totally renewed its architecture using high-flown baroque outlines that were well suited to the optimism that had spread among the colony's population, both because of the return of a Portuguese dynasty to the throne in Lisbon (1640) and the decisive victory over the Dutch in Guararapes (1649). The stiff mannerism and strict rules of the sixteenth-century treatise writers were replaced by a new spatial expression in which the exuberance of decoration played a major role. Only the architecture of the ruling class, however, conformed to this new style, since ordinary people remained faithful to the colonial idiom derived from Portuguese culture, which had combined with indigenous elements. There was, therefore, a period of transition during which the major concern was to rebuild or restore ruined buildings to their original design, with the new taste applied only to their interiors. The churches and convents of the religious orders remained unchanged in type, contrasting with an official form of architecture that reflected nothing of the indigenous style, but imitated Italian models that had filtered in through the Portuguese.

Salvador, capital of the colony and the country's nerve center, was the city in which the transition style showed itself most openly. The old church of the college of the Society of Jesus, converted into a cathedral (pages 46–47), retains the Vignolesque style of Francisco Dias's design until work was concluded (1672), but the decoration of its interior (finished only in the following century) reveals decidedly baroque elements of Italian and Portuguese derivation. The sacristy, which houses chests inlaid with ivory and tortoise shell, and paintings from Italy and Flanders, is worth noting. Friar Macário de São João also worked in Salvador. He was of Spanish origin (?–1676) and came to Brazil in 1648, summoned by the colony's Benedictine abbot, Friar Gregório de Magalhães. In the capital, this architect designed the churches of the convent of Santa Theresa (1666–1697) and the monastery of São Bento (1679–1871), using for both Vignola's plan for the Church of Jesus in Rome, with its single nave and shortened transept surmounted by a hemispherical dome. The Sanctuary of Nossa Senhora dos Prazeres dos Montes Guararapes is also attributed to Friar Macário. It was

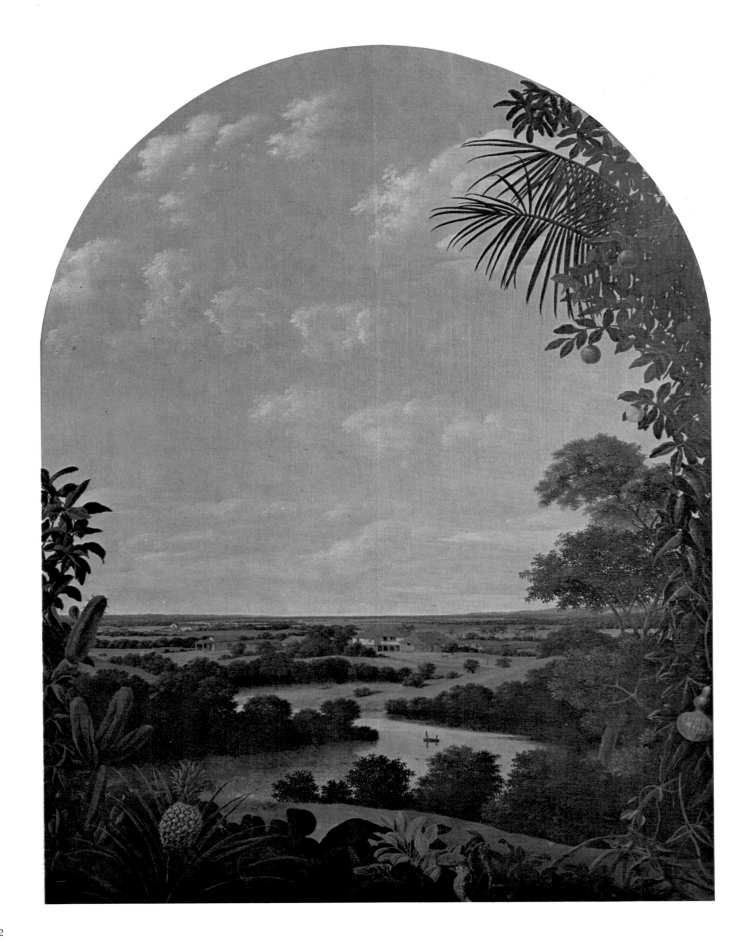

Frans Post, *Brazilian View*, 1652. Oil on canvas; 111.02″ × 82.67″ (282 cm × 210 cm). Rijksmuseum, Amsterdam.

erected in Pernambuco on the site of the battle with the Dutch. Although greatly altered during the following century, the interior retains seventeenth-century features, such as the *azulejos* that decorate the walls of the nave. It is one of the greatest churches of this period.

In Rio de Janeiro, the chief architectural project of the second half of the seventeenth century was the construction of the church of the monastery of São Bento (page 48), begun in 1617 by Francisco Frias de Mesquita. After 1669, the work received a considerable boost

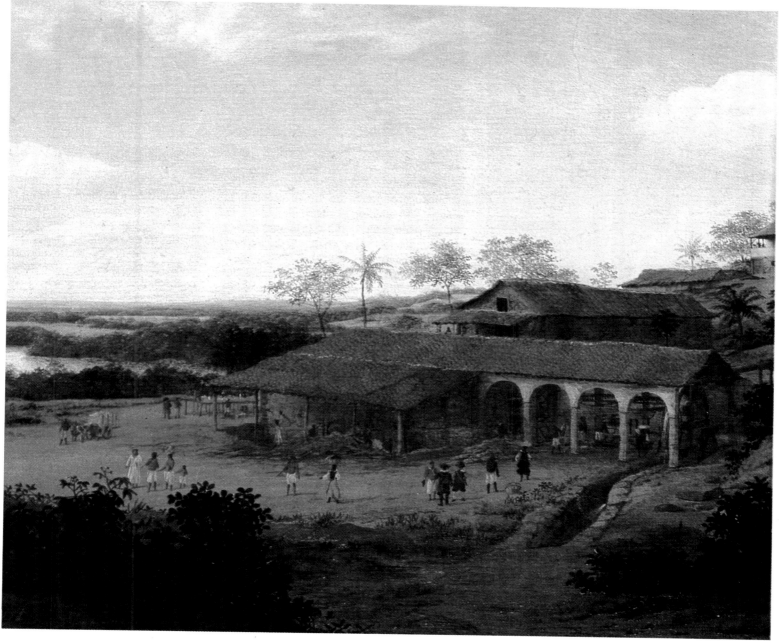

Below, Albert Eckhout (circa. 1610–1665), *Dance of the Tapuias*. Oil on canvas; 67.32″ × 116.53″ (171 cm × 296 cm). National Museum of Denmark, Copenhagen. *Bottom left*, Albert Eckhout, *Negress from the Costa do Ouro*, 1641. Oil on canvas; 106.29″ × 70.86″ (270 cm × 180 cm). National Museum of Denmark, Copenhagen. *Bottom right*, Albert Eckhout, *Mamluk Woman*, 1641. Oil on canvas; 108.66″ × 64.17″ (267 cm × 163 cm). National Museum of Denmark, Copenhagen.

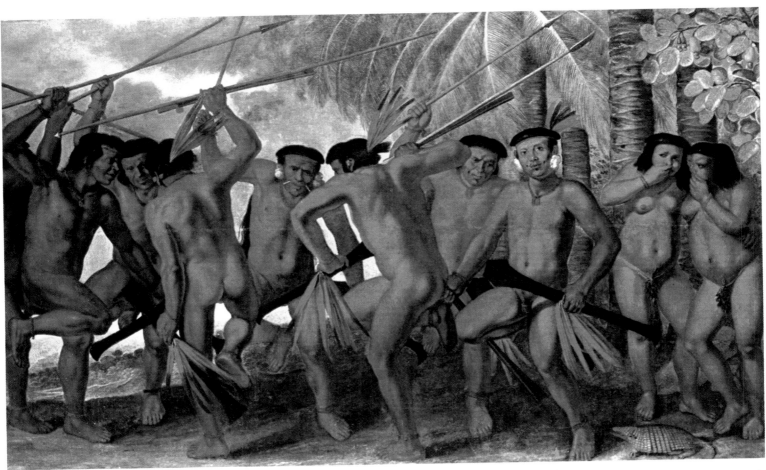

due to the intervention of the architect Friar Bernardo de São Bento Correia de Sousa (1624–1693), who respected the original design in the monastery's reconstruction while in the church he replaced the aisles with eight chapels. For the sumptuous interior decoration of the church, he could call on Friar Domingos da Conceição da Silva (circa 1643–1718), one of the greatest sculptors of Portuguese origin that Brazil ever had. It seems that Friar Domingos, who did not become a friar until he was forty-seven, had previously studied sculpture in Portugal. It is known for certain that in 1669 he was already working for the monastery of São Bento in Rio de Janeiro, making sculptures in painted wood and carvings for the portals of the church (which were begun in 1671), for the high altar, for the chest kept in the sacristy, for the arch of the Nossa Senhora da Conceição Chapel (1714–1717) and for the pillars of the nave (page 48). At the same time, for the monastery of São Bento of Olinda, he produced *The Dead Christ* (1679) and *Jesus Crucified*

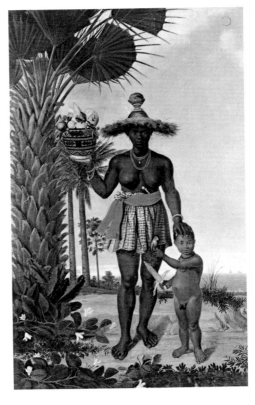

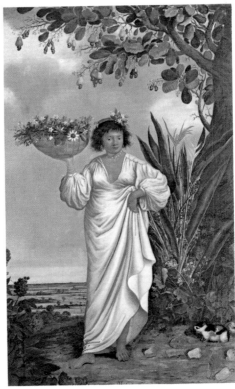

Albert Eckhout, *Indian Hunter*. Tapestry; 126.37″ × 84.25″ (321 cm × 214 cm). Museu de Arte, São Paulo. This belongs to a series of tapestries called *Nouvelles Indes* designed on paper boards (1735–1740) by François Desportes to replace Eckhout's originals.

The originals were sent as a gift to king Louis XIV of France, in 1678, by Maurice of Nassau. In 1687, Eckhout's originals were given to the Gobelin workshops, which reproduced them until 1730, wearing them out completely.

(1688; page 49), considered to be his masterpieces.

In contrast to the works of European artists, seventeenth-century Brazil saw the first truly national artistic expression in the retables for churches of minor importance in the interior of the country. They were made of carved wood and painted by indigenous craftsmen, usually Mamluks, who drew freely on retables imported from Portugal in the previous century for the main churches of the religious orders, especially the Jesuits. The prototypes, plateresque in style, were mostly in the form of a structure with columns decorated with floral motifs and flutes, which framed painted panels and niches for statues and supported a pediment in which another painted panel was inserted. The Portuguese retables have been lost but those of anonymous Brazilian artists, of much greater interest, have been saved, like those in the Chapel of Santo Antônio in São Roque, of Nossa Senhora da Conceição de Voturuna in Santana do Parnaíba (page 36), and of Santo Alberto in Moji das Cruzes. Another type of retable, whose origin remains a mystery, although it may be connected with the Franciscan and Carmelite orders, has spiral columns and statues in niches and an archivolt at the top. The decorative exuberance of each panel already reveals a baroque license that tended to integrate the altar into the architectonic space of the church, abandoning the classicizing orderliness of mannerism. Unfortunately, due to the inaccuracy of the sources of records kept in the older churches, it is not possible to establish a correct pattern of the development of Brazilian retables, although it is known that the type with spiral columns was very widespread in the seventeenth century and widely used in the following century, too, whereas the former type had completely disappeared by the first half of the eighteenth century.

Most of the religious images that existed in Brazil's churches in the seventeenth century were, however, of Portuguese origin. The Jesuits in particular spared no expense in importing statues from the homelands even though the Society's records hold the names of sculptors and carvers, such as João Correia or Mateus da Costa, who were said by the compilers to be gifted artists. There is also evidence, however, of works that were without doubt sculpted in Brazil and whose authors are un-

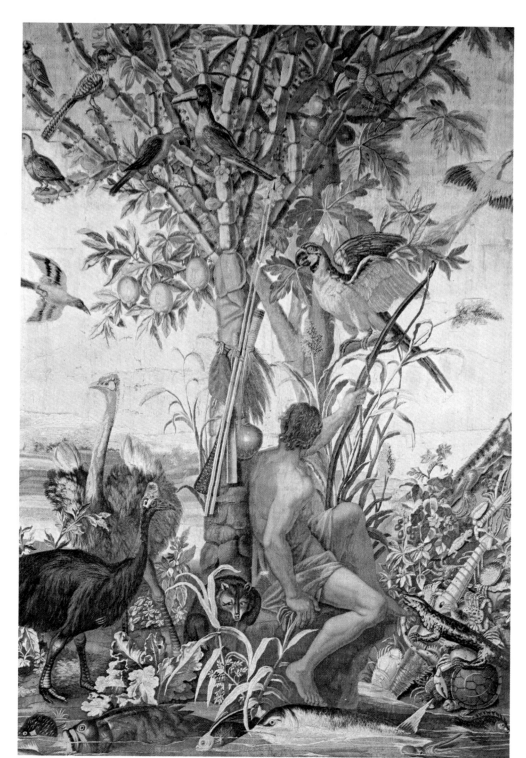

fortunately unknown. We only know the biographies and works of three great sculptors: Domingos da Conceição da Silva, who worked in the monastery of São Bento in Rio de Janeiro, Agostinho da Piedade and Agostinho de Jesus. Friar Agostinho da Piedade, born in Portugal at the end of the sixteenth century (he

died in Salvador in 1661), came to Brazil while still a young man. His name appears for the first time in 1620 in the records of the monastery of São Bento of Salvador, where he was ordained a priest, and he was the administrator of the Itapoã estate and, later, the chaplain of Nossa Senhora das Graças. It seems that

45

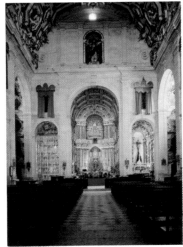

he sculpted only for a few years, perhaps from 1625 to 1642, using terra-cotta and a simple baker's oven. Four of his works are signed: *Our Lady of Montserrat* (1636), *St. Anne the Teacher* (*Santana Mestera*, 1642), *St. Catherine* and the *Infant Jesus*. Of his remaining works, some reliquary busts (now in the Museu de Arte Sacre, Salvador) made for the monastery of São Bento are noteworthy: *St. Lucy*, executed around 1630 with parts in engraved silver that are among the oldest examples of Brazilian silver work (page 50), *St. Cecilia, St. Agueda, St. Barbara, St. Scholastica, St. Catherine* (page 50), *St. Gregory the Great* and *St. Anselm*. Friar Agostinho da Piedade also made statuettes, such as the two figures of *Our Lady of Montserrat* (Instituto Histórico e Geográfico da Bahia, Salvador; monastery of São Bento, São Paulo), *St. Peter Repentant* (Nossa Senhora do Monte Serrate, Salvador; page 51) and the previously mentioned *Infant Jesus* (circa 1640, monastery of São Bento, Olinda). As regards technique and style, Friar Agostinho da Piedade's work poses

some interesting problems of interpretation. The relationship of his works with those of the potters of Alcobaça in Portugal, from where he probably came, is undeniable, but it is also possible to detect a permeation of the aesthetic ideals of the Renaissance and a stiffness that is very far from the baroque spirit. The figure of the *Infant Jesus* sitting with his legs crossed and his head resting on one hand calls to mind Buddhist images, with which the artist may have been familiar through small ivory statues brought by chance to Salvador by merchants or missionaries. *St. Peter Repentant* poses a much more complicated problem, since its intense dramatic force and heightened realism have led some scholars to doubt its attribution to Friar Agostinho da Piedade.

Friar Agostinho de Jesus, a native of Rio de Janeiro (he was to die there in 1661), was ordained as a priest in Portugal, where he lived between 1628 and 1634. In 1641 he was already at the monastery of São Bento in Salvador where he was probably a pupil of Friar Agostinho da Piedade. He then spent a

few years in Santana do Parnaíba, where he left many sculptures. Around 1650 he was in São Paulo and finally he entered the monastery of São Bento in Rio de Janeiro. The twenty or so terra-cotta sculptures that have survived to the present day show that Friar Agostinho de Jesus adopted only the technique of his teacher, preferring more mobile, graceful forms that had a moderately baroque flavor, particularly manifest in *Our Lady with the Infant Jesus* (1641; collection of Graça Couto, Rio de Janeiro), *St. Scholastica* (Basilica of São Bento; São Paulo), and *St. Bernard* (Museu de Arte Sacra, Salvador).

In seventeenth-century Brazil, painting (naturally with the exception of the Protestant painters of Nassau) was aimed at producing works treating sacred subjects, for churches and convents and was created by religious men and a few laymen. Of the painters of the period, only a few names and a few identifiable works remain. The artists of many church paintings have still to be identified. Included in this group is the Dutchman Paulo Belchior, who came to

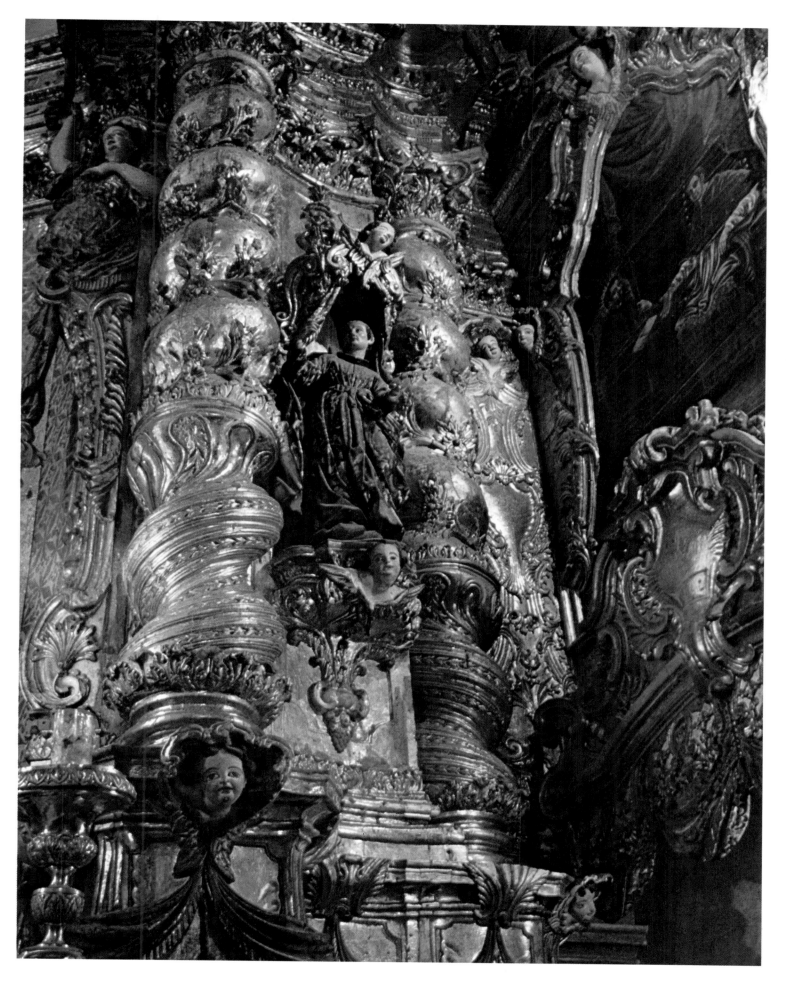

Pulpit and side chapels of the Church of the monastery of São Bento in Rio de Janeiro. The carving was executed mostly by Friar Domingos da Conceição (circa 1643–1718). Construction of the church and monastery, begun in 1617 by the architect Francisco Frias de Mesquita (1587–1645), received a great boost after 1669 thanks to the architect Friar Bernardo de São Bento Correia de Sousa (1624–1693), and was completed in the eighteenth century.

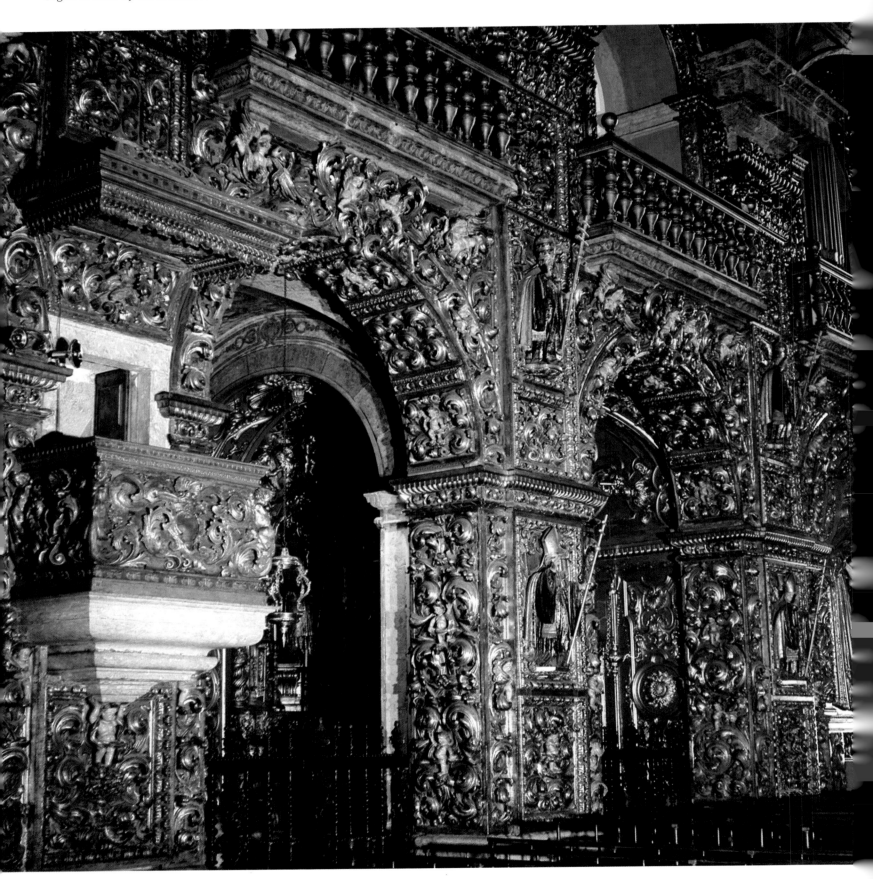

Friar Domingos da Conceição, *Jesus Crucified*, 1688. This crucifix, considered to be the artist's masterpiece, is in the monastery of São Bento in Olinda.

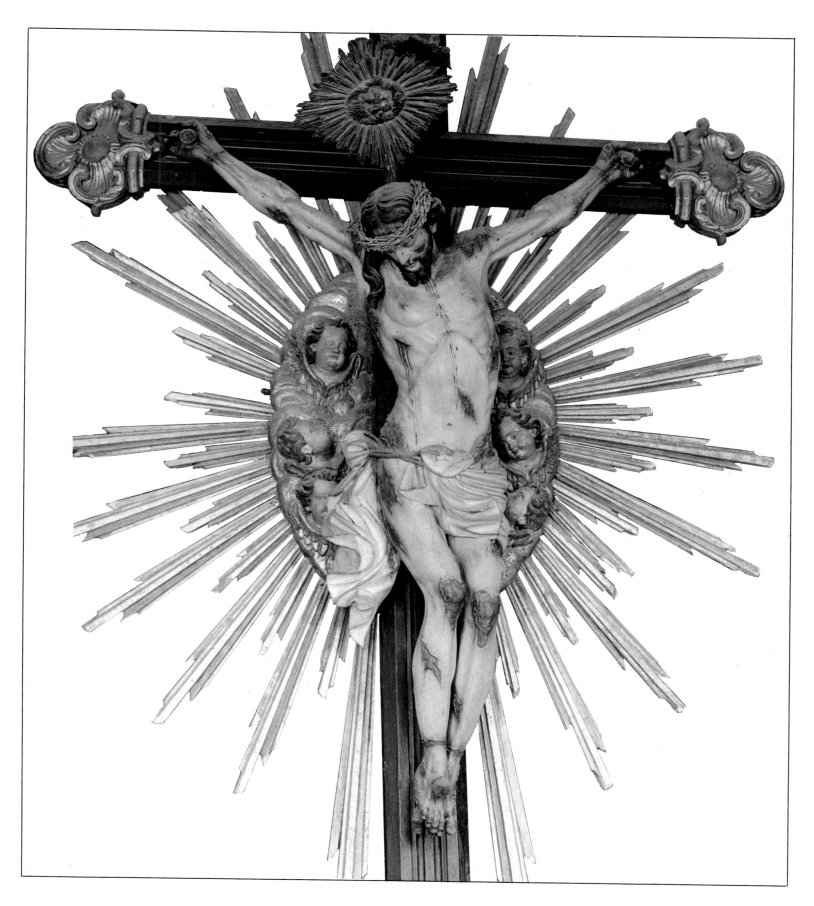

Friar Agostinho da Piedade: *Below left, St. Catherine of Alexandria*, circa 1640. Terracotta; 21.65" (55 cm). *Right, St. Lucy*, circa 1630. Engraved silver, painted lead head; 20.07" (51 cm). Both works are in the Museu de Arte Sacra, Salvador.

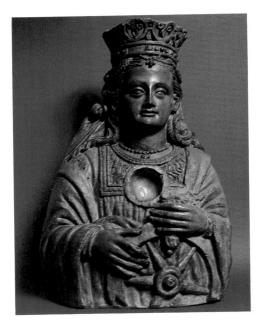

Brazil in 1597 and worked in the Jesuit houses and colleges in Salvador, Santos and Rio de Janeiro (where he died), and the Flemish painter João Batista (1557–1609), who in 1606 was taken into the Society of Jesus in Pernambuco and who decorated the college in Olinda.

Another Dutchman, Baltasar de Campos (1614–1687) arrived in Brazil in 1661 and painted the series of paintings (now lost), showing the *Life of Christ*, for the sacristy of the Church of São Francisco Xavier of the Santo Alexandre college, in Pará. João Filipe Bettendorff (1625–1698) from Luxembourg, rector and later superior of the Jesuit mission, produced paintings for the churches in the villages of Gurupatuba and Inhaúba, in Pará.

As for Antônio de Lustosa, active in Salvador during the second half of the seventeenth century, it is known only that in 1679 the brothers of the confraternity of the Misericórdia commissioned him to paint their processional banner. In Salvador, Eusébio de Matos (1629–1692), brother of the poet Gregório de Matos, founded the Bahia School of Painting. None of his works remain, but according to an old tradition he was a pupil of the Dutch painters of Maurice of Nassau and perhaps of Albert Eckhout, who stayed in Salvador in 1641.

Lourenço Veloso should also be remembered. He was born in Goa and was probably trained in Lisbon. The only work that can definitely be attributed to him is the portrait of *Capitão Francisco*

Fernando da Ilha, painted in 1699, which shows Veloso to be a talented artist and proves that he must have been familiar with the portraiture of Rembrandt and El Greco.

The only painter whose work has been definitely identified is Friar Ricardo do Pilar, who was born in Cologne, Germany, between 1630 and 1640, and died in Rio de Janeiro in 1702. He came to Brazil around the middle of the 1670s after having completed his artist's apprenticeship in a German or Flemish studio. The most striking influences reflected in his work are, in fact, those of the old Cologne school and of his great contemporary, Rembrandt, which explains the juxtaposition in his work of obvious archaisms (especially in the iconographic choices) and unexpected technical boldness. All the paintings known to be by Friar Ricardo do Pilar were executed for the monastery of São Bento in Rio de Janeiro. Four panels showing *The Apparition of the Virgin to St. Ildefonso, St. Anselm and St. Albert* and *The Nursing of St. Bernard* for the apse of the abbey church of the monastery date back to the period between 1670 and 1673. The two panels showing *The Apparition of the Virgin to the Blessed Walter de Birbech* and to *St. Ruperto de Deutz* in the same place date back to 1676 or 1677. In 1683 the remaining eight panels that decorate the walls and ceiling of the apse were finally completed. Again, they portray apparitions of the Virgin to other Benedictine saints—the *Death of St. Dominic* and the *Death of St. Jócio* (page 53).

The *Christ of the Martyrs*, considered to be Friar Ricardo do Pilar's masterpiece, was made for the sacristy of the monastery and dates from the last few active years of the artist. This painting has obvious stylistic affinities with fifteenth- and sixteenth-century Portuguese paintings: works such as the *Ecce Homo*, by an unknown artist, (Museu de Arte Antiga, Lisbon) or *Christ Glorified*, by the Master of Sardoal in the mother church of Sardoal, and *The Good Shepherd*, by Friar Carlos, kept in the Lisbon Museum. Another *Christ of the Martyrs*, by an unknown artist, (convent of Santo Antônio, Rio de Janeiro) could be considered an iconographic source for Friar Ricardo do Pilar's work. It is difficult to give a critical appreciation of his work without taking into account his deep religious

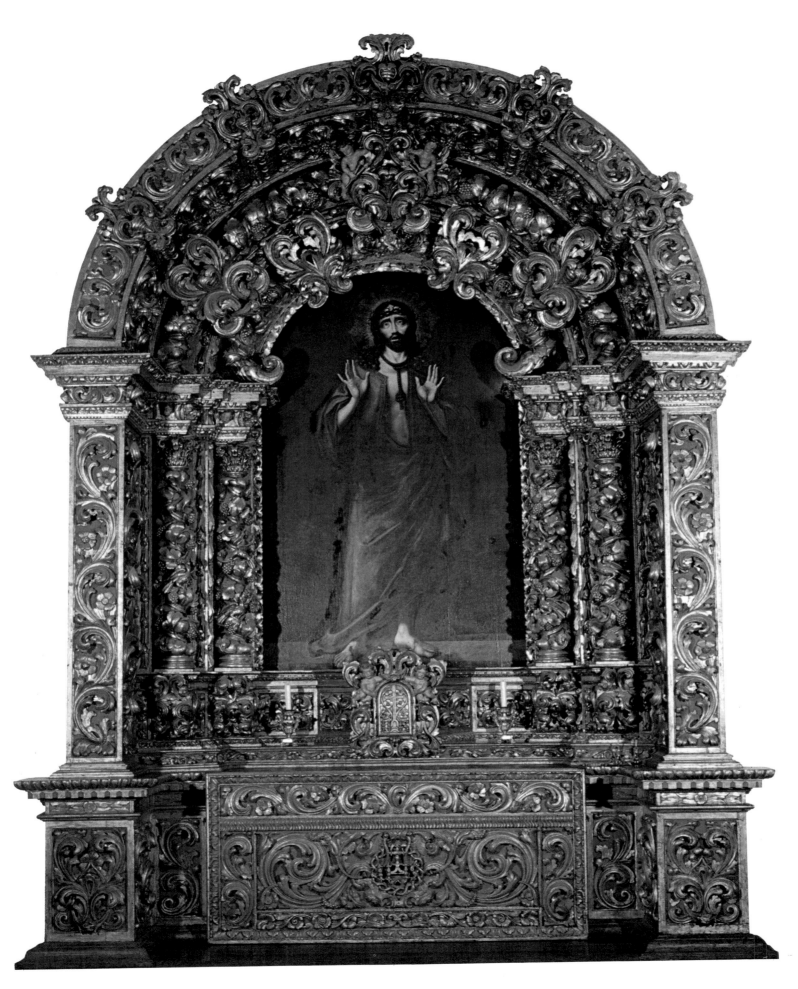

faith and his inclination toward mysticism as exalted in the brief biography compiled in 1773 by Friar Paulo da Conceição Ferreira de Andrade for the monastery of São Bento's records.

Applied Arts

Craftwork in seventeenth-century Brazil was limited. From the few examples still in existence, it can be concluded that furniture was no different from that in Portugal. Cabinets, tables with turned legs, chests and tester beds are lightly embellished with geometrical or floral decorations, inlaid with wood and ivory and are characterized by simple shapes and a solid appearance. Only the chests show a certain Oriental influence.

By the end of the seventeenth century, most goldsmiths were Negroes and mulattoes, despite a ban on pursuing this trade that was placed on Negroes, Jews, Moors and American Indians.

In 1644 there were seven goldsmiths in the Bahia region, one of whom was Francisco Vieira. By the end of the century there were twenty-five. Gold and silver, still scarce in Brazil at that time, came from Argentina via Peru and other Spanish dominions. Objects for church decoration were generally simple. Elaborate decorations and settings for semiprecious stones were reserved for the accessories of statues of saints, such as crowns, halos or bishops' staffs.

Jewelry for private customers was sumptuously decorative.

Crockery for domestic use was mostly of pottery imported from Portugal and Spain, or tin and silver items produced locally. Porcelain objects from India and China were luxury items, and they appear in the inventories of private houses in the last years of the sixteenth century.

Small sacred images for worship in the home were made by anonymous craftsmen in wood or terra-cotta. Their simple, angular lines convey with folkloristic immediacy the ecstatic expressions of the saints. Only toward the end of the seventeenth century were they embellished with bright polychrome.

53

The Baroque

The Baroque

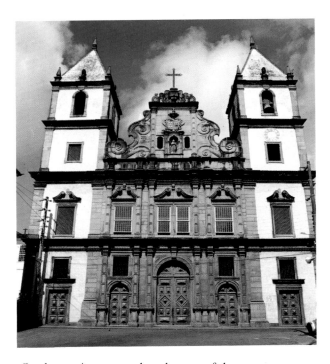

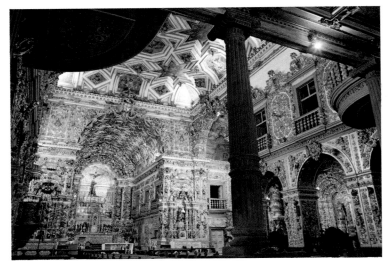

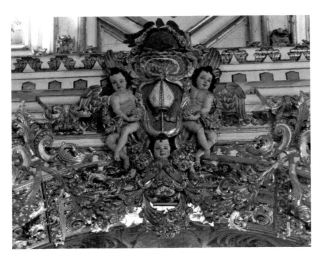

On the previous pages, the telamons of the transept in the Church of São Francisco, Salvador.
Above, facade of São Francisco in Salvador. The church, which belongs to the Franciscan convent, was begun in 1708.
Above right, main nave of São Francisco. The church was designed in 1702 by the architect Gabriel Ribeiro.
Right, detail of the gilt carvings that completely cover the church's interior walls.
Opposite, detail of the main nave ceiling of São Francisco. The various panels, painted between 1736 and 1758 by an unknown artist, celebrate the glory of the Madonna.

The mines, discovered at the end of the seventeenth century, marked the beginning of the golden century for Brazil in that they gave impetus to artistic creativity, especially in Minas Gerais which was the center of the gold area, and to the formation of a national ideal within the colony. The concentration of wealth accentuated regional differences in the vast territory, giving rise to very distinct artistic expressions in every part of the country. Each one of them, however, bears the hallmark of the baroque style, which in Brazil flourished almost a century later than it did in Europe. It is for this reason that the study of eighteenth-century Brazilian art is usually carried out according to geographical criteria rather than by following a general line of artistic development.

Bahia

Salvador, the administrative center of the colony until 1763, was also the center for the production of sugar, which in the eighteenth century, was no longer destined for the international market but directed toward meeting the needs of the mining population. The São Francisco river, which has its source in the heart of Minas Gerais and flows into the Atlantic between Recife and Salvador, became the main means of communication for trade between Nordeste and the mining region. The wealth that had accumulated in the capital served only to further promote the process of artistic renewal, which was a consequence of the Portuguese regaining Nordeste. The field of architecture was especially affected. In Salvador,

however, architects continued to imitate models imported directly from Portugal, but they were certainly not insensitive to Italian influences. The city came to offer a wealth of architectural elements, and its churches, whose magnificence attracted hordes of pilgrims, served as models for numerous churches in the Bahia region.

At the foot of the hill on which the upper part of the town was situated, on the site of an existing chapel, the confraternities of the Most Holy Sacrament and the Immaculate Conception decided to erect a church dedicated to Nossa Senhora da Conceição da Praia and commissioned a military architect, Manuel Cardoso de Saldanha to design it. He was sent to Portugal to supervise the cutting of the stones needed for the construction, which were later shipped to

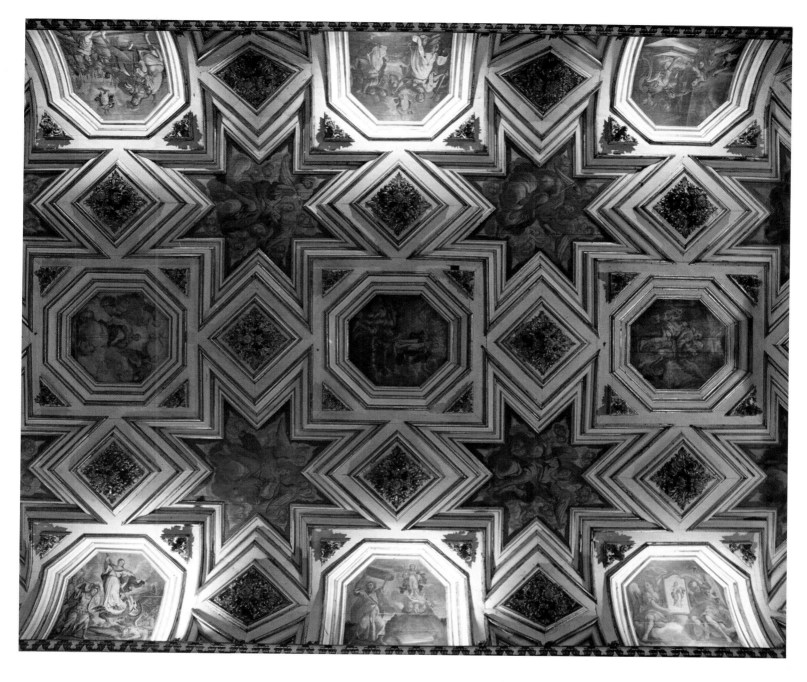

Brazil as ballast on cargo ships. Work began in 1739 under the direction of Eugênio da Mota, who was replaced in 1769 by Antônio Luíz da Silva. The design combined mannerist elements with markedly baroque innovations such as the huge rectangular nave with rounded corners, which shyly suggests an octagonal plan akin to typical eighteenth-century European polygon versions.

But the group of buildings that are most famous and representative of eighteenth-century Salvador are the church and convent of São Francisco (pages 54–55 and 56–57). The first house of the Franciscan order, erected in 1587, had been destroyed during the Dutch invasion. In 1686 the rebuilding of the convent had begun, and in 1708 work began on the church. The convent was de-veloped around a monumental square cloister. The church, the facade of which derived from a sober, mannerist model, was entirely rebuilt, with the conventional Franciscan layout with a single nave abandoned in favor of a solution with three aisles, the two side aisles considerably lower than the central one. The church was designed in 1702 by Gabriel Ribeiro, an architect with Portuguese training who died in Salvador in 1719. The inner walls of the church were completely covered with gilt wood carvings, according to the aesthetic ideal of the "golden church" fashionable in Lisbon.

Among the many religious buildings erected in Salvador in the eighteenth century, we should also mention the following: the Church of Nossa Senhora do Pilar, built in the first half of the century with freestone imported from Portugal, whose facade (completed in 1770) is decidedly rococo in style; the Basilica of Nossa Senhor do Bonfim, begun in 1740, which contains a very large collection of silver church orna-ments and votive offerings; the church and convent of Nossa Senhora da Palma, rebuilt in 1711 around a large, rectangular cloister, and decorated inside, at the end of the century, with rococo and neo-classical motifs; the convent of Nossa Senhora do Desterro, or of Santa Clara, built between the end of the seventeenth century and the beginning of the eight-eenth century, whose bell tower has bulbous roofing, as distinct from other Bahian churches whose bell towers are topped by a pyramidal structure usually

Below left, carved paneled ceiling in the apse of the Church of Nossa Senhora da Conceição da Lapa, which belongs to the convent of the same name, in Salvador.
Below, baldachin that surmounts the high altar of the Church of Nossa Senhora da

Conceição da Lapa. The carvings decorating the high altar, built in the shape of a shell, were done in 1755 by Antônio Mendes da Silva, who also carved the decorations on the apse ceiling.

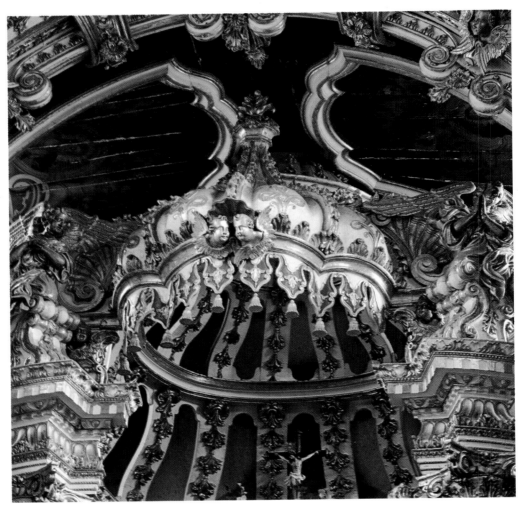

covered in *azulejos*; and the convent of Nossa Senhora da Conceição da Lapa (pages 58–59), dating from the first half of the eighteenth century and linked to the events leading up to Brazilian independence—Sister Joana Angélica de Jesus was assassinated in an attempt to defend the rebels who had taken refuge there.

Secular architecture also deserves a mention. One of Salvador's most important noble town residences, for example, is the house of the baron of Rio Real which, in addition to the usual two stories, has a belvedere, a characteristic feature at that time which also appears in monasteries. The entrance is decorated with a marble floor that precedes the grand staircase made of high-quality wood. Another example, Saldanha House in Salvador, although built after the death of Gabriel Ribeiro in 1719, is generally attributed to Ribeiro. It suffered a fire in this century, but its stone and lime structure was saved, along with some decoration that owes much to the facade of the Church of the Tertiary Order of the Carmelites in the same town. Count Arcos's house, dating from the second half of the eighteenth century, was situated on the outskirts of the town when built. Its architectural composition as well as the staircase completing the facade, are clearly in the baroque style of the marquis of Pombal's time, and the attractive *azulejos* inside date from the beginning of the nineteenth century. The magnificent archbishop's residence, built at the beginning of the eighteenth century, was connected by a tunnel to the old primatial church of Bahia. It is built on the brow of the hill that separates the upper part of the town from the lower part and has three stories and an inner courtyard. It seems to reflect the late influence of Italian Renaissance houses. Unhão House, built at the end of the seventeenth century, when the judge of the Supreme Court, Pedro de Unhão Castelo Branco, lived there, took on its present appearance only in the following century. Outside the main building, there was an "agro-industrial complex" involved in the exportation of sugar and the production of *aqua vitae*. The facade of its church still reflects the rococo style even though it probably dates from the early nineteenth century. The top floor of the main building, built in the eighteenth century, was turned into the Museu de Arte Popular by Lina Bo Bardi in 1962. In the Recôncavo region of Bahia, along the main rivers, various *engenhos* for the production of sugar sprang up, a few of which are very important and of some architectural interest. Despite the lack of satisfactory iconographic records, it is known that initially they were very rustic constructions, especially in the industrial part. Everyone organized themselves according to the topographical conditions of the sites, which were chosen close to

Detail of one of the spiral columns that
support the baldachin of the high altar in the
Church of Nossa Senhora da Conceição da
Lapa. This is the work, along with the other
carvings, of Antônio Mendes da Silva.

navigable waterways or the sea so as to be able to load the sugar easily.

Sometimes the entire agricultural and industrial complex was housed in a single building. At other times, especially for the more important complexes, the residential part and church were separate and were laid out with architectural refinement, or, rather, with expressive intentions linked to questions of social rank. This is what happened at the Engenho Freguesia, for example, which had the installations for production at water level and the four-floor residence on the hill slope. The two upper stories were linked directly to the chapel, whose appearance shows the importance of religion in agricultural establishments. Today the Recôncavo Museum is based in the Engenho Freguesia.

There were not many sculptors in Salvador in the first half of the eighteenth century. Manuel Gonçalves Pinheiro, João Alves Carneiro, Antonio Duarte and Inácio Dias de Oliveira are some of those whose definitely identifiable work has been passed down to us. The work of a group of artists active in the city toward the end of the century is, however, better known. In 1758, the Church of the Tertiary Order of Mount Carmel commissioned Francisco Chagas, nicknamed "O Cabra" ("The Mestizo") and born probably at the beginning of the century, to sculpt three images of the Savior. Since the church was destroyed by fire in 1788 and rebuilt only in 1803, it is not possible to establish with certainty whether the two statues of Christ now existing in the church can be identified as Chagas's works. The *Dead Christ*, also in the Church of the Tertiary Order of Mount Carmel can, however, be attributed to him.

Félix Pereira Guimarães (1734–1809), who made the statues of St. John and St. Mary Magdalene, also worked for the Church of the Carmelites. The most important work of this artist has been lost—the carved decoration of the retable, the galleries and the triumphal arch of the Church of São Pedro, built in 1785—but we still have the retables of the side altars of the Church of the Santa Casa de Misericórdia, completed in 1790, which already show neoclassical elements alongside older rococo ones.

Seventeenth-century Bahia's greatest sculptor was, however, Manuel Inácio da Costa (1763–1857), who always remained faithful to the animated rococo forms.

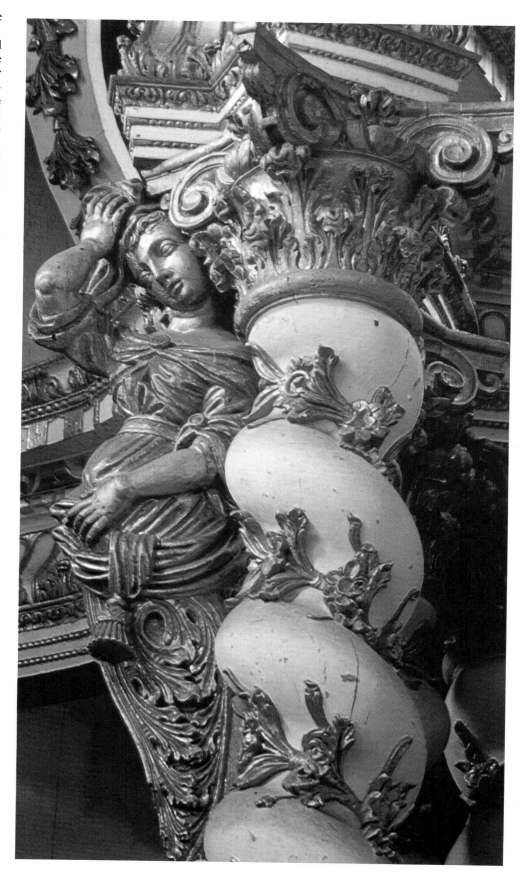

St. Anne the Teacher (Santana Mestra).
Polychromed wood; 39.37″ (100 cm). Made
circa 1730 by a Jesuit in the Colégio de
Salvador for the convent of Nossa Senhora
das Mercês in the same town. The group is
now kept in the Museu de Arte Sacra in
Salvador.

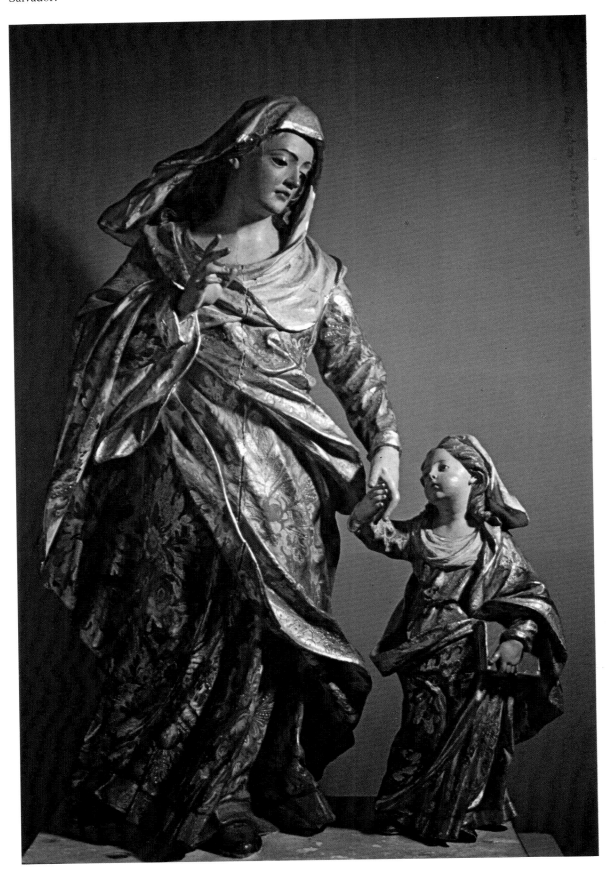

Many painted wooden statues are attributed to him, such as *Christ at the Column* (Museu de Arte Sacra, Salvador; page 61), *St. Peter of Alcântara* (1790 or 1793; Church of São Francisco) and *St. Dominic* (1833; Church of the Tertiary Order of São Francisco). Another of his works was the allegorical chariot at the Instituto Geográfico e Histórico da Bahia, made in 1826 to celebrate the participation of the Bahian people in the struggle for national independence, which symbolically portrays free Brazil as a mulatto adorned with feathers trampling on a serpent that symbolizes tyranny. It also appears that Manuel Inácio da Costa made figurines, animals and other objects in stone, jasper, terracotta and *cajá* bark for Christmas cribs.

More extensive records than those on the sculptors are available on the painters who worked in seventeenth-century Salvador. The activity of the French painter, Carlos Belleville (1657–1730) is of particular interest. He entered the Society of Jesus in 1680 and from 1698 lived for ten years in China, where, in Canton, he designed the church of the French mission. On the return journey to Europe he stopped off, due to an illness, in the Brazilian capital, where he later obtained permission to reside. In the Society's records, Father Belleville is referred to as a sculptor, carpenter and painter, but it is only in this last capacity that he has left a trace of his activity in Brazil. The ceiling for the Church of Belém da Cachoeira, the group of paintings for the convent of St. Theresa in Salvador (now in the Museu de Arte Sacra) and his works for Bahia cathedral show the Jesuit painter's European training, enriched, however, by an obvious taste for chinoiserie and decorative motifs inspired by the flora and fauna of Brazil.

Francisco Coelho (1699–1759) from Portugal also belonged to the Society of Jesus. In 1740 he painted a *Last Supper* and fifteen portraits of saints and missionary Jesuits in Brazil for the new refectory of the Colégio da Bahia in Salvador. In 1757, Father Coelho, who is thought to have produced paintings for the church, Jesuit college and seminary of Jequitaia, was transferred to Rio de Janeiro.

Perspective-illusionistic painting, which spread in Europe under the example of Father Andrea Pozzo to decorate ceilings of baroque churches, had its first expo-

Christ at the Column (Senhor da Coluna). Polychromed wood; 45.66″ (116 cm). Attributed to Manuel Inácio da Costa (1763–1857), Bahia's greatest sculptor of the period. The statue is kept at the Museu de Arte Sacra in Salvador.

Anonymous, *Visit of the Governors to the Chapel of Grace*, second half of the eighteenth century. Oil on canvas; 74.80″ × 114.17″ (190 cm × 290 cm). Church of Nossa Senhora da Graça, Salvador. The painting shows two separate scenes. In the foreground the official cortege returns from the votive visit. In the background Indians dance and two historical characters of the sixteenth century take part bearing garlands of flowers, Catarina de Paraguaçu and her husband, Diogo Álvares Correia.

nent in Salvador in Antônio Simões Ribeiro (died in Salvador in 1755), whose work has unfortunately been lost and is known only from sources. This Portuguese painter who, in his own country, had painted the ceiling of the library in Coimbra university with the collaboration of Vicente Nunes, came to the capital in 1735. In that same year he decorated the vault of the Church of the Santa Casa de Misericórdia and, in 1745, the church of the convent of Santa Clara do Desterro. It is therefore likely that he had a strong influence on Bahia's two major perspective painters,

Domingos da Costa Filgueira and José Joaquim da Rocha.

Domingos da Costa Filgueira (died in Salvador in 1797) painted the ceiling of the Church of Nossa Senhora da Saúde e Glória in 1769, a work that was seriously damaged by repainting in the nineteenth century. In 1770, he worked for the Tertiary Order of São Francisco da Penitência, decorating the ceiling of the sacrarium, still preserved, and that of the first floor, now lost.

The most talented painter of eighteenth-century Salvador is considered to be José Joaquim da Rocha (1737–1807)

from Rio de Janeiro, who was already active in 1764 as the assistant of a little-known painter, Leandro Ferreira de Sousa working on the Santa Casa de Misericórdia. Since for three years, from 1766 to 1769, his name does not appear in any documents, the artist is thought to have made a journey to Europe, and to have stayed in Italy, to perfect his style. On August 28, 1769 he took part in the competition for the decoration of the ceiling of Nossa Senhora da Saúde e Glória, which was won by Domingos da Costa Filgueira. At the end of 1772 or at the beginning of the following year, he

Anonymous, *Prodigious Graces and Miracles of Our Lady of Suffrages (Nossa Senhora dos Remédios)*, 1749. Oil on canvas; 43.30″ × 49.60″ (110 cm × 126 cm). Church of Nossa Senhora do Monte Serrate, Salvador. This votive offering, which tells of the "graces and miracles" conceded by Our Lady to her faithful follower, Agostinho Pereira da Silva from Portugal, is one of eighteenth-century Bahia's most important paintings.

won the competition for the decoration of the ceiling of the Church of Nossa Senhora da Conceição de Praia, which, when completed, immediately made him famous. Some of the ceilings of José Joaquim da Rocha have been destroyed, but that of the Chapel of the Savior in the Convento do Carmo and that of the confraternity of the Senhor Bom Jesus dos Aflitos have been saved. As for the *Glorification of St. Augustine* in the Church of Nossa Senhora da Palma, widely attributed to him, it was certainly devised by José Joaquim da Rocha but was painted by his pupil Veríssimo de

Sousa Freitas.

After 1780, commissions became so numerous that the artist had to regularly draw on the help of his pupils, as was the case for the eight processional banners and the series of paintings illustrating the *Life of the Virgin* for the Santa Casa de Misericórdia. Of the group of works painted for the Church of Nossa Senhora da Palma, the eight portraits of Augustinian saints can perhaps be attributed to Veríssimo de Sousa Freitas, but the four large panels painted around 1790, portraying the *Circumcision, The Presentation at the Temple, The Holy*

Family and *St. Peter* are thought to be definitely signed by da Rocha. In the early nineteenth century, he was still active, but his last important work dates from 1796: the decoration and six panels for the sacristy of the Church of Pilar. José Joaquim da Rocha is a rare example in his time, since his style, especially in some of his figures of the Virgin, reflects more of the Italian influence than the Spanish or Portuguese, and his faith in scenes molded on mannerist models often enters into conflict with the animated lines of the fantastic baroque structures that frame them. As to his

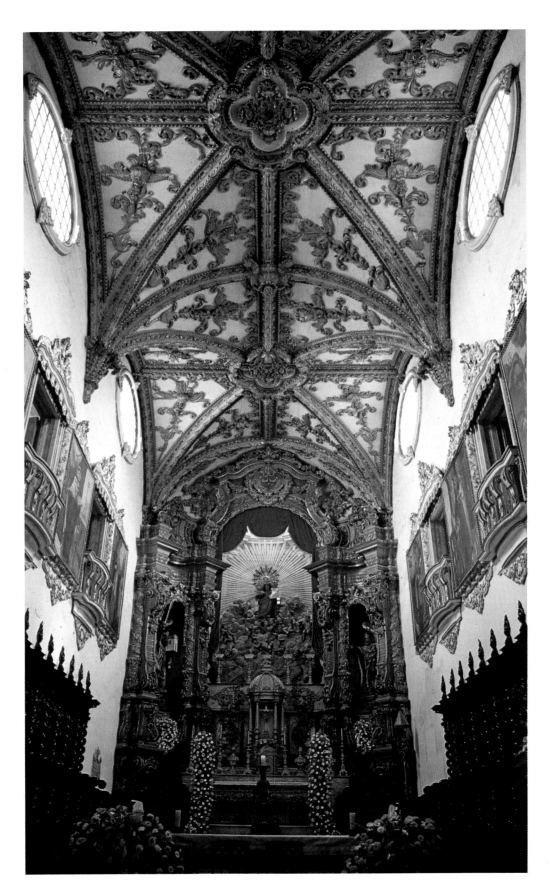

private life, it can be said that he never managed to make a fortune. He gave all that he earned to the poor or spent it on food for prisoners. In 1797 he sold a house that he owned and, according to tradition, gave the money to his favorite pupil to whom we shall return later. Da Rocha died alone in 1807 in a modest house and was buried in the Church of Nossa Senhora da Palma for which he had so lovingly worked. His works reveal a flawless personality that adopts correctness in drawing and original liveliness in color, although he was unable to break away from European models and often repeated their themes.

Among José Joaquim da Rocha's numerous pupils, the favorite was José Teófilo de Jesus who, at his master's expense, stayed in Portugal from 1797 to 1801 to perfect his style with Pedro Alexandrino de Cavalho, Vieira Lusitano and other painters of that period. A large number of easel paintings are usually attributed to him. Among those definitely signed are the four panels for the Church of the Tertiary Order of São Francisco da Penitência and those for the Church of the Bonfim and Nossa Senhora do Rosário in Cachoeira. In addition, José Teófilo de Jesus continued da Rocha's tradition of perspective-illusionistic painting both in Salvador, where in 1816 he supervised the decoration of the Church of the Tertiary Order of the Carmelites, and in many churches in the present day states of Bahia and Sergipe. Another of da Rocha's pupils, Antônio Joaquim Franco Velasco (1780–1833), painted the ceilings of Bahia churches, such as the Bonfim (1818–1820) but he made his name above all as a portrait painter, depicting the town's notables in an already neoclassical style (*Portrait of a Lady*, *Boy with a Puppy*; both done in 1817 and kept at the Fundação Castro in Rio).

Velasco's assistant in the Church of the Bonfim, his pupil José Rodrigues Nunes from Salvador, does not stand out for any great capacity to be imaginative. One description of him was that "he preferred to copy the old masters rather than create his own compositions." Nevertheless, some of his portrait work was exceptional.

Before leaving the region, we should mention those anonymous paintings that compensate for the lack of finishing touches and technique with iconographic flavor and documentary interest. A huge

Facade of the Church of Nossa Senhora do
Carmo in Recife. Architecturally, the novelty
of this church lies in its plan, which shows
the transition to an aisleless church in the
form of a hall.

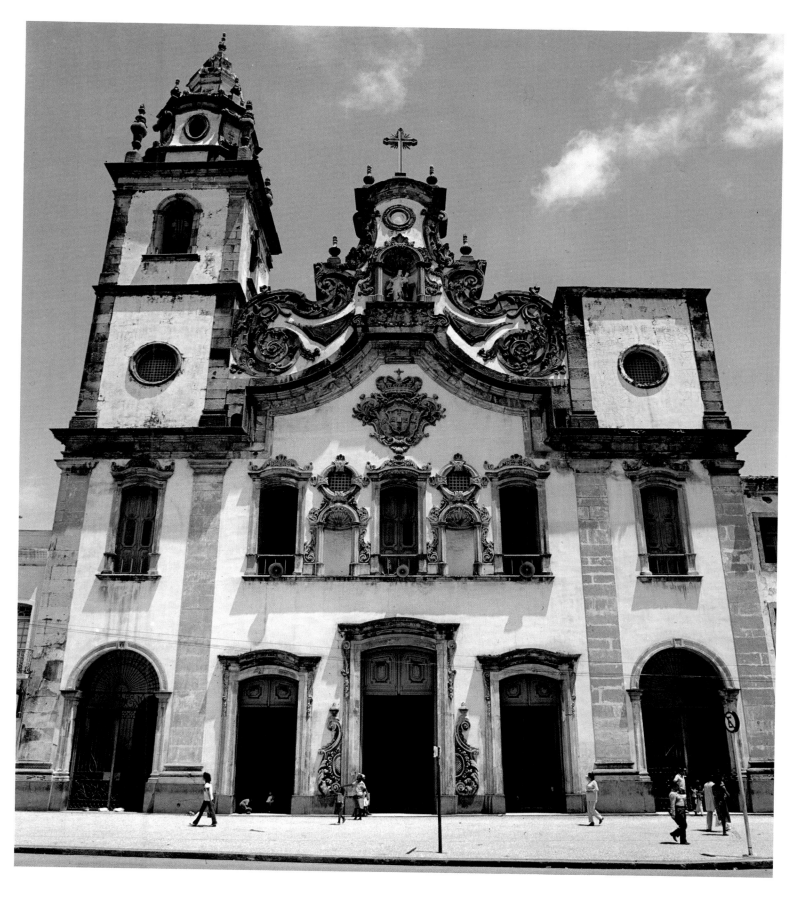

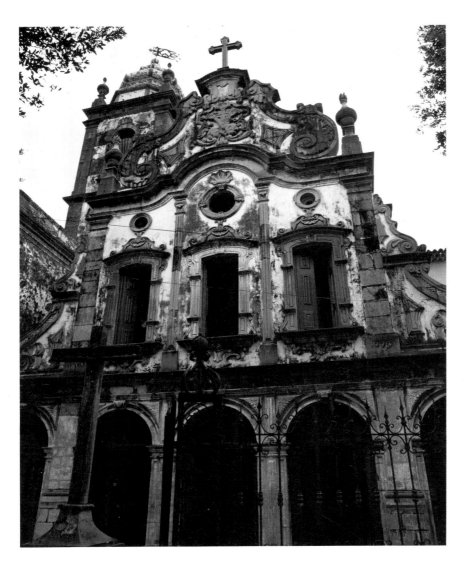

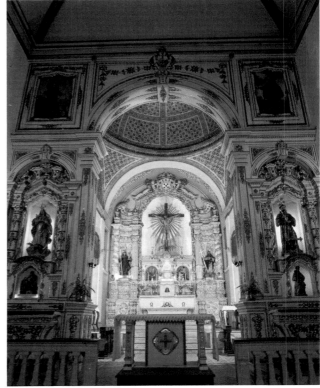

canvas measuring almost 6′ × 10′
(2 m × 3 m), in the Church of Nossa
Senhora da Graça in Salvador, was
painted in the second half of the eight-
eenth century and shows the "visit the
governors made with the city authorities
to the chapel every year on the day on
which the Church celebrates the birth of
St. John the Baptist" (page 62). Against
the background of the intensely blue
Bahian sea, in which tiny sailing boats
are just visible, the painting shows two
scenes, with minute figures divided by
a hedge: a procession of official car-
riages that will carry their owners from
the church back to town and, on the
beach, an Indian dance in which two
sixteenth-century characters, Catarina
de Paraguaçu and her husband Diogo
Álvares Correia, are taking part with
garlands of flowers in their hands. In the

small church of Nossa Senhora do Monte
Serrate in Salvador, there is a votive
offering dating from 1749 that is one of
Bahia's most important paintings of that
century (page 63). Almost like a comic-
strip story, with captions on scrolls, the
painting tells of the trials and tribulations
of the Portuguese Agostinho Pereira da
Silva, from the time he left his native
town to when he became a friar after
having tried to make his fortune in Minas
Gerais. A large framed scroll summarizes
the "wonderful graces and miracles per-
formed by the Virgin, Our Lady of
Suffrages to her devotee Agostinho
Pereira da Silva, both in worldly life and
as a priest." The various episodes are
arranged within the composition of the
painting, each explained with captions
such as, "beset by two terrifying cobras,"
and, "at risk of being murdered by the

people of São Paulo." The painting's
historic value is considerable since gold
prospectors and *bandeirantes* are shown
in the dress of the period.

Nordeste

The eighteenth century was not a pros-
perous period for the economy of
Nordeste since the international sugar
market suffered a serious crisis at this
time, both because of overproduction
caused by the expansion of the sugar
industry in the Antilles and because of
the decrease in the work force, absorbed
mostly by regions in southern Brazil. In
order to overcome the crisis, monopo-
listic commercial companies were created.
They were supported by the state and
financed by private capital. In Nordeste
they promoted the production of sugar,

The Chapel of the Tertiary Order of São Francisco de Assis, known as the Capela Dourada, belongs to the monastery of Santo Antonio in Recife. It is the work of Antônio Fernandes de Matos and was completed in 1695, but work for the decoration of the interior continued into the eighteenth century.

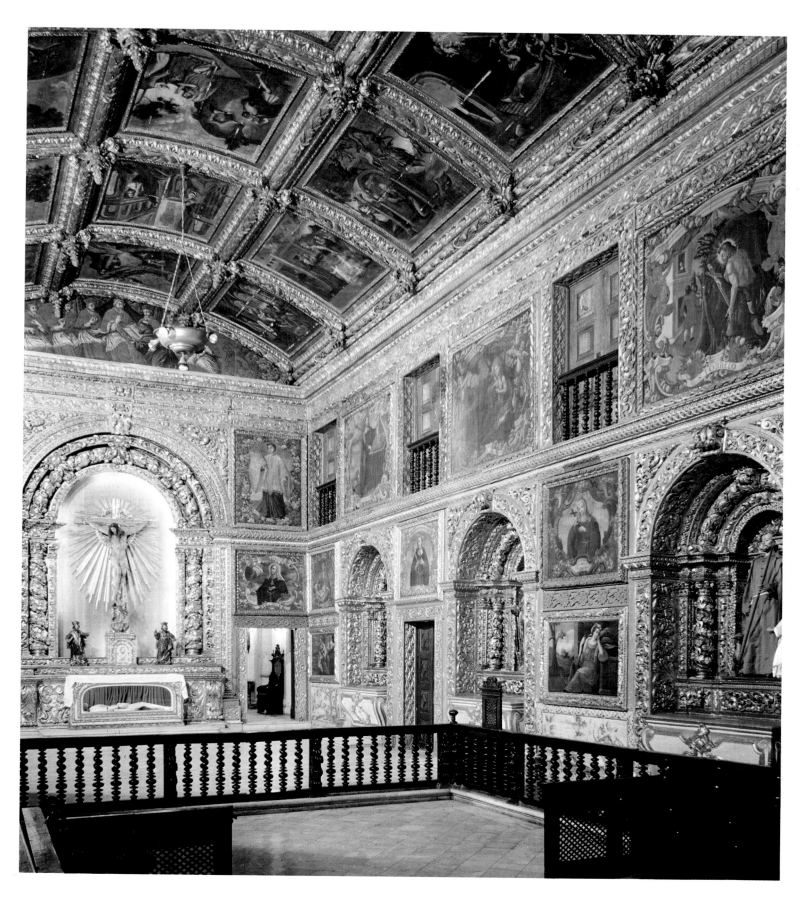

The Chapel of Nossa Senhora da Conceição, known as the Capela das Jaqueiras, belonged to an old farm now falling within the urban area of Recife. It was built in the second half of the eighteenth century and has the typical plan of Pernambuco rococo churches.

Bottom right, detail of the interior of the Capela das Jaqueiras in Recife, in which one of the nave walls with a pulpit and tile (*azulejos*) decoration can be seen.

tobacco, cotton and building timber. In 1735, the company of Grão-Pará and Maranhão was founded and in 1759 that of Pernambuco and Paraíba with its headquarters in Recife. There was therefore a considerable increase in Recife's population which led to expansion of the urban center by reclaiming land between the Beberibe and Capiberibe rivers. Transformed into a flowering commercial center, Recife became the main city in Nordeste, taking the place of Olinda, the aristocratic center of the sugar refinery proprietors.

In the previous century, after the expulsion of the Dutch, the restoration of old churches plundered by the invaders had been completed. In the eighteenth century many religious buildings emerged with new architectural features. One of the chief examples of a polygonal plan is the Church of São Pedro dos Clérigos, begun in 1728 and completed in 1782, which followed a design by the Portuguese architect Manuel Ferreira Jácome (1670–after 1737), who arranged the interior in two sections of different widths, the smaller section being the octagonal nave encircled by ambulatories. Jácome, who had probably worked with his fellow countryman, the architect Antônio Fernandes de Matos, who died in 1701 and was active in Pernambuco at the end of the seventeenth century, also had a hand in the cloister of the covent of the Tertiary Order of São Francisco in Recife and was involved in the expansion of the city's port.

In this period, two types of facade predominate: a simpler one derived from the mannerist style and a rococo one, with highly decorated and exuberant pediments with twists and turns, an exceptionally tall bell tower topped with a bulbous roof, and an elaborate profile. The rococo facade first appeared in the monastery of São Bento in Olinda, designed by Francisco Nunes Soares (active in Pernambuco in the second half of the eighteenth century), upon which work began in 1761. The new style was fully realized, however, in the facade of the Church of Nossa Senhora do Carmo in Recife (page 65), completed in 1767. The interior of the building (page 64), which was begun in the last quarter of the previous century under the supervision of Antônio Fernandes de Matos, still represents a moment of transition

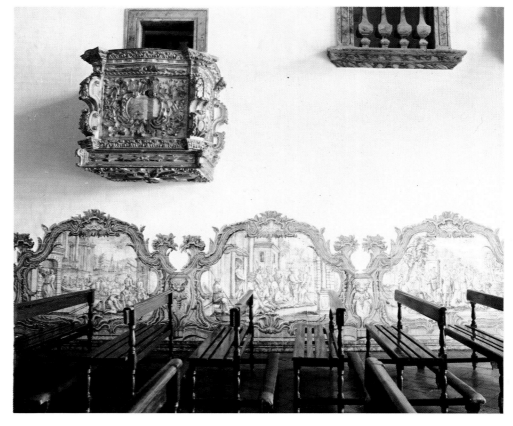

Church of the Franciscan convent of Santo Antônio in João Pessoa, Paraíba. It was founded before Dutch rule (1624–1654) and recovered by the Capuchins in 1656. In 1701 work was begun to build the Chapel of the Tertiary Order and the convent, whose cloister was completed in 1730. The conventual church has an enormous courtyard with tiled walls.

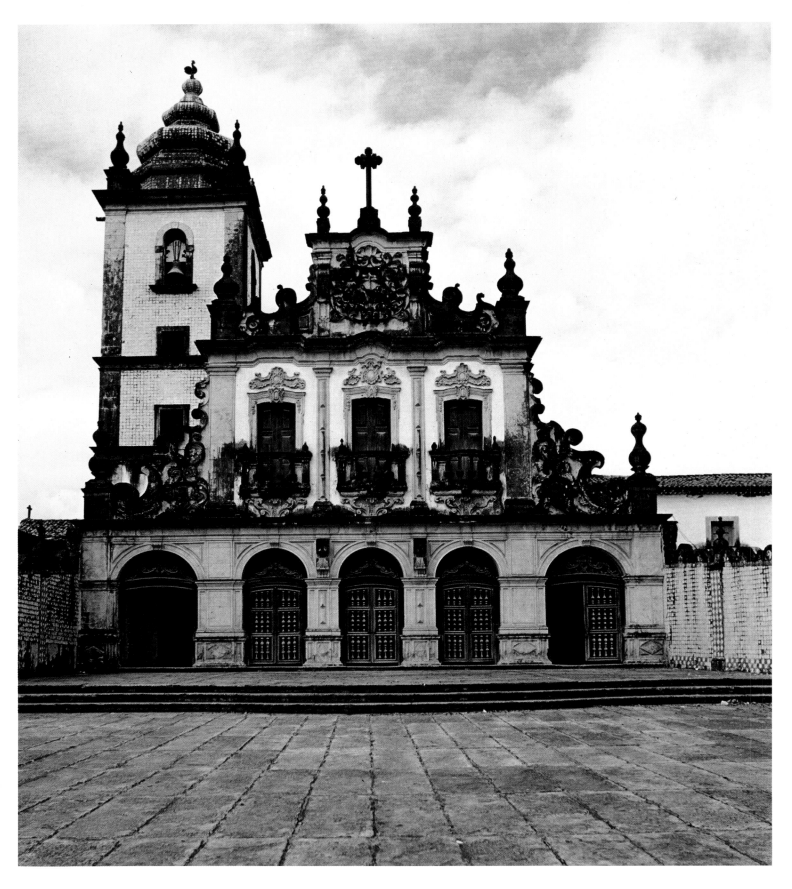

Left, Chapel of the Tertiary Order of the convent of Santo Antônio in João Pessoa, with the triumphal arch of the high altar (*top*) and a detail of the carving on it (*bottom*).

Below, Narthex of the Church of the Franciscan convent of Santo Antônio in João Pessoa, Paraíba.

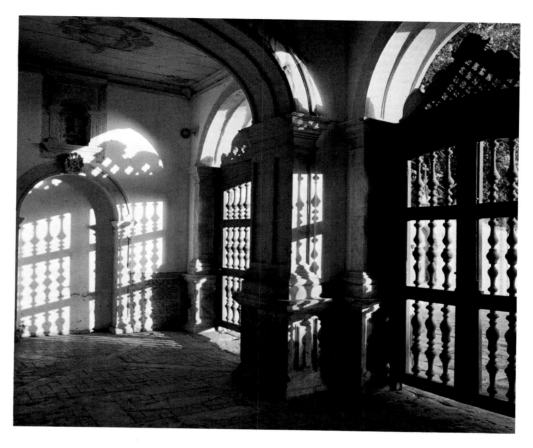

toward a plan in the form of a hall. This type of plan, which was to characterize many of Pernambuco's eighteenth-century churches, was later adopted by the Portuguese architect in the Chapel of the Tertiary Order of São Francisco de Assis (1695; page 67), annexed to the convent of Santo Antônio in Recife, also known as the Capela Dourada for its gilt wood decorations.

Because of its characteristics, the rococo style proved to be particularly successful in the chapels and small churches built in the eighteenth century on Pernambuco's large agricultural estates. The most famous is the Chapel of Nossa Senhora da Conceição, or Capela das Jaqueiras (named after the fruit trees grown on the farm where it was built, now part of the town of Recife; pages 68–69), which was built in 1766. Since it bears many similarities in its plan and facade to the church of the monastery of São Bento in Olinda, it has been attributed to the same architect, Francisco Nunes Soares.

In other regions of Nordeste hit by the economic crisis, architectural development was not very great. Unable to call in architects from Portugal, as Recife could, in the small coastal towns and interior villages local artists simply copied the styles from the wealthier center. However, beyond an apparent uniformity of architectural composition it is possible to detect regional differentiation due to the building materials available on site and climatic conditions.

In João Pessoa, capital of the state of Paraíba, in addition to the convent of the Carmelites and the Church of São Bento, the convent of Santo Antônio (pages 70–71 and 72–73) was completed. It is considered to be the masterpiece of Franciscan architecture in Brazil. The original building dates back to a period before Dutch rule, but the construction of the actual complex, with the order's chapel and convent, was begun in 1701 and the cloister completed by around 1730. The unusual proportions of the facade, with a narthex (front portico), suggest that the builders were partly inspired by sanctuaries in India, well-known to this missionary order. An oriental influence also seems obvious inside, in the decorations of the church's pulpit and the order's chapel.

The Franciscans built convents all over Nordeste, adopting a linear layout that developed around a cloister, as in the case of the convent of Penedo in the state of Alagoas, founded in the seventeenth century but completed in 1783. The annexed Church of Santa Maria dos Anjos (pages 74–75), completed around 1758, has a classical structure despite baroque decorations, whereas its interior shows the influence of the Bahian style in its decorations with *azulejos* depicting religious scenes on the lower part of its white walls and in the large ceiling panel, painted in perspective-illusionistic style.

Meanwhile, inland, civil architecture was being crystallized with prudent solutions. In the large centers, mainly Recife, houses combining commerce in the lower porticos with living accommodation on the upper floors continued to be built. This layout had already been used but more refined compositions arose, with typically rococo decorations appearing timidly in the doorways and in details of the windows. Unfortunately, most of these buildings have disappeared and those still extant in Recife, João Pessoa and São Cristóvão have been completely

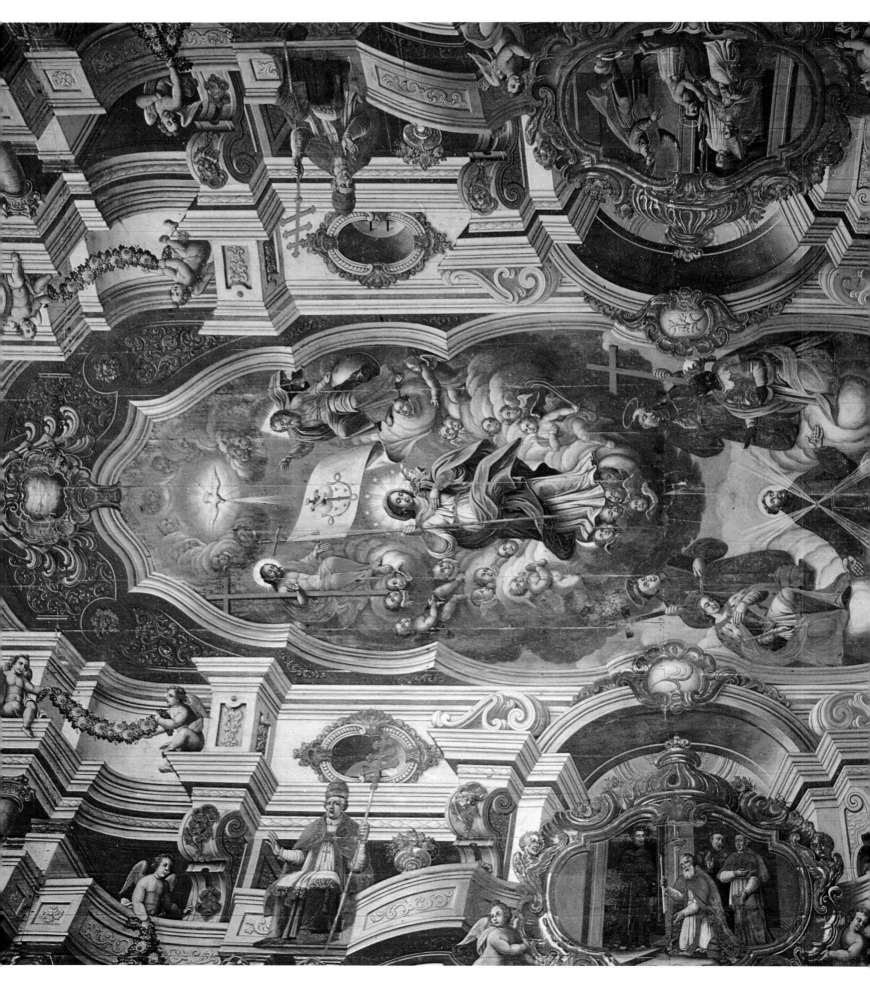

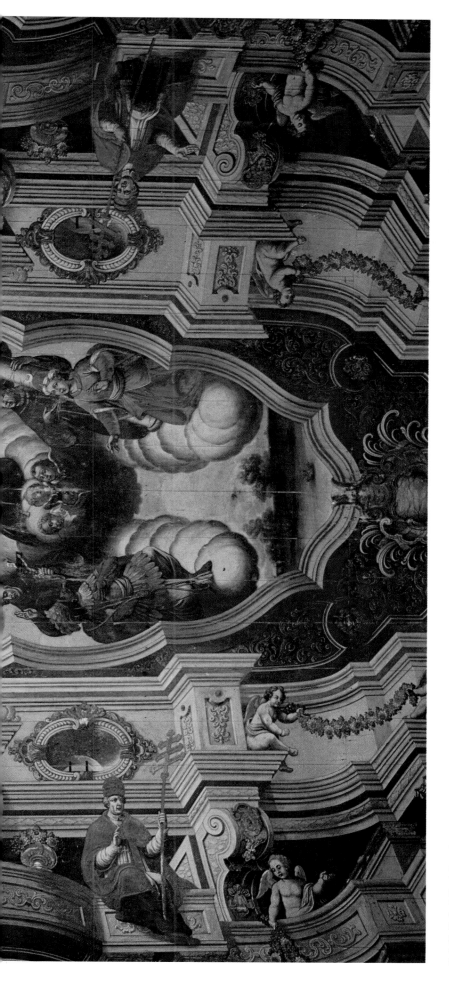

Above, view of the interior of the conventual Church of Santo Antônio in João Pessoa. In the foreground is the entrance arch of the Chapel of the Tertiary Order and in the background the intermediate floor of the chancel with its fretwork balustrade. *Left*, ceiling of the conventual Church of Santo Antônio. This work, 131.23′ long by 49.21′ wide (40 m × 15 m), is by an unknown artist and is one of the major examples of Brazilian perspective painting. It celebrates the glorification of St. Francis of Assisi in the presence of important ecclesiastical dignitaries.

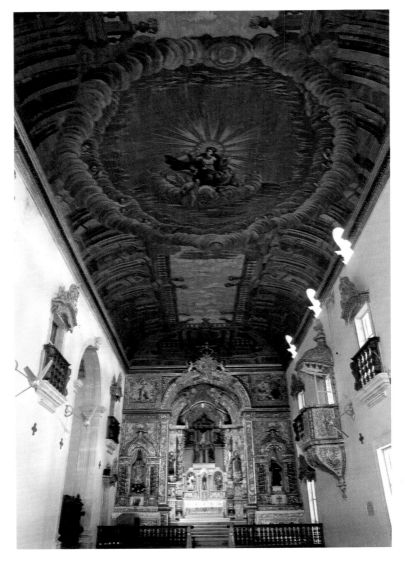

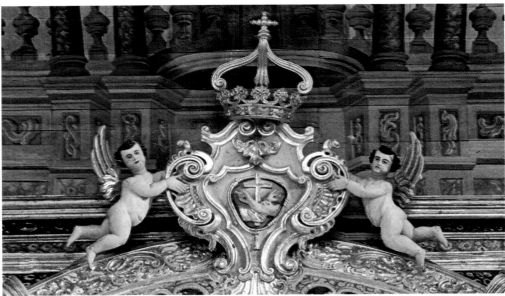

altered by various reconstruction works carried out at the beginning of the nineteenth century. In this period, for example, all the eaves were replaced with neoclassical platbands and the wooden balconies with cast-iron grilles. At the end of the eighteenth century, in Recife there were villas in the suburbs and farms along the rivers or by the sides of country roads. An example of this type of building is the Solar da Madalena, which belonged to councillor João Alfredo. Although a few subsequent alterations have been made, it has preserved its old magnificence as a nobleman's residence. In the more popular buildings and in the sugar refineries and cattle farms, there was a greater effort to find architectural solutions to match the climate. People chose or invented expedients suited to differing conditions: some places were always hot and humid, some hot and dry, and in others situated in the mountains inland days were hot and nights cold.

There is little information on the sculptors, carvers and craftsmen who made sacred statuettes of a popular nature and worked in the state of Pernambuco during the eighteenth century. Their names are not recorded in the sources and research on them has only begun. It is known, however, that the sculptor and painter Antônio Spangler Aranha was born and worked in Recife and, in addition to sculpting sacred images in wood, jasper and ivory, he worked with gilt. Traditionally, he also possessed musical talents and wrote poetry. The only definitely authentic work of this cultured and versatile artist is *São Diego de Alcalá* of 1748, in the Church of Nossa Senhora do Amparo in Recife.

Around the middle of the century, in Recife a sculptor and carver named João Pereira was active. In 1746 he made stone statues of *Our Lady of the Immaculate Conception* and *St. Anthony* for a bridge that was demolished in 1913. At that time the first statue disappeared but the *St. Anthony* is currently preserved in the Church of the Divino Espírito Santo in Recife.

Eighteenth-century Pernambuco painting is also little known because many documents have been lost and artists did not usually sign their works. In addition, many paintings have been altered over the years, often becoming unrecognizable and as a result dispersed or even destroyed. It can be stated, however, that,

Facade of the Church of Santa Maria dos Anjos which dates from the mid-eighteenth century. The church belongs to the convent of São Francisco, whose first stone was laid in the seventeenth century but which was not completed until the end of the eighteenth century. The foundation plan, which follows the typical Franciscan model, is developed around the cloister, completed in 1783.

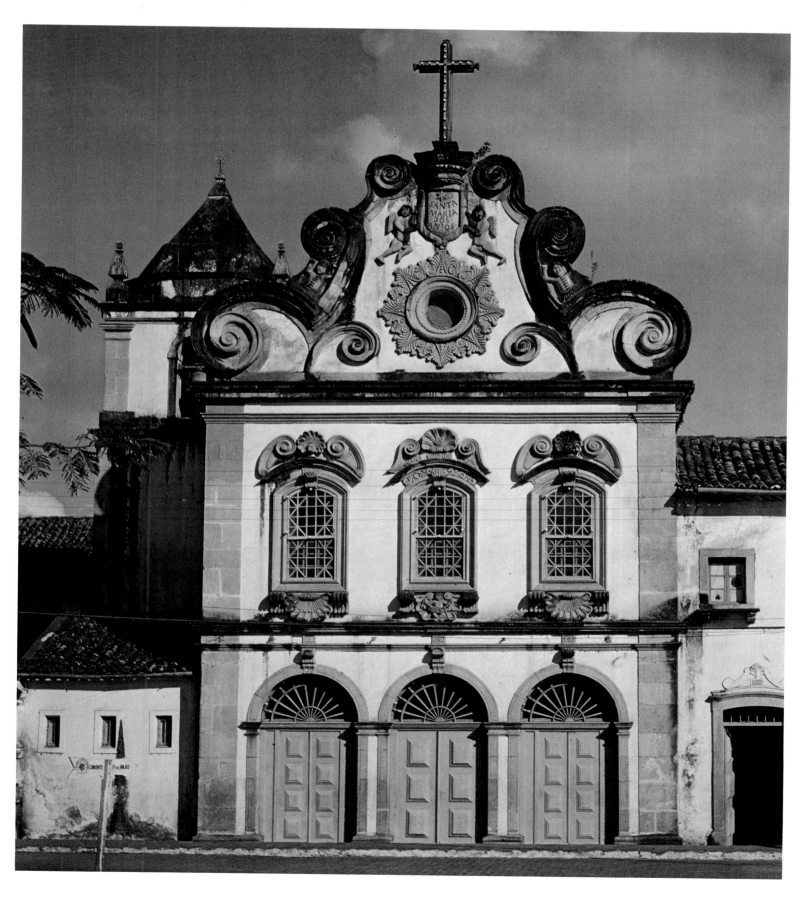

Attributed to João de Deus Sepúlveda (eighteenth century), the *Battle of the Guararapes* is in the chancel of the Church of Nossa Senhora da Conceição dos Militares in Recife. This work, commissioned in 1781, depicts the decisive battle won on April 19, 1648 by the Portuguese over the Dutch which took place in the Guararapes Mountains. *Left and right*, two details of the *Battle of the Guararapes*.

as with all colonial Latin American painting, the painting of eighteenth-century Pernambuco is linked to European trends, which it tried to imitate despite chronological discrepancy and obvious technical limitations. Flemish, Spanish and, to a lesser extent, Italian influences alternate with the predominantly Portuguese style of these paintings, forming a fascinating collection of anonymous works in which vivid colors enliven rough and sketchy drawings with a definitely popular flavor.

One example of anonymous painting is the large collection from the late seventeenth to early eighteenth century that decorates Recife's Capela Dourada (page 67), depicting scenes of martyrdom and Franciscan saints. Another group of anonymous paintings, presently in Igaraçu's Franciscan convent, comprises four panels (page 78–79 and 80–81) originally from the Church of São Cosme and São Damião of the same town. The first panel portrays the Portuguese landing and their victory over the Igaraçu Indians in 1530; the second represents the founding of the Church of São Cosme and São Damião; the third tells of the miraculous event that prevented the Dutch from plundering the church's tiles and the last is a portrayal of the 1685–1686 plague.

The most important Pernambuco painter whose activities have been partially reconstructed is, without doubt, João de Deus Sepúlveda. He came from a family of painters comprising his father, Antônio, and his sisters, Luciana, Lucinda, Teresa and Verônica. João de Deus Sepúlveda, a mulatto, was probably born in the 1740s and, in addition to having an interest in the plastic arts, also developed his musical skills. He appears to have followed a military career, since in some documents he is referred to as a lieutenant. The oldest of Sepúlveda's works still preserved today is a series of paintings depicting the *Life of St. Theresa* in the Church of St. Theresa of the Tertiary Carmelite Order in Recife. They have subsequently been badly retouched and only some of the details show the original colors.

On June 14, 1764, Sepúlveda signed a contract with the confraternity of the Church of São Pedro dos Clérigos in Recife for the decoration of the nave ceiling. This work, which took four years to complete, is considered to be the masterpiece of Pernambuco colonial painting. It portrays *St. Peter Blessing the Catholic World*, the central figure being the saint seated on a scarlet throne and encircled by saints and apostles in dramatic, lofty poses. The painted chancel ceiling of the Church of Nossa Senhora de Conceição dos Militares in Recife is also attributed to Sepúlveda because of its style. Commissioned in 1781 by the governor, José César de Meneses, it depicts the *Battle of the Guararapes Mountains* (page 76–77), celebrating the first victory over the Dutch with a lively sense of narrative that is unharmed by the detail of the miraculous intervention of the Virgin and the ingenuous tone of the individual episodes. Lastly, other paintings in the same church, such as *The Baptism of Christ* and *The Resurrection*, could be the work of Sepúlveda.

Two other painters were active in Recife in the second half of the eighteenth century. One was Francisco Bezerra. In 1785 Bezerra was commissioned to paint ten panels (now lost) on the *Life of St. Peter* for the Church of São Pedro dos Clérigos, and in 1791 he painted works on the *Life of St. Benedict* for the sacristy of the monastery of Olinda Church. The other painter was Manuel de Jesus Pinto who, in 1792, decorated the sacristy of the Church of St. Theresa of the Tertiary Order of the Carmelites with paintings and gilt work. The chancel ceiling of the Church of São Pedro dos Clérigos, painted between 1806 and 1807, is also attributed to him.

José Elói worked on the sacristy of the Church of São Bento monastery in Olinda, where in 1785 he painted a ceiling panel with scenes of the *Life of St. Benedict*. In 1789 he painted an altar panel depicting the *Pietà*.

Maranhão and Pará

The captaincy of Maranhão, established in 1532, remained practically uninhabited until the French installed themselves there in 1612, founding the town of São Luís. Three years later it was reconquered by Jerônimo de Albuquerque, but most of the French colonists were allowed to remain in the region to populate it. Francisco Frias de Mesquita was among the Portuguese who took part in the war against the French. He was responsible for the town plan of São Luís and the construction of a series of fortresses, including the Santa Maria

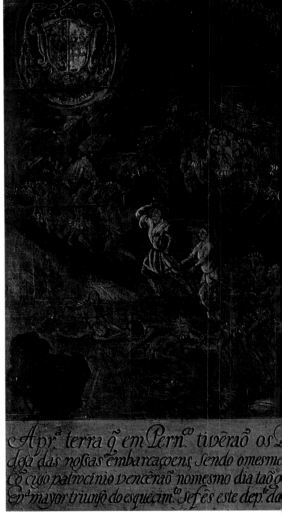

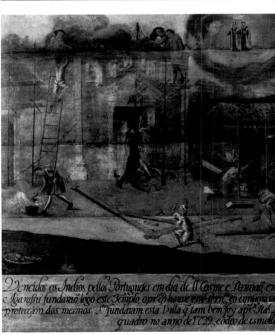

Three of the four *Igaraçu Panels*, 1729, by an unknown artist. They once belonged to the Church of São Cosme e São Damião in Igaraçu, Pernambuco. They are now kept in the Franciscan Convent of Santo Antônio in the same town. The subjects treated in the panels are *(top to bottom and left to right)*:

The Arrival of the Portuguese and Their Triumph over the Igaraçu Indians in 1530, oil on panel; 57.87″ × 88.18″ (147 cm × 224 cm); *The Founding of the Church of São Cosme e São Damião and the Town of Igaraçu*, oil on panel; 57.48″ × 94.88″ (146 cm × 241 cm); *The*

Miracle that Prevented the Dutch, in 1632, from Plundering the Tiles of the Church of São Cosme e São Damião, oil on panel; 57.48″ × 94.88″ (146 cm × 241 cm). The fourth *Igaraçu Panel* is shown on the following pages.

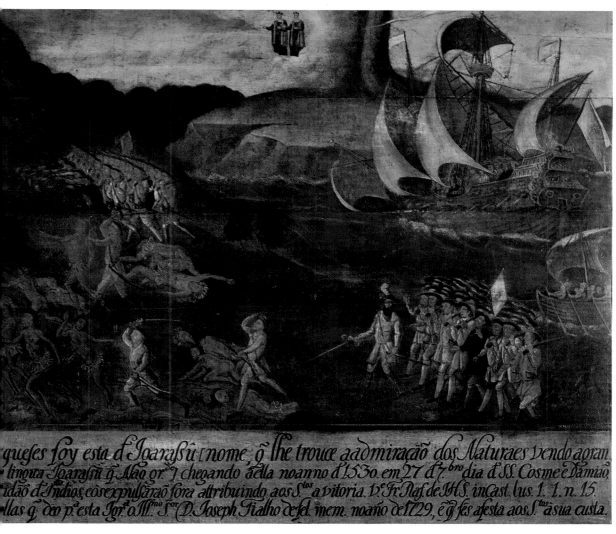

queſes foy esta d'Joaraſsû nome, ô lhe trouce aadmiraçaõ dos Naturaes vendo agran
lingua Joaraſsû q Maõ gr I chegando áella noanno d 1530 em 27 d 7bro dia d SS. Cosme e Damiaõ,
idaõ d'Indios côsexpulſaraõ fora attribuindo aos Stos a vitoria. Dr Fr Raf de JHS. incast. lus. 1. 1. n. 15.
llas q deo pa esta Jgra o Illmo Sor D. Joseph Fialho de fel. mem. noaño de 1729, e q fes afesta aos Stos ásua custa.

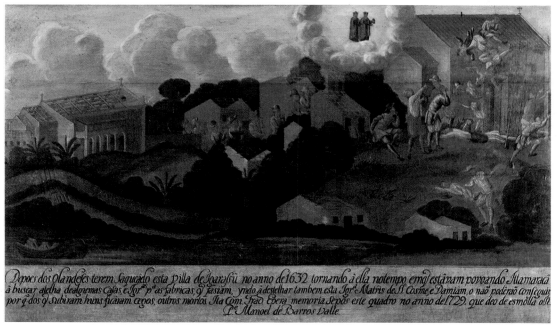

nr de taõ gr beneficio noniesmo lugar da Vitoria q foy este de
los Sr donde foraõ sempre continuas as suas maten e debaixo da
S incast. lus. LL. n. 15 exc mayor memoria semandou por este
s Mach. Fr Cadguitor da Pr.

Depocs dos Olandeſes terem ſaquado esta villa de Jgaraſsû no anno de 1632 tornando á ella notempo emq estáuam povoando Jtamaraca
á buscar atelha dealgumas Caſas e Jgra pa as fabricas, q fasiam, yndo á destelhar tambem esta Jgra Matris de SS Cosme e Damiam, o naõ poderaõ conſeguir
por q dos q subiram huns ficaram cegos, outros mortos Ha Cōm Fraō Ebera memoria depos este quadro no anno de 1729, que deo de esmólla o Pr.
Pr Manoel de Barros Valle.

The fourth *Igaraçu Panel* (the other three are shown on the previous pages) is divided into bands and shows *The Miracle that Spared the Town of Igaraçu, Protected by São Cosme and São Damião, from the Plague which in* *1685–1686 Decimated the Populations of Goiânia, Itamaracá, Olinda and Recife*. Oil on panel; 57.87″ × 94.88″ (147 cm × 241 cm). The *Igaraçu Panels* are considered the most curious work of colonial painting.

fortress in Guaxenduba. In 1615, Francisco Caldeira Castelo Branco was given the task of conquering the lands around the Amazon on behalf of the Crown, and in 1616 he founded the Forte do Presépio at the mouth of the Amazon river. The fort served as a departure base for expeditions into the interior and around it the town of Belém was to develop. Five years later the state of Maranhão and Pará was founded under the direct control of Portugal, and its capital was established at São Luís.

During the seventeenth century a series of agricultural villages sprang up along the banks of the rivers in the Amazon basin. They developed, for the most part, around Franciscan and Jesuit missions and comprised wooden dwellings with roofs of leaves in the mold of native settlements. The dwellings and the religious buildings fell victim to the ravages of time and the incursions of the Dutch who, capturing São Luís in 1641, acted in a very different manner to Nassau's men in Pernambuco.

Only in the eighteenth century, with the creation of the General Trading Company by the marquis of Pombal, did any real building develop in Maranhão. The company granted credits and supplied building materials and a work force of slaves. The company introduced Negroes into Maranhào.

São Luís, at the beginning of the nineteenth century, became the fourth-largest town in Brazil thanks to the wealth from the trade in cotton grown in the inland areas. Portuguese immigrants, who represented the majority of the population, started up private building plans, which were inspired by models from the homeland and constituted a unique example in colonial architecture. Town villas, two or three stories high, were built of sandstone and completely covered with multicolored ceramic paving tiles. Although the ground floor had no special features, the upper floors differed from the original models in that the garrets extended above the roofs to serve as belvederes, and the corridors at the back of the buildings had windows shielded by blinds to alleviate the discomfort of the equatorial climate.

Opposite São Luís, on the other side of São Marcos Bay, the town of Alcântara developed through the company's efforts, but today it is almost completely uninhabited. Its ruins, evidence of a typical town plan of a sparsely-populated

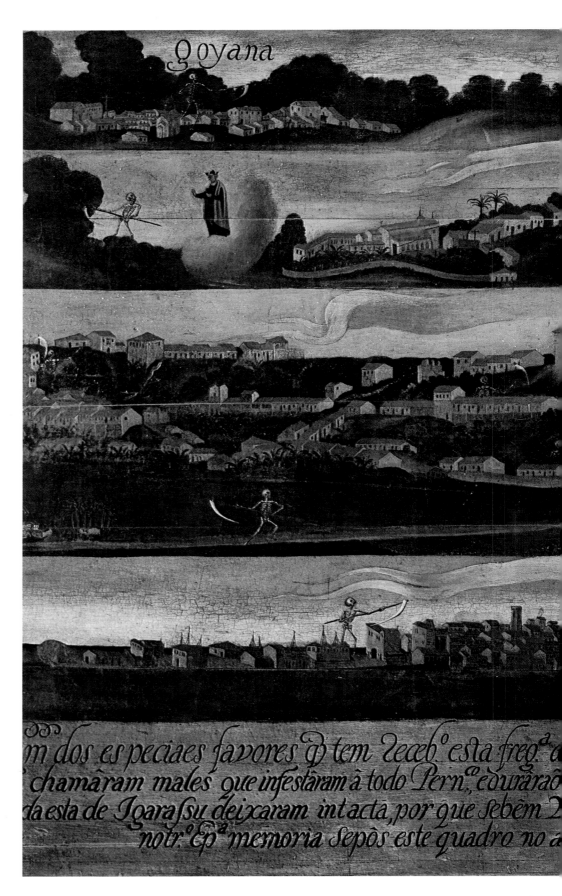

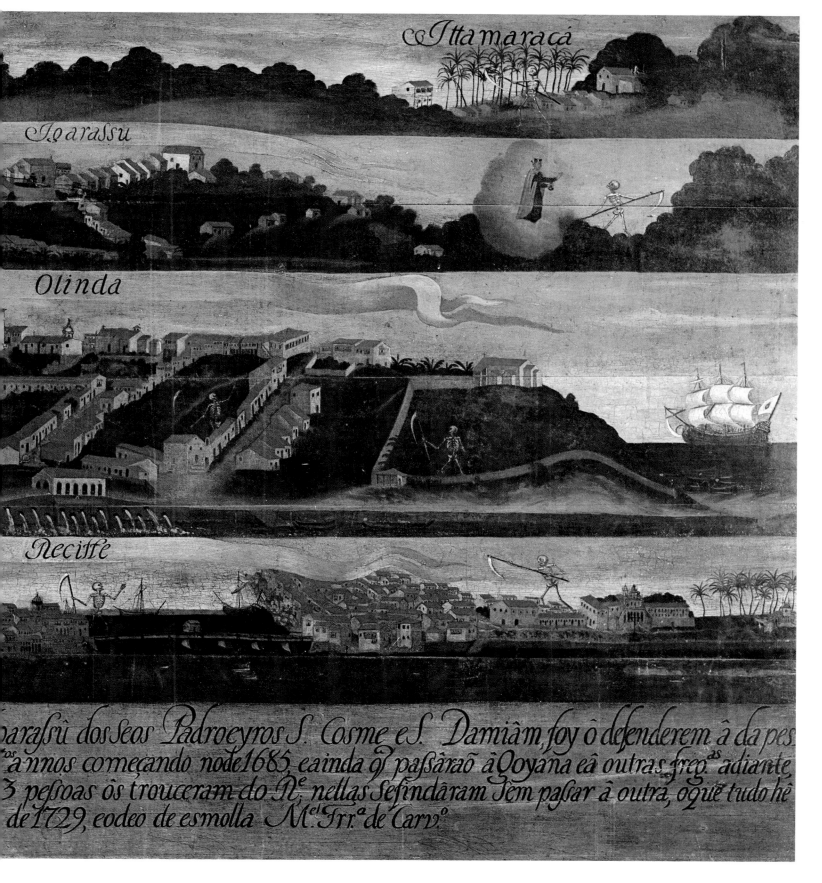

Ittamaracá

Igarassu

Olinda

Reciffe

...arassû dos seos Padroeyros S. Cosme e S. Damiâm, foy ô defenderem â da pes...
...os annos começando node 1685, e ainda of passarão à Goyana eâ outras freg.as adiante
...3 pessoas òs trouceram do R.e nellas Sefindâram Sem passar à outra, oque tudo hê
de 1729, eodeo de esmolla M.el Frr.a de Carv.o

81

Below, the facade of the Church of Nossa Senhora das Mercês in Belém (Pará), built by the Italian architect Antonio Giuseppe Landi (1708–1790). Landi, engaged by the Portuguese Crown as a military engineer, introduced neoclassicism into Brazil.

Right, Joaquim José Codina (eighteenth century), *Church and Square of Mercy.* Water color from *Viagem Filosófica* by Alexandre Rodrigues Ferreira. Biblioteca Nacional, Rio de Janeiro. Codina faithfully reproduced the Church of Nossa Senhora das Mercês and its square as they appeared at that time.

center, show a wide central square from which spacious roads, with two-storey villas, branch off.

After the 1750 Madrid Treaty, which resulted in Spain and Portugal sending missions of technical men of different nationalities to their colonies to settle the boundaries of the various lands, both southern Brazil and the Amazon regions were explored by expeditions of soldiers, engineers, topographers and astronomers. The expeditions often established points of demarcation by building fortifications. The most important of the numerous fortresses built in the Amazon territory were Príncipe da Beira in Guajará-Mirim and São João do Macapá in Amapá. Both fortresses were designed by Italians, the first by Domenico Sambuceti and the second by Enrico Antonio Galluzzi, a Mantuan who worked in Brazil for sixteen years. From 1753 to 1759, another Italian took part in one of these expeditions. He was Antonio Giuseppe Landi (1708–1790), who had been a pupil of Ferdinando Galli da Bibiena and had taught architecture and perspective in Bologna.

On his return to Belém at the end of the Amazon journey, Landi was commissioned by the governor of the town, Manuel Bernardo de Melo e Castro, to build a palace which was "well-designed

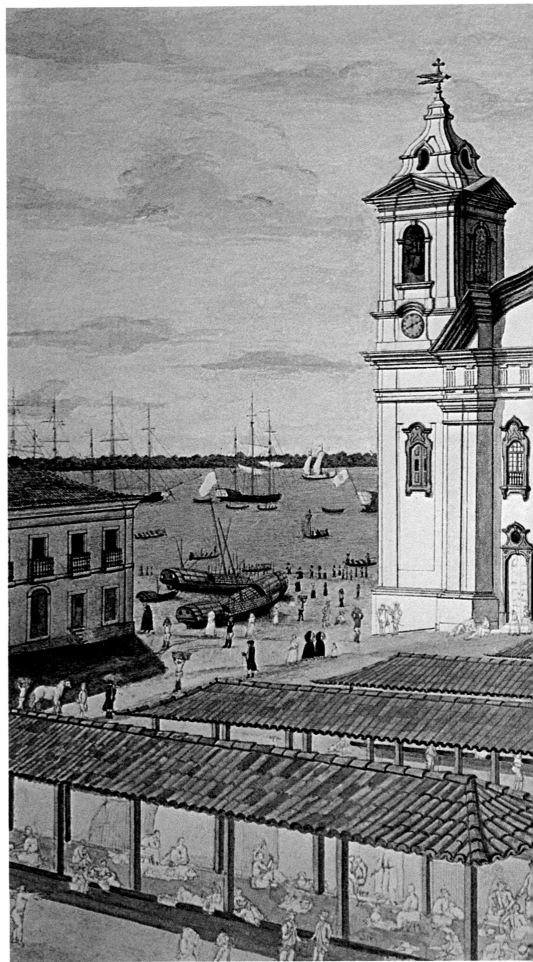

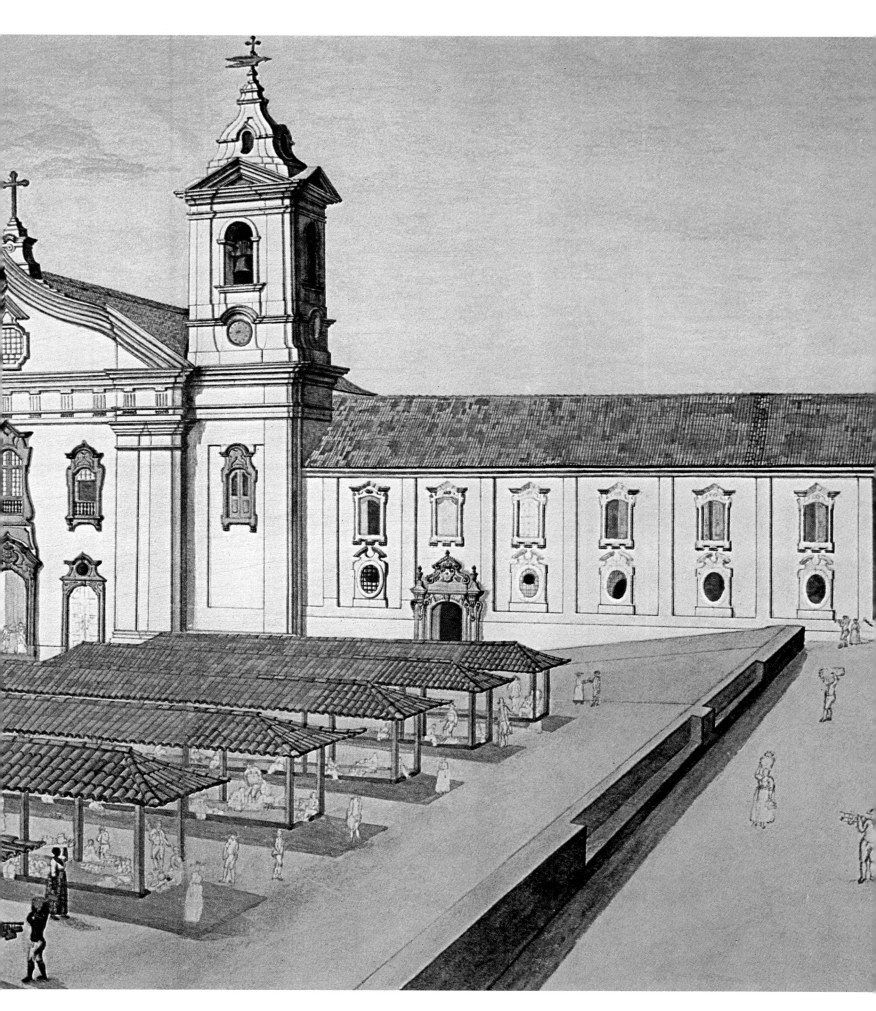

and sufficiently large to be a residence befitting the dignity ... of the governors and captain generals." In 1753, Belém had, in fact, been raised to the rank of capital of Pará, now separated from Maranhão, and this led to a considerable development in building. The new constructions obeyed the stylistic criteria that were being adopted at the same time by the marquis of Pombal, prime minister of Portugual, in the reconstruction of Lisbon, which had been almost completely destroyed by the 1755 earthquake. Without completely abandoning the rococo style, Belém architecture shows clear signs of neoclassical taste.

For the governors' palace, completed in 1771, Landi designed a compact and linear structure decorated with classical elements and rationally subdivided into three stories. Landi also built numerous private villas and the military hospital in Belém. We also have him to thank for the Church of Santana (1761) with its neoclassical facade and domed roof, an extremely rare feature in Brazil; the Church of Nossa Senhora do Rosário dos Pretos in Campina, designed in 1767 and built in 1820; the rebuilding of the old church of the convent of the Carmel (1766); and in 1777 the complete reconstruction of the church of the convent of Nossa Senhora das Mercês (page 82). The work that best synthesizes the fusion between the Brazilian-Portuguese tradition and the neoclassical style is the Church of São João Batista, designed in 1767 and built between 1772 and 1777. It is small and elegant with a circular plan made into an octagon and a classical facade slightly broken up by rococo moldings, bringing to mind early sixteenth-century Italian churches with a central plan.

It should be noted that Landi worked in Belém more or less at the same time that Aleijadinho was creating his rococo masterpieces in Minas Gerais. In other Brazilian states the baroque inheritance was handed down. However, in Pará, due to the lack of a pre-existing tradition and to the presence of a talented architect sensitive to the spirit of renewal in European art, a fully neoclassical architecture developed fifty years ahead of that in Rio de Janeiro, where only in 1816 was the new style to be introduced by Grandjean de Montigny.

Studies on the subject have not yet begun, but it does not appear that sculpture and painting had any particular importance in the figurative culture of the two northern states of Brazil. There is a reference to the activities of the Jesuit, Father João Xavier Traer (1668–1737), as a sculptor in Belém. He was Austrian and had already worked in Lisbon before coming to Brazil in 1703. The carved wood pulpits in the Church of São Francisco Xavier, annexed to the present-day Belém seminary, and a group of works in various Jesuit missions in the region are attributed to him. It seems likely that the the wooden images

Joaquim José Codina (eighteenth century), *The Gunboat N.S. do Pilar e S. João Batista.* Water color from *Viagem Filosófica* by Alexandre Rodrigues Ferreira. Biblioteca Nacional, Rio de Janeiro.

Details of carvings on one of the side altars (*below*) and the apse (*right*) of the Church of the Tertiary Order of São Francisco da Penitência in Rio de Janeiro. They are the work of Manuel de Brito, from Portugal, who began this project in 1726.

of saints, produced in the eighteenth century, were made by native artists (such as the Indians Manuel, Angelo and Faustino as recorded in 1718 in the registers of the Colégio de Santo Alexandre in Belém) who translated baroque models into ingenuous forms.

The religious paintings and altarpieces still remaining are generally anonymous. It is known that the Jesuit Father Luís Correia (born in Portugal in 1712) worked for the present-day Belém seminary between 1732 and 1742, but none of his works have been identified. However, in the opinion of some scholars he was the author, together with João Xavier Traer (who had also painted in Lisbon) and Agostinho Rodrigues (born in Lisbon in 1721) of all the altarpieces in the Church of São Francisco Xavier.

Two artists linked to the scientific and military expeditions into the Amazon region were Joaquim José Codina and José Joaquim Freire. They accompanied the naturalist Alexandre Rodrigues Ferreira between 1783 and 1792 on his journey into the Amazon forests, documenting the flora, fauna, geography and ethnography of those lands with hundreds of drawings and watercolors which later served to illustrate the *Viagem Filosófica* by Alexandre Rodrigues Ferreira (pages 82–83 and 84–85).

Rio de Janeiro

At the beginning of the eighteenth century, after the discovery of gold in the state of Minas Gerais, Rio de Janeiro became the most important center of trade between the gold area and Portugal. Its importance increased with the opening of the *Caminho Novo* ("New Road") which linked the mining area directly with the city, replacing the old road, which started in São Paulo and went through Parati.

Until then, Rio de Janeiro had been a little coastal town that had a few elegant buildings, such as the monastery of São Bento, the convent of Santo Antônio, the Jesuit college and a number of baroque churches.

Trade with the mining area was so important that in 1763 the town became the capital of Brazil in place of Salvador, despite the fact that it was constantly exposed to attacks by French pirates. Around 1735, however, construction work had begun. Harbor fortifications were extended and buildings were erected. The buildings were destined to turn the town into a well-equipped trading emporium that exported gold and distributed necessary consumer goods, including sugar grown in the area around the bay, to the mining region. Governor Aires de Saldanha ordered a series of civil engineering works to be carried out. The works culminated in the construction of the aqueduct in the high part of town: a grandiose stone structure with two rows of arches. It was under the rule of the count of Bobadela, with the help of Alpoim, however, that the city grew and changed its appearance.

Born in Portugal, José Fernandes Pinto Alpoim was eighteenth-century Rio's chief architect and military engineer. He arrived there in 1738 to give a course on military engineering. In 1740 he designed a hospital for the Franciscans, then he was sent to Minas Gerais, where he drew the town plan of

Interior of the Church of the Tertiary Order of São Francisco da Penitência in Rio de Janeiro. Construction of the church began in the second half of the seventeenth century and was completed in 1773. Francisco Xavier de Brito, a relative or perhaps only a work-companion of Manuel de Brito, assisted in the church's interior decoration from 1735. He created the triumphal arch of the apse.

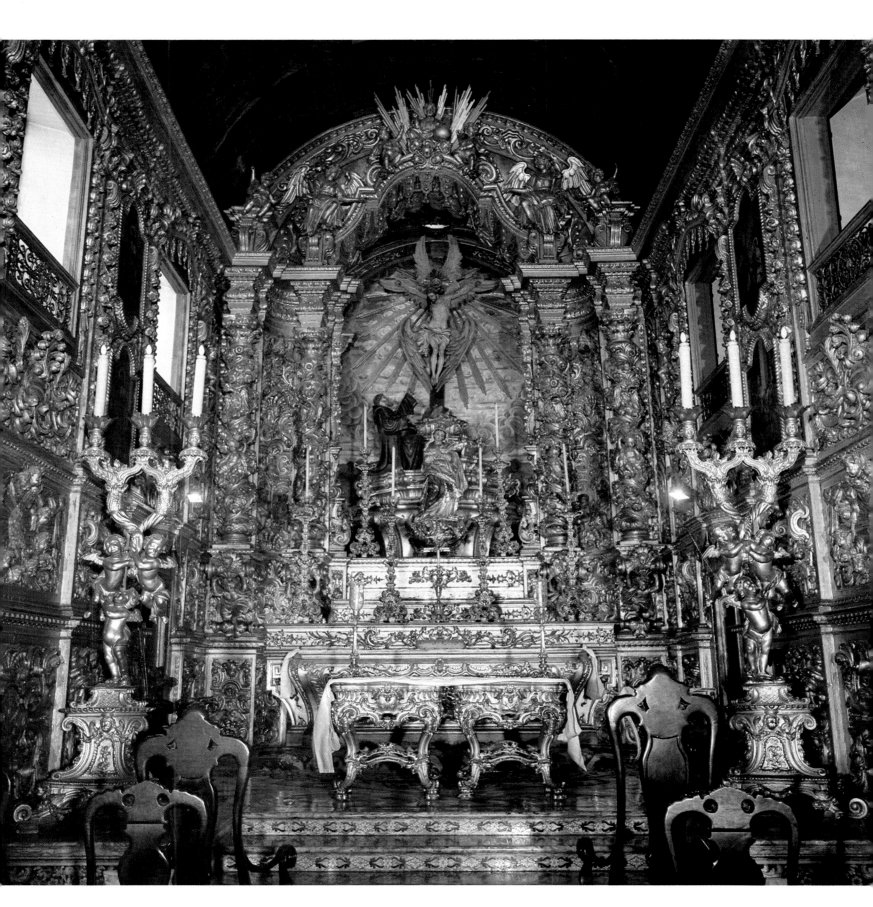

João Francisco Muzzi, (*below*), *Fire at the Retreat of Nossa Senhora do Parto* and (*opposite, above*), *Reconstruction of the Retreat of Nossa Senhora do Parto*, circa 1789. Oil on canvas; 39.37″ × 48.81″ (100 cm × 124 cm). Fundação R.O. Castro Maya, Rio de Janeiro.

Opposite, below, detail of the second painting, showing Master Valentim, designer of the new project, and the viceroy Dom Luís de Vasconcelos, responsible for the reconstruction of the building.

Mariana and built a residence for the governors in Ouro Prêto: a building with harsh lines, designed as a rectangular fortified house with four bastions. After his return to Rio de Janeiro, Alpoim designed a new residence for the governors, which later became the town hall, and villas for the Teles de Meneses family. He then supervised work to complete the aqueduct. Alpoim is also credited with the designs for the residences of the Benedictine bishop, Antônio do Desterro, and of one of his brothers in Rio Comprido and Niterói (now within the city of Rio itself), the convents of Ajuda and St. Theresa, and

the cloister facade in the monastery of São Bento. Lastly, according to some scholars, around the middle of the century Alpoim introduced the use of windows protected by curved bar gratings.

The greatest innovations in Rio's architecture, however, are due to another military architect, Lieutenant Colonel José Cardoso Ramalho, to whom the plan for the Church of Nossa Senhora da Glória do Outeiro is attributed. The first example in Brazil of a baroque polygon plan, it was designed around 1720. It inspired Alpoim in the construction of the Church of Nossa Senhora da Conceição da Boa Morte.

In the second half of the eighteenth century, almost all of the churches of Rio de Janeiro followed either a polygonal plan or the traditional plan of a rectangular nave with side aisles. An exception is the Church of Nossa Senhora da Candelária, designed by general Francisco João Róscio in 1775 with a latin cross plan and stone and marble decorations showing a clear Italian influence.

The most striking of the churches with a rectangular plan are those of the Tertiary Order of Nossa Senhora do Carmo and of São Francisco de Paula, both dating from 1752, and Santa Cruz

The Retreat of Nossa Senhora do Parto was a kind of reformatory set up in Rio de Janeiro for women who "dared to displease" their fathers or husbands. The building was destroyed by a fire on August 23, 1789. Two days after the disaster, reconstruction work began and was completed in December of the same year. These two canvases have great documentary value due to the accurate representation of the furniture, clothing and means of transport in Rio de Janeiro at the end of the 1700s.

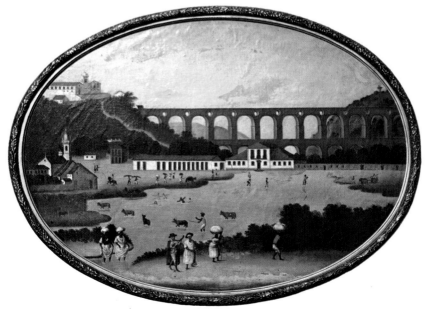

These five panels—oil on canvas, 32.67″ × 44.48″ (83 cm × 113 cm)—attributed to Leandro Joaquim (1738?–1798?), represent *(top to bottom and left to right)*: *Procession or Pilgrimage by Sea to the Lepers' Hospital*, also known as *Venetian Festival*; *View of the Boqueirão Lagoon and the Carioca Arches*; *Whaling*; *Military Review in Royal Palace Square*; *View of the Church of Glory*. They were painted for one of the pavilions of the Passeio Público (public park) built by the painter with Master Valentim. Today the panels are kept in the Museu Histórico Nacional, Rio de Janeiro, where there is also a sixth panel (*Naval Scene*) which completes the series.

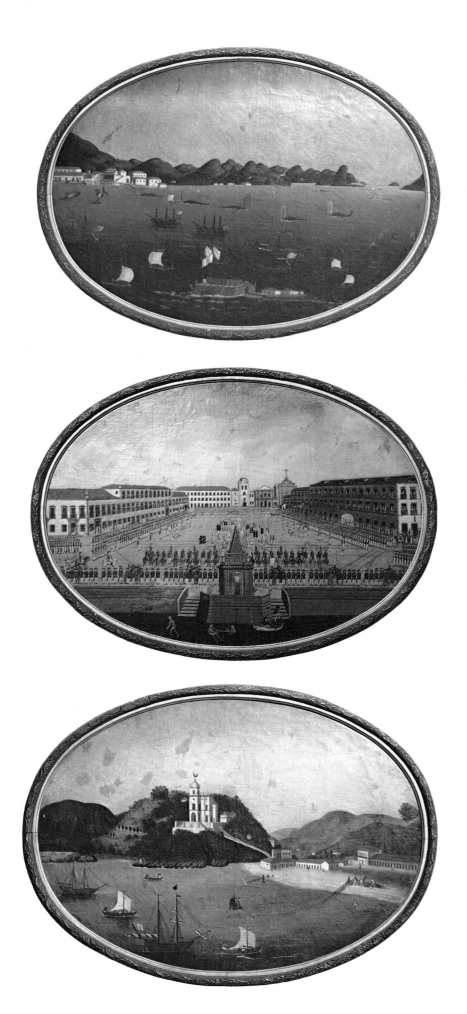

dos Militares, designed in 1780 by general José Custódio de Sá e Faria, a Portuguese military engineer who came to Brazil in 1751 to head an expedition for the demarcation of the southern confines.

After the change of capital city, sugar plantations and farms sprang up around the Guanabara Bay and within the state of Rio de Janeiro. The proprietors' residences tended to be built on standard lines, indicative of the generalization of a model capable of satisfying the requirements of the rural aristocracy.

The model for the master's villa may have been the result of long years of isolation characteristic of the poorer areas, where information was continuously exchanged among the same individuals, who were cut off from the rest of the world. Alternatively, the model may have resulted from a single influential builder, who probably belonged to a religious order.

The fact remains that this type of building is fairly characteristic, and its most interesting feature is the wide portico in front of the facade supported by walled columns made in circular sections, vaguely Tuscan in style, with the gaps decorated with fancy carved panels. The portico, which sometimes surrounded the entire house, served to protect the walls from the sun and sometimes had reception and accommodation areas to which the chapel and guest quarters could be connected.

This type of rural dwelling, common also in the states of São Paulo and Minas Gerais, is typical of regions divided into large estates. The houses, separated from each other by great distances and far from the towns, had to be meeting places where religious ceremonies could be held as well as places for travelers to stay overnight.

Eighteenth-century sculpture in Rio de Janeiro includes a few important personalities, among whom were the two

Below, Água sugar refinery in Ilhabela on the island of São Sebastião, São Paulo, eighteenth century. *Bottom left*, Thomas Ender (1793–1875), *Man from São Paulo with Poncho* (detail), 1817. Pencil drawing. Akademie der Bildenden Künste, Vienna. *Bottom right*, the Sítio do Padre Inácio, Cotia, São Paulo, eighteenth century.

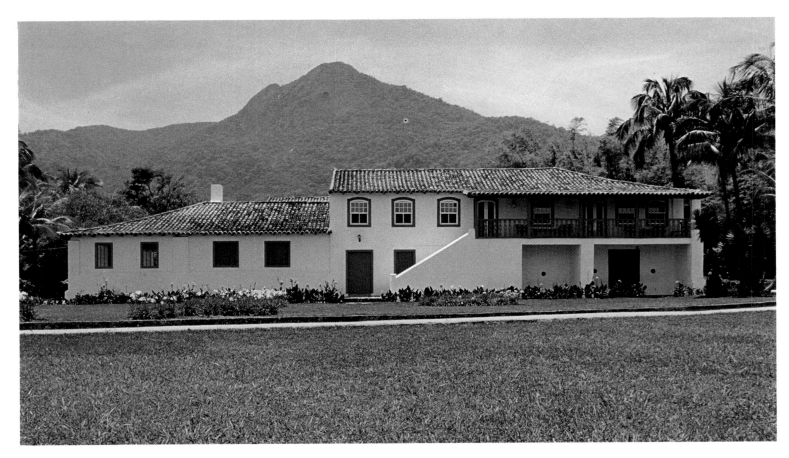

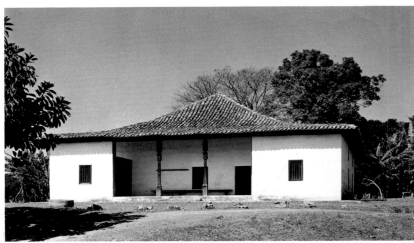

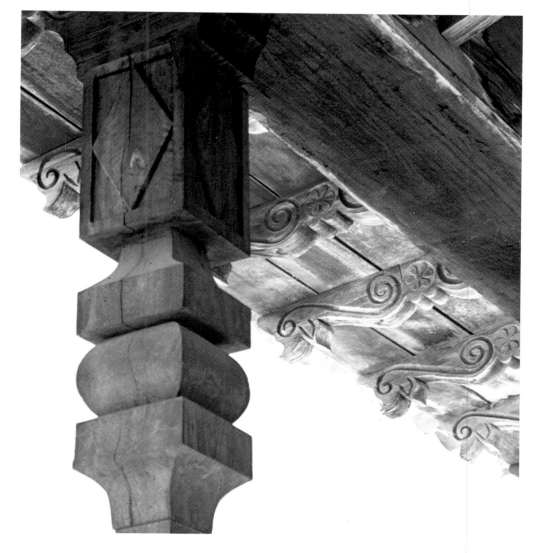

Left, the eaves of the Sítio do Padre Inácio, Cotia, São Paulo, have corbels carved in the shape of dolphins. Eighteenth century.
Below, waterwheel at the Santa Ana farm in São Sebastião, São Paulo.

authors of the gilt wood decorations in the Church of the Tertiary Order of São Francisco da Penitência (pages 86–87), Manuel de Brito and Francisco Xavier de Brito from Portugual, the former described in contemporary records as a carver and the latter as a sculptor. It is not known whether they were related, but their works, which gave rise to the "Brito style," show similarities and seem to derive from models of the contemporary Lisbon school.

Manuel de Brito came to Brazil in 1726 and in June of the same year was already working on the apse retable of São Francisco da Penitência. Six years later he did the carvings on a pulpit in the same church.

Francisco Xavier de Brito began to take part in the decoration of this church in 1735, the year in which the contract was signed for carving the triumphal arch and cornice of the apse. In 1738 Francisco Xavier completed the six side altars and the following year Manuel de Brito was commissioned by the confraternity of the Tertiary Order to decorate the walls between the altars. The works of the two artists are complementary and integrate harmoniously, as if the de Britos worked according to mutual agreement. Some decorative details are used by both sculptors and the structure of the high altar, designed by Manuel, was taken up by Francisco Xavier in the side altars.

Francisco Xavier de Brito later moved to Vila Rica (where he was to die in 1751) and worked on the decoration of the apse of the mother church of Nossa Senhora do Pilar (1746). Then, with Manuel Gomes da Rocha, he made a few sculptures for the apse of the Church of Santa Ifigênia do Alto da Cruz. It could be said that in the state of Minas Gerais, as in Rio de Janeiro, a true "Brito style" spread which was also to influence Aleijadinho.

The peak of eighteenth-century sculpture was attained by Valentim da Fonseca e Silva, called Master Valentim, the greatest sculptor of colonial Brazil after Aleijadinho. He was born in Serro Frio between 1740 and 1750, the son of a minor Portuguese nobleman and a Brazilian creole and, according to tradition, spent his early youth in Portugal. He belonged to the confraternity of Nossa Senhora do Rosário (where his death was recorded on March 1, 1813) and worked exclusively in Rio de Janeiro.

Friar Jesuíno do Monte Carmelo (1764–1819), angels bearing baskets and garlands of flowers in a detail of the apse ceiling of Nossa Senhora do Carmo in Itu. The entire ceiling is shown at the top of the next page.

Bottom, Friar Jesuíno do Monte Carmelo, *St. Mark*, eighteenth century. Oil on canvas; 55.11″ × 44.48″ (140 cm × 113 cm). Museu de Arte Sacra, São Paulo.

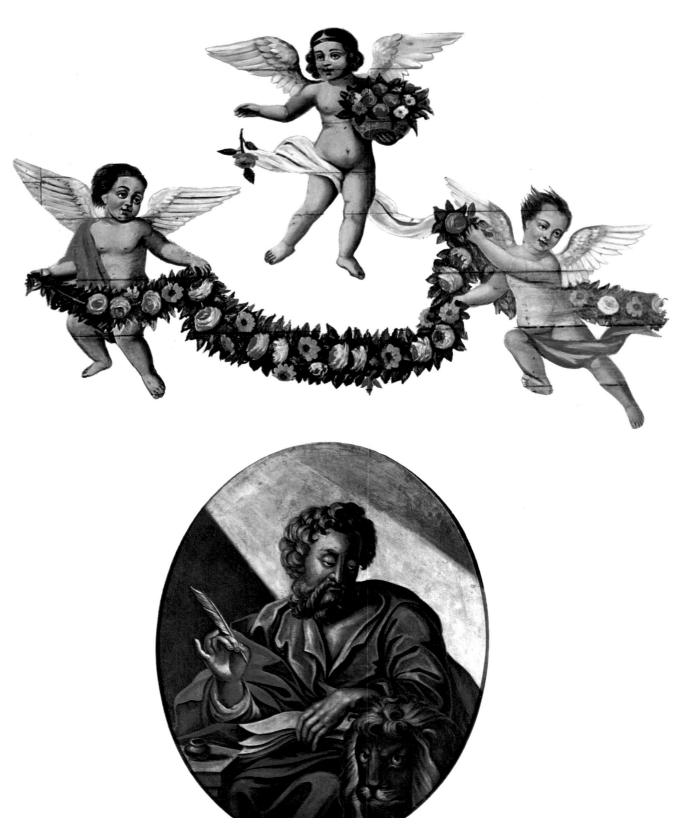

Right, Friar Jesuino do Monte Carmelo, apse ceiling of Nossa Senhora do Carmelo in Itu, São Paulo; *bottom*, detail of the same ceiling with the central figure of the patroness. This is the only colonial church decorated with oil paint.

After his probable apprenticeship with the Portuguese carver Luís da Fonseca Rosa, who worked in the Church of the Tertiary Carmelite Order in Rio de Janeiro, Master Valentim was active in the same church from 1773 to 1800. Between 1793 and 1795 he made the pendants and other silver ornaments for the monastery of São Bento, and between 1801 and 1813 he made the high altar and decorations for the Capela do Noviciado of the Church of São Francisco de Paula. Master Valentim is also credited with all the ornamentation inside Santa Cruz dos Militares, with the two wooden statues of St. Matthew and St. John for the same church, now kept in the Museu Histórico Nacional, and with the high altar of Nossa Senhora da Conceição da Boa Morte. The artist also designed some of the fountains in Rio and the Passeio Público, the latter with the help of the painter Leandro Joaquim (Rio de Janeiro, 1738?–1798?) and the decorators, Francisco dos Santos Xavier and Francisco Xavier Cardoso Caldeira. Master Valentim created in his Passeio Público (opened in 1783) a garden of illusions with benches covered in *azulejos*, pavilions decorated with views by Leandro Joaquim (now in the Museu Histórico Nacional in Rio; pages 90–91), fountains in the form of alligators and birds, an iron coconut palm, four stone staircases, bronze statues of *Apollo*, *Mercury*, *Diana* and *Jove*, two pyramidal spires and an impressive gate.

Many painters worked in Rio de Janeiro in the course of the eighteenth century, creating a style which drew its origins from the work of Friar Ricardo do Pilar and continued to exist even after the arrival in 1816 of Debret and the other members of the French Artistic Mission. The style's most prominent representative was Caetano da Costa Coelho, who probably originated from Portugal and was in Rio in 1706.

His activity is documented up to 1749. Coelho worked mainly for the Church of the Tertiary Order of São Francisco da Penitência, beginning the gilt work on the carvings, the *Calvary* panels and the chapel ceiling in 1732; he painted the *Glory of St. Francis* on the ceiling of the church's nave between 1737 and 1743. Coelho's importance is due not only to the intrinsic quality of his painting but also to the fact that he was the first in the colony to adopt the perspective-illusionistic style spread through Europe

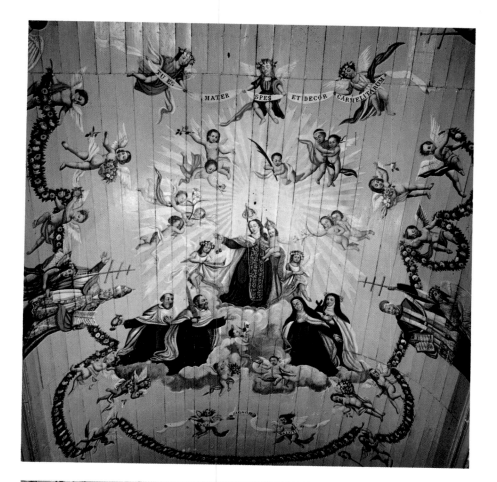

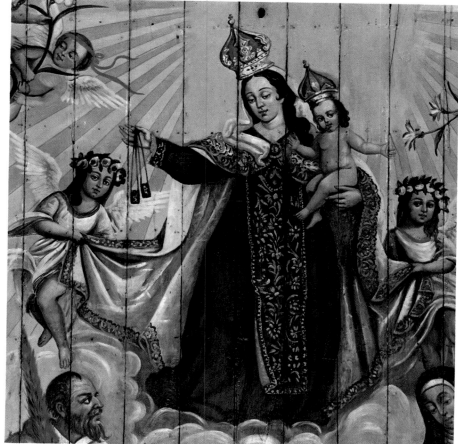

Thomas Ender (1793–1875), *The Town of Goiás*. Engraving; 16.53" × 22.04" (42 cm × 64 cm). Fundação Raimundo Castro Maya, Rio de Janeiro. This is how the town looked in 1830.

by Andrea Pozzo and his followers.

The work of José de Oliveira Rosa from Rio (died 1769) was more closely linked to Friar Ricardo do Pilar's style. He produced sacred paintings, allegories and portraits and worked for the convent of Santa Teresa and the monastery of São Bento. João Francisco Muzzi, one of his pupils, painted scenery for the Casa da Ópera and the Manuel Luís Theater. He was also responsible for the illustrations of the *Mapa Botânico* (Biblioteca Nacional, Rio de Janeiro) and two canvases of documentary interest: the *Fire at the Retreat of Nossa Senhora do Parto* (a reform school for women who dared to rebel against their fathers or husbands) and the *Reconstruction of the Retreat of Nossa Senhora do Parto* (Fundação Raimundo Ottoni de Castro Maya, Rio de Janeiro; pages 88–89).

Leandro Joaquim was another artist who was born and died in Rio de Janeiro. He was the pupil of João de Souza and in addition to being a painter was also an architect. He put forward a plan for the rebuilding of the Retreat of Nossa Senhora do Parto, destroyed by fire in 1789; he may also have been a scene-painter in the Manuel Luís Theater. Various sacred paintings and a group of six oval panels (pages 90–91) have been attributed to him. The latter are among the most beautiful paintings produced in Rio de Janeiro. The *Maritime Scene* (which shows the arrival of an English merchant fleet sailing from Australia), *Whaling* and the *Maritime Procession or Pilgrimage*, with its air of a Venetian festival, and the *View from the Church of Glory* are all striking for for their bright colors and the movement of forms and figures, and are of documentary importance.

Manuel Dias de Oliveira (1764–1837) from Rio, perfected his studies in painting first in Lisbon and later in Rome with Pompeo Batoni. He was author of the altarpieces for Rio's churches and of commemorative paintings such as the *Allegory of the Birth of Princess Maria da Glória* (1819). From 1800 he was the first director of the Aula Pública de Desenho e Figura, where he introduced the study of models, forbidding copying from prints.

The last two exponents of the Rio school were connected with the Portuguese Court, which had moved to Brazil in 1808 as a result of the French invasion of Portugal. They were José Leandro de Carvalho (died in Rio de Janeiro in 1834) and Francisco Pedro do Amaral (died in 1831). The former was mainly the portrait painter of João VI and the aristocracy, whereas Amaral supervised the decoration of the Casa Imperial and many private residences.

The Land of Herdsmen

The first nucleus of the colonization of the country was established in 1532 in the territory of the present-day state of São Paulo, then the captaincy of São

José Joaquim da Veiga Vale (1806–1874):
below, St. Joseph Wearing Boots.
Polychromed wood; 29.52″ (75 cm); Museu
de Arte Sacra, Boa Morte, Goiás; *right, St.
Michael the Archangel.* Polychromed wood;
31.49″ (80 cm); Museu de Arte Sacra, São
Paulo.

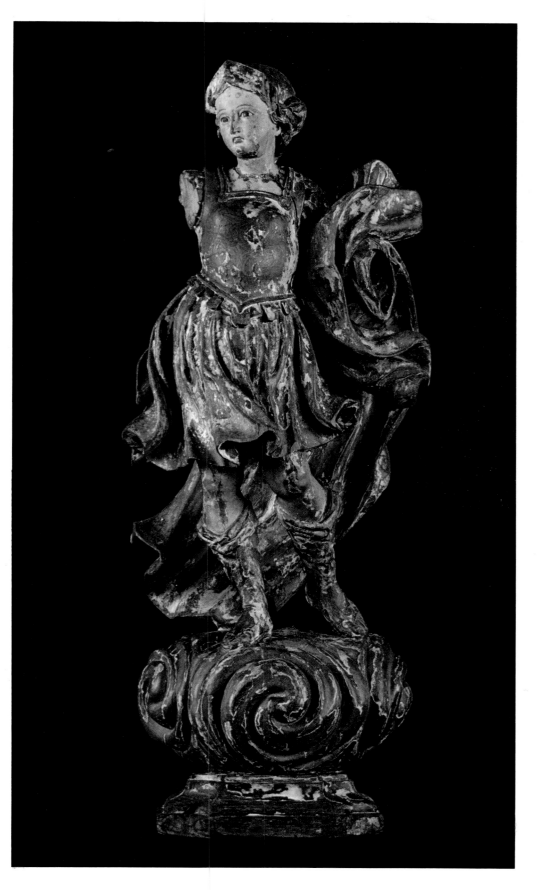

Above, statue of a saint; *right*, polychromed wooden statue portraying *St. Anthony the Abbot*. Both works are in the Museu das Missões, built in the grounds in front of the old Church of São Miguel in Santo Angelo, Rio Grande do Sul.

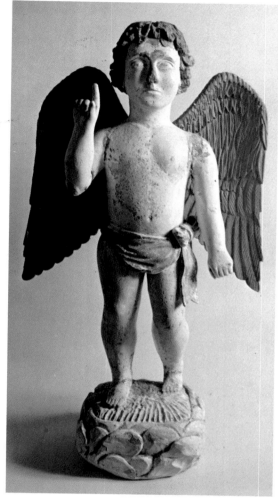

Vicente, where the town of São Vicente was founded by Martím Affonso de Sousa. The Portuguese intended to start the cultivation of sugarcane, which, in the north-eastern region, proved to be very profitable. São Paulo's coastal strip was unfit for this type of cultivation due to the fact that it was narrow, and the settlers who had established themselves there were forced to find more suitable land. Ignoring the general rule of staying on the coast (Friar Vincente do Salvador said that the settlers were wasting their time trying to work the coastal lands) the Portuguese managed to overcome the difficult obstacle of the coastal mountain range and made their way toward the Piratininga plateau, where they founded Santo André da Borda do Campo in 1553 and São Paulo in the following year.

Far from the center of colonial rule, isolated among the mountains and exposed to constant flooding by the Tamanduateí and Anhangabaú rivers, the population of the state of São Paulo led a poor and austere life for the whole of the seventeenth century, farming on a subsistence level. When the news spread about the opening of the mines in Minas Gerais at the end of the century, the people of São Paulo lost no time in organizing expeditions to go and search for gold and precious stones. The capital itself, São Paulo, went through a period of complete stagnation due to the absence of valid men. Despite the poor quality of materials used (mostly *taipa de pilão*, that is earth pressed into the form of a board, just over one-and-a-half feet wide), the architecture in the state of São Paulo developed on the basis of a small variety of types of building, due to the isolation of the region. By remaining cut off from Portuguese influences, which were by contrast very strong in the coastal towns, São Paulo modified to a large extent Spanish-American models derived from the Jesuit missions in Paraguay and Argentina.

São Paulo architecture manifested itself above all in agricultural settlements that sprang up between the seventeenth and eighteenth centuries along the upper and middle courses of the Paraíba river and throughout the Planalto region.

Toward the end of the eighteenth century, new architectural features were adopted in the Rio Grande basin, where there was a concentration of large cattle-rearing estates. By using more refined building techniques, the old single-story rural houses of *taipa de pilão* were replaced by two-story buildings with stone walls and entrances on two levels so as to solve the problem of the sloping terrain.

While São Paulo's urban architecture offered no important innovations as compared to the previous century, during the

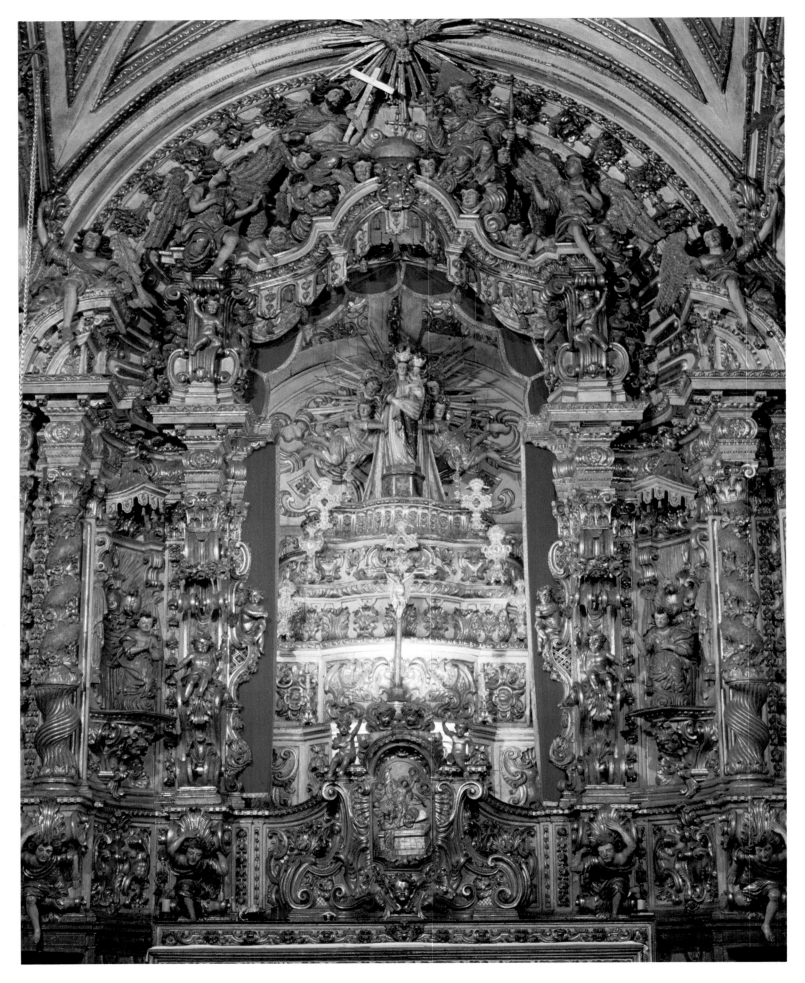

Church of Nossa Senhora do Pilar in Ouro Prêto: high altar (*left*), nave ceiling (*center*) and detail of the apse tribune (*right*). The decoration of the apse was begun in 1747 by Francisco Xavier de Brito, on a design by Francisco Branco de Barros Barriga to which Brito later made considerable alterations.

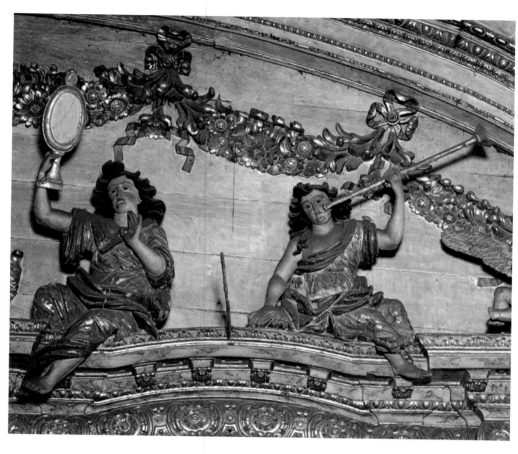

eighteenth century a well-defined style was developing along the coast for the sugar refineries. The ruins of some of them still exist today in the forests on the slopes of the Serra do Mar, which, at one time, were covered by sugarcane plantations whose produce was sent to the mining areas. On the island of São Sebastião, the Água sugar refinery (page 92) and the São Matias refinery have been restored, while in the small town of São Sebastião, on the other side of the canal that separates the island from the mainland, are the remains of the Santa Ana farm (page 93). The sugar refining plant itself was worked by a mill connected to a stone aqueduct. The same building housed both the rooms for processing the product and the owner's residence. The facades were characterized by a portico with a veranda above, which was accessed by a staircase and sometimes gave direct passage into the chapel.

The coastal towns of the São Paulo region were nothing more than poor, tiny ports with little traffic and modest, if not precarious, buildings. Only coffee was to shake these sleepy towns from their slumber; towns such as Ubatuba, São

Sebastião and Santos. Some of their modest churches have structural interest; for example, the mother church of São Sebastião has a nave with two rows of columns supporting the roof beams, similar to the Paraguayan missionary churches. The town has a house whose ceiling, dating from the beginning of the nineteenth century, shows some Rio de Janeiro landscapes that are very interesting as iconographic documentation. The churches of Santos were restored according to the tastes of that period and fitted with altarpieces and ornaments. Although incomplete, the small church of the monastery of São Bento has pleasing proportions—its tall, narrow nave is unexpected, but tasteful. The Church of the Carmel, today overshadowed by tall buildings, also deserves mention. Another example of Santos' architecture is the Casa do Trem, the only building in the town dating back to the seventeenth century, although altered in the following century. The date of its erection is revealed by the clear predominance of filled spaces over voids.

For the whole of the eighteenth century, a tradition of painting did not take

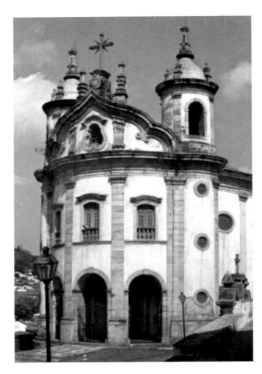

Above, facade and, *right*, one side of the Church of Nossa Senhora do Rosário in Ouro Prêto, eighteenth century. The plan of the church, attributed to António Pereira de Sousa Calheiros, comprises two large ellipses which connect to form the nave and apse.

form in the state of São Paulo as it did in other regions of Brazil, despite the presence of two very talented artists: José Patrício da Silva Manso and Friar Jesuino do Monte Carmelo. Da Silva Manso, who was born in Santos or perhaps in Minas Gerais and died in São Paulo in 1801, decorated the Church of São Bento in São Paulo in 1777 and then worked for the churches of the Tertiary Carmelite Order and São Francisco in the same town but also produced paintings for the Benedictine convents of Santos and Rio.

Jesuíno Francisco de Paula Gusmão (1764–1819) was a painter, architect and musician who, on entering the Carmelite Order, took the name of Jesuíno do Monte Carmelo. He worked in Itu, initially as da Silva Manso's assistant in decorating the mother church of the town, and then on the apse ceiling of the Church of Nossa Senhora do Carmo (pages 94–95) and as designer of the Church of the Patriocinio. In São Paulo he painted the nave ceiling and a series of panel paintings for the Church of the Tertiary Carmelite Order, in addition to ten oval paintings with figures of saints for the convent of Santa Theresa, currently in the Museu de Arte Sacra, São Paulo (page 94).

Goiás

In 1722, Bartolomeu Bueno da Silva, who was born in São Paulo and was a pioneer in the colonization of the Goiás region in the interior of Brazil, discovered gold at the sources of the Vermelho, a tributary of the Tocantins, thus attracting a large number of prospectors. Five years later, he founded the village of Santana, which in 1739 was raised to the rank of town and named Vila Boa de Goiás (present-day Goiás). The architecture that developed in the region bore the clear São Paulo stamp, but the most typical feature of eighteenth-century Goiás architecture is the treatment of the windows, which were protected by special swinging shutters with elegant gratings.

In the small centers of the region many small churches were built. Usually they were constructed of *taipa de pilão*, as was the mother church of Nossa Senhora do Rosário in Pirenópolis, and plainly decorated with wooden carvings. Most of the wooden statues of saints were imported from Portugal, from other regions

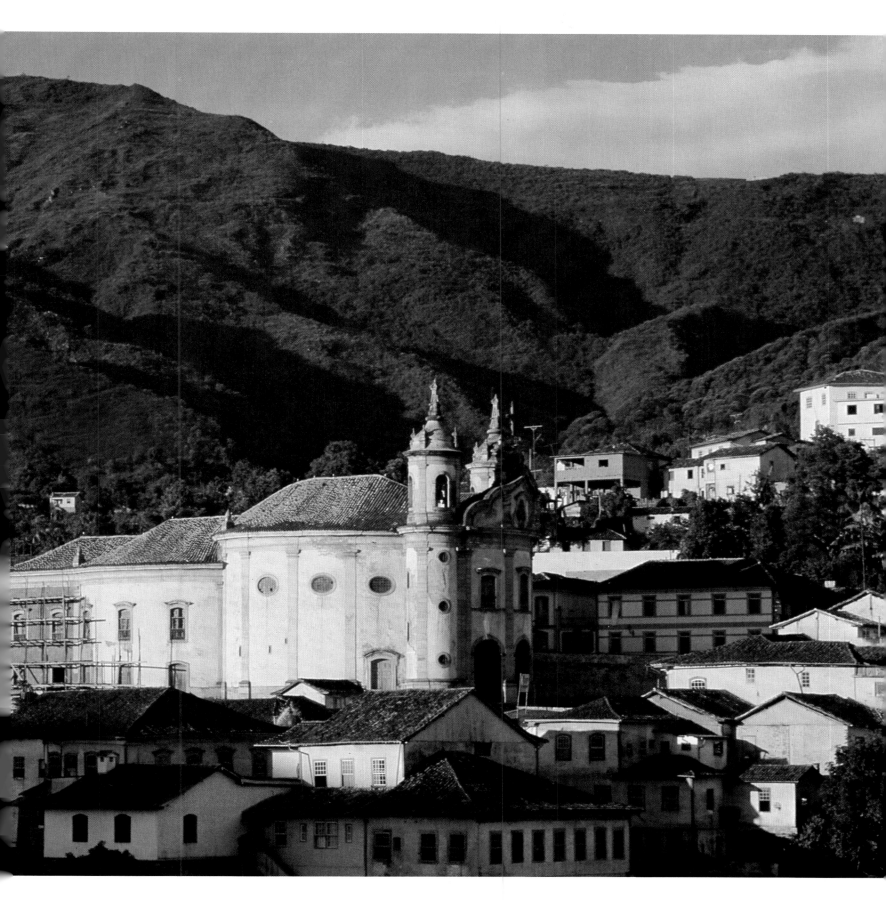

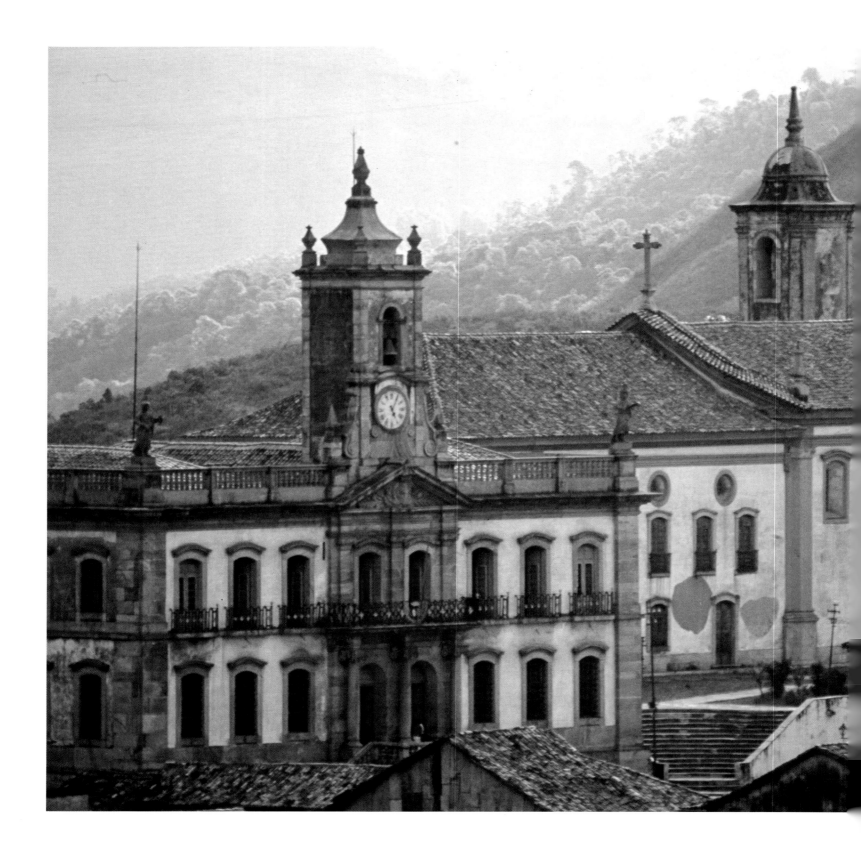

Left, facade of the courthouse and prison building, with the clock bell tower (on the left in the photograph) and Nossa Senhora do Carmo (in the background; a general view of this church is on page 118), Ouro Prêto.

Below, plan for the courthouśe and prison building in Ouro Prêto, by governor Luís da Cunha de Meneses. The building, begun in the neoclassical style in 1784, was completed by the mid-nineteenth century. Today it houses the Museu da Inconfidência.

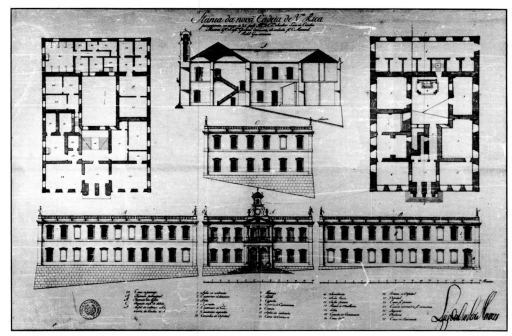

in Brazil and from Spanish colonies, even though sculptors, carvers and traveling craftsmen worked in Goiás.

Of those artists, only the works of José Joaquim da Veiga Vale (1806–1874) have been identified. Although born in the nineteenth century, he is considered a perpetuator of the eighteenth-century tradition, since his works are clearly baroque in style. More than two hundred painted wooden statues with gold leaf have been attributed to him. Some of them are kept in the Museu de Arte Sacra, Boa Morte, Goiás (page 97).

Southern Brazil

Around the middle of the eighteenth century the population and colonization process of Brazil's southern territories developed on three clear fronts: the coast, almost uninhabited by order of the Crown, the lands along the mountain routes, used by colonizers of European origin coming from São Paulo, and the inner area where the Jesuits had settled to carry out their catechizing activites. The Jesuit area of colonization, known by the generic name of *missões* ("missions"), included the western part of the present-day state of Rio Grande do Sul and territories that presently belong to Argentina and Paraguay. The missions had sprung up due to the initiative of the Society of Jesus, with no patronage from either the Portuguese or Spanish Crown,

since at the time the missions were created (1610) those lands did not yet belong to Portugal, and had not been included in the Spanish colonization area, although in theory they were answerable to the colonial rule of Asunción. Having established themselves in a real no-man's-land, the Jesuits could carry out a process of integration with the *guarani* native population, a process that was very different from the policy of the expropriation of wealth practiced by the colonizers elsewhere in South America.

Independent from colonial rule for almost one hundred and forty years, the missions had a marked autochthonous development in self-sufficient villages where community farming offered guaranteed sustenance for the population, making it possible to devote a good deal of time to religion and art. Chroniclers of the time sung the praises of the *guarani's* artistic sensitivity, which became evident in their very first contacts with the Jesuits and was established through music. The Jesuits began choral singing of holy songs in order to attract the natives, who very soon integrated themselves into the group and learned to use European musical instruments. For the *guarani*, organs and violins became familiar objects, not to mention violas, drums and flutes, which they learned to make themselves.

The actual missions were built by the fathers of the Society of Jesus together

Courthouse and prison building of Mariana, Minas Gerais. This building, begun in 1784, is the work of the architect José Pereira dos Santos.

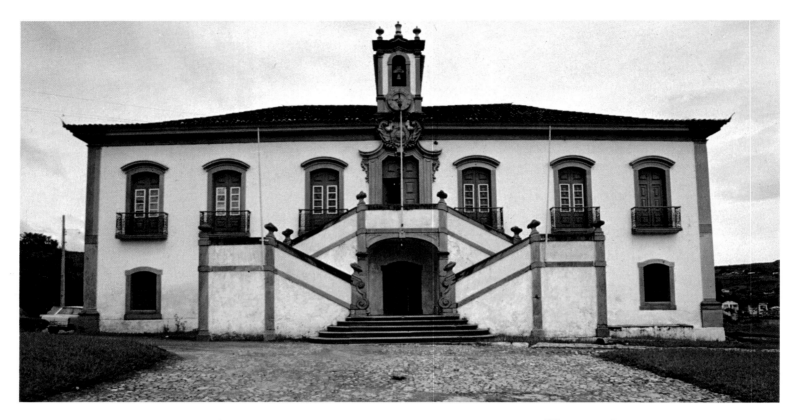

with the natives, starting off by building the church. Sometimes, initially, it was a simple chapel which, as the population increased, tended to turn into a splendid place of worship. Naturally, since the natives were unable to construct complex types of buildings, the missionary churches copied European models lock, stock and barrel, within the limits of the competence of the Jesuit architects and the ability of the local workforce to assimilate. The impressive ruins of the Church of São Miguel in Santo Angelo, Rio Grande do Sul, still exist today. The church was designed by the Italian Jesuit Giovanni Battista Primoli according to the Vignolesque style of the Church of Jesus in Rome. The large Church of São Miguel, on which work was carried out from 1737 to 1744, was never completed but its ruins constitute the most important testimony of the missionary culture in Brazil.

In Jesuit villages, the church was usually erected at one of the extremities, with the facade facing a large square around which were residential buildings. On either side of the church, storehouses, workshops, the infirmary and the cemetery were built. The Jesuits, initially isolated and supporters of peaceful colonization, tended to build their mis-

sions on a hilltop or on an elevated piece of land along the banks of a river—areas easily defended against possible aggressors. The *guarani*, however, were not aggressive if they were left to cultivate their fields in peace. Through their contact with the Jesuits they enriched their culture by assimilating European techniques in painting, sculpture and music which they applied in original forms to Christian religious themes. The missionaries limited themselves to fulfilling the role of spiritual guides and did not interfere in the government of the native population, which periodically elected its own leaders. Unfortunately, the paintings of the natives in the missions have all been lost although some examples of *guarani* pottery and sculpture have been preserved. In the Museu das Missões, built by Lúcio Costa on the open ground overlooking the ruins of São Miguel, there is a large number of statuettes and architectural fragments (page 98–99) from the entire region. On the basis of this collection it can be said that sculpture in the missions shows a marked influence of Renaissance forms passed through a primitive, tropical filter giving it a delicate flavor of a civilised forest inhabited by the pure of spirit who knew how to absorb the highest values of

Western culture.

The missions were not completely isolated, however, because from the end of the sixteenth century the region was to suffer the incursions of the *bandeirantes* from the state of São Paulo. That region, then very poor, survived through agriculture. Its colonial inhabitants, unable to sell any of their products, joined together to form *bandieras*—armed expeditions that set off toward the interior and the south to capture natives and sell them as slaves to the rich sugarcane plantations in Nordeste, which were always in need of laborers. Around 1650, the *bandeirantes* clashed with the Jesuits in the mission area about the slave trade. Slave trading was brought to an end only in the following century as a result of the decline of northern sugar refineries and the discovery of gold in Minas Gerais, which was to attract most of the poor people from the southern coast of Brazil.

After the 1750 Treaty of Madrid, whereby Spain and Portugal resolved the question of the frontiers of their South American colonies, the missions rapidly declined. Neither Lisbon nor Madrid were concerned about these independent settlements in the forests and the Jesuits, who had been opposed to the slavery

Below, the so-called Casa dos Contos was erected in 1784 in Ouro Prêto for the *contratador de ouro* João Rodrigues de Macedo. Its design is attributed to Antônio Pereira de Sousa.

Right, gallery inside the Casa dos Contos and, *bottom*, the hall. The writer and poet Cláudio Manuel da Costa was imprisoned and died in this house. He was a member of the insurrectional movement, Inconfidência Mineira (Mining Treason), which emerged at the end of the eighteenth century in the state of Minas Gerais and was suppressed in 1789.

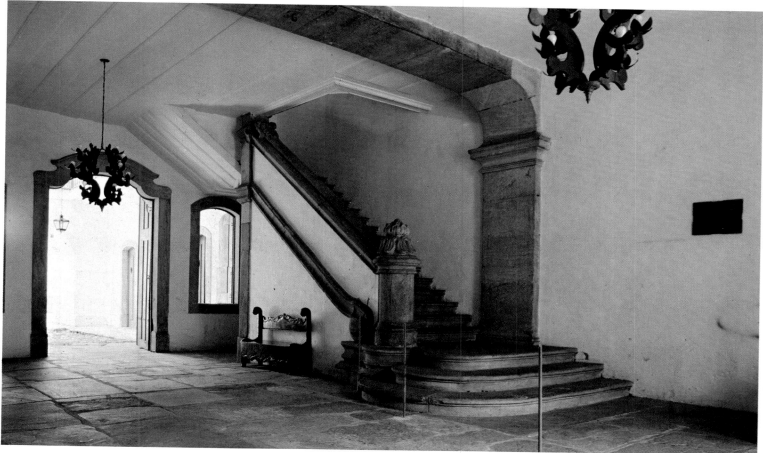

The organic in Mariana cathedral presented
by the prince regent Dom João V in 1751.
This instrument, an example of the "Brito
style," shows elements of chinoiserie in its
lower part.

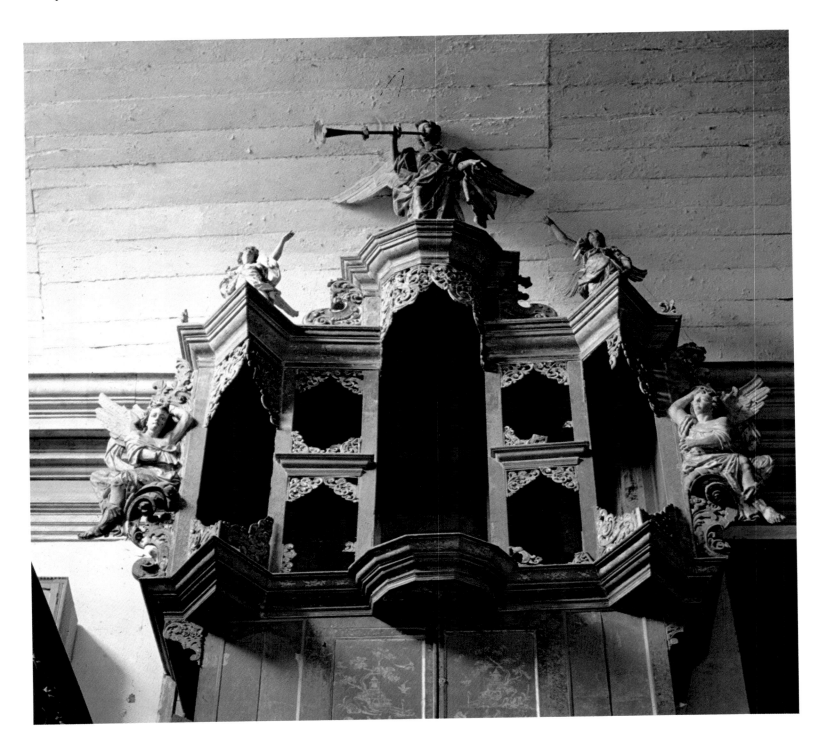

Detail of the carvings of the high altar in the mother church of Nossa Senhora da Conceição, built in Catas Altas, Minais Gerais. The carvings of the interior of the church were begun in 1738; those of the high altar were completed in 1755 and are attributed to Francisco Xavier de Brito.

expeditions against the natives, vehemently refused to pay taxes. In 1753, the *bandeirantes*, who had become regular soldiers of the Portuguese Crown, joined with the Spanish forces and attacked and destroyed the missions on Brazilian territory. The religious men and natives sought refuge in the Spanish colonies but there, too, the missionary settlements were razed to the ground. The expulsion of the Jesuits in 1759 from Portuguese and Brazilian soil prevented any subsequent attempt at reconstruction.

Minas Gerais

Around the middle of the sixteenth century, all that was known about the present-day state of Minas Gerais was that it was a mountainous region, always enveloped in fog, with valleys covered by impenetrable forests. Stories spread about hidden riches in those inaccessible mountains, but information was too imprecise to decide on sending an exploratory expedition. Only the people of São Paulo penetrated that mysterious world to capture the natives in order to send them as slaves to the labor market of Nordeste. In 1674, the expedition of Fernão Dias Pais finally set off for the interior in search of mines, in answer to a personal request from king Affonso VI who wished to extend his dominions beyond the coastal area of Brazil. The expedition was a failure but it marked an important point in the history of the mining region since it founded many villages, planted crops of maize and bitter cassava and opened the way for the people of São Paulo, who, coming mainly from Taubaté, began traveling regularly through the vast mountain region.

Toward the end of the century large quantities of gold began to be discovered in the escarpments by the rivers and in pebbles washed downstream by stronger currents. In 1693 Antônio Rodrigues de Arzão from Taubaté discovered the Casa da Casca mine, and in 1698 Antônio Dias, from the same town, reached the outskirts of the gold area of Tripuí, at the foot of Itacolomi, present-day Ouro Prêto. Shortly afterwards a priest, Father Faria, discovered gold.

News quickly spread and the call of gold attracted groups of adventurers from all over Brazil. There were very few entrances to the mines and they were difficult to discover. The most well-known one was across the gorge of

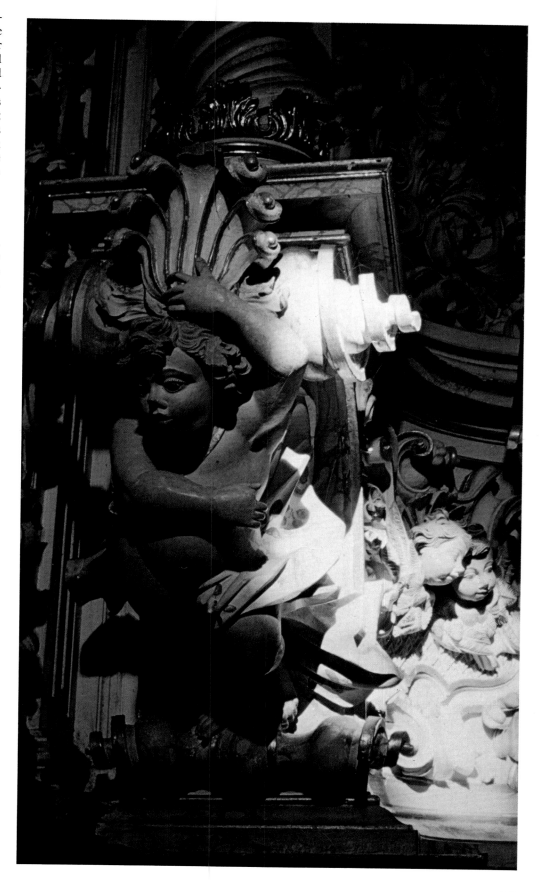

On these two pages, from left to right,
Aleijadinho (1730/38–1814), *Crowning with Thorns, The Road to Calvary* and *The Crucifixion.* These groups of sculptures in wood, comprising life-size figures, represent three of the seven episodes created by the artist between 1796 and 1799 to show the *Passion* of Christ. The various scenes are in six chapels built on the slope leading up to the Sanctuary of the Senhor Bom Jesus de Matosinhos in Congonhas do Campo, Minas Gerais.

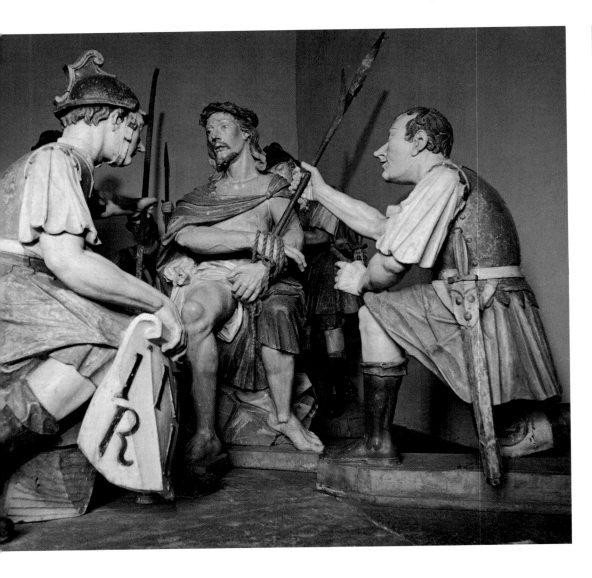

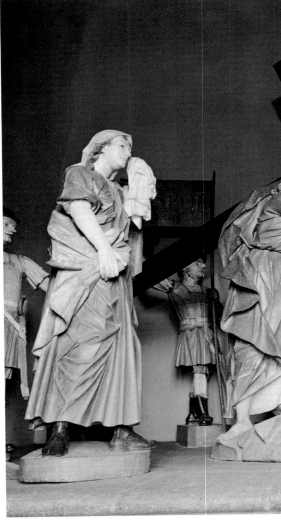

Embau, near the present-day town of Cruzeiro. Despite dreadful living conditions, the first villages founded by the gold prospectors grew rapidly, creating the main centers of the area: Vila Rica de Nossa Senhora do Pilar de Ouro Prêto, Ouro Branco, Sabará, Tijuco, Serro, Mariana, Caeté, Congonhas do Campo, São João del Rei, Catas Altas and Conceição do Mato Dentro.

There was a massive influx of immigrants into the region after Garcias Rodrigues Pais opened a direct road between the mining area and Rio de Janeiro. The people of São Paulo mixed with various groups from Bahia, Rio, and even Portugal. The urgent need for hands to work the mines meant that a large number of slaves had to be sent to Minas Gerais from the sugarcane plantations in Nordeste. Old statistics show that in the first half of the eighteenth century sixty per cent of the population comprised Negro slaves and of the remaining forty per cent, two thirds were mestizos and mulattoes. White prospectors were a minority, although they made up the ruling class.

In the beginning, material difficulties and a lack of resources prevented an immediate manifestation of Portuguese culture. In the buildings, furniture, domestic implements, clothing and even in the most rudimentary manufacturing processes, the Portuguese, who dedicated themselves mainly to trade, adopted native techniques. The mulattoes were the chief exponents of the arts, and it was a genuinely Brazilian mulatto, Aleijadinho, who was to express a truly national art form. In order to have full control over the region, the governors

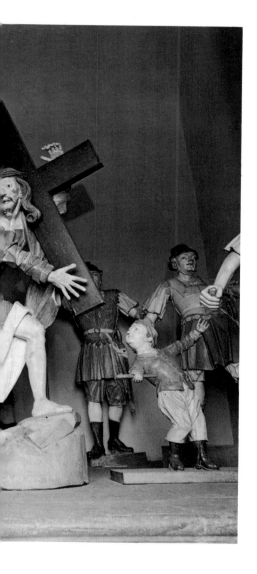

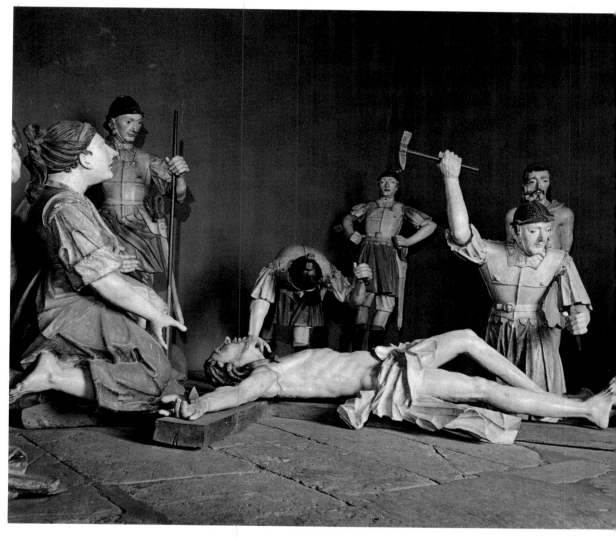

installed a police regime in Minas Gerais. The religious orders were denied permission to build convents; printing and teaching were forbidden. (In the coastal areas, schools were held in the convents and were centers for the spread of culture). There were no industries, except for the production of a rough cloth for the slaves' *tangas* (loin cloths). All manufactured goods came from other states in the country and were carefully inspected by government officials.

Minas Gerais therefore lived its golden age as a closed society, organized in a completely different way than the patriarchal societies on the coast. The inhabitants were not only divided into ethnic or racial groups, but also into corresponding religious confraternities. These confraternities, which were independent civil organizations, practically reduced the priests (all of whom belonged to the secular clergy) to simple employees and were in perpetual conflict with each other. There were many conflicts among the confraternities: for example, the white confraternities banned access to coloreds and to whites married to black or mestizo women, while in Diamantina there was an extremely strong rivalry between the black and mulatto confraternities.

Without doubt, however, the confraternities gave the greatest impetus to the development of architecture in Minas Gerais. They were usually quite wealthy, even those of the Negro slaves, and they always tried to build their churches and meeting houses with the aim of showing off their own importance and prestige. Baroque architecture benefited from this spirit of emulation and made Brazil heir to an extremely important artistic tradition in the panorama of universal art.

This form of architecture did not develop immediately. The early São Paulo buildings in the developing villages were nothing more than temporary, rudimentary constructions—huts of pine branches and rough wooden beams, the cracks stopped up with clay. Eventually, for the more important buildings intended to last, *taipa de pilão* was used, which was characteristic of the São Paulo region, but this building technique was not suitable for Minas Gerais. It was difficult to carry the rare clay soil from the bottom of the valley across the stony terrain and, in addition, the rocky slopes made it impossible to make the terracing necessary for erecting the *taipa* walls. Moreover, floods from sudden, heavy showers eroded the compressed soil,

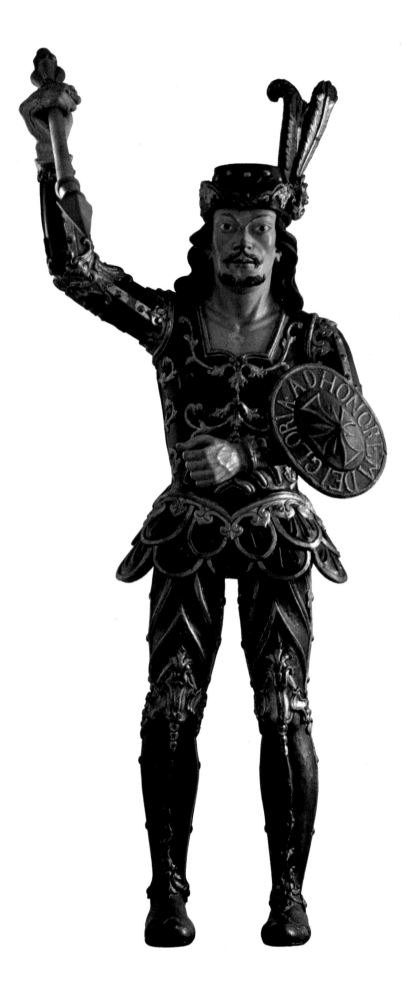

jeopardizing the entire building. The tenacity of the people of São Paulo, however, was such that *taipa de pilão* churches and houses still exist today. Builders, both from São Paulo and Portugal, very soon adopted the *taipa de mão* technique. This technique was used solely to fill in the gaps (between the load-bearing structures) with panels unable to withstand stress. These panels, comprising vertical and sometimes horizontal laths filled with earth, were applied to the wooden framework. Gradually stone began to be used, initially for the foundations of the more complex wooden buildings, and then for small houses and modest chapels that were characterized by an extremely simple form. These buildings had a disposition of masses at right angles, white walls enclosed by supporting pillars, stone elements and spires, which were usually colored blue with indigo extracted from plants of the region.

Taipa and stone churches began to betray differences in the origins and cultural training of their builders. Alongside the Mamluk workforce were many Portuguese carpenters and masons from Algarve, Oporto and above all Trás-os-Montes, experts in cutting stone suitable for large walls. Although the exteriors were always quite plain, the interiors were extremely rich in gilt work, carved altars and illusionistic-perspective ceiling paintings, such as those in the small churches of Nossa Senhora do Ó and Nossa Senhora da Conceição in Sabará, Mariana cathedral and the small Carmelite church in Diamantina. The straight lines of the white interior walls, however, did not harmonize with elaborate baroque designs and on occasion unorthodox solutions were adopted. For example, for the Church of Nossa Senhora do Pilar in Ouro Prêto (pages 100–101), in 1736 Francisco Antônio Pombal from Portugal designed a polygonal nave with wooden walls within the rectangular plan of the pre-existing *taipa de pilão* construction. Moreover, the sculptors, carvers, cabinet-makers, upholsterers, painters and gilders developed a style completely independent from that of architectural structures, retaining an extremely wide freedom of expression.

A difficult process led to the structure of the churches being matched to their interiors in the small but wealthy region of Minas, bordered by São João del Rei,

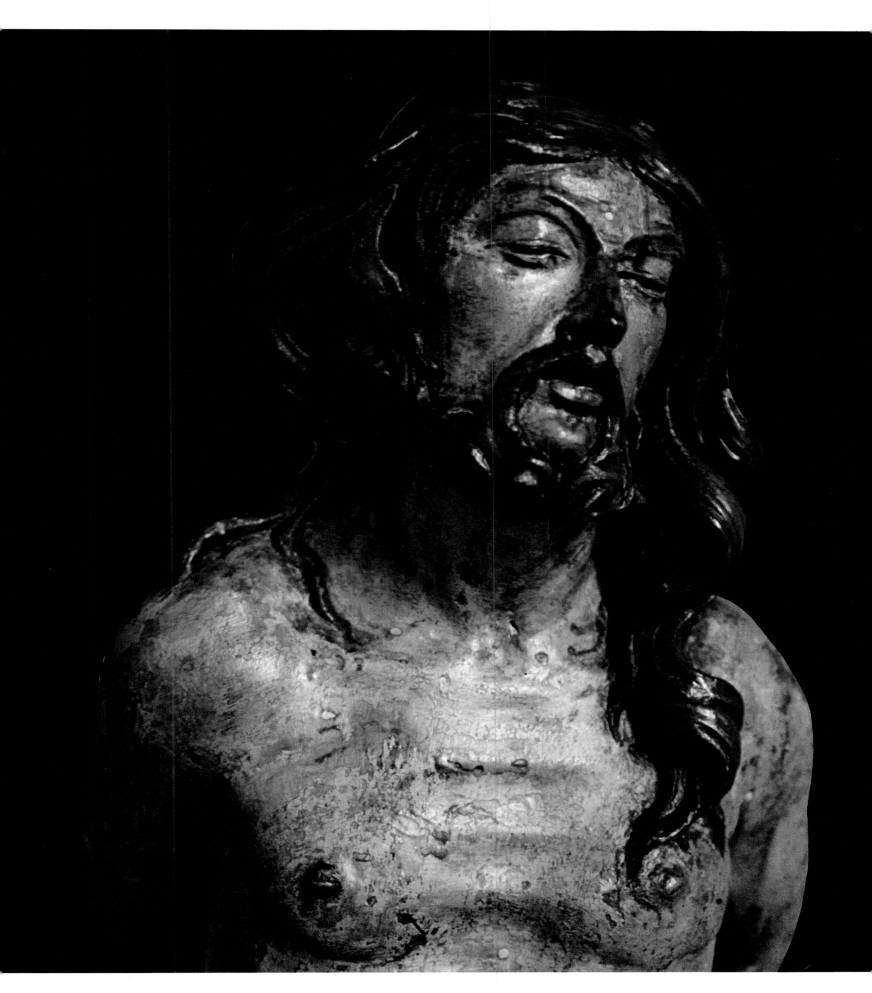

Opposite, facade of São Francisco de Assis, Ouro Prêto. The church was designed in 1764 by Aleijadinho who, ten years later, modified the design of the facade. It is considered to be his architectural masterpiece. He also did the carvings that decorate the apse—a detail is shown, *left*, of the triumphal arch and, *below*, the ceiling. The painting is the work of Manuel da Costa Ataíde (1762–1830).

Congonhas do Campo, Mariana, Sabará, Caeté and the group of villages around the present-day town of Belo Horizonte. The builders eventually achieved a plastic unity in which every element is interrelated, producing enveloping, continuous spaces by means of curving walls, undulating cornices and intertwined decorations. Thus, for the first time, they showed their great imaginative capacity and a sensitivity which, calling on elements drawn from tradition, recreated a new and authentic baroque language. This was a true expression of freedom that flourished at the height of an oppressive regime: freedom to break the rules imported by the Europeans, to create the unexpected as if in a deliberate attempt to disobey the erudite guidance imposed by the government.

In the first half of the eighteenth century, in this region governed by a police regime and cut off from the rest of the world, new aesthetic canons were still being sought. Architecture had not yet freed itself from the tradition of simple triangular pediments and windows protected by straight bars. In this atmosphere, the presence of José Fernandes

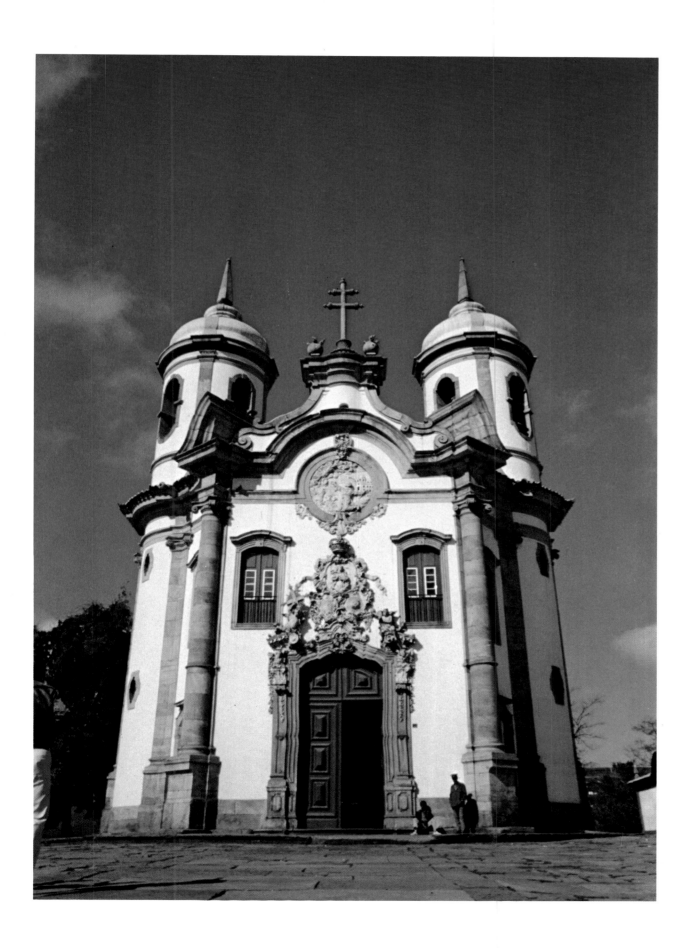

The lavabo in the sacristy of the Church of São Francisco de Assis, Ouro Prêto. In this work, attributed to Aleijadinho, blind faith (*detail, right*) is portrayed by a blindfolded Franciscan friar.

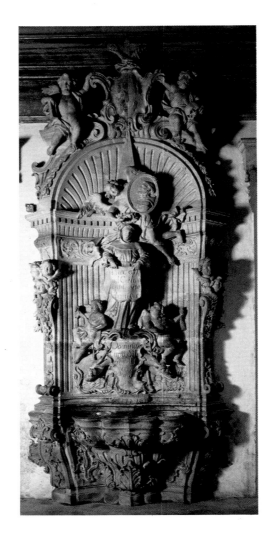

Pinto Alpoim, a military engineer who had already worked in Rio de Janeiro, had very little influence.

In Minas around 1740, Alpoim was given the task of designing the governors' palace in Vila Rica, a project that was to be completed later by Manuel Francisco Lisboa, the father of Aleijadinho. Basically, it was a matter of supplying drawings for a totally Portuguese building, according to the wishes of the governor, Gomes Freire de Andrade. Perhaps Alpoim taught the local builders a better system for achieving certain building features or the novelty of windows with curved bars, but that was all. The integration of the various arts, characteristic of the baroque in the mining region, was made possible only by systematic group work where, above all, local materials and their ideal applications were tried out. The technique of building walls with stones and *canga* (ferrous clay), was improved by the use of lime, which made it possible to build higher, thinner and, if required, curved walls.

Builders, masons, stone-cutters and carvers began to see the chance to work together. The confraternities favored the education of artists, who were beginning to acquire a sense of professionalism. Architects and builders gave advice, drew up contracts and competed with each other. This development of the builders' social condition was to lead to the improvement of architectural techniques.

Pediments with straight lines were no longer made. Instead there were notched tympanums decorated with exuberant ornamentation which, in the curving lines of the cut stone, suggested the crystallization of a new stylistic unity. Majestic portals emerged, on which Aleijadinho was to leave the mark of his creative genius. The small pyramids of tiles covering bell towers were replaced by stone domes whose bulbous shapes heralded a new form of architecture.

In addition, a new type of church building was becoming established: two circular-section towers flanked the facade, unlike those of the past that were inserted in the corners of rectangular plans that had a nave and two aisles, such as the mother churches of Sabará or Mariana, built at the beginning of the century. An aisleless plan was adopted, with the chancel above the entrance and a spacious apse off the bottom wall, flanked

The Church of Nossa Senhora do Carmo in Ouro Prêto was designed in 1766 by Manuel Francisco Lisboa, Aleijadinho's father. Four years later, the son became involved in the project, altering the original design.

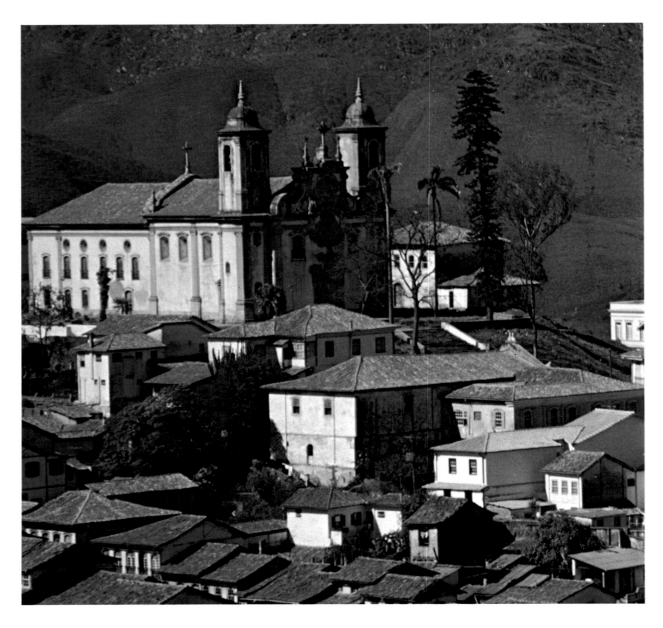

by two corridors leading into the sacristy at the back. Between the apse and the sacristy was a staircase to an upper room for confraternity meetings.

There were very few variations on this type of building. There were, of course, exceptions, such as the churches of São Pedro dos Clérigos in Mariana and Nossa Senhora do Rosário in Ouro Prêto (attributed to Antônio Pereira de Sousa Calheiros; pages 102–103), whose plans are based essentially on two ellipses that intersect, creating an enveloping space. These two churches also had a covered area before the nave, perpetuating in Minas the coastal tradition of porticos. There has been much discussion and

research on the possible influences present in these two churches or on the models that inspired their construction. Some opt for the Church of Glória do Outeiro in Rio de Janeiro, whereas others prefer the Church of São Pedro dos Clérigos built in Oporto, Portugal, by Nazzoni, an Italian architect.

In public works, except for a few fountains, creative drive cannot be found, since the designs came directly from the overseas government, which was absolutely against aesthetic experiments in its colonies. For example, the monumental courthouse and prison building (pages 104–105) in Ouro Prêto, begun in 1784 based on a design by

governor Luís da Cunha de Meneses, already shows the neoclassical composure typical around the end of the century. On this subject we should also mention the courthouse and prison building in Mariana (page 106) which was begun on a design by José Pereira dos Santos in 1784.

As regards private construction, dwellings usually had several stories and were built next to each other, following the contours of the terrain along a twisting urban stretch. Their basic plan was mostly that which was widespread in all Brazilian towns. The bedrooms were in the inner area; the living quarters faced toward the road and verandas were

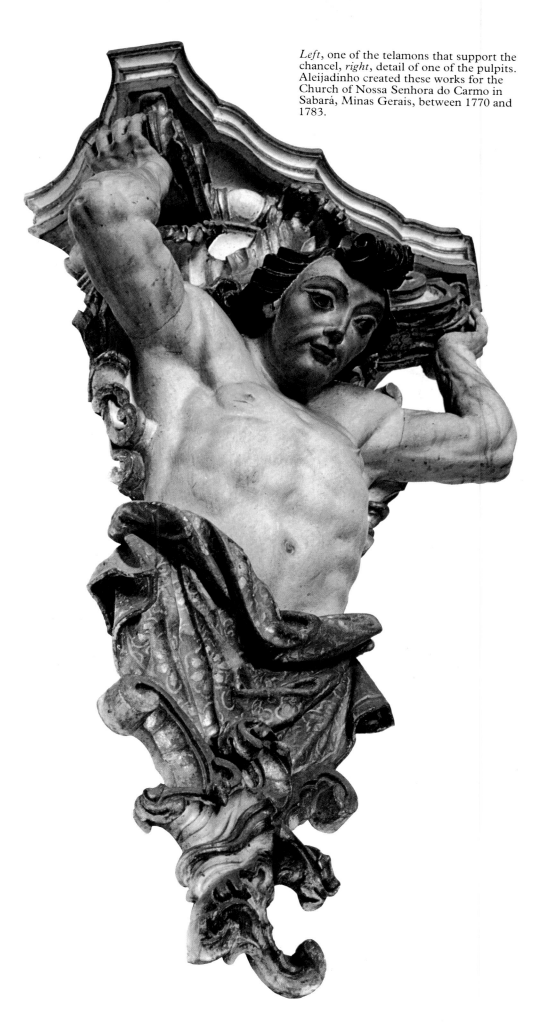

Left, one of the telamons that support the chancel, *right*, detail of one of the pulpits. Aleijadinho created these works for the Church of Nossa Senhora do Carmo in Sabará, Minas Gerais, between 1770 and 1783.

Bottom, the lavabo in the sacristy of Nossa Senhora do Carmo, Ouro Prêto, which critics and tradition attribute to Aleijadinho.

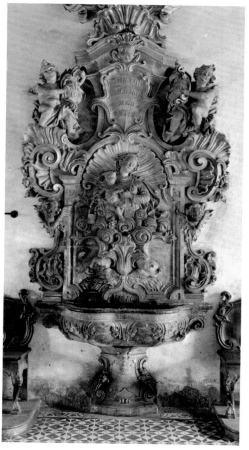

119

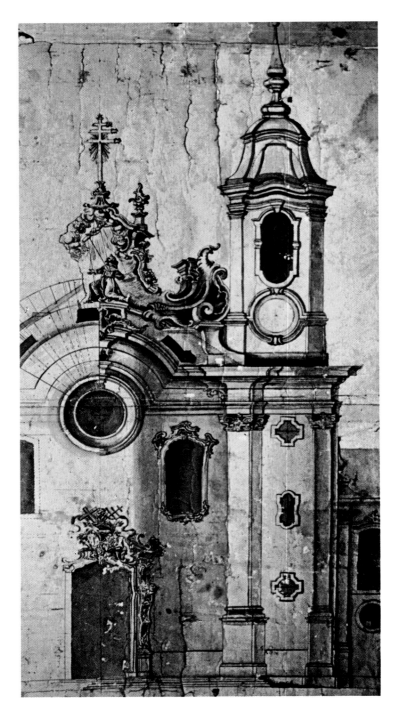

connected to the kitchens at the back. On occasion, this layout was varied by creating halls on the ground floor, for example, which had shops on either side. There were no social differentiations, and the dwellings of the humblest people were built alongside those of the wealthy families, like the Casa dos Contos built in Ouro Prêto in 1784 by the architect Antônio Pereira de Sousa (page 107).

The artistic development of Minas Gerais was halted by the gradual exhaustion of the mines and by the emergence of patriotic unrest that came to a head between 1789 and 1792 with the plot of the Inconfidência ("treason") movement, led by Joaquim José da Silva Xavier, known as Tiradentes, until his capture and subsequent sentencing to capital punishment. Furthermore, another style, neoclassicism, was establishing itself. It was imported by the Portuguese Court which, in 1808, moved to Rio de Janeiro as a result of Napoleon's invasion of Portugal.

In the course of the eighteenth century, the art of carving assumed a fundamentally original appearance in Minas and, with the work of Aleijadinho, reached a high level of expressive intensity, exceeding the limits of decoration. This great artist used many techniques already adopted by a group of talented carvers who had worked out a mature style with its own well-defined characteristics.

The beginning of the style peculiar to the mining region is usually attributed to the work of Francisco Xavier de Brito, who created the side altars of the Church of the Tertiary Order of São Francisco da Penitência in Rio de Janeiro. There he introduced, together with Manuel de Brito, the use of figures in marked relief, according to the trend in Lisbon prevailing in the 1730s. It is difficult, however, to establish its true genesis, since in the expenses books of Minas' churches there are frequent references to modifications made by the person executing the design of an author and usually the name of the author is not given. Moreover, the same three or four artists are recorded in all the churches that were decorated with the new type of carving.

It is certain, however, that after 1736, when Antônio Francisco Pombal, Aleijadinho's uncle, made the irregular decagon-shaped inner space of the Church of Pilar, Ouro Prêto, in wood,

Below, São Francisco de Assis in São João del Rei, Minas Gerais. The design of the facade (*opposite*), worked out in 1774 by Aleijadinho, was later modified during construction by the builder, Lima Cerqueira. The church, with its monumental courtyard, is a typical example of colonial baroque architecture.

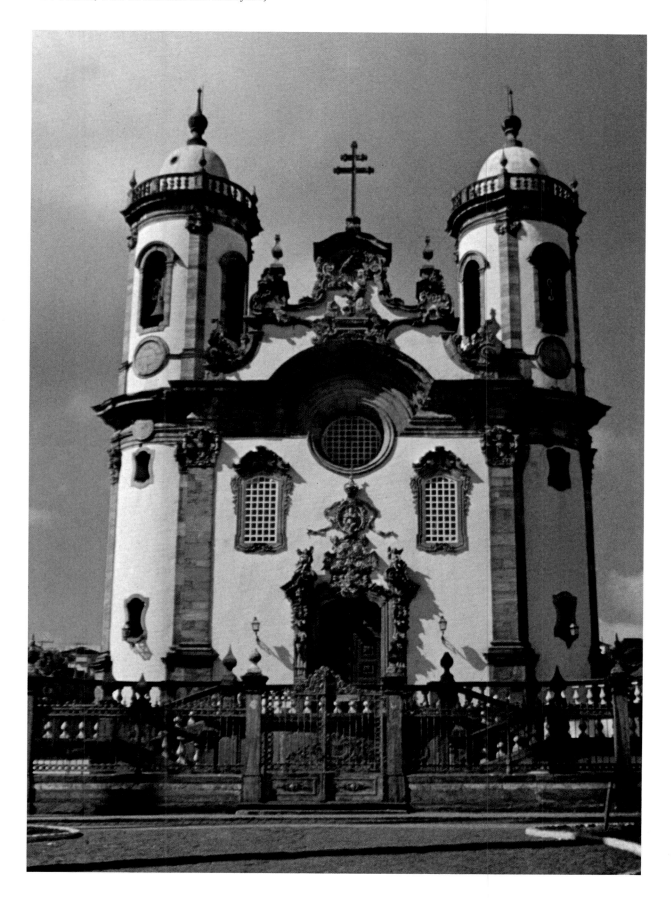

The Sanctuary of the Bom Jesus de Matosinhos, Congonhas do Campo, with the front staircase of the *Prophets* whose statues were sculpted by Aleijadinho in soapstone between 1800 and 1805.

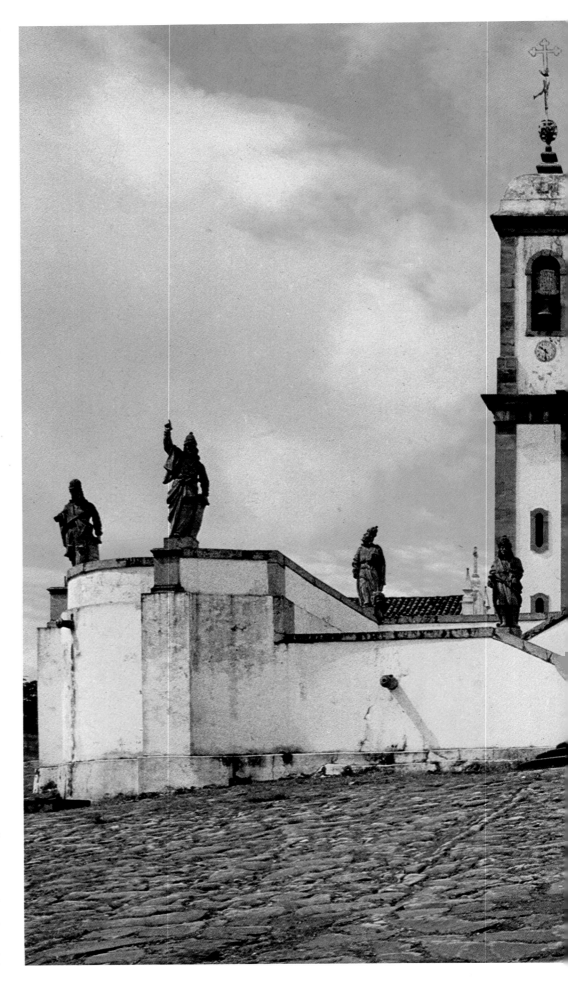

two other churches were decorated with carvings that had not only a plastic function but also an architectonic one. These churches were Nossa Senhora da Conceição in Catas Altas (page 109), on which carving was begun in 1738 and completed in 1755, and the Church of Santa Ifigênia in Ouro Prêto. A few altars that also reflected the new style were those of Nossa Senhora da Conceição in Mariana cathedral, the high altar of Nossa Senhora da Conceição in Ouro Prêto and the high altar of the mother church in Caeté.

Artists who developed the new style, especially in a plastic sense, were Francisco Branco de Barros Barriga, José Coelho de Noronha and Francisco Xavier de Brito, plus a group of sculptors on which little documentary information exists, which includes Francisco de Faria Xavier, Antônio Francisco Lisboa (Aleijadinho's namesake) and Filipe Vieira. Barriga is the author of the drawing for the high altar of the Church of Nossa Senhora do Pilar in Ouro Prêto (page 101) and he worked as a carver in Santa Ifigênia. From 1747, Brito executed and modified the initial design for the high altar of Nossa Senhora do Pilar and worked in Catas Altas (page 109). Noronha carved the altar of Nossa Senhora da Conceição in Mariana cathedral and the high altars of Santa Ifigênia and the mother church of Caeté. As for Vieira, he worked in the Church of Santa Ifigênia and made the high altar of Nossa Senhora da Conceição in Ouro Prêto.

A characteristic sign of Francisco Xavier de Brito's work is the marked relief of the figures of angels and certain details in the structure of the altars, similar to those of São Francisco da Penitência in Rio de Janeiro. José Coelho de Noronha had already begun his work before Brito's arrival in Minas (1741), and there is no documentation to prove that the latter designed the Mariana cathedral altars.

It must be remembered that some differences exist between the carvings of Rio and those of Minas, such as greater lightness and wider free spaces between the ornaments in Minas. As regards the latter characteristics, it could be admitted that Brito's contribution was not the only one and that his colleagues may also have been involved.

A certain homogeneity in the carvings of different churches, regardless of their

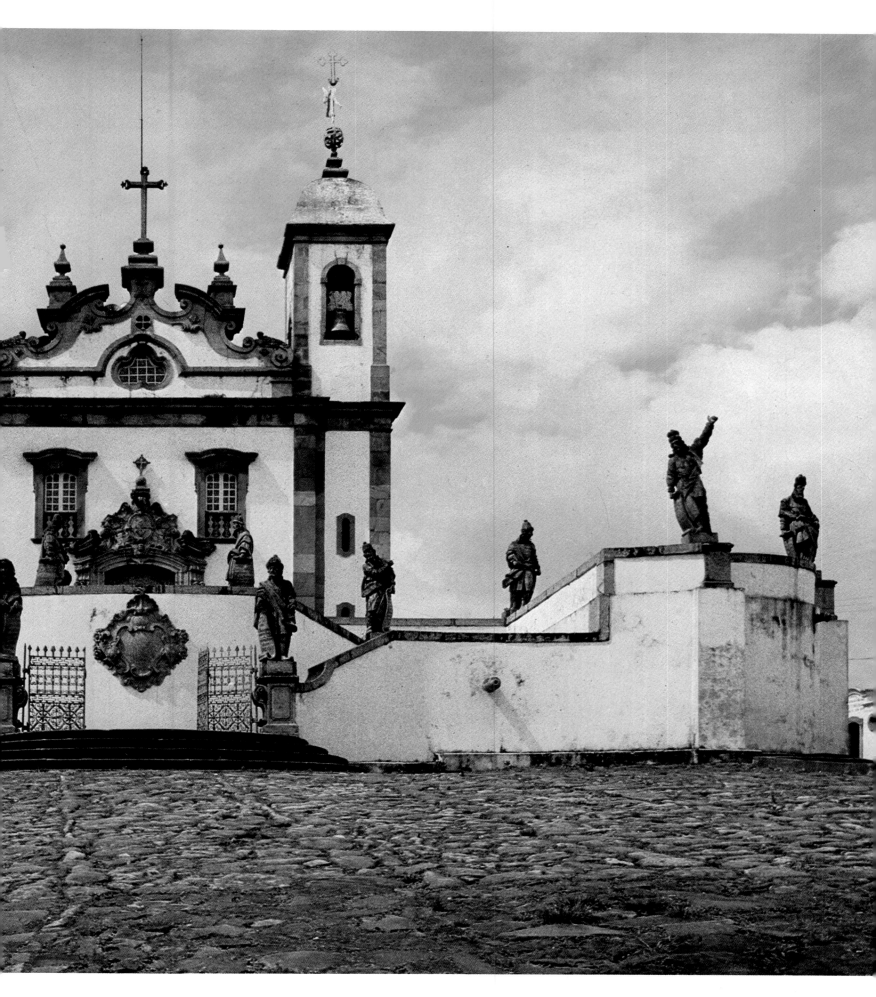

creators, leads one to conclude that the technical quality, the marked relief of the figures and the lively twisting of the structures are the result of an interaction of influences, the outcome of which harmonizes perfectly with the architectural features.

The greatest artist of Minas Gerais is Antônio Francisco Lisboa, called Aleijadinho ("the Little Cripple"). He was born in Ouro Prêto in 1730 or 1738, the son of a Portuguese architect and builder, Manuel Francisco Lisboa, and a slave, Isabel. His father passed on his artistic knowledge, which had the baroque stamp, to him, while the influence that his mother, of African origin, had on him is usually taken to be the expressionistic tendency of his sculptures. In order to better understand his personality, it should be remembered that Aleijadinho lived in restless eighteenth-century Vila Rica (the old name of today's Ouro Prêto) at a time when gold attracted men of different origins to search for it.

Having only ambition and faith as common denominators, this community of adventurers built churches decorated with gold, and buildings, fountains, bridges and oratories along the narrow, winding streets and the basic squares. Wealth led to the formation of a pseudo-aristocracy of self-styled nobles, clerics, judges and poets, and civil and military authorities. This was the intellectual élite that encouraged artistic activity and promoted the ideas of nationalism and emancipation which were to feed the Inconfidência plot.

Certainly, the teachings of his father, who had vast experience as a designer and builder, were fundamental for the young Aleijadinho. However, he may have enriched his training alongside the painter and draftsman João Gomes Batista and the sculptors and carvers Francisco Xavier de Brito and José Coelho de Noronha. In addition to these artists, we should also mention the erudite company of the poet Cláudio Manuel da Costa, whose library was visited by the young Lisboa, and the friendship with some religious men who lent the boy missals and illustrated Bibles. Thirsty for knowledge and inspiration, Antônio Francisco admired the engravings and dedicated himself to reading sacred texts. Knowing Latin well, he combined his inclination for art with an appreciation for literature.

The prophet *Baruch*, sculpted by Aleijadinho from two blocks of stone, is one of the eight smaller statues of the group and has more realistic anatomical proportions.

Ezekiel, which together with Isaiah, Jeremiah and Daniel forms part of the series of the four larger statues of the *Prophets* staircase.

On the basis of what is known about the circumstances of the community involved in literature and the arts, it can be stated that Aleijadinho was the disciple of the cultural circle of Ouro Prêto and that carving was his great master. Thus it is possible to explain the many influences of different origin present in his work. Without ever having left Minas Gerais, except for a trip to Rio de Janeiro, Antônio Francisco Lisboa knew the world through the books and illustrations that struck his imagination.

His first biographer, Rodrigo José Ferreira Bretas, described the artist's physical appearance: "He was swarthy, had a loud voice, a stimulating manner of speech and an irascible temperament. He was short, thickset and malformed. His face and head were round and the latter quite large. He had black curly hair, a thick, dark beard, a straight, rather pointed nose, thick lips, large ears and a short neck." In the Arquivo Público Mineiro there is a portrait of him painted at the end of the eighteenth century. Later, Henrique Bernardelli idealized his face in one of his canvases.

Aleijadinho was almost fifty when he was struck by an illness which devastated his body, eating away his fingers and disfiguring his face. It was assumed to be syphilis or the effects of an aphrodisiac drug taken as a stimulant for his work, but it is more likely to have been leprosy. Knowing the exact nature of the illness could lead to a different interpretation of his last works. It is known, for example, that he was forced to work with the chisel tied to his hand, and there could be a correlation between the deformation of the figures in the *Passion* in Congonhas and the difficulties he encountered in their execution, even though that deformation of expression seems absolutely intentional.

Despite the prejudices toward artists and mestizoes, Aleijadinho was very famous in his own lifetime. Religious confraternities vied with each other to commission altars, pulpits, ornaments and architectural projects from him. The most important towns and villages in Minas Gerais, such as Ouro Prêto, Congonhas do Campo, São João del Rei, Sabará, Mariana, Catas Altas, Caeté, Cocais and Tiradentes, wanted him to

work for them. As a result of a Royal
Decree of July 20, 1782, which estab-
lished a register of notable events in the
region about which "there was certain
proof," the second town councillor of
Mariana senate, Joaquim José da Silva
often referred to Aleijadinho and his
work. The document has not yet been
recovered but there is a partial transcrip-
tion of it in an article published in 1858
in the *Correio Oficial de Minas (Traços
Biográficos Relativos ao Finado Antônio
Francisco de Lisboa...)* which tells of the
most important events in the life and
work of the artist. A list of Aleijadinho's
major works begins with the carved
wooden altars dedicated to St. Anthony
and St. Francis of Paula, completed in
1760 for the Church of Nossa Senhora do
Bom Sucesso in Caeté, followed in 1761
by the soapstone fountain of Father Faria
in Ouro Prêto, considered to be his first
work sculpted in stone. In 1763, the
artist was involved in the project for the
facade and bell towers of São João Batista
in Barão de Cocais, and in 1764 he
supplied the drawings for the Church of
São Francisco de Assis in Ouro Prêto
(pages 114–115) for which a few years
later, he was to make the ornaments.
This church is considered by some
scholars to be his masterpiece for the
close harmony achieved between the
exterior and the interior.

Between 1769 and 1771 Aleijadinho
made the soapstone sculptures for the
facade and portal of the Church of Nossa
Senhora do Carmo in Sabará, for which
he was later to do the interior decoration
in wood (page 119). In 1770 he also took
on the task of the Church of Nossa
Senhora do Carmo in Ouro Prêto (page
118). Aleijadinho took over the project
from his father, who had begun construc-
tion of the building four years earlier,
and made a few basic changes, linking the
facade to the towers by reconstructing
the molding and joining the portal decora-
tions with those of the oculus. In later
years he worked in his home town, doing
the decorations, among other things, for
Nossa Senhora das Mercês e Perdoes and
Nossa Senhora do Pilar, the design for
the high altar of the Church of the
Confraria dos Negros de São José (1772)
and the statue of St. Michael for the
facade of São Miguel e Almas (1778). In
1774, he designed the Church of São
Francisco de Assis in São João del Rei
(pages 120–121) which, although altered
during construction work, is considered

to be one of his masterpieces for the
formal purity of its structure.

The fame of Aleijadinho is linked,
above all, with the works he created for
the Sanctuary of the Senhor Bom Jesus
de Matosinhos in Congonhas do Campo,
which include groups for scenes of the
Passion in the six chapels on the slope
leading up to the church and twelve
statues of the *Prophets* (pages 122–123)
positioned on the staircase in front of the
building. The *Passion* scenes, created
between 1796 and 1799, portray the *Last
Supper*, the *Prayer in the Garden of
Gethsemane*, the *Capture of Jesus*, the
Flagellation and the *Crowning with
Thorns*, the *Road to Calvary* and the
Crucifixion (pages 128–135). The figures,
sculptured in wood, reflect the charac-
teristics of the material in their primitive
immediacy and rough expressions which
sometimes make the cruel characters

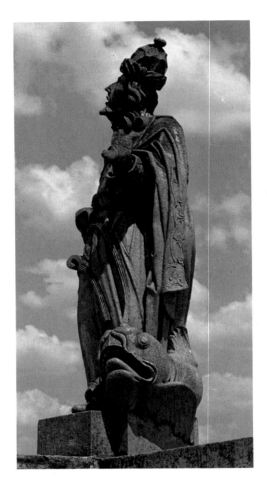

Jeremiah (*right*, full figure and, *below*, detail) and *Isaiah* are the two statues standing by the entrance on the *Prophets* staircase.

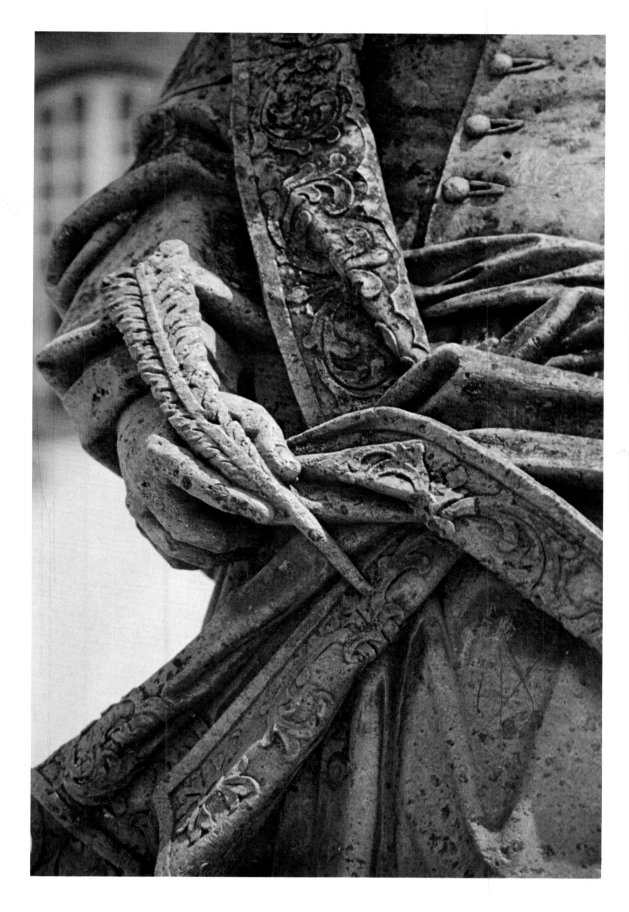

appear caricatures. The *Prophets (Isaiah, Jeremiah, Baruch, Ezekiel, Daniel, Hosea, Jonah, Joel, Obadiah, Habakkuk, Amos* and *Nahum*; pages 124–127) were sculpted in soapstone between 1800 and 1805 and, despite the use of a material which would have allowed a natural form of modeling, the expressions on their faces is so accentuated that it transcends human features: they curse, protest, and perhaps pray and are ideally linked in a dialogue with the heavens.

In the last years of his life (Aleijadinho died in Ouro Prêto in 1814) the artist again worked in his hometown on two wooden altars for the Church of Nossa Senhora do Carmo (1807) and then in the village of Tiradentes, supplying the drawings for the facade of Santo Antônio. If Aleijadinho was an innovator in architecture, a "creator of unique church structures, both in the design of their plans and in their facades" (Silva Teles), his sculpture is the result of many influences. Against a baroque backdrop, which was the style of his time, there are traces of the gothic, expressionists elements and renaissance remnants. The great artist of Ouro Prêto did not limit himself by canonic rules but expressed his plastic talent freely. Having lived in an atmosphere of unrest which heralded the emancipation of the country, he himself was an emancipated artist, united with his land, a precursor of the national spirit forming in Minas Gerais which was to have its most heroic moment in the Inconfidência.

The French Artistic Mission, which from 1816 introduced formalism into Brazil, especially in court circles, did not become acquainted with Aleijadinho's work and, to a certain extent, prevented the natural development of the baroque, by now a genuinely Brazilian style above all in Minas Gerais. A silence of more than a century fell upon Aleijadinho's work. Only toward the middle of the twentieth century was there a revival in interest for this unique character, furthered, paradoxically, by the Semana de Arte Moderna in 1922 and a few movements that sprang up, intent on "discovering" or "rediscovering" Brazil, whose great revelation was to be Ouro Prêto. In the same period there was a tendency in Rio de Janeiro to return to colonial things. Finally, opposites met and Aleijadinho began to be studied. Books and articles were written and many conferences were held. In 1969 Helio Gravatà was to publish an ample bibliography on the artist.

A great many exhibitions were also held, the most memorable being those in Rio de Janeiro and Montevideo with photographs of the *Prophets*, and the floating exhibition of 1965 on the *Princesa Isabel* which docked at Salvador, Recife, Fortaleza, Santarém, Belém and Manaus. In 1968 the Museu do Aleijadinho was opened in the mother church of Nossa Senhora de Antônio Dias, in the district of Ouro Prêto where the artist was born and died.

Judgments on Aleijadinho's work became increasingly enthusiastic at home and abroad, with contributions from poets, novelists, playwrights and even filmmakers. Considered by Brazilian critics to be "the major figure in Minas art," he also earned the title, "the Brazilian Michelangelo," from European critics, while in 1946 Germain Bazin wrote "Aleijadinho can be included among the great masters of the Italian Renaissance."

In Minas Gerais, painting developed thirty years after architecture and sculpture. The many painters included the great Manuel da Costa Ataíde, who was the most important artist of the colonial period and represents the peak and conclusion of pictorial tradition in the mining region. After him tastes changed; the influence of the Court, which reflected foreign movements, and a change in the way of life led to the production of works in which an ingenuous learning predominates. Even though it was not always at a very high level, the painting of Minas Gerais brilliantly answered the need to cover the wooden ceilings of churches with paintings, producing with more or less originality a wealth of figurative art that has still not been thoroughly studied.

The first known ceiling in Minas Gerais is in the apse of the mother church of Nossa Senhora de Nazaré in Cachoeira do Campo, painted in 1755 by Antônio Rodrigues Belo (born 1702) from Portugal. Shortly afterwards, in 1760, the ceiling of the apse of Mariana cathedral (page 141) was painted according to a still-archaic taste by Manuel Rebelo e Sousa (born in Portugal; died in Ouro Prêto in 1775), who was active in Minas Gerais in 1752 when he was engaged in painting and gilt work for the mother church of Santo Antônio in Santa

The Last Supper is the first of seven groups of wooden sculptures created by Aleijadinho between 1796 and 1799 to illustrate some of the episodes of the *Passion* of Christ. The various scenes are arranged in six chapels on the slope leading up to the *Prophets* staircase of the Sanctuary of the Bom Jesus de Matosinhos, Congonhas do Campo. *The Last Supper* group occupies the first chapel, the *Garden of Gethsemane*, the second, the *Capture of Jesus*, the third, the *Flagellation* and *Crowning with Thorns*, the fourth, the *Road to Calvary*, the fifth and the *Crucifixion*, the sixth.

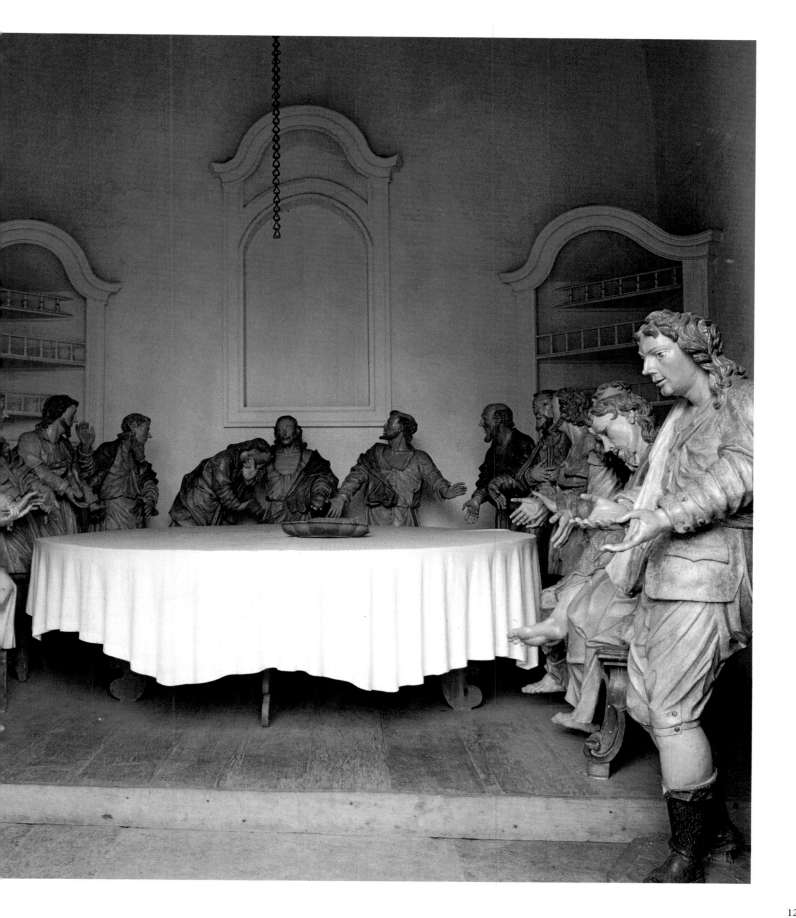

Bárbara. In the same period he produced a mural painting and gilt work for the altars of Nossa Senhora da Conceição in Catas Altas. Rebelo then painted the ceiling in Santa Ifigênia do Alto da Cruz in Ouro Prêto (1768) and four panels for Holy Week in Nossa Senhora de Nazaré, Santa Rita Durão (1772).

José Soares de Araújo from Portugal (died in Diamantina in 1799) was more creative and sensitive. He was active from 1765 around the diamond-producing area. Like Caetano da Costa Coelho in Rio de Janeiro, de Araújo reached the solution of using a rather small central panel so that the celestial vision appears to be seen from a skylight. He used dark and rather dull colors, however, in the architectural part that serves as a frame. Moreover, de Araújo barely brings out the tones of the saints' vision. The reason for this closed sky, unusual for baroque style, could be attributed to the physic dimension of the collective confinement to which all the inhabitants of Minas were subjected.

In 1765, de Araújo painted a few works for the Church of the Tertiary Carmelite Order of Diamantina and in the following year began to paint the apse ceiling of the Church of Nossa Senhora do Carmo in the same city. From 1778 to 1784 he painted and gilded the nave and ceiling of the same church (page 138). From 1779 he worked on the apse of Nossa Senhora do Rosário dos Pretos and in 1782 he began the ceiling of the Church of the Tertiary Order of São Francisco in Diamantina. Finally he decorated the roof of the nave and apse of the Church of Santana in the village of Inhaí. Among the painters who worked in the Diamantina area, Manuel Antônio da Fonseca and Silvestre de Almeida Lopes stand out. In 1787 the former painted the panels for the nave ceiling of São José in Itaponhoacanga with a marked graphic fluency and great skill in achieving harmony. Silvestre de Almeida Lopes painted the apse ceiling of Nossa Senhora do Amparo (1790) and the sacristy ceiling of São Francisco de Assis (1795; page 140) in Diamantina. In 1796 he created his greatest work in the apse of Nosso Senhor Bom Jesus de Matosinhos in Serro. There is some controversy regarding the artist of four panels portraying the *Passion of Christ*. They are attributed to Silvestre de Almeida Lopes, Manuel Antônio da Fonseca or Manuel da Costa Ataíde and are kept in the sacristy of the

Right, three of the five statues illustrating the episode of the *Garden of Gethsemane*: Jesus with one arm outstretched (also in the detail below) and Peter with John sleeping (in the detail left). This group of sculptures by Aleijadinho is housed in the second of the chapels leading up to the Sanctuary of the Bom Jesus de Matosinhos.

Detail of the figure of Christ, the central
figure in the scene depicting the *Road to
Calvary*, created by Aleijadinho and kept in
the fifth chapel leading up to the Sanctuary
of the Bom Jesus de Matosinhos, Congonhas
do Campo.

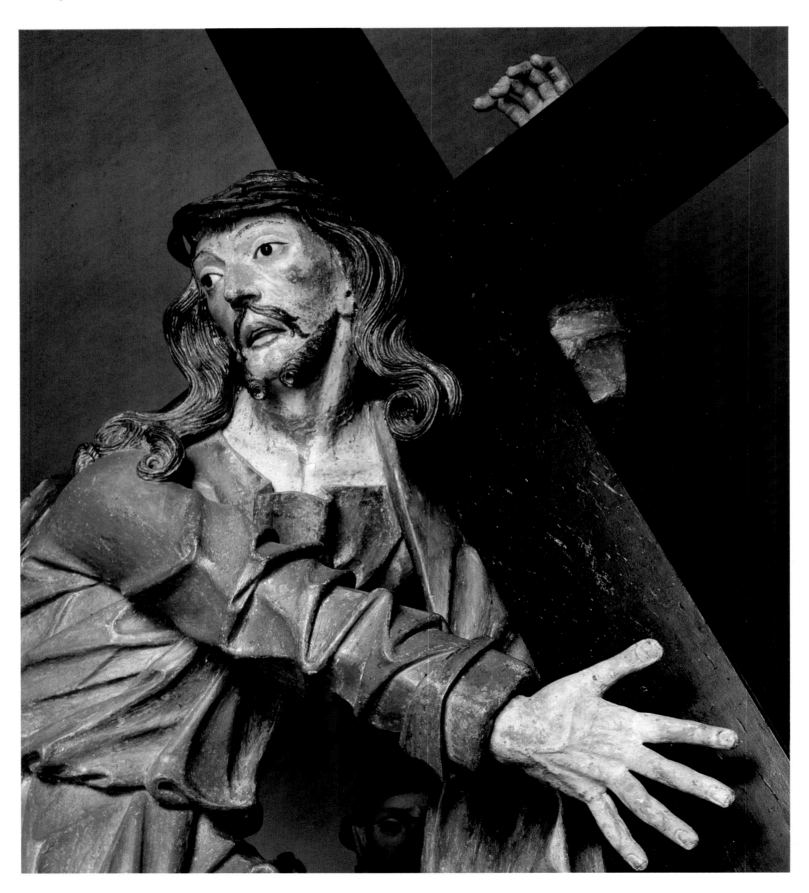

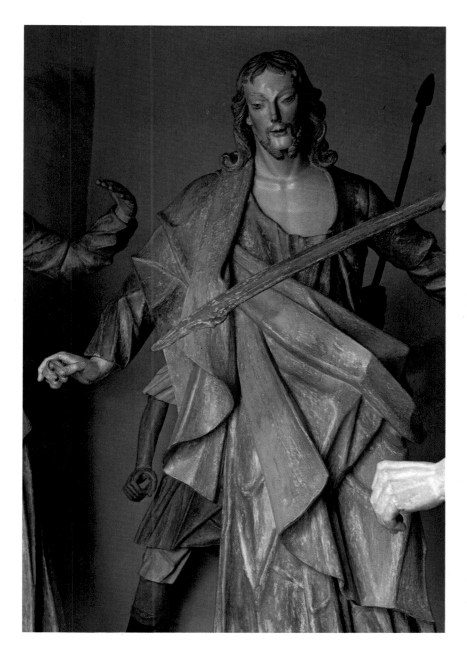

Two details of the group of sculptures showing the *Capture of Jesus*: Christ (*left*) returns the ear of a soldier (*below*) cut off by Peter. The scene is housed in the third chapel.

Church of Conceição do Mato Dentro. They show two aspects of Minas painting. The first is the typical restricted space already noted in the work of José Soares de Araújo and absent in that of Ataíde, which could rule out the authorship of the latter. The second aspect shown is the exchange of influences between painting in the diamond and the gold regions. For example, despite the differences in composition, design, pictorial technique and the positioning of the characters' heads, there are unquestionable similarities between the panels and the works of Ataíde in the posture of the figures and exaggerated size of their shoulders. The rhythm of the composition is that of Fonseca whereas the figures seem to be by Silvestre.

Miguel Pereira de Carvalho, known only for one work, the sacristy ceiling of the Church of the Tertiary Order of São Francisco de Assis in Ouro Prêto, offers a solution that was also used by Ataíde. A celestial vision with saints (in this case St. Francis), clouds and fluttering angels is painted on the ceiling as if it were an easel painting. In the perspective-illusionistic paintings of the Italians like Andrea Pozzo, the architectural elements usually rise up from the sides, coming up from the actual wall and the foreshortened figure with the celestial vision is positioned in the middle. There are other simpler features without the illusionary continuation of the architecture, even a balustrade at the edges that is unconnected with a central medallion.

In eighteenth-century Minas Gerais painting, renderings of architecture were painted in perspective, opening into large, foreshortened celestial visions between arches and columns or between other decorated, twisting supports reaching up to a central baldachin positioned at the very top either because of the actual elevation of the vault or because of the optical illusion produced by the perspective. The scene beneath the baldachin, surrounded by vaults and shells imitating the architectural ornament, had elements of composition similar to those of an easel painting.

In the last quarter of the eighteenth century, at least five painters adopted this solution which was to be exalted by Ataíde: Bernardo Pires da Silva, João Nepomuceno Correia e Castro, Manuel Ribeiro da Rosa, Antônio Martins da Silveira and João Batista de Figueiredo.

Between 1773 and 1775 Bernardo Pires da Silva painted the apse ceiling of the Sanctuary of the Bom Jesus de Motosinhos in Congonhas do Campo with the *Deposition of Christ* (page 139).

Two details of the *Crucifixion*, the seventh of the sculpted groups created by Aleijadinho to celebrate the *Passion* of Christ. *Below*, one of the compassionate women and, *right*, Jesus crucified, considered to be one of the artist's masterpieces.

This scene is in the last of the six chapels housing the wooden statues of the *Passion* which, together with the stone statues on the *Prophets* staircase (see pages 122–127), comprise the major artistic pride of the Sanctuary of the Bom Jesus de Matosinhos

in Congonhas do Campo. At the same time, they represent the artist's greatest sculptural creation.

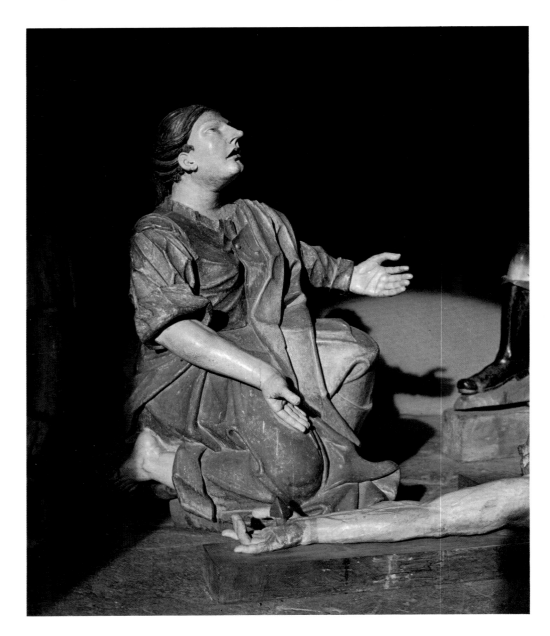

In 1774 he produced the panels and gilt work in the apse of the mother church of Pilar in Ouro Prêto. João Nepomuceno Correia e Castro is thought to have been born in Mariana where he worked for the cathedral and Church of the Tertiary Order of São Francisco. Between 1777 and 1787 he painted the nave ceiling of the Sanctuary in Congonhas, later retouched by Ataíde, and some of the wall panels.

Manuel Ribeiro da Rosa was born in Mariana and died in Ouro Prêto in 1808. Of the works he produced for São José in Ouro Prêto between 1779 and 1783, only the baldachin painting of the *Marriage of the Virgin* has remained. It is currently

preserved in the Museu Arquidiocesano in Mariana.

Antônio Martins da Silveira is remembered for his vigorous brush work that had great narrative effectiveness. He painted the two panels in the Church of Nossa Senhora das Mercês e Perdões (1760 or 1761) in Ouro Prêto and the apse ceiling of Nossa Senhora da Boa Morte (1782) in Mariana; the latter work is considered to be a virtuoso demonstration of creating an illusion of great space in a small area.

According to a generally accepted tradition, João Batista de Figueiredo, originally from Catas Altas, was the master of Manuel da Costa Ataíde. His

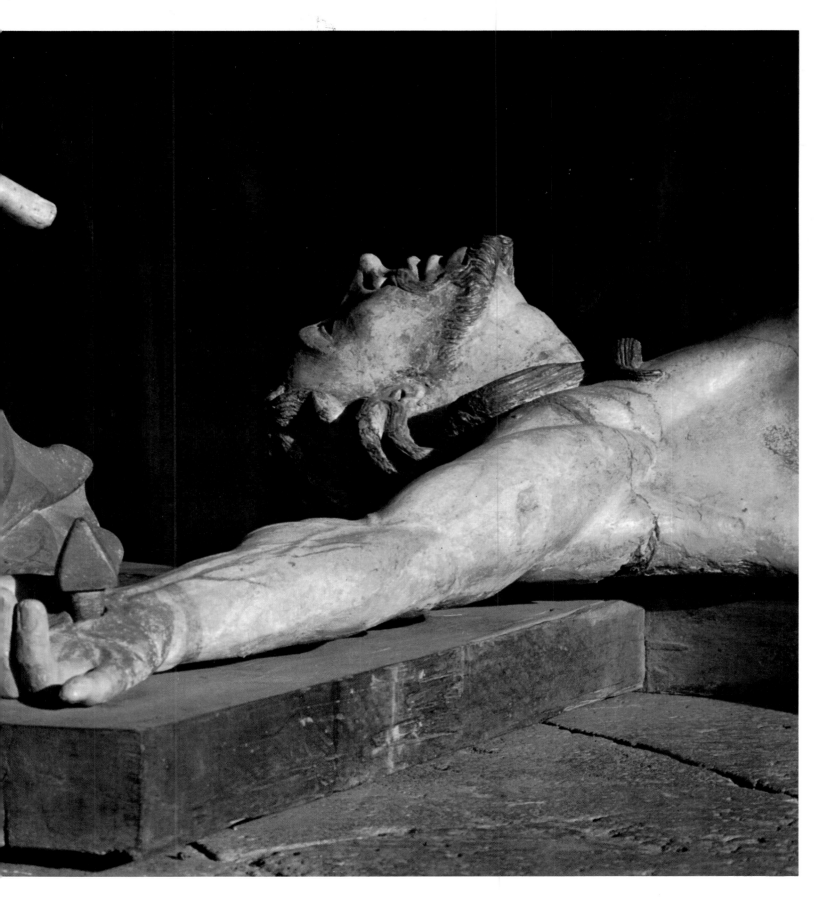

Detail of a painting by Manuel da Costa
Ataíde (1762–1830) on the apse ceiling of the
mother church of Santo Antônio in Santa
Bárbara, Minas Gerais. This painting, the
artist himself wrote, was completed in 1822.

involvement in the work on the Church of Nossa Senhora do Rosário in Santa Rita Durão is confirmed by sources and by the signature "João Batista" in the *Annunciation* scene for the chancel ceiling. In the apse, the shell-shaped ornaments of the architectural elements supporting the central baldachin show a dexterity that does not appear in the chancel ceiling and an elegance completely lacking in the nave ceiling. The shell-shaped ornaments, however, have the same animation as the drapery of the four painted saints in the apse, especially *St. Gregory* and *St. Augustine*. The latter, with mulatto features, is striking for the twisting rhythm of the figure, the rendering of the hair and beard and the curved, flame-shaped miter, in contrast to the central scene which is rather hard and redeemed only by the two mulatto angels.

A few ceilings, close to the style of Ataíde, João Batista and Bernardo Pires da Silva, deserve to be remembered. Neither their author nor date of execution are known. Apart from an unspectacular architectural frame, the painting for the apse ceiling of Nossa Senhora do Rosário in Itabira comprises figures that are exceptional for their delicacy. The same unknown artist may have also created the apse ceiling of São Francisco de Assis in Caeté, whose composition of three visions linked by clouds supported by architectural elements is very rare, if not unique. We should also mention the nave ceilings of Nossa Senhora de Nazaré in Santa Rita Durão (page 142), those of São Tomé das Letras by Joaquim José da Natividade, wrongly attributed to Ataíde, and the nave ceiling of Bom Jesus de Matosinhos in Itabirito. Lastly, more for his friendship with Ataíde (with whom he collaborated) than for the quality of his works, Francisco Xavier Carneiro (1765–1840) should be mentioned. Like Ataíde, he painted a few of the statues of Aleijadinho's *Passion* in Congonhas do Campo. From 1802 to 1828 he worked in the Church of the Tertiary Order of São Francisco de Assis in Mariana, where he probably painted the nave ceiling (page 142).

Manuel da Costa Ataíde, the author of huge, high-quality works and master of a use of color sometimes expressing folkloric vigor and sometimes pictorial sharpness, is outstanding in the limited panorama of Brazilian colonial painting.

He was born in Mariana, probably in 1762, and according to some scholars was a mulatto. This supposition is either due to the fact that he painted mulatto saints, angels and Madonnas or the fact that some of Brazil's major artists were mulattoes. Contemporary records, however, disclaim this hypothesis. In 1782, Ataíde received payment for an unidentified work he painted for the Chapel of the Tertiary Order of the Carmelites in his home town in 1784. Still in Mariana, he obtained commissions from the confraternity of the Tertiary Order of St. Francis. In May 1799, he was given the task of painting the apse ceiling with the *Ascension of the Virgin* in the Church of the Tertiary Order of São Francisco de Assis in Ouro Prêto and a few painting assignments for the *Passion* series (the *Last Supper*, the *Flagellation of Christ* and the *Crucifixion*) in Congonhas do Campo. Few of his other paintings are documented and therefore it is difficult to establish a chronology of Ataíde's prolific production. His works can, however, be divided into four groups: perspective ceilings, ceilings in the form of a painting, canvas paintings and decorative paintings. As regards the ceilings, it is certain that between 1800 and 1809 he completed the nave ceiling of São Francisco in Ouro Prêto, in 1822 he recorded doing painting and gilt work for Santo Antônio in Santa Bárbara and for the mother church in Itaverava, and in 1823 he worked for Nossa Senhora do Rosário in Mariana.

Examination of the figures and general structure of his works makes it possible to establish a sequence beginning with the apse ceiling of Santo Antônio in Itaverava, executed at the end of the eighteenth century, followed by the huge perspective painting at São Francisco in Ouro Prêto, a project that continued for a few years. The apse ceiling of Santo Antônio in Santa Bárbara must have already been completed, despite the fact that it is sometimes considered to have been done at the same time. The nave ceiling of Santo Antônio in Ouro Prêto probably postdated the Santa Bárbara ceiling but was painted in the final years of the Ouro Prêto project. The 1823 apse ceiling of Nossa Senhora do Rosário in Mariana is the last of the series.

The painting for the apse of the church in Itaverava portrays in its central panel the *Virgin with the Holy Trinity*. The movement of the figures is elegant and

Nave ceiling of the Church of Nossa Senhora do Carmo in Diamantina, Minas Gerais. This painting by José Soares de Araújo, executed between 1778 and 1784, depicts the prophet Elijah ascending to heaven in a chariot of fire.

Opposite, the apse ceiling of the Sanctuary of the Bom Jesus de Matosinhos, Congonhas do Campo. This work, painted by Bernardo Pires da Silva between 1773 and 1775, shows the *Deposition of Christ*.

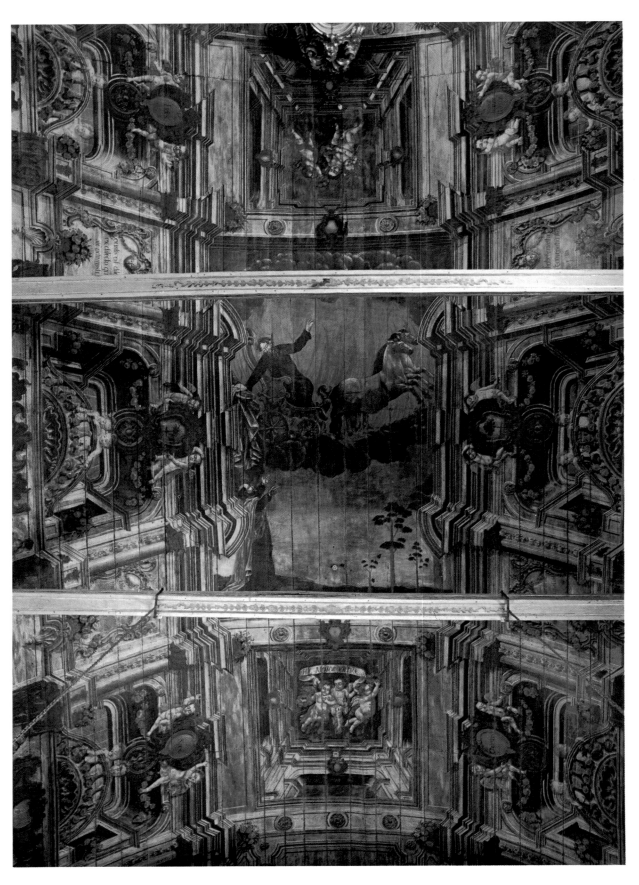

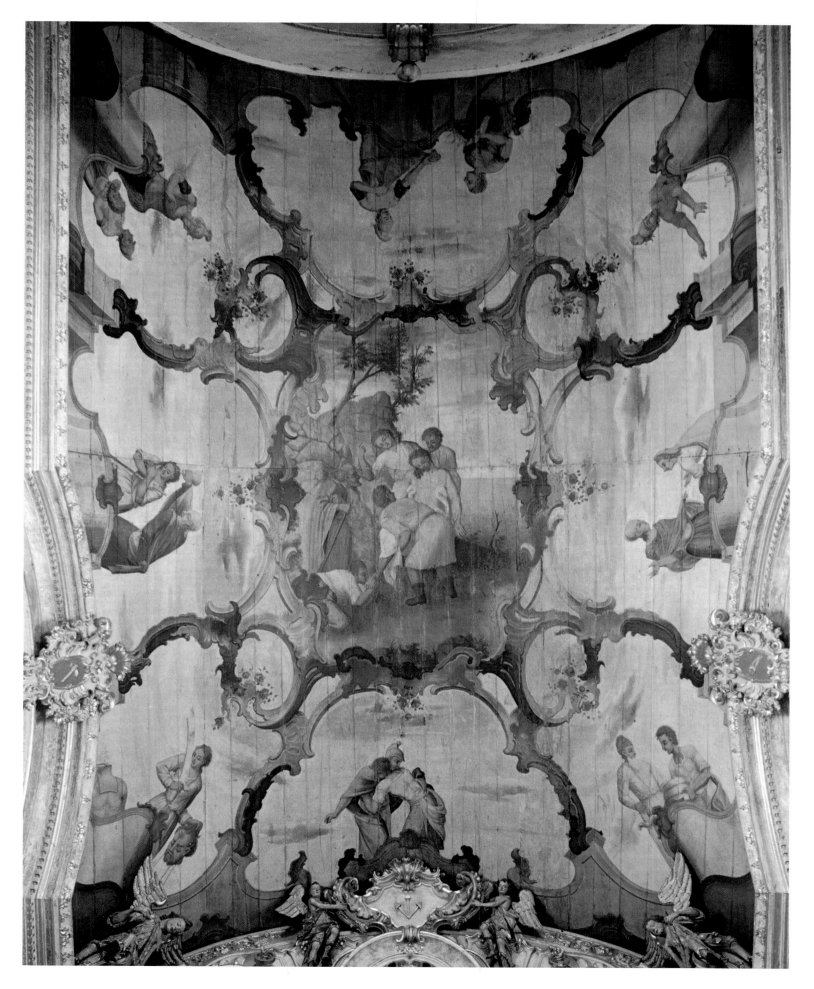

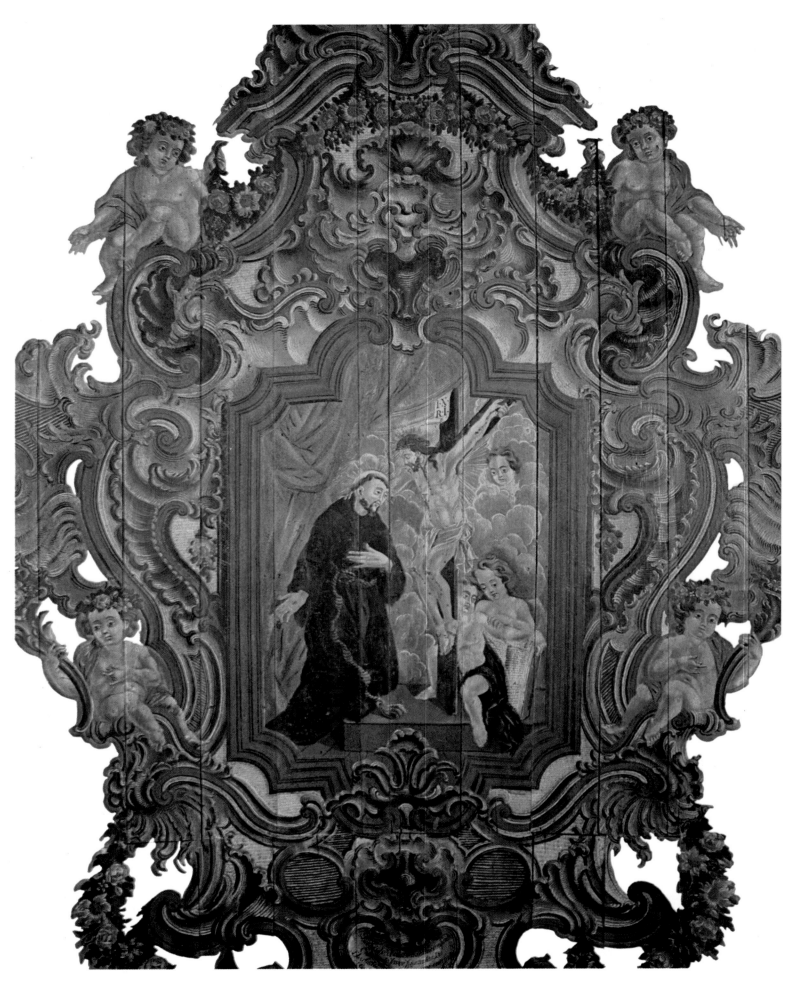

Left, detail of the center of the sacristy ceiling of São Francisco de Assis, Diamantina. The work was painted in 1795 by Silvestre de Almeida Lopes.

Below, the apse ceiling of Mariana cathedral, Minas Gerais, by Manuel Rebelo e Sousa. This work was painted in 1760.

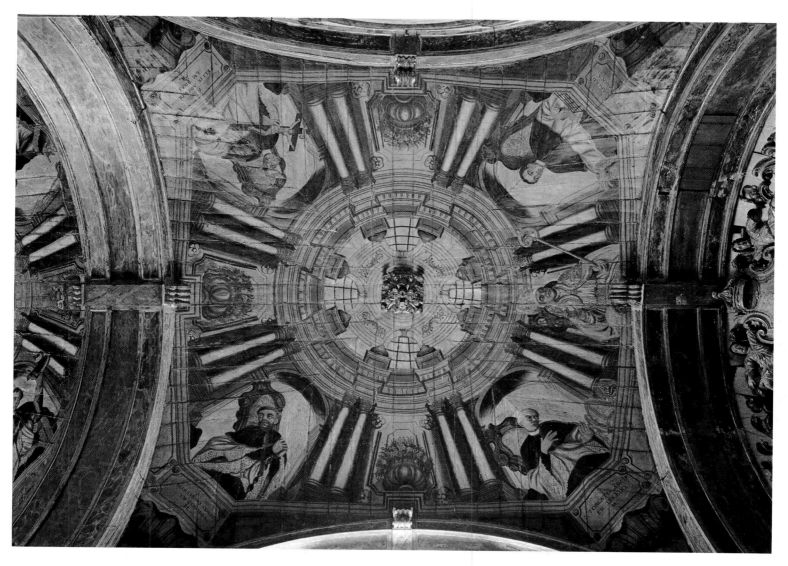

casual. Their proportions, in comparison with the architectural elements, add to the space and suspend them high up in the skies. The vaults, done with great mastery, are painted in vivid shades of red and blue. Ataíde's masterpiece, both for its conception and for its intrinsic creative value, is considered to be the nave ceiling of the Church of São Francisco de Assis in Ouro Prêto (page 146). The curvature of the vault and the shape of the church, with an irregular octagonal plan and four smaller convex walls, certainly facilitated this magnificant composition, with the largest painted sky of all Brazilian painting. Four pulpits with the Doctors of the Church are portrayed above the convex walls, and four pulpits with groups of angels above the larger walls. The central panel depicts a mulatto Virgin surrounded

by clouds and angels, who are also mulattoes.

The ceilings for the apse of Santo Antônio in Santa Bárbara (pages 136–137) and for the nave of Santo Antônio in Ouro Branco (the only one with an oval central baldachin instead of a cross-shaped one) date back to the beginning of the eighteenth century. The apse ceiling of Nossa Senhora do Rosário in Mariana, painted in 1823, reproduces a simplified version of the one in Itaverava. There are only two square ceilings. They are in the form of panels in the sacristy of São Francisco and depict the *Agony in the Garden* and the *Death of St. Francis*. Apart from the fact that they are positioned in the roof, from a formal point of view they do not differ from easel canvases. Decorative paintings, created for a fixed location, have the

same spatial layout as canvas paintings. Since definite dates are rare, the two types of painting are usually examined together to establish a chronology. The first certain date is 1799 for a panel imitating the *azulejos* decoration with *Scenes from the Life of Abraham* for the apse of São Francisco in Ouro Prêto. The other paintings in the church's apse and nave were presumably executed between 1804 and 1807. The decorations of the oratory in the sacristy of Nossa Senhora do Carmo in Ouro Prêto date back to 1812. The episode of the *Stations of the Cross* and the *Madonna of the Carmel with St. Simeon Stock* (page 147), which were painted for the Carmelite confraternity of the town date back to 1818. They are now kept in the Museu da Inconfidência in Ouro Prêto. The *Last Supper* dates from 1828 (page 144–145)

Below, medallion by an anonymous artist on the nave ceiling of the mother church of Nossa Senhora de Nazaré in Santa Rita Durão, Minas Gerais. *Right*, detail of the center of the nave ceiling of the Church of São Francisco de Assis, Mariana. The painting is attributed to Francisco Xavier Carneiro (1765–1840). *Bottom*, anonymous, *Friar Manuel da Cruz*, circa 1764. Oil on canvas; 51.18″ × 41.73″ (130 cm × 106 cm). Museu Arquidiocesano, Mariana.

and is painted on canvas in the refectory of Caraça seminary. Another factor that could assist in establishing a chronological sequence in Ataíde's work is iconography. Many of the *Last Suppers* painted in Brazil were inspired by Francesco Bartolozzi's engraving that was published in many mass-books between the end of the eighteenth century and the beginning of the nineteenth century. Ataíde's *Last Supper*, kept in the Museu Arquidiocesano in Mariana, is almost an exact copy of the engraving. Other interpretations of the same theme vary from a simple composition, like the one for the Church of São Miguel e Almas in Ouro Prêto (page 145), to a composition in which figures of servants and variants in the still life groups on the table are introduced to enliven the scene. This work was probably inspired by the group of the *Last Supper* in Congonhas do Campo, sculpted by Aleijadinho and painted by Ataíde.

Manuel da Costa Ataíde was the heir to a craft tradition directed more toward the faithful execution of pre-established models than artistic creation. However, he broke away from that tradition by

In 1812 or 1813, Joaquim Gonçalves da Rocha painted the nave ceiling (*below*) of the Church of Nossa Senhora do Carmo in Sabará, Minas Gerais. The painting shows the prophet Elijah ascending to heaven in a chariot of fire, leaving his disciple, Elisha, on earth. According to the trend at that time, figures of saints, looking over balconies, form a frame for the central theme.

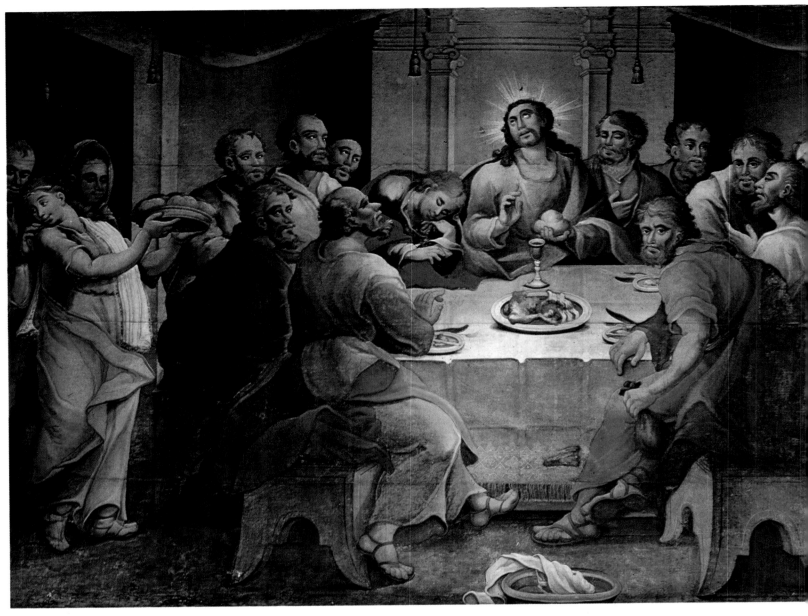

introducing innovations in the faces of his characters and in the composition and groups of figures which he enriches and renders more complex. The faces of his characters are characterized by huge eyes with heavy eyelids, fleshy lips, small foreheads and turned-up noses, while their bodies are thickset with wide, rounded shoulders. Ataíde's figures, like his landscapes and skies, are not realistic. The indeterminate, derived through engravings of European models, in the light of the tropics takes on a typically Brazilian flavor and reflects the natural geniality of a painter pure in heart and in constant harmony with the world.

Applied Arts

Brazilian art, with national characteristics, often expressed itself more openly in the applied rather than the major arts. Although it may not be possible to pick out basic differences between eighteenth-century colonial and Portuguese gold-work, it can, however, be said that colonial work distinguished itself from that of the homeland in its ingenuousness and a greater boldness of form, noticeable above all in objects made for everyday use. Brazilian pieces are plainer than Portuguese ones, which are characterized by greater technical skill in workmanship but less originality.

The sober, strict style of the beginning of the century gradually lost ground to rich rococo ornaments, which impaired the lines of objects with a profusion of shells, twists, acanthus leaves, scrolls, chinoiseries and every other type of extravagance. The discovery of gold made up for the lack of silver, even though the precious metal and diamonds extracted from the mines were not for Brazil but were sent straight to Portugal. The Crown prohibited goldsmiths to work in the producing centers but the laws were often broken, at least in the states of Bahia and Minas Gerais, as were the decrees that forbade Negroes, Indians and mulattoes from practicing the craft.

After a flood of counterfeit gold coins in 1742, Rio de Janeiro's workshops were forced to operate in a district in the center of town, where they could be controlled more easily. A few years later the same precaution was taken in Salvador. In 1753 the authorities in Rio further restricted the freedom of goldsmiths by confining them to just one street, in which there were over 142 workshops. The number of goldsmiths' workshops had therefore risen: Canon Raimundo Trindade recorded over 100 in Minas Gerais alone, and at the end of the century there were 400 master craftsmen and 1,500 apprentices working in Rio de Janeiro.

In 1766 a royal decree, revoked only in 1815, ordered the closure of all goldsmiths' workshops in the states of

Below, right: Last Supper, engraving by Francesco Bartolozzi (1728–1815). This print, by the Italian master engraver who died in Lisbon, inspired Manuel da Costa Ataíde (1762–1830) to create various works on the same subject: *below*, a *Last Supper* that Ataíde painted for the Church of São Miguel e Almas in Ouro Prêto. Oil on canvas; 82.67″ × 70.86″ (210 cm × 180 cm). His best known work is the *Last Supper* (*left*) painted in 1828 and kept in the Caraça seminary, Minas Gerais. Oil on canvas; 94.48″ × 173.22″ (240 cm × 440 cm). *Bottom*, detail of the sacristy ceiling of the Church of Nossa Senhora do Carmo, Ouro Prêto. The painting is attributed to Manuel da Costa Ataíde.

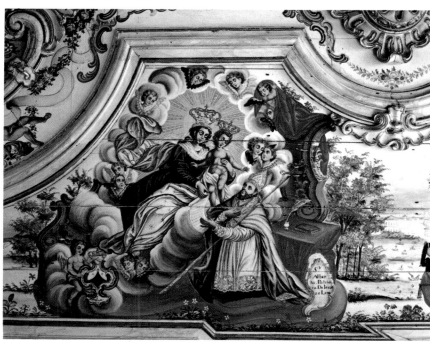

Pernambuco, Rio de Janeiro, Bahia and Minas Gerais, inflicting extremely severe punishments on transgressors. But the law was not always rigorously applied and by the end of the century a great many clandestine workshops were in operation.

Eighteenth-century Brazilian furniture imitated the Portuguese and was produced in a series of styles named after the monarchs ruling in that period: Dom João V (1706–1750), Dom José I (1750–1777) and Dona Maria I (1777–1792). The Dona Maria I style continued until 1816 with the name of Regência or Dom João VI. In the period of Dom João V there was a move away from the criteria of the previous century. A style strongly influenced by the Portuguese began to take hold. It was, in its turn, rich in Dutch and English (especially Chippendale) elements, but it distinguished itself from Portuguese models with extremely exuberant ornamentation in the late baroque manner with motifs inspired by the flora and fauna of Brazil. The Dom José I style matched the spread of rococo decoration

inspired by French models, despite the continuation of the English influence. Under the reign of Dona Maria I there was a return to simpler lines and plainer ornamentation, which opened the way for the neoclassical style, Dom João VI.

Continuing the pattern begun in the middle of the seventeenth century, the finer porcelain was imported into Brazil from China on ships of the India Company. It comprised pieces almost exclusively made to order for western tastes. Toward the middle of the eighteenth century, porcelain was classified into "families": green, pink, black, and so on, depending on the predominant color of the glazed background. After a trade agreement between Dom João VI and George III, which opened the Brazilian market to English products, Chinese porcelain was gradually replaced by porcelain from England. The china kilns built by the Jesuits since the sixteenth century certainly did not produce any type of artistic pottery; it was not their purpose nor were they capable of doing so. The case of Friar Francisco Rebelo is, however, curious. He was born

in Braga in 1713 and came to Brazil in 1740. He is referred to in the Society of Jesus records as a sculptor of terra-cotta statues. In 1743 Francisco Rebelo was in Vigia in Pará, where, exactly two centuries later, a nativity scene with terra-cotta figures which could have been made by him were found.

In a report of 1760 on the assets of the São Marcos pottery works in Maranhão, some of the things listed were "three or four potter's wheels." The origins of Saramenha pottery are unknown but its production dates back to at least the early nineteenth century, and perhaps even as early as the end of the eighteenth century in the Saramenha area, near Ouro Prêto. It is possible that, like the china produced in other regions in Minas Gerais, it had connections with the Portuguese china so highly valued by the inhabitants of Minas in the last quarter of the eighteenth century.

The use of *azulejos* as a covering for buildings also became widespread in the eighteenth century (pages 2–3). Whereas ceramic tiles of the previous century were brightly-colored with a predomi-

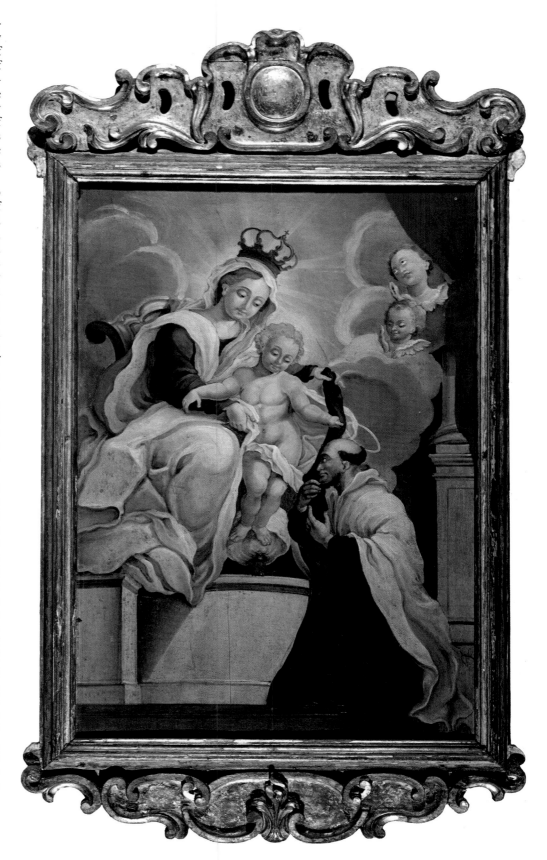

Manuel da Costa Ataíde (1762–1830),
*Madonna of the Carmel with St. Simeon
Stock*. Museu da Inconfidência, Ouro Prêto.

nance of blues and yellows, the eight-eenth-century *azulejo* tiles were mostly white and blue and portrayed scenes of the lives of saints, representations of works of mercy, maritime themes, land-scapes, pastoral scenes and had decorative frames with baroque motifs. A typically Brazilian innovation was the use of *azulejos* to cover the facades of dwellings and public buildings, in addition to the interiors of large houses and religious buildings.

Lastly, the eighteenth century was also the period when the manufacture of small religious statues, concentrated above all in the states of Bahia, Pernambuco and Minas Gerais, reached its height. The favorite material was wood, usually cedar, with the harder woods used for bases and crucifixes. In the state of Bahia, however, ivory was regularly used, both for entire statuettes and for just the face and hands of a wooden piece. After the first half of the century, in Minas Gerais and the state of Bahia steatite was also used, especially in the production of small images for or-atories. Almost all these statuettes were polychromed, even those of ivory and steatite. Only toward the end of the century were the two materials used in their natural state or for pieces only partly painted.

It is in the more refined images from Bahia and Pernambuco that it is possible to detect Italian, French and Oriental (Indian or Chinese) influences. The south proved to be less susceptible to foreign influences and the states of Rio de Janeiro and São Paulo remained faithful to the Portuguese tradition. In addition, there were reciprocal influences between Bahia, Pernambuco, Maranhão and Minas Gerais, where an extremely austere style prevailed. The bases of statuettes followed the current style of Dom João V, Dom José I or Dona Maria I. The base, initially a simple support, gradually became more important and was decorated with angels and twists until it was transformed into an elaborate pedestal. Toward the end of the century, popular images lost their characteristic expressiveness and, in the nineteenth century, declined to a shoddy level as a result of indiscriminate mass production.

Neoclassicism and Eclecticism in the Nineteenth Century

Neoclassicism and Eclecticism
in the Nineteenth Century

On the previous pages, Nicolas-Antoine
Taunay (1755–1830), *The Square in Rio de
Janeiro in 1816*. Oil on canvas; 17.7″ × 22.04″
(45 cm × 56 cm). Museu Nacional de
Belas-Artes, Rio de Janeiro.
Above and right, Adrien-Aimé Taunay
(1803–1828): *Brazilian Scene*, 1819. Water
color; 7.48″ × 10.23″ (19 cm × 26 cm); and
*Family from the Interior of Brazil on a
Journey*, 1818. Water color; 13″ × 15.35″
(33 cm × 39 cm). Both works are at the
Fundação R.O. Castro Maya, Rio de Janeiro.
Below, Agostinho José da Mota (1821–1878)
Melon and Pineapple. Oil on canvas;
13.77″ × 20.47″ (35 cm × 52 cm). Museu
Nacional de Belas-artes, Rio de Janeiro.

The French Artistic Mission and Neoclassicism

From the middle of the seventeenth
century, the Portuguese economy was
closely tied to that of England. In
addition, from 1694 links between Brazil
and Portugal were ensured partly by
English ships. In 1801 France dealt a
harsh blow to the Portuguese and
English alliance. Napoleon persuaded
Spain to attack Portugal, and in order to
obtain peace, Portugal was forced, among
other things, to close her ports to the
English fleet. The Court at Lisbon was
divided into an English faction, which
supported the traditional alliance with
London, and a French faction, which saw
in the possibility of friendship with
France an opportunity to break
England's dominion over the seas.

In 1807, Napoleon's troops invaded
Portugal and Dom João VI, leaving
England with the task of defending his
realm, left for Rio de Janeiro (which in
1763 had become the capital of the
colony) with the entire Court and most of
the government officials, forming a ret-
inue of about 15,000 people. After calling
in at Salvador, the royal family reached

Augusto Müller (1815–?), *Portrait of Grandjean de Montigny*. 25.98″ × 21.65″ (66 cm × 55 cm). Museu Nacional de Belas-Artes, Rio de Janeiro.

Rio on March 7, 1808. In the town, which then numbered not more than 50,000 inhabitants, arrangements had to be made to accommodate the new arrivals. Dom João VI installed himself in the viceroy's palace, immediately formed a cabinet and set up administrative bodies.

While he was in Salvador, Dom João conceded the opening of Brazilian ports to international trade, since Portugal's maritime trade had been interrupted as a result of the French occupation, thus abolishing the Crown's monopoly. Furthermore, a month after his arrival he revoked a decree passed in 1785 that had forbidden the setting up of industries within the colony. He later liberalized the cultivation of olives and mulberries and created, with a government act, the Banco do Brasil.

Although not a cultured man, Dom João admired and respected the arts and made it his business to ensure the formation of a civil and military élite. With machinery brought over from Portugal he founded Brazil's first printing house, which began to operate on May 13, 1808, and was to print scientific and literary works as well as the country's first newspaper, *A Gazeta do Rio de Janeiro*. On the suggestion of the count of Linhares, the prince regent promoted the establishment of schools, libraries and museums. Various institutes of higher education were later formed, and in order to assist in the schools' organization, teachers, scientists and artists were called in from abroad. Among these, the members of the French Artistic Mission were particularly important. The Mission arrived in Rio de Janeiro in 1816 and the circumstances that gave rise to it are still obscure. It could have been the marquis of Marialva who, on the suggestion of the naturalist Humboldt, obtained permission to invite the French artists to Brazil from the count da Barca (Antonio Aranjo de Azevedo), minister of Foreign Affairs. Or the artists themselves might have chosen, for political reasons, to go to Brazil.

On March 26, 1816, Joachim Lebreton, head of the Mission dis-

embarked in the Bay of Guanabara. He had previously been secretary of the Fine Arts section of the Institute of France and had resigned for political reasons when Louis XVIII came to the throne. He was accompanied by Nicolas-Antoine Taunay, a genre and battle painter and member of the Institute; Jean-Baptiste Debret, historical painter; the architect Auguste-Henri-Victor Grandjean de Montigny; the sculptor Auguste-Marie Taunay; the carver Charles Simon Pradier; the composer Sigismund von Neukomm, as well as various craftsmen.

Considering the different professions of the members, the aim of the Mission was to found a school of arts and crafts. The institute which opened in Rio de Janeiro on August 13, 1816 was called Escola Real das Ciências, Artes e Ofícios. Over the years it changed its name several times until in 1826 it became the Academia Imperial e Escola de Belas-Artes. The Mission was to encounter many difficulties, however, which increased immediately after the death of Lebreton, in 1819, when the Portuguese painter Henrique José da Silva became the director of the school by favor of the baron de São Lourenço. The latter had taken the place of count da Barca (who died in 1817) and, in contrast to his predecessor, favored his Portuguese compatriots or at least the Brazilians.

Nicolas-Antoine Taunay could not stand up to opposition from the new director and in 1821 returned to France. Debret, who was more tenacious, remained in Brazil for ten more years and was able to witness the general acceptance of his ideas on teaching art. The most talented artist of the French Mission was, without doubt, the painter Nicolas-Antoine Taunay. Born in Paris in 1755, he began his artistic studies at the age of thirteen and was a friend of Fragonard. His landscape studies, painted from life in the forests of Saint-Germain, Fontainebleau and Compiègne, date from the beginning of his career. In 1776 he traveled around Switzerland, and in 1784, as an associate member of the Académie Royale, he won a three-year scholarship to attend the Accademia di

Jean-Baptiste Debret (1768–1848): *below, Coach Carrying the Holy Sacrament to Wealthy or Important People*. Water color on paper; 7.08" × 9.84" (18 cm × 25 cm); *bottom, Court Official on His Way to the Palace,* 1822. Water color on paper; 6.29" × 8.26"

(16 cm × 21 cm). Both works, kept at the Fundação R.O. Castro Maya in Rio de Janeiro, were used with others to illustrate *Pictorial and Historical Journey in Brazil,* which Debret wrote and published between 1834 and 1839.

Charles Landseer (1799–1879), *Inhabitant of the Interior of Pernambuco*. Water color; 14.96" × 8.26" (38 cm × 21 cm). C. Paula Machado Collection, Rio de Janeiro.

Francia in Rome. From 1814 he exhibited at the Paris Salon. A member of the Institute of France since the year of its foundation (1795), he also did some work for the Sèvres works. Nicolas-Antoine Taunay experienced a period of intense activity under Napoleon, especially as a battle painter.

Taunay's Brazilian works include landscapes with small figures, scenes depicting daily life, biblical, mythological and historical subjects and delicate portraits of children. The thirty or so views of Rio de Janeiro and its surrounding areas (pages 148–149), which capture the atmosphere of the Brazilian capital with great sensitivity reflect his style well.

Félix-Emile Taunay, who was born in 1795 in Montmorency, was just twenty when he came to Brazil with his father, who was his teacher and whom he later replaced as landscape teacher at the Academia Imperial in Rio. He taught there until 1851 and, in 1834, replaced Henrique José da Silva as director. He

practiced landscape, historical and portrait painting, showing himself to be a talented artist. He died in Rio de Janeiro in 1881 but had for some years abandoned his artistic activities due to premature failure of sight.

Adrien-Aimé Taunay, the last of Nicolas-Antoine's six sons, was born in 1803 in Paris and at the age of fifteen accompanied Freycinet's scientific mission as a draftsman on board the ship *Urania*. After returning to Rio de Janeiro in 1820, he set off five years later with Langsdorff's scientific mission to Mato Grosso and Pará, replacing Rugendas as artist alongside Hercule Florence, one of the pioneers of photography. He drowned in a river in Mato Grosso in 1828 and left behind about 150 water colors in which he depicted everyday life in Brazil with sensitivity and liveliness (page 150).

Nicolas-Antoine's only brother, Auguste-Marie Taunay, was born in Paris in 1768. He attended the atelier of the sculptor, Moitte, and in 1792 won the Prix de Rome, but owing to political circumstances at that time, could not study at the Academy of France. From 1802 to 1807 he was a sculptor at the Sèvres works and in 1807 was commissioned to decorate the Louvre staircase and the Arc du Carousel. He exhibited at the Salons and made numerous statues for cemeteries and public places. In 1816 he accompanied his brother to Brazil and was appointed teacher of sculpture in the Escola Real. Auguste-Marie Taunay's first assignment in Brazil, alongside Debret and Montigny, was the display for the public celebrations which took place in 1818 in Rio de Janeiro for the acclamation of Dom João VI as king of Portugal, Brazil and Algarve.

When Nicolas-Antoine returned to France, Auguste-Marie stayed on in Brazil, opening a private sculpture school since the Academia de Belas-Artes building, still unfinished, did not have the necessary rooms. He died in 1824 in Rio, leaving behind very few works.

Jean-Baptiste Debret (1768–1848)

Below, Richard Bates (1775–1856), *The Arches and Convent of Santa Theresa*, circa 1820. Color print; 8.26″ × 10.62″ (21 cm × 27 cm). Fundação R.O. Castro Maya, Rio de Janeiro. *Bottom*, Emeric Essex Vidal (1791–1861), *Mr. Fox's Country House in the Orange Valley*, 1829. Water color; 7.87″ × 11.81″ (20 cm × 30 cm). Libreria L'Amateur collection, Buenos Aires. *Opposite, above*, Charles-Othon, count of Clarac (1777–1847), *Brazilian Forest*, 1816, Burin engraving, 21.65″ × 26.37″ (55 cm × 67 cm). *Below*, Alfred Martinet (nineteenth century), *Rio de Janeiro*. Lithograph; 19.68″ × 18.89″ (50 cm × 48 cm). Both works are at the Fundação R.O. Castro Maya, Rio de Janeiro.

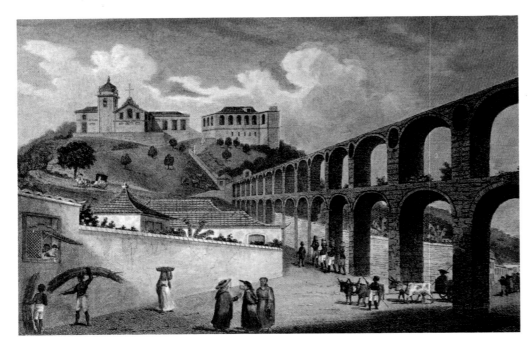

sufficient rooms to take in a greater number of students, and even then Grandjean de Montigny had not yet completed the work on the Academia de Belas-Artes building. The following year, of the thirty-eight students registered at the school, twenty-one were following the painting course.

Debret had the task of organizing Brazil's first public exhibition, which was opened on December 2, 1829 in the rooms of the Academia Imperial. From the catalogue, financed by the artist, there appear to have been 115 works: 33 by the teachers and 82 by the pupils. A second exhibition was held in 1830. After Debret left for France, it was not until December 1840 that Félix-Émile Taunay organized the third. Debret's first exhibition is famous for his *Pictorial and Historical Journey in Brazil*, which he wrote and illustrated (page 154).

Grandjean de Montigny, born in Paris in 1776, was a pupil of the architects Charles Percier and Pierre Fontaine. He won the Prix de Rome in 1799 and two years later went to Italy where he was given the task of supervising the restoration work on the building and gardens of the Villa Medici, just bought by the French government. In 1808 he returned to France but shortly afterwards was appointed the first architect of Westphalia by Jerome Bonaparte and for three years worked in Kassel. After Waterloo, Czar Alexander I asked Percier and Fontaine to find a painter and architect for his court. Debret and Grandjean de Montigny were recommended to him, but both artists preferred to join the Mission bound for Brazil. In 1816, Montigny disembarked in Rio, accompanied by his wife, four children, two pupils and a maid.

His first task, entrusted to him by count da Barca, was to design the building of the future Academia de Belas-Artes, which was to have three floors, the top one being for the European teachers. On the death of the count, in 1817, work was interrupted and resumed a few years later. Montigny, unable to hold lessons owing to the lack of suitable rooms, became involved in various building projects, public and private, which included elements of local tradition in their neoclassical plans. In 1823 he decided to open a private school of architecture but immediately afterwards work resumed for the construction of the Academia, on the basis of a less

from Paris was the cousin of David, whom he accompanied to Italy when he was still a boy, and was also related to François Boucher. In 1785 he registered at the Académie Royale, but when the French Revolution broke out he was forced to leave his artistic studies to take up civil engineering. He later became teacher of drawing at the École Politechnique. He won a prize at the 1798 Salon and from 1806 dedicated himself to huge canvases exalting the Napoleonic era. After the fall of the emperor and the death of his only son he decided, together with Grandjean de Montigny, to leave for Russia, but both artists later decided to join the French Mission to Brazil. Debret was very active in Rio de Janeiro for the royal family. He painted scenery for the São João Theater and helped organize the displays for the acclamation of Dom João VI. In 1820, he was appointed teacher of historical painting but had to wait for three years before he had an atelier where his first pupils could meet. Only in 1826 did he obtain

157

ambitious plan. This work was completed in 1826. (The building was demolished in 1937).

From his arrival in Rio de Janeiro until the year of his death (1850), Montigny was responsible for many architectural and town plans of which, unfortunately, very few were put into practice. His involvement in urban planning, however, served radically to change the appearance of the town, with the arrangement of the imposing Praça Municipal, the roads and squares around the Senado building and the center of Rio which was linked to the suburbs.

It is sometimes said that when the French Artistic Mission arrived in Brazil, the country's art and architecture were in a period of stagnation and complete decadence. However, some of Brazil's most important artists, such as Manuel da Costa Ataíde in Minas Gerais, Franco Velasco and José Teófilo de Jesus in the state of Bahia, Jesúino do Monte Carmelo in São Paulo and Manuel Dias de Oliveira in Rio de Janeiro were still alive although their careers had by then reached an end. Moreover, if the introduction of a methodological form of teaching put an end to the empiricism that had prevailed until then (which was nothing else but the old system of apprenticeship, adapted to the circumstances and the country's lack of facilities), it is also true that it ended up making Brazilian art academic, causing it to lose its spontaneity.

The French Artistic Mission was important more for the intrinsic value of some of its members than for its methods of teaching, and it was not a determining factor in the introduction of neoclassicism. After the work of Antonio Giuseppe Landi (who died in Belém in 1790), neoclassical ideals were no longer a novelty and in Rio de Janeiro itself a painter like Dias de Oliveira was, in the final analysis, neoclassical.

The support given to the Mission could only stir up, as in fact it did, the hostile reaction of the Portuguese and Brazilian artists who saw themselves being looked down upon and left to their own devices. It should not be forgotten that French art and taste were imposed by the Court as was the 1824 Constitution. The idea behind the French Artistic Mission was to replace one type of cultural colonialism, to which the Brazilian population had already become accustomed, with another that

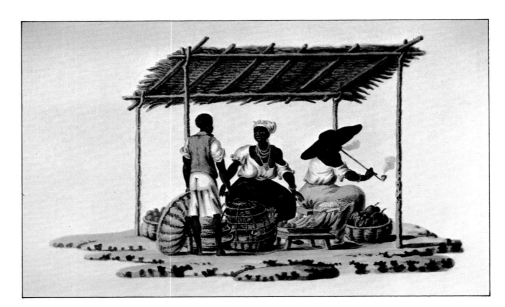

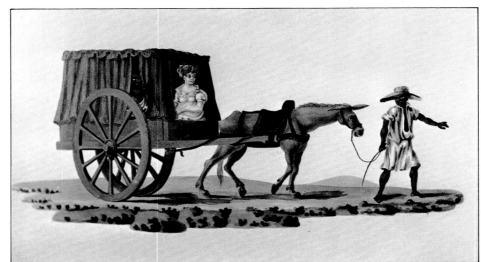

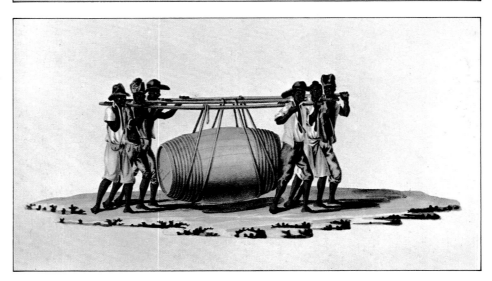

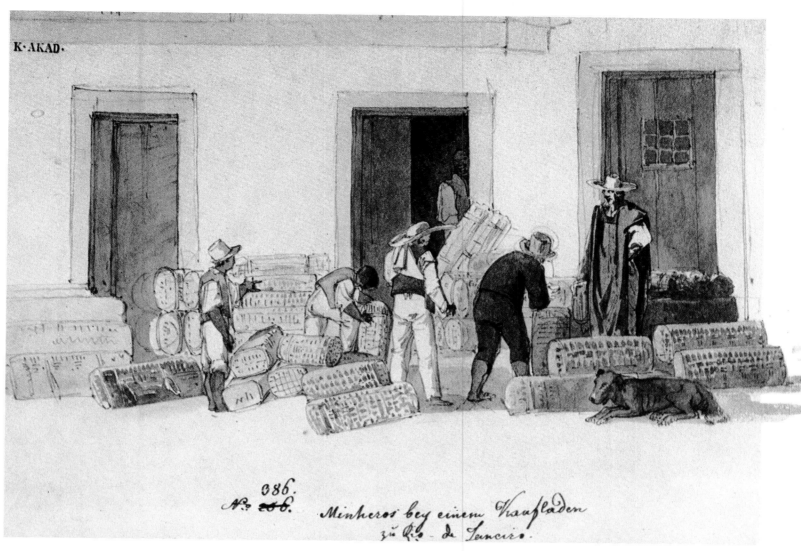

K·AKAD·

№ 386.

Minheiros bey einem Kaufladen
zu Rio de Zaneiro.

K·AKAD·

726.
Eingang des Landhaufes do Conto de Barca.

Johann-Moritz Rugendas (1802–1858):
below, *Mineiros Coast in Rio de Janeiro;*
10.62″ × 14.17″ (27 cm × 36 cm); *bottom*,
Mandioca; 9.84″ × 11.81″ (25 cm × 30 cm).
Lithographs from *Pictorial Journey through
Brazil*, published in 1835. Biblioteca
Nacional, Rio de Janeiro.

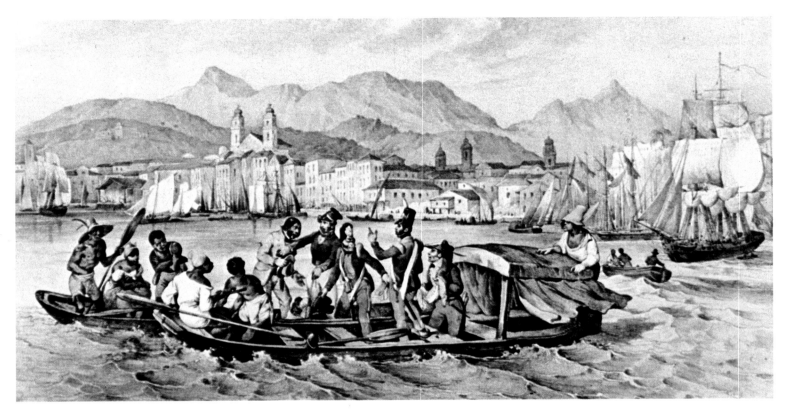

was without doubt more sophisticated but was also foreign to the national temperament.

It cannot be denied that the artists who came to Brazil with Lebreton had a considerable influence on the country's art. Within the field of architecture, Grandjean de Montigny helped to accentuate the neoclassical tendency introduced by the Court architects. Some of them, especially the military ones, had worked on the reconstruction of Lisbon (destroyed by the 1755 earthquake) under the supervision of the marquis of Pombal and in their official capacity had applied the rules of neoclassical composition. Those towns that were directly linked to the royal administration, such as Belém and São Luís do Maranhão, had civil architecture that was clearly influenced by the "Pombal" style. Even a poor town like São Paulo experienced the introduction of neoclassical elements, such as the triangular pediment, in its architecture. The presence of the Court made Rio de Janeiro not only the country's administrative capital and center of political decisions, but also the driving force behind new artistic trends.

The new government immediately sought to modernize Brazil's main centers, which were made up of narrow

Johann-Moritz Rugendas, *View of the Coast near Bahia.* Lithograph; 14.17″ × 10.62″ (36 cm × 27 cm). From *Pictorial Journey through Brazil,* published in 1835. Biblioteca Nacional, Rio de Janeiro.

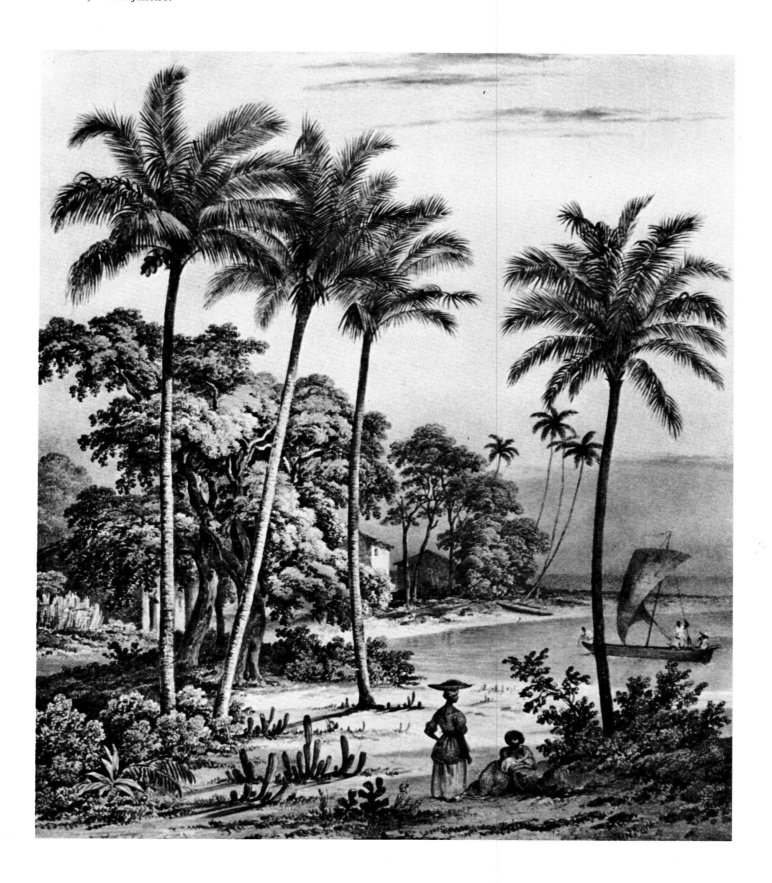

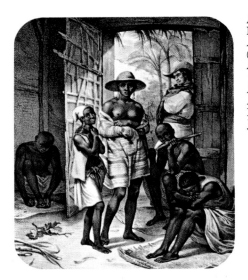

Left and below, Johann-Moritz Rugendas (1802–1858): *Newly Arrived Negroes*; 11.41″ × 9.44″ (29 cm × 24 cm); and *Sugar Refinery*; 7.48″ × 10.62″ (19 cm × 27 cm). Lithographs from *Pictorial Journey through Brazil*, published in 1935. Biblioteca Nacional, Rio de Janeiro.

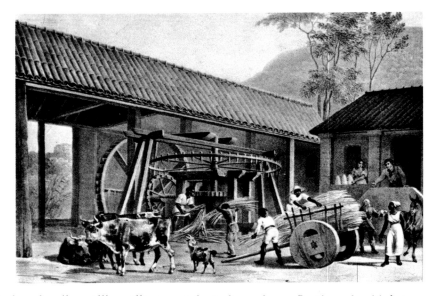

At that time, the cultivation of coffee, introduced to Brazil at the end of the previous century, spread rapidly, since it offered farmers, especially in the Rio de Janeiro area and in southern Minas, the chance to get rich quickly. The middle course of the Paraíba river, in the first half of the nineteenth century, saw the emergence of numerous aristocratic dwellings, built in accordance with neoclassical composition.

Neoclassicism was introduced into Nordeste by Francisco do Rego Barros, count of Boa Vista, who governed Pernambuco for almost thirty years. From 1839, he called about 100 European artists and craftsmen to Recife to modernize the town's buildings and its sugar industry under the supervision of the German, Augusto Koersting.

In 1840 he appointed Louis Léger Vauthier from France as the director of public works in the province of Pernambuco. Vauthier, during his six-year period in Recife, completed a series of projects which served as a model for the entire region, in addition to a few noblemen's residences and the Santa Isabel Theatre (1845).

Brazilian Neoclassical Painters and Other Foreign Painters

Neoclassical painting began to spread with Jean-Baptiste Debret's first pupils: Francisco Pedro do Amaral (died 1831), who was from Rio and was an exponent of the Rio school which represented a link between the colonial tradition and the new aesthetic ideals; Simplício Rodrigues de Sá (died 1839) from Lisbon, who became the official Court portraitist; José de Cristo Moreira (died 1830) from Portugal, who painted sea and landscapes; the portraitist Francisco de Sousa Lobo, born in Minas, who painted historical subjects; and José da Silva Arruda (died 1833), who painted portraits and animal studies. Manuel de Araújo Porto Alegre (1806–1879), who in 1831 accompanied Debret to France (where he was also the pupil of Gros), was one of the most versatile talents of his generation: draftsman, caricaturist, teacher of painting, art critic, writer, poet and finally ambassador in Prussia and Portugal. As a painter he concentrated on portraits, historical pictures and landscapes. He was born in Rio Pardo (Rio Grande do Sul) and died in Lisbon.

The most talented painters to emerge

streets, infected and evil-smelling alleys and old houses with Moorish elements in their fences, windows and doors. All of the older part of Rio was considered aesthetically unacceptable by the newly-arrived nobles. Wooden balconies, verandas protected by trellises and shutters and awnings over stone facades had to be removed as soon as possible; the slightly oriental appearance had to be banished from the town chosen to be capital of the realm. The desire for decorum coincided with the commercial interests of the English who soon exported to Brazil masses of building materials: sheets of copper, lead and iron and all kinds of nails and tools.

The more orthodox form of neoclassicism was introduced to Brazil by Grandjean de Montigny, who had numerous pupils, some of whom were quite talented, such as Justino de Alcântara Barros, responsible for the new lantern in the Church of the Candelária, Manuel de Araújo Porto Alegre, José Maria Jacinto Rebelo, who designed the present-day Itamarati building, Francisco Joaquim Bethencourt da Silva and many more. These pupils took on the task of spreading neoclassical architecture throughout the entire territory that was under the direct influence of the Court, giving a new appearance to public buildings, to the farm villas on the outskirts of the town and to the residences of the new coffee plantations. Thus, neoclassicism, brought by the Court and encouraged by the French Mission, became the empire's official style and was welcomed by all the provinces for its new constructions which were symbols of the country's progress and liberty.

Johann-Moritz Rugendas: *below*,
Washerwomen from Rio de Janeiro;
6.29″ × 9.05″ (16 cm × 23 cm); *bottom, Tapuia
Village*; 8.66″ × 11.02″ (22 cm × 28 cm).
Lithographs from *Pictorial Journey through
Brazil*, published in 1835. Biblioteca
Nacional, Rio de Janeiro.

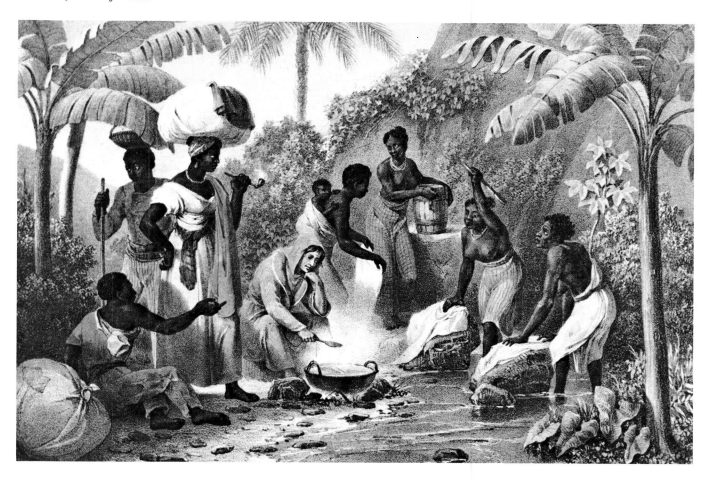

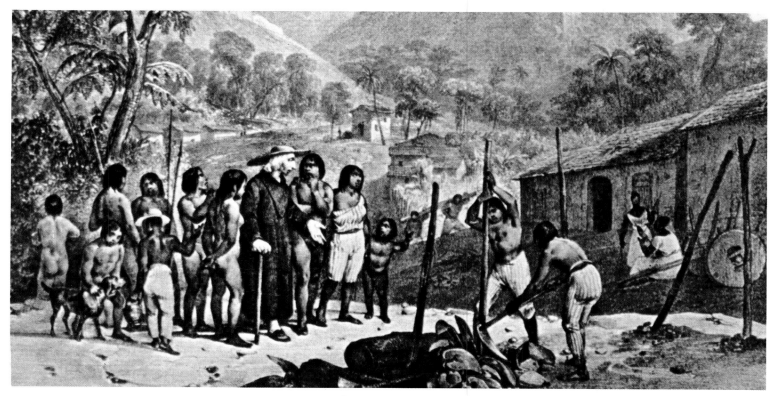

from the Academia de Belas-Artes, however, were Augusto Müller and Agostinho José da Mota. Augusto Müller (born in Baden in 1815) was the holder of the landscape chair from 1851. He painted historical pictures and portraits (*Portrait of Grandjean de Montigny*, Museu Nacional de Belas-Artes, Rio de Janeiro) and distinguished himself especially in landscape painting for his steady brushstrokes and masterly use of color. His most famous works are his views of the Bay of Guanabara that he was commissioned to paint, between 1835 and 1840, by the United States consul, William Wright. Agostinho José da Mota (1821–1878) was the first to win (in 1850) the European scholarship. The following year he left for Rome where he perfected his style with Jean-Achille Benouville. His best paintings, landscapes of Rio and still lifes of flowers and Brazilian fruits (*Melon and Pineapple*, Museu Nacional de Belas-Artes, Rio de Janeiro; page 150), are characterized by their sobriety.

Frederico Guilherme Briggs was also a pupil at the Academia de Belas-Artes. He was born in Rio de Janeiro, the son of an Englishman. In 1832 he opened a printing house in his native town in which he produced lithographs of Brazilian landscapes and everyday scenes. After a stay in England in 1837, he began printing music scores and commercial products,

not neglecting, however, artistic works such as the *Costumes of Brazil* album with fifty colored lithographs, almost all signed by the painter Joaquim Lopes de Barros Cabral Teive. In 1840 he formed a partnership with the Prussian lithographer, Peter Ludwig, and published the *Souvenir of Brazil* album (pages 152–153), comprising thirty colored lithographs, between 1846 and 1849. They were probably based on original water colors by the German painter Edward Hildebrandt who had visited Brazil in 1844. Briggs made an important contribution to the spread in Brazil of political caricatures and the satire of everyday life.

While the first pupils of the French Mission created their works, Miguel Arcanjo Benício da Assunção Dutra (1810–1875) was working in Itu (state of São Paulo). He was better-known as Miguelzinho Dutra. A writer, musician, goldsmith and tailor, as well as a painter, he was the trustee of a typical regional tradition which was completely foreign to the artistic renewal imposed by the Court. Dutra's candid, spontaneous realism lead the artist to concentrate on peasants and ordinary folk. His small water colors (page 155) depict provincial and backward Itu and its inhabitants, traditional celebrations, the cultivated fields and farms on the outskirts.

Throughout the nineteenth century, Brazil called in many foreign painters, most of whom were attracted by the beauty of the tropical landscape. Others, however, were portraitists who satisfied the requirements of rich clients seeking to perpetuate the image of their prosperity. Some of the artists were amateurs, but most had academic training. Almost all of them set up in Rio de Janeiro or nearby, rarely venturing into the provinces in search of new views. Many of these painters had already lived in Brazil before the arrival of the French Mission and some had even preceded the arrival of Dom João VI.

Richard Bates (1775–1856) was among the first English painters to visit Brazil in the course of the nineteenth century. He opened a shop in Rio de Janeiro selling precision instruments and in his free time painted views of the capital (page 156), using water color as his prefered medium. Another Englishman, Henry Chamberlain (1796–1844) came to the capital in 1815 with his father, who was a diplomat. In 1822, having returned to England, he published an album of aquatints entitled *Views and Costumes of the Town of Rio de Janeiro and Surrounding Areas* which included two water colors by Guillobel.

Emeric Essex Vidal (1791–1861) stayed in Brazil in 1816 and 1836. In 1820 he

Pedro Américo, *The Carioca*, 1882. Oil on
canvas; 81.88″ × 53.14″ (208 cm × 135 cm).
Museu Nacional de Belas-Artes, Rio de
Janeiro.

Vitor Meireles (1832–1903): *below*, *Moema*, 1863. Oil on canvas; 50.78″ × 74.80″ (129 cm × 190 cm); Museu de Arte, São Paulo; *bottom*, *The Oath of Princess Isabella*, 1872. Oil on canvas; 46.06″ × 102.36″ (117 cm × 260 cm); Museu Imperial de Petrópolis, Rio de Janeiro.

published an album of *Pictorial Illustrations of Buenos Aires and Montevideo* which included some views of Rio de Janeiro and surrounding areas (page 156).

During his travels, Augustus Earle from London (1793–1839) stopped off in Brazil in 1820, from 1821 to 1824 and lastly in 1832, painting landscapes and everyday and genre scenes characterized by immense spontaneity.

Maria Graham (1785–1842) lived in Rio de Janeiro from 1821–1823 as the governess of Princess Maria da Glória and returned to England between 1824 and 1825. By that time she had already published her *Diary of a Journey to Brazil and a Stay During Part of the Years 1821, 1822 and 1823*, with illustrations taken from her own water colors and the works of Augustus Earle.

Charles Landseer (1799–1879), the British painter and draftsman, arrived in Rio in 1825 in the retinue of Sir Charles Stuart, head of the mission which marked England's recognition of Brazil's independence from Portugal, which was proclaimed in 1822. During the two years in which he resided in the country, Landseer produced about 300 drawings and water colors portraying the inhabitants (page 154), customs, costumes and landscapes of Brazil.

Opinions differ as to which of the artists who stayed in the country introduced lithography to Brazil. The Swiss Johann Jacob Steinmann (1800–1844) came to Brazil in 1825 and the following year he opened a lithographic studio in Rio. Steinmann, who had studied with Engelmann and trained with Senefelder, the inventor of lithography, returned to Europe in 1835 and published an album of *Souvenirs from Rio de Janeiro* with illustrations of scenes from everyday life

Vitor Meireles, *Battle of the Guararapes*,
1879. Oil on canvas; 16.20′ × 30.28′
(4.94 m × 9.23 m). Museu Nacional de Belas-
Artes, Rio de Janeiro.

framed in decorative motifs inspired
by tropical flora. From 1825 Hercule
Florence (1804–1879) from Nice also
became involved in lithography. He came
to Brazil in 1824 as an artist on the
Langsdorff expedition and portrayed
nature (page 155) and the Indians. Two
Frenchmen are also considered to be
pioneers of lithography in Brazil:
Armand Julien Pallière (1784–1862)
from Bordeaux, who lived in Rio from
1817 to 1830 and was commissioned by
Dom João to produce views of the
capital, Minas Gerais and São Paulo, and
Louis-Alexis Boulanger (1800–1873)

from Paris, who in 1829 opened a
lithographic studio in Rio with Carlos
Risso and who, in addition to extensive
commercial production, produced a large
number of portraits.

Contemporarily with the Artistic
Mission led by Lebreton, other French
artists were working in Rio de Janeiro.
One such artist was count Charles-
Othon-Jean-Baptiste de Clarac (1777–
1847), who arrived in the capital in 1816.
During his short stay he painted the
Brazilian Forest (Fundação R. C. Maya,
Rio de Janeiro; page 157), considered by
the naturalist, Humboldt, to be the most

faithful representation of the tropics.
One of his compatriots, Claude-Joseph
Barandier (died in São Paulo in 1867)
arrived in Rio around 1840. He became
one of the most sought-after portraitists
of the nobility and high society of the
capital, although he sometimes applied
himself to historical painting also. After
visiting Pernambuco, Bahia and Rio
Grande do Sul, François-René Moreau
(1807–1860), a pupil of Gros, arrived in
Rio in the same period. In addition to
portraits of illustrious Brazilians, he pro-
duced numerous paintings celebrating
Brazil's recent history, as did his brother

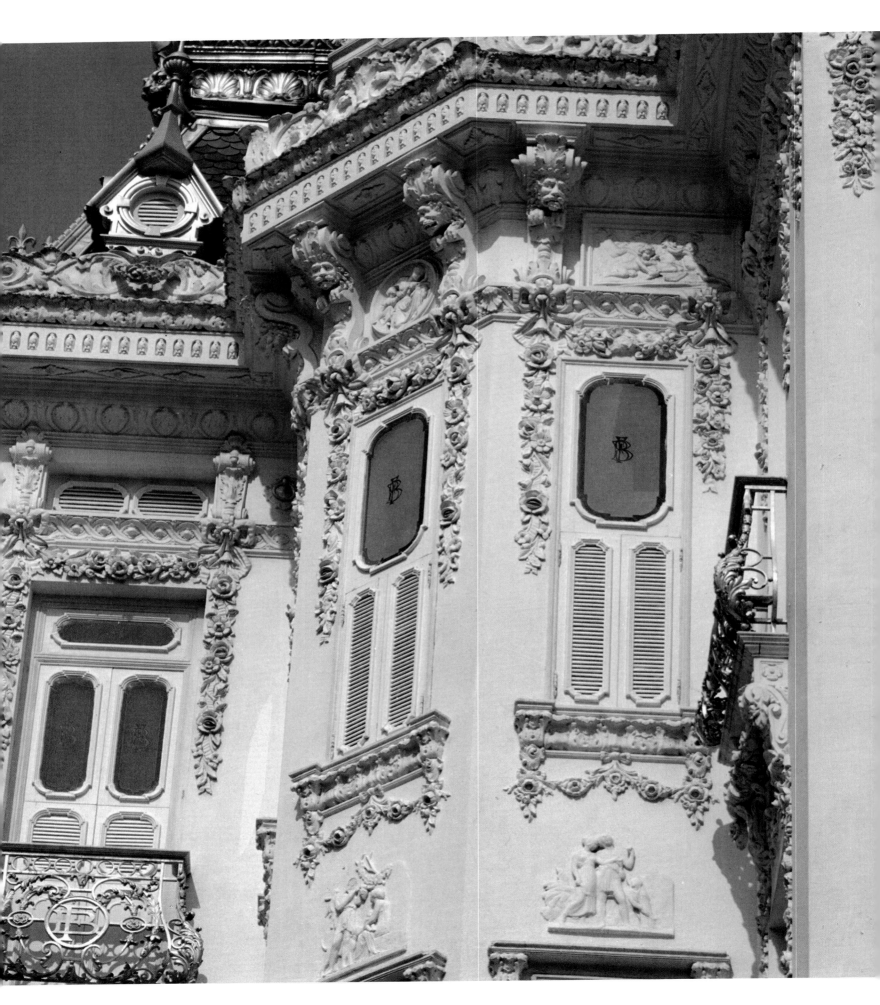

Louis-Auguste Moreau (1818–1877) who also produced lithograph scenes of life in Rio.

Alfred Martinet, a landscape and portrait painter, came to Rio in 1841 and worked as a lithographer (page 157) at Heaton and Rensburg and in the Laemmert printing house. Iluchar Desmons (born in 1803) settled in Rio in 1840 and became famous as a drawing teacher. He was quite a talented landscape artist, and in 1855 he published his album *Panorama of the Town of Rio de Janeiro*, made up of thirteen lithographs taken from original drawings produced in the previous year.

We should also mention the artists Raymond-Auguste Quinsac de Monvoisin (1790–1870) who came to Rio in 1847 and who in his portraits and landscapes always fluctuated between a sober style derived from neoclassicism and romantic inspiration; the landscape painter Henri-Nicolas Vinet (1817–1870), who was a pupil of Corot and came to Brazil around 1850; the portraitists Jean-Baptiste Borély (who died in Minas Gerais) and Auguste Petit (1844–1927), who came to Brazil in 1864 and was the painter of the Court and aristocracy before the proclamation of the republic (1889) and, after that, painted rich merchants, soldiers and clergymen.

Portuguese artists were also active in nineteenth-century Brazil. Joaquim Cândido Guillobel (1787–1859), a colonel in the imperial army, became famous for his small water colors, which he began to produce around 1814, portraying a lively

Rio Negro Residence (detail of the facade) in Manaus, state of Amazonas. Nineteenth to twentieth century.

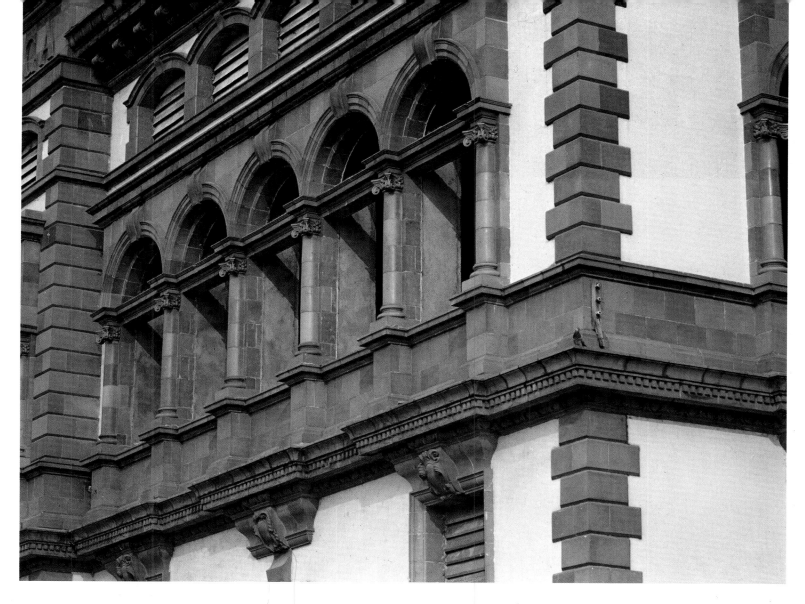

The Customs building (*above*, detail of the facade; *right*, general view), built in England, was transported stone by stone to Manaus and reassembled in 1902.

Left, Rio Negro Residence (general view) in Manaus, state of Amazonas. Nineteenth to twentieth century.

and delightful view of Rio de Janeiro's society at the beginning of the nineteenth century (page 158). Augusto Rodrigues Duarte (1848–1888) arrived in Rio from Portugal as a child and was a pupil of Vítor Meireles at the Academia Imperial. He painted genre scenes, historical paintings and academic-style landscapes. In 1874 he moved to Paris and four years later exhibited his most well-known work, *Atala's Funeral*, at the Exposition Universelle.

In 1817 the Austrian painter, Thomas Ender (1793–1875), came to Brazil in the retinue of Princess Leopoldina. When he returned to Europe the following year he had already produced about 800 drawings and water colors showing everyday scenes and landscapes of Rio de Janeiro, Minas Gerais and São Paulo which reveal a heart-felt sensitivity toward the land of Brazil (page 159). Another Viennese, Franz Joseph Frühbeck (born in 1795) also arrived in Brazil in 1817 and remained for six months producing a series of tempera paintings of the suburbs and main buildings of Rio de Janeiro which on his return to Europe were to serve as models for oil paintings. Pieter Gottfried Bertichen (born in 1796)

Manaus town market, state of
Amazonas, was built in 1882,
perhaps on a design by Gustave
Eiffel. On this page, three
details of the exterior.

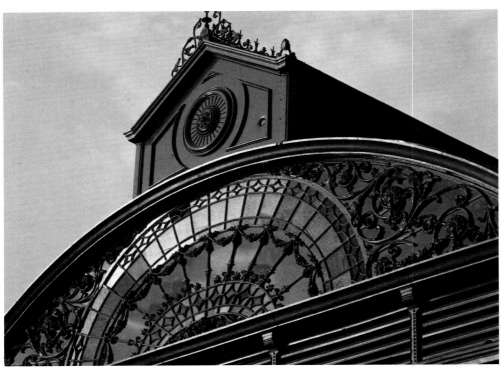

from Holland lived in Rio de Janeiro and
Petrópolis from 1837 to 1856. From 1845
he showed his landscapes at Rio's fine art
exhibitions. He was responsible for the
forty-six illustrations for *O Brasil
Pitoresco e Monumental* (Rio de Janeiro,
1856). Paul Harro-Harring (1798–1879)
from Denmark was a very special figure.
He was sent to Brazil in 1840 by an
antislavery magazine to study the condi-
tion of black slaves in the country. A few
views of Rio and some paintings showing
the life of the African slaves and their
descendants are all that remain of his
short stay. At the end of 1840 the
Swiss landscape painter, Abraham-Louis
Buvelot (1814–1888), also arrived in Rio.
He took part in the exhibitions with
solidly structured works and in 1845,
together with Louis-Auguste Moreau,
produced an album of lithographs show-
ing urban and panoramic views of Rio de
Janèiro.

Johann-Moritz Rugendas (1802–1858),
a descendant of a famous German family
of artists, lived in Brazil between 1821

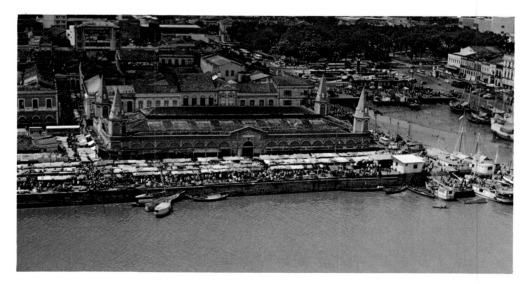

Belém town market, state of Pará. The market was built between the nineteenth and twentieth centuries. A general view (*above*) and two details of the iron structures (*top*), which were imported directly from France. Sudden wealth due to rubber instigated fast construction, with the use of prefabricated elements from abroad.

and 1825 and in 1847 returned to Europe after having visited Chile, Argentina, Peru, Bolivia, Uruguay and Mexico. In his vast production of drawings and water colors he records what he saw during his travels, from landscapes to scenes of everyday life. The 100 lithographs (pages 160–161 and 162–163) that illustrate his *Pictorial Journey through Brazil* (1835) form a sensitive and lively chronicle of the country. Baron Carl Robert of Planitz (1806–1847) settled in Rio de Janeiro in 1831 and as a landscape artist was meticulous in rendering detail but conventional in his approach. In 1840 he published an album in Hamburg entitled *Twelve Views of Rio de Janeiro*.

The painter and draftsman Edward Hildebrandt (1818–1869) spent a few months in Brazil in 1844 with the scientific expedition sponsored by king Frederick William IV. With a lively involvement in his subjects, he portrayed landscapes, human types and the flora and fauna of Rio, São Paulo, Salvador and Recife. In 1867 he published a diary

Amazonas theater in Manaus, state of Amazonas. The theater was opened in 1896. The French architect, Charles Peyroton, who had already built the theater in Rio de Janeiro, was involved in its construction. The exterior decoration of the Amazonas theater (*below*, general view) is the work of the Italian Enrico Mazzolani. The interior is by the Brazilian Crispim do Amaral and the Italian painter Domenico de Angelis. *Right and below right*, the foyer and performance room of the Amazonas theater.

of his journey illustrated with numerous drawings. Another German, Ferdinand Krumholz (1810–1878) had studied in Vienna, Rome and Paris. After having been a court painter in Lisbon (1844–1847) he resided in Rio de Janeiro from 1848 to 1853 where he painted many portraits and genre scenes.

In 1852 the artist Friedrich Hagedorn (1814–1889) came to Brazil for a period that extended until 1865. He painted views of Rio de Janeiro and other Brazilian towns, such as Juiz de Fora, Salvador and Recife, with great sensitivity. Emil Bauch (born in Hamburg in 1828) stopped off initially in the capital of Pernambuco but later moved to Rio de Janeiro, where several times he exhibited landscapes and portraits at the Academia Imperial. From 1869, together with Henri-Nicolas Vinet, he gave landscape painting lessons in his studio. In 1858 the draftsman Heinrich Fleiuss (1823–1882) settled in Rio de Janeiro and opened a printing house there. From 1860 he published *A Semana Ilustrada*, with sketches and caricatures in his own hand, which in 1876 was replaced by *Ilustração Brasileira*, closed down two years later. Fleiuss printed Brazil's first advertising poster and in 1863 set up the first studio where the technique of wood cutting was taught.

Georg Grimm (1846–1887) arrived in Rio in 1874 after his studies at the Berlin academy and extensive journeys around Europe, north Africa and the East. In 1882 he presented over 100 landscapes of all the places he had visited to the Sociedade Propagadora de Belas-Artes and they were such a success that he was given the chair of landscape, flower and animal painting at the Academia Imperial. Two years later he was forced to resign this position because, as a supporter of painting from life, he held his lessons in the open air. Brazil's best landscape artists, however, formed part of his group: Castagneto, Parreiras, Caron, and García y Vásques. His influence remained strong until the beginning of the 1922 modernist movement. Thomas Driendl (1846–1916) assisted Grimm in the decorations for the Liceu

de Artes e Ofícios. He lived in Rio de Janeiro from 1879 and applied himself to genre painting, portraits and decorative frescoes.

A few Italian painters who worked in Brazil include Alessandro Cicarelli (1811–1879) from Naples who painted portraits, military and genre scenes and who stayed in Brazil from 1840 to 1848. Luigi Stallone arrived in Rio in 1843 and in the same year showed five portraits at the academy's exhibition. As a result of his lack of success he moved to the south of the country and applied himself mainly to landscape painting but the bulk of his output has been lost. Nicolò-Antonio Facchinetti from Treviso (1824–1900) arrived in Brazil in 1849, having already completed his training as an artist. Technically excellent and having the meticulous attention of an archivist, he painted landscapes of Mantiqueira, São Tomé das Letras and other areas of Brazil—paintings sensitively rendered by steady lines and a delicate use of color.

Just before the outbreak of the war with Paraguay, Edoardo De Martino (1838–1912), a naval officer originally from Meta, arrived in Brazil. In 1867 he was given the task of recording the action of the Brazilian navy in the battles of Curuzu and Humaitá. During his long stay in Brazil, De Martino, before moving to England as a painter at the court of queen Victoria, painted over 300 seascapes and naval battle scenes.

In 1860 Angelo Agostini from Vercelli (1843–1910) settled in São Paulo and four years later began his activities as a political caricaturist, publishing a few periodicals which were more or less short-lived, such as *O Diablo Coxo* and *O Cabrião*. After moving to Rio de Janeiro he stepped up his production, supplying drawings and caricatures for *Vida Fluminense*, *O Mosquito* and *Revista Ilustrada*, in which from 1884 he published *The Adventures of the Ill-Fated Zé*, considered to be Brazil's first comic-strip story. As a painter, Agostini cultivated landscape and portrait painting, standing out for his skill in the use of colors.

Between 1893 and 1905 a pupil of Domenico Morelli also lived in São Paulo. He was Antonio Ferrigno (born in Salerno in 1863). He concentrated on views of the town and illustrations depicting the work on the coffee plantations. Another of Morelli's pupils,

Beniamino Parlagreco from Sicily (1856–1902), arrived in Brazil in 1895 and performed in all the genres, excelling, however, as a landscape painter.

Pedro II and Academic Painting

Around the mid-nineteenth century, Rio de Janeiro with its 400,000 inhabitants was the most important town of Latin America, considered to be an "opulent capital." Its society was exclusively agricultural, with its wealth based on the cultivation of coffee, which had recently replaced that of sugar cane. The economic prosperity was linked to political stability in that the last rebellion against the empire (in 1848 in Pernambuco) was swiftly stifled and then followed by a general amnesty. These conditions led

the country to a high level of artistic and cultural development. A great personal contribution was made by emperor Pedro II, who came to the throne in 1840 and whose involvement in favor of the arts, literature and sciences was indefatigable.

Meanwhile, the teaching imparted by the Academia de Belas-Artes of Rio de Janeiro was beginning to bear fruit, while continuing to remain faithful to European models. It is understandable that the Brazilian artists who received commissions from a monarch with conservative tastes, and who studied in Europe on scholarships from the academy or the Exposições Gerais de Belas-Artes, very rarely came into contact with the avant-garde artists of the day when in Paris or in the other great cultural centers of the nineteenth century. It is

also true that although the war between Brazil and Paraguay, which lasted from 1864 to 1870, cost thousands of human lives and an enormous amount of money, for Brazilian artists the war offered the pretext for the invention of heroic scenes to the glorification of the empire. This freed them from becoming involved in the everyday reality that was marked by the serious problem of the slavery of the black population, abolished only in 1888, a year before the proclamation of the republic. It was in this cultural climate that the greatest exponents of academic painting worked: Vítor Meireles, Pedro Américo, Zeferino da Costa and Arsênio Cintra da Silva.

Pedro Américo de Figueiredo e Melo, the son of a violinist, was born in Areia in the state of Paraíba in 1843 and died in

Florence in 1905. After his studies at the Academia de Belas-Artes in Rio he was sent by the emperor to train in Europe. From 1859 to 1864 he attended courses held by Ingres, Léon Cogniet, Flandrin and Horace Vernet at the École des Beaux-Arts in Paris. In the French capital he also acquired a scientific, literary and philosophical education which in later life led him to write essays on aesthetics, novels and poetry. As well as France, he visited Italy, England, Holland and Belgium. On his return to Rio de Janeiro he taught historical painting, archaeology, art history and aesthetics at the Academia Imperial. He was elected deputy to the constituent assembly in 1890 and put very worthwhile cultural projects before parliament, such as those relating to the establishment of three universities, the founding of a national fine arts gallery and the law on

copyright. His early works, produced when he was still a pupil at the academy, treat religious subjects. Later Américo applied himself to biblical themes, historical and allegorical subjects (pages 164 and 165) and the large commemorative canvases he was commissioned to paint by the government. His forte, however, was portrait-painting.

Vítor Meireles de Lima was born in 1832 in Desterro (present-day Florianópolis) and died in Rio de Janeiro in 1903. At the Academia Imperial he studied under José Correia de Lima, who had been a pupil of Debret. In 1853, after winning a scholarship, he stayed for a short time in Paris, later traveling to Rome and Venice. He returned to Paris, living there for a few years, and in 1861 successfully showed his *First Mass in Brazil* (Museu Nacional de Belas-Artes, Rio de Janeiro) in the Salon. The following year he came back to Brazil where, still basically linked to the teachings of the French Mission, he applied himself to historical paintings, creating the large, commemorative canvases of Brazil's colonial era (*The Battle of Guararapes*, Museu Nacional de Belas-Artes, Rio de Janeiro; page 167), to rendering the war with Paraguay, biblical subjects and to portraits of court dignitaries (page 166). In his mythological themes and literary subjects, such as *Moema* (Museu de Arte, São Paulo; page 166), taken from a poem by Santa Rita Durão, Meireles shows a romantic sentiment that goes beyond neoclassical arrangements of composition.

João Zeferino da Costa was born in Rio de Janeiro in 1840 and died there in 1915. He was a pupil of Vítor Meireles at the Academia Imperial de Belas-Artes. After winning a scholarship to Europe, he attended the Accademia di San Luca in Rome for two years, winning first prize for historical painting in 1871. In 1877 he returned to Brazil where he took over the chair of historical painting at the academy from Meireles and gave lessons in landscape painting and drawing. In 1878 Pedro II commissioned him to produce the paintings for the Church of Nossa Senhora da Candelária. In six large panels, intended for the central nave, Zeferino da Costa told the story of commander Antônio Martins de Palma who, taken by surprise in the high seas by a violent storm, promised to erect a church to Our Lady of Candlemas on the land where he would come ashore. The dome, apse, chancel and consistory were

Below, Rodolfo Amoedo (1857–1941), *Girl in Vermilion*. Water color on paper, 12.59″ × 9.44″ (32 cm × 24 cm). Museu Nacional de Belas-Artes, Rio de Janeiro.

also decorated by Zeferino da Costa, who worked there for three years with the help of some of his pupils such as Castagneto and Oscar Pereira da Silva. Specializing in genre and biblical subjects, Zeferino da Costa had a great influence on Brazilian painting through his activities as a teacher since, by adopting methods more modern than those used in the academy, he encouraged his pupils to paint from life, both for the human figure and for landscapes.

Arsênio Cintra da Silva (1833–1883), from Recife, spent three years in Europe, between Paris and Rome, where he learned to paint using tempera, a technique he appears to have introduced to Brazil. In 1861 he settled in Rio de Janeiro, becoming famous in high society for his tempera paintings done in Europe which generally portrayed picturesque scenes and Arab subjects. In landscape painting, Cintra da Silva was one of the precursors of the *en plein air* practice, but his early success was soon replaced by an atmosphere of envy in artistic circles which embittered the painter, causing him to become a recluse in the later years of his life. In addition to having a bucolic tendency, his works show a study of aerial perspective painting and a poetic spirit that distances him from the conventional styles of his day.

Coffee, Rubber and Eclecticism

Only after 1825 did the state of São Paulo become accustomed to wealth engendered by the cultivation of coffee, which after 1850 spread to the entire Paraíba valley and the Campinas area, where the new plantations sprang up alongside those of the sugar cane.

The town of São Paulo entered into a phase of development only after 1867 when English engineers, called in by the viscount of Mauá, built the railway from Santos to Jundiaí. Since São Paulo could make use of the benefits derived from the cultivation of coffee only fifty years after the advent of neoclassicism in Rio de Janeiro it was virtually ignorant of the style of architecture which characterized the imperial Court, passing from the rural *taipa* to eclectic-style brick buildings.

At the end of the eighteenth century, after the mines were exhausted, most of the population of Minas Gerais settled on the border of the São Paulo area, spreading their own style of architecture. The compact structure of the São Paulo house, erected on leveled ground, was replaced by the typical Minas house, built on sloping ground which made it possible to erect two-story buildings with direct access from the outside. This was

the typical structure of the dwellings in coffee plantations.

They were not isolated constructions, however, since they were part of one large complex which included—apart from the large terraces used to dry the coffee—buildings for equipment, workshops and stores which were nearly always situated on either side of the proprietor's residence. Thus a large courtyard was formed whose entrance, completed by a *taipa* wall, was decorated by a high portal. The courtyard was used for all the everyday activities and, on holidays, for the dances of the slaves, whose quarters were nearby although clearly separated from the main complex. Of course, there were a few exceptions to this layout, one of which is the São Paulo coffee plantation residence of the second half of the nineteenth century.

In the state of Rio de Janeiro, in the Vassouras area and in the Bananal region more rational buildings were implemented to bring an improvement in the cultivation of the coffee. Usually, however, individual choices in the organization of space prevailed and the neoclassical style was adopted for proprietors' residences.

None of these villas in the middle course of the Paraíba represents the spirit of São Paulo architecture. They are of stone, brick and *taipa de mão* which do not belong to the culture of the

bandeirantes. The use of *taipa de pilão* did not spread easily beyond the town of Areias, a meeting point for São Paulo coffee growers and growers from Minas Gerais and the state of Rio de Janeiro.

In this period the plan of the typical rural dwelling, situated on a hillside, was developed. In the front part of the house there were two large drawing rooms separated by a corridor which led to the rear, where there was the family living room with a large dining table in the middle. Between the living and the drawing rooms were the bedrooms. Guest bedrooms were reached through the drawing rooms, whereas the family's bedrooms communicated with the living room. The kitchen and servants' quarters were in a side wing, within the body of the building. Unlike the sugarcane growers of Nordeste, the owners of the coffee plantations were always towns people who had other occupations in addition to their agricultural one. They were often politicians, bankers, journalists and industrialists. Their town houses were constantly being refurbished since, as the owners spent most of their time in them, they had to reflect the owner's financial power. The coffee growers, by calling in foreign architects to build their luxurious residences, introduced eclecticism to Brazil.

The term eclecticism in architecture refers first to the coexistence of neo-classicism with neogothicism and, second, to the adoption of varied old or exotic styles and the mingling of their elements. In Brazil, eclecticism took on an erudite and a popular aspect: the former in buildings designed by foreign architects, since Brazilian architects almost always perpetuated the neoclassical tradition of the Rio school of Grandjean de Montigny; the latter in buildings erected by builders who adapted the facades to suit the style of the day, leaving the internal structure unchanged, however.

The São Paulo owners were the first to possess luxurious residences in town. Some had elegant multi-story villas built according to the canons of traditional architecture, such as at São Luís do Paraitinga, which is an example of formal unity and architectonic coherence. Others, demonstrating that they were up to date with foreign trends and making a show of their individualism, which set them apart from the still "uncultured" atmosphere of the towns, made arrangements to call in architects from abroad or brought back plans of famous architects from their travels. The towns of the Paraíba valley, Campinas and, later, São Paulo had buildings that were decorated with refinement, adopting a neoclassical and neorenaissance style. It was not, however, the serene, composed neoclassicism of the Napoleonic era, spread by the French Mission, but a more exuberant style, rich in decoration, with stucco reliefs imported from abroad, vases and statues of Oporto porcelain, huge windows and elaborately worked wrought iron from France and Belgium. Initially some growers tried to retain the traditional *taipa*, as a sign of refusal of the immigrants' techniques, but as *taipa* made it impossible to decorate the buildings, they adopted the solution of covering the outside walls with bricks to serve as a support for the ornaments and reliefs.

While the ruling class was building its rich and "erudite" houses, ordinary people went along with the innovative movement as far as they were able, using new building materials, mainly brick and rectangular tiles.

The mixture of styles and, above all the inventiveness and imagination of the builders characterized those Brazilian

Eliseu Visconti, ceiling of the Teatro
Municipal in Rio de Janeiro, painted
between 1905 and 1908.

Top left, Henrique Alvim Correia (1876–1910): *Nude with a Hat and Stockings*; drawing, 10.23″ × 8.26″ (26 cm × 21 cm); Museu Nacional de Belas-Artes, Rio de Janeiro; *top right* and *above*, drawings by Correia with social and moral themes.

towns transformed by the wealth produced by coffee and a growing industry and by the new cultural climate that had taken hold with the proclamation of the republic in 1889. Rio de Janeiro, capital of the new federal state, suddenly experienced eclectic architecture and was fundamentally reorganized. After the abolition of slavery, the new republic, which had entered into an industrial phase, was forced to accept massive immigration, which meant the introduction of new customs and different cultures bringing basic changes to architectural layouts and the urban structure. With the increase in population in the towns and the formation of a working class, all the problems of a typical modern town were born.

Following the example of Buenos Aires, which had become a large European-type metropolis at the beginning of the twentieth century, President Rodrigues Alves implemented drastic measures in the urban reorganization of Rio de Janeiro. These included its expansion, the construction of a new port with modern installations and the opening of the Avenida Central (present-day Avenida Rio Branco), the nerve center of

the town. All the buildings along this road were built at the same height but in varied styles chosen on the basis of a public competition which, however, was restricted only to the facades, leaving the owners to choose the plans for the interior.

Another Brazilian capital which suddenly had to meet the new demands of progress was Ouro Prêto. The old Vila Rica, in fact, never became a real modern town due to the impossibility of making the necessary improvements. It remained a group of mining villages which, with time, spread out and joined together. Therefore, a decision was made to build a new capital in a place that had more suitable topographical and climatic conditions. For this, the district of Sabará was chosen, near Belo Horizonte. It was only with the advent of the republic that the project was put into practice with the creation of a commission presided over by the engineer Aarão Reis.

The plan of the new capital was designed by merely establishing the main roads, without taking into consideration the topographical position in its entirety. The arrangement of the main roads was determined by two superimposed check-ered grids, one for the roads and one for tree-lined avenues which diagonally crossed the squares formed by the roads. Finally, all the streets were enclosed within a large ring road, the Avenido do Contorno. Inaugurated in 1897, Belo Horizonte was a town built entirely of eclectic buildings.

At the beginning of the new century even the towns of northern Amazonas were changed to suit the new eclectic style, as a result of the sudden wealth brought by the new rubber plantations. The rich proprietors of the region had not only the plans for their residences sent from abroad, but also the entire buildings themselves, from English bricks to Belgian lamps and French furniture, in a display of luxury which lasted for only about twenty years, until the appearance of Asian rubber on the international market. Manaus and Belém still preserve residences and public buildings (pages 168–169 and 170–171) that bear witness to this ephemeral splendor.

On occasion, the ambition to build quickly led the public administration to order prefabricated buildings with iron structural elements. Such buildings still exist: Belém's markets (page 173) and the market in Manaus (page 172) which seems to have been designed by the engineer Eiffel and is outstanding for its elegant iron decorations.

Similarly important are the theaters of the two capitals. The theater in Belém has a neoclassical exterior, while Manaus's theater (opened in 1896) is more pretentious in its exuberant decorations; in fact, it is eclectic in its interior and its exterior due to the enormous variety of styles (pages 174–175). The Frenchman, Charles Peyroton, worked there. He had already created the theater in Rio de Janeiro and was also to work in Belo Horizonte and the Paraíba Valley in the service of the coffee growers.

The presence of art nouveau in Brazilian architecture was only slightly felt and merely inspired a few facade decorations without making its mark on the interior structures of buildings. In Rio de Janeiro we should mention the Eiffel Tower shops, designed by an architect of Spanish origin, Adolfo Morales de los Rios (1858–1928). From 1891 the Frenchman, Victor Dubugras (1868–1933), worked in São Paulo, as did the Swede, Carlos Ekman (born in 1866), who was responsible for the Vila

Penteado, which was built in 1903 with extremely elegant art nouveau decorations and is now the Facultade de Arquitetura e Urbanismo.

At the time of the first World War, the later expression of eclecticism had spread in the form of the neocolonial style, as had similar tendencies that had developed in other South American states. Its main exponent was the Portuguese architect, exiled from Portugal for political reasons, Ricardo Severo, who worked in São Paulo with the builder, Ramos de Azevedo, in designing numerous residences and dwellings. Dubugras also followed the new style in rebuilding the Largo da Memoria and in the buildings of the Caminho do Mar.

The Belle Époque: The Art Nouveau Period

Brazil's Belle Époque is usually considered to have taken place between 1889, when the republic was proclaimed, and 1922, the year the Semana de Arte Moderna was founded in São Paulo. It would be impossible to understand the developments of painting in these years in Brazil without bearing in mind its close links with French art. In the second half of the nineteenth century, French art had a great influence on painters and sculptors all over the world through the five large international exhibitions held in Paris. The first was in 1855 and consecrated Delacroix and romanticism, to which Courbet's *Pavillon du Réalisme* was opposed; the second, in 1867, sanctioned Courbet's affirmation and rejected Manet's works; the third, in 1878, marked the beginning of the success of the impressionists; the 1889 exhibition was a triumph for the symbolists and finally the 1900 exhibition represented the climax of art nouveau. Brazilian painters were present at the last three exhibitions. Augusto Rodrigues Duarte attended the 1878 exhibition, in 1889 Henrique Bernardelli won the bronze medal and Manuel Teixeira da Rocha the gold, and in 1900 Pedro Américo, Pedro Weingartner and Eliseu Visconti, who won a silver medal, exhibited their works. The prizes did not always correspond to the merits of the artists since, at the exhibitions, which were designed as huge fairs for French industry and trade with the declared aim of winning new markets, almost as many medals were handed out as there were exhibitors.

However, by taking part in the exhibitions or simply visiting them (in 1878 Décio Vilares was in Paris, in 1889, Belmiro de Almeida and in 1900, Pedro Alexandrino) artists from various countries could become acquainted with the latest trends, which they often decided to follow. It was in this way that realism, impressionism, symbolism, pointillism and art nouveau became widespread in the Americas and, specifically, Brazil.

After 1860 and until the beginning of the twentieth century, firstly in France and then throughout the western world, a special genre of painting asserted itself, namely bourgeois realism. Completely estranged from the social needs of Courbet's realism, bourgeois realism kept aloof from the renewal in painting, reflecting the artistic preferences of the bourgeoisie during the years of its greatest triumphs. An analysis of the Belle Époque shows that it should be referred to only one class, the bourgeoisie, and that only in relation to this class does it acquire any meaning. Bourgeois realism is a much more accurate and sociologically valid reflection of the ruling class than impressionism, symbolism or the other avant-garde movements of the day.

Aurélio de Figueiredo (1856–1916), *Interior*,
1891. Oil on canvas, 50″ × 26.77″
(127 cm × 68 cm). Agnaldo de Oliveira
Collection, São Paulo.

In comparison to the trends preceding
it, bourgeois realism represents a retro-
grade step, in that its exponents seek to
go back to the old tradition, considering
themselves to be the heirs and guardians
of the past. For this reason, they attach a
great deal of importance to technique, to
clear-cut virtuoso drawing. As regards
content, portraits and religious and alle-
gorical subjects are invariably rendered
in a bourgeois spirit, while realistic forms
show ideal situations in which the aspi-
rations and fears, triumphs and dis-
appointments of the ruling class are
reflected. The aesthetics of bourgeois
realism therefore lie in a moral philo-
sophy to which the painters subordinate
themselves, and although some of its
exponents are talented painters, the style
is in fact empty with its facile appeal to
sentimentalism and eroticism and often
falls into mere rhetoric.

In the early years of the twentieth
century, some Brazilian painters turned
their attention toward impressionism and
pointillism and, in spite of seemingly
lagging behind France, where cubism
was already under way, they still re-
presented a significant step forward from
the cold formalism previously practiced
in Brazil. Around 1900, both symbolism
and art nouveau were welcomed by
various artists such as Visconti, Amoedo
and Latour, but four years later there
were many painters who drew inspiration
from impressionism, even though their
knowledge of it was imprecise. On the
other hand, the divisionist elements
adopted by Visconti for the decoration of
the foyer in the Teatro Municipal in Rio
de Janeiro (begun in 1913) were con-
sidered bizarre and extravangant.

Some painters of the Belle Époque are
hailed as some of Brazil's most important
painters. One such artist is José Ferraz
de Almeida Júnior (1850–1899) who was
the pupil of Vítor Meireles at the
Academia de Belas-Artes in Rio de
Janeiro, and later, from 1876 to 1882,
studied under Cabanel in Paris. When he
returned to Brazil, he exhibited some of
his European paintings, such as *The
Model's Rest* (Agnaldo de Oliveira Col-
lection; page 176), in Rio de Janeiro, and
he later settled in Itu, going away only in
1897 for a second sojourn in Paris. In his
works—historical pictures, religious and
genre paintings (page 177), portraits
and landscapes—his full-bodied, sensual
brush strokes bring to mind those of
Courbet, becoming more luminous in the

Henrique Cavaleiro (1892–1975), *La Parisienne*, 1920. Oil on canvas, 25.59″ × 21.25″ (65 cm × 54 cm). Agnaldo de Oliveira Collection, São Paulo.

Leopoldo Gotuzzo (born in 1887), *Entrance to My Garden*. Oil on canvas, 28.34″ × 26.37″ (72 cm × 67 cm). Museu Nacional de Belas-Artes, Rio de Janeiro.

canvases with Brazilian themes.

Jerônimo José Teles Júnior (1851–1914) was another painter of the Belle Époque. He originally came from Recife and kept away from any school or artistic trend, practicing his landscape painting as an amateur after having attended lessons given by Agostinho José da Mota in Rio de Janeiro and knowing Edoardo De Martino in Porto Alegre. His paintings—stirring interpretations of the Nordeste landscape—were at first timid and meticulous but, toward the end, reflected a painstaking style emphasized by brightness of color.

Despite his academic training, Décio Rodrigues Vilares (1851–1931) from Rio, who studied with Cabanel in Paris from 1872 and then perfected his work in Florence with Pedro Américo, often painted faces and profiles of women in sensitive and modern tones, which make him one of the most genuinely Brazilian representatives of the Belle Époque. These are superb figures of women, drawn with a firm hand and showing extreme elegance, the colors blending together in delicate tones. Décio Vilares was also a sculptor and caricaturist; he joined the positivist circle in Paris and produced various works, most of which have been lost, on the main themes of the movement.

From 1878, Pedro Weingartner (1853–1929), the son of German immigrants who had settled in Porto Alegre, studied in Hamburg and Karlsruhe, Germany. In 1882 he moved to Paris where he was a pupil of Tony Robert-Fleury and Bouguereau. In 1885 he went to Rome where he began the most important stage of his activity with genre paintings or paintings inspired by ancient Rome, later followed by works that illustrated the lives of the herdsmen of the Rio Grande do Sul plain. Weingartner lived in Rome until 1920 but made several trips to Brazil to paint landscapes, scenes of everyday life and portraits in the interior of Rio Grande, always remaining indifferent to the avant-garde movements that were gaining a foothold in Europe. His most successful work was *La Faiseuse d'Anges* (Pinacoteca do Estado, São Paulo; pages 180–181), painted in 1908 in Rome according to the canons of Wilhelm Leibl's German realism.

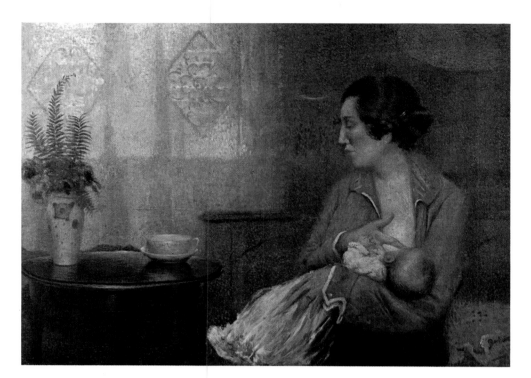

Rodolfo Amoedo (1857–1941) from Salvador was a pupil of Vítor Meireles in Rio de Janeiro and studied in Paris from 1879 to 1887, first attending the Académie Julian and then receiving lessons from Cabanel and Puvis de Chavannes at the École des Beaux-Arts. On his return to Brazil he was appointed teacher of painting at the academy in Rio and later painted many decorative works in the capital. Amoedo, an eclectic painter, who in his large genre canvases passed indifferently from romanticism to Puvis-style realism to presymbolism, showed himself to be more sensitive and personal in his small sketches and his oil or water color studies (pages 180 and 181).

Originally from Minas Gerais, Belmiro Barbosa de Almeida (1858–1935) had Agostinho José da Mota and Zeferino da Costa as teachers in Rio de Janeiro. After a short stay in Rome, he lived partly in Rio de Janeiro and partly in Paris, establishing himself initially with genre paintings such as *Low Spirits* (1887, Museu Nacional de Belas-Artes, Rio de Janeiro) and portraits of youths and women from refined circles. Finally settling in Paris after the first World War, de Almeida did not remain indifferent to avant-garde movements and in the last years of his life became interested in futurism.

Henrique Bernardelli (1858–1936) was born in Chile of a family of artists, and was brother of the sculptor Rodolfo and the painter and violinist Félix. He trained in Rome under Domenico Morelli after his studies in the Academia de Belas-Artes under Zeferino da Costa, Vítor Meireles and Agostinho José da Mota. On his return to Rio de Janeiro in 1886, he exhibited a group of works treating popular subjects in the Morellian style. The works were not understood by the public and critics, so the artist adopted a more conservative style, falling into mannerism. Bernardelli painted historical and genre paintings, portraits and landscapes and painted the decorations for the Teatro Municipal in Rio de Janeiro, the Museu Paulista and the Museu Nacional de Belas-Artes.

A landscape artist and painter of historical works and nudes, Antônio Diego da Silva Parreiras (1869–1937) trained in the Academia de Belas-Artes under Georg Grimm. In 1888 Parreiras moved to Italy, where he attended the Accademia in Venice, and then visited other European countries. In Brazil and France he soon became popular for his numerous paintings on Brazilian history, such as the *Conquest of Amazonas*, produced for the state of Pará, and *Zumbi* (page 179), and for his female nudes such as *Iracema* and *Brazilian Flower* (page 178), which were most popular among the Parisian public.

The Italian, João Batista Castagneto (1862–1900) who came to Brazil in 1875, attended lessons given by Georg Grimm and later, from 1891 to 1894, lived in Toulon. Most of his works were seascapes, although he sometimes painted landscapes and interiors, adopting an almost impressionistic style which likened him to Eugène Boudin.

Pedro Alexandrino Borges (1864–1942) from São Paulo was a painter of still lifes, a genre rarely practiced in Brazil. He trained at the Academia de Belas-Artes and, after completing his studies with de Almeida Júnior, went to Paris from 1897 to 1906 and studied under Cormon, Chrétien and Antoine Vollon.

João Batista da Costa (1865–1926) studied at the Academia de Belas-Artes with Zeferino da Costa and Rodolfo Amoedo. In 1894 he won the scholarship to Europe and in Paris studied under Tony Robert-Fleury and Jules Lefebvre. He then spent some time in Germany and Capri.

Eliseu D'Angelo Visconti (1866–

Gustavo dall'Ara (1865–1923), *Group of Houses in Santa Teresa*. Oil on canvas, 15.35″ × 23.62″ (39 cm × 60 cm). Agnaldo de Oliveira collection, São Paulo.

1944), born in Italy in Giffoni Valle Piana in the province of Salerno, arrived in Brazil with his family when he was less than a year old. He gave up his musical studies in 1884 and enrolled at the Liceu de Artes e Ofícios in Rio and then at the Academia de Belas-Artes, winning a European scholarship in 1892. In Paris he attended the École des Beaux-Arts and took lessons on decorative art given by Eugène Grasset at the École Guérin. After a brief return to Rio in 1901, during which he successfully organized the first exhibition of his own works, from 1902 to 1918 he lived alternately in the Brazilian and French capitals. Commissioned by the prefect of Rio, Pereira Passos, between 1905 and 1908, in his Paris studio Visconti painted the drop-scene, circular ceiling panel and proscenium of the Teatro Municipal in Rio (pages 184 and 185), for which he was also to paint, between 1913 and 1916, the decorative works in the foyer and, between 1934 and 1936, a new frieze for the proscenium. In the years between 1923 and 1926 he produced a series of decorations for the Conselho Municipal and the Tiradentes building, which, however, do not have the same division-ist lightness as do the works for the theater foyer. A figure painter, creator of genre scenes and landscapes, and deco-rator, Visconti was not very prolific and his works can be divided into six periods. The years between 1888 and 1897 pro-duced his first landscapes, his academic works and those done during his first stay in Europe; between 1898 and 1908 Visconti produced the landscapes in the Jardin du Luxembourg in Paris, sym-bolist paintings such as *Youth* (1898, Museu Nacional de Belas-Artes, Rio de Janeiro; page 183) and impressionist-influenced compositions; from 1909 and 1912 Visconti went through a transition phase characterized by the accentuated realism of his figure compositions and by the bright colors in his landscapes (page 182); his Saint-Hubert impressionist landscapes date from 1913 to 1919 as do his divisionist works such as the foyer of the theater in Rio; between 1920 and 1930, finally returning to Brazil, the artist produced works with a clear flavor of realism; between 1931 and 1944 he shows a return to the impressionist style in the Teresópolis landscapes and in paintings such as *Laundry* (Agnaldo de Oliveira collection).

We should also mention Eugênio Latour (1874–1942), a painter of land-scapes and figure compositions of a symbolist style, who was one of those who decorated the Brazilian pavilion at the 1911 Turin International Exposition;

Francisco Sant'Olalla (1870–1895): *above, Vale do Paraíba Farm;* 13.77″ × 21.65″ (35 cm × 55 cm); private collection; *right, A Quiet Read;* oil on canvas, 12.59″ × 9.84″ (32 cm × 25 cm); Agnaldo de Oliveira collection, Rio de Janeiro.

Lucílio de Albuquerque (1877–1939), who practiced all genres of painting, taking inspiration from both impressionism and symbolism; and his wife, Georgina de Albuquerque (1885–1962) who during her long activity remained faithful to impressionism, of which she was one of the first exponents in Brazil.

The work of Henrique Alvim Correia (1876–1910) was very unusual. He traveled between Lisbon, Paris and Brussels and in both his paintings and his carvings adopted an imaginative style, with marked satirical tones for his scenes with social and moral themes (page 186).

Hélios Aristides Seelinger (1878–1965) was influenced by Germanic idealism. He was a pupil of Franz von Stuck in Munich until 1900 and painted frescoes and symbolic and allegorical scenes. Rodolfo Chambelland (1879–1967), one of the decorators of the Brazilian pavilion

at the Turin Exposition, often adopted the divisionist technique in his portraits and genre scenes. Another of the Turin pavilion decorators, Artur Timóteo da Costa (1882–1923), can be considered one of the precursors of modern art in Brazil (page 187).

Henrique Campos Cavaleiro (1892–1975) was also sensitive to European avant-garde movements. After the first World War he moved to Paris, where he remained until 1924. After an initial divisionist period, he drew inspiration from Cézanne and cubism (page 190).

We should remember Francisco Aurélio de Figueiredo e Melo (1856–1916) who painted late-romanticist pictures (page 189); Oscar Pereira da Silva (1867–1939) who painted historical works, portraits, genre scenes (page 188), still lifes and academic-style landscapes; da Silva's pupil Dario Vilares Barbosa

(1880–1952), a genre (page 188) and landscape painter; Leopoldo Gotuzzo (born in 1887) who completed his studies in Italy in 1909 and painted nudes, still lifes and landscapes (page 190); Galdino Guttmann Bicho (1888–1955), who produced his best works at the beginning of his career with portraits (page 191) and divisionist landscapes; Antônio Garcia Bento (1897–1929), who painted seascapes using a spatula, thus achieving an impressionistic effect (page 191); the Spaniard Francisco García Sant'Olalla (1870–1895), who came to Brazil in the last year of his life and painted landscapes (page 193) and urban scenes there; and Gustavo dall'Ara (1865–1923), a Venetian landscape painter (page 192) and caricaturist who settled in Brazil in 1889.

The Modern Revolution

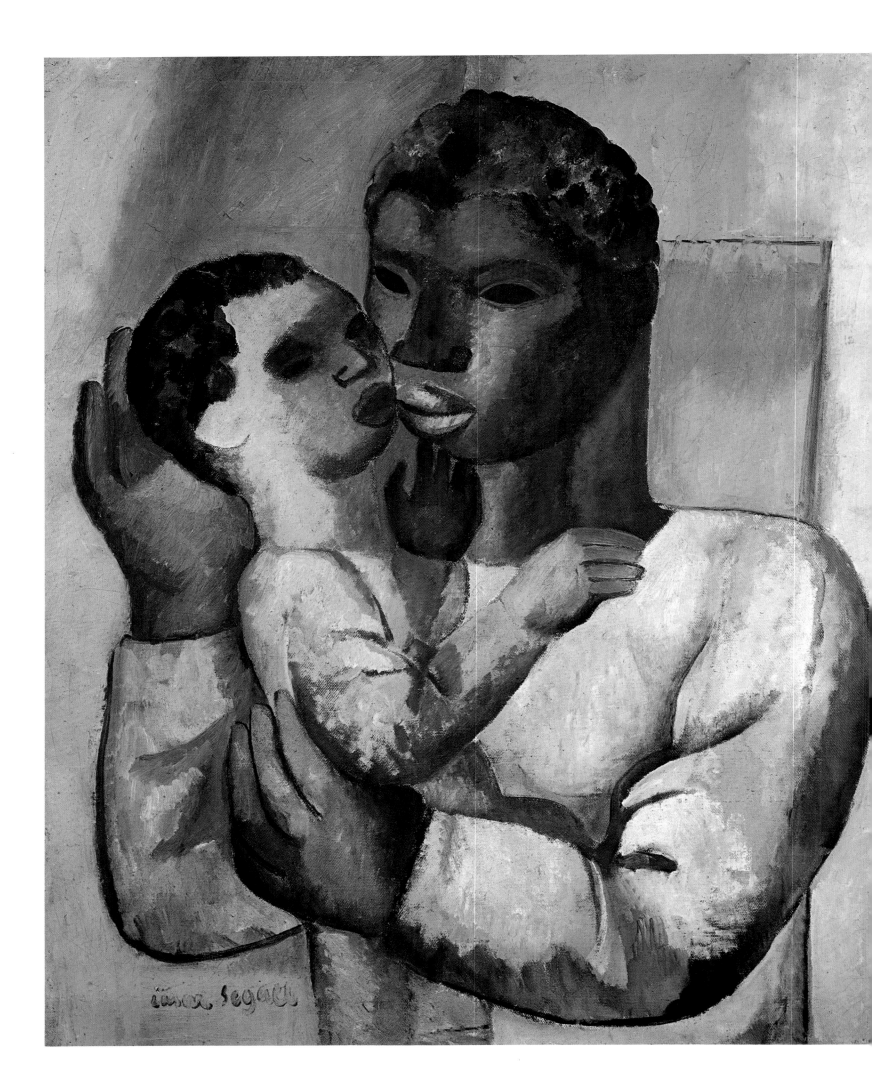

The Modern Revolution

Lasar Segall, Anita Malfatti, Vítor Brecheret and the Semana de Arte Moderna

Within the field of visual arts three isolated events brought on the 1922 Semana de Arte Moderna in São Paulo: the exhibitions by Lasar Segall in São Paulo and in Campinas in 1913, the one by Anita Malfatti in December 1917 and the 1920 discovery, by a group of artists and intellectuals, of the sculptor Brecheret. These events paved the way for modernism, which represents the point of fundamental renewal in Brazilian art.

The first of the three above-mentioned important artists, Lasar Segall (1891–1957), was a painter, sculptor, draftsman and engraver. He began his apprenticeship in his home town, Vilna, Lithuania, and went to the Berlin academy from 1907 to 1909, the year when he was expelled for having taken part in the Freie Sezession, an exhibition by artists who were against official aesthetics. In 1910 he moved to Dresden as a student teacher at the academy and organized the first exhibition of his own material, showing works deeply influenced by the impressionist style of Max Liebermann. The following year he became interested in expressionism, and then made a trip to Holland. In 1913 he came to Brazil, exhibiting his works in São Paulo and Campinas. He returned to Germany and at the outbreak of the war was interned in a concentration camp, as he was a Russian citizen. In 1923 he settled in São Paulo and the following year held another personal exhibition, in addition to decorating the Pavilhão de Arte Moderna by Olívia Guedes Penteado. In 1925 he married one of his pupils, Jenny Klabin, later taking Brazilian nationality, and began painting themes linked to his new

197

Lasar Segall (1891–1957), *The Street of
Prostitutes,* 1956. Oil, 45.27″ × 56.29″
(115 cm × 143 cm). Museu Lasar Segall, São
Paulo.

country: mulattoes with their children in
their arms (page 196), sailors and prosti-
tutes, *favelas* (the groups of ramshackle
huts built in the foothills) and banana
trees (page 197). In 1929 Segall began to
sculpt in wood, stone and plaster those
same suffering, solitary figures that he
had already rendered in his paintings,

drawings and engravings.

In 1932, after an exhibition in Paris,
Segall, together with other artists, found-
ed SPAM (Sociedade Pró-Arte Moderna)
of which he was the true protagonist. He
produced two of his most important
series of paintings in 1935—the Campos
do Jordão landscapes and the *Portraits*

of Lucy (his young pupil Lucy Citti
Ferreira). Those series reflect a period of
serene lyricism before his paintings on
social themes, embarked upon in 1936,
which foreshadow the imminent world
war, massacres (page 199) and genocide.
An exhibition organized in 1943 at the
Museu Nacional de Belas-Artes in Rio de

Janeiro, not without it being disputed by academic painters and traditionalists, finally established Segall as one of Brazil's major artists.

Lasar Segall was a typically expressionist artist with a European technique and temperament, who had become truly Brazilian, as evidenced by the way in which he interpreted the life and landscape of his new country. He was never more sincere than when he portrayed the underprivileged and oppressed and in his great works with social overtones he echoed the Goya of the *Desastres de la Guerra* or the Picasso of *Guernica*.

In 1912, Anita Catarina Malfatti (1896–1964) from São Paulo, after her early studies with her mother, who was an amateur painter, went to Germany to attend the Berlin academy, where she was a pupil of Lovis Corinth. A short trip to southern Germany to see an exhibition by French impressionists and post-impressionists was followed by a stay in Paris before she returned to Brazil in 1914. Anita Malfatti held the first exhibition of her own works in São Paulo and then left for New York where she attended courses given by Homer Boss and met Juan Gris, Marcel Duchamp, Isadora Duncan, Leon Bakst, Gorki and Diaghilev, who introduced the young Brazilian girl to cubism. On her return to São Paulo in 1917, Anita, urged on by her friends, put on another exhibition. Her works met with fierce criticism from Monteiro Lobato who, although on the one hand drummed up the support of all the young artists and writers for Anita, on the other made her lose confidence in her ability and prevented her from developing her own style coherently in the years that followed (pages 200 and 201).

Vítor Brecheret (1894–1955) attended the Liceu de Artes e Ofícios in São Paulo in 1912 but the following year left for Europe, thanks to his uncle and aunt who, believing in his talent, gave all their savings to him so that he could finish his studies in sculpture. At that time Brecheret was much influenced by sculptors like Bourdelle, Mestrovic and Rodin. When the latter died, Brecheret went to Paris solely to attend his funeral. Brecheret returned to São Paulo in 1919 and with the help of an architect, Ramos de Azevedo, acquired a studio in the Palácio das Indústrias, which was still in the process of being built. He worked there for a few months in total seclusion

before he was discovered at the beginning of 1920 by Di Cavalcanti, Seelinger, Menotti del Picchia and Oswald de Andrade. On June 27, 1920, in the Byington building in São Paulo, Brecheret exhibited his model for the *Monument to the Bandeiras*, which he was intending to enter for the competition suggested by Washington Luíz, to pay homage to the *bandeirantes* era. Despite praise received from Luís and its success with a public able to appreciate a piece of modern art firmly anchored to tradition,

the monument was not created because the idea of the competition was abandoned. Only in 1936, on the instigation of Armando de Sales Oliveira, could Brecheret begin the work (37 figures sculpted from a granite block 164.04′ (50 m) long, 52.49′ (16 m) wide, 32.80′ (10 m) high), which was unveiled on January 25, 1953 in Ibirapuera Park in São Paulo (page 203). In April 1921 in the Byington building, Brecheret showed his work, *Eva*, whose plaster cast had been exhibited in Rome in 1919. It was

immediately bought by the São Paulo prefect and earned the artist an award from the government for a trip to Europe. Before he departed, Brecheret left 12 works for the São Paulo Semana de Arte Moderna. A few months after his arrival in Paris he won a prize at the Salon d'Automne for his *Temple of My Race*.

Brecheret was again awarded a prize at the Salon d'Automne in 1923 for his *Burial*, and he later exhibited at the same salon in 1924 (*Perfume Bearer*; page 202), in 1925 (*Dancer*) and 1926, also taking part in the Salon de la Société des Artistes Français in 1925 and the Salon des Indépendants in 1929, with *After Bathing* and *Flight into Egypt*.

A founding member of SPAM in 1932, the sculptor held his own exhibitions in various towns. Influenced by art deco after his early interest in French sculpture, Brecheret moved from gigantic monumental forms to delicate small marbles and little bronzes, always standing out for his search for a clean linear form. In the last years of his life he discovered Brazilian native art and produced a series of statues of Indians and animals.

An advertisement in the *Correio Paulistano* newspaper on January 29, 1922 announced the setting up of a Semana de Arte in the Teatro Municipal of São Paulo between February 11 and 18. Graça Aranha, one of the intellectuals organizing the Semana, declared that he intended to offer the public of São Paulo "a perfect demonstration of the best that exists among us in sculpture, architecture, music and literature from a strictly current point of view." The organizational committee included Paulo Prado, Alfredo Pujol, René Thiollier and José Carlos Macedo Soares. Among the participants whose presence was announced were musicians such as Villa-Lobos, Guiomar Novais, Ernani Braga and Frutuoso Viana; writers like Mário de Andrade, Ronald de Carvalho, Alvaro Moreira, Oswald de Andrade, Menotti del Picchia, Renato de Almeida, Ribeiro Couto, Sérgio Milliet, Guilherme de Almeida and Plínio Salgado; artists like Vítor Brecheret, Wilhelm Haarberg, Anita Malfatti, Di Cavalcanti, Ferrignac, Zina Aita, Osvaldo Goeldi, Regina Graz and John Graz, and the architects Antônio Moya and Georg Przyrembel.

It is likely that the Semana was born from an idea of Di Cavalcanti and a suggestion by Marinette Prado, later

Below, Vítor Brecheret (1894–1955), *Daisy*, circa 1920. Marble, 23.22″ × 20.86″ (59 cm × 53 cm). Palácio dos Bandeirantes, São Paulo.

Right, Vítor Brecheret, *The Perfume Bearer*, circa 1924. Gilded plaster, 134.25″ × 40.15″ (341 cm × 102 cm). Pinacoteca do Estado, São Paulo.

expounded by Paulo Prado, which referred to the possibility of organizing something similar to the Deauville cultural festivals in São Paulo. However, the aim of the Semana was to revive the stagnant artistic and cultural environment of São Paulo, attempting also to free Brazilian art from the links that still tied it to Europe. The fact is that the young people taking part in the aesthetic revolution of 1922 did not feel sufficiently sure of their own strength. Graça Aranha was a sort of guarantor for their seriousness, capable of gaining respect from sectors less receptive to modern art.

The participants who definitely attended the Semana were the architects Antônio Moya and Georg Przyrembel, the sculptors Vítor Brecheret and Wilhelm Haarberg, the painters and draftsmen Anita Malfatti, Di Cavalcanti, John Graz, Martins Ribeiro, Zina Aita, João Fernando (Yan) de Almeida Prado, Ignácio da Costa Ferreira (Ferrignac) and Vicente do Rego Monteiro. The questionable modernism of the works exhibited and the confusion of styles was reflected in the misleading titles of some of the paintings and drawings, such as *Divisionist Impression* (Malfatti), *Impressions* (Zina Aita), *Dadaist Landscape* (Ferrignac) or *Cubism* (Vicente do Rego Monteiro). Stylistically, in fact, the 1922 futurists (as the public wrongly insisted on calling them) dabbled a little in everything—from pointillism to expressionism—except actual futurism.

Opinions on the real importance of the Semana still differ today. Some see in the exhibition the start of modern art in Brazil, and others deny that it has had any real following. However far the type of modernism presented at the Semana may seem from actual modernism and however much the aesthetic ideals of its main leaders seem confused, it cannot be denied that the exhibition represented, for the artistic development of Brazil, a real watershed, "the outlet of a national independence movement which came from far away" (Menotti del Picchia) and which above all "was not an isolated gesture of rebellion ... but ... a group movement, in which important personalities had joined together and which was

Vítor Brecheret, *Monument to the Bandeiras*, 1936–1953. Granite, 164.04′ × 52.49′ × 32.80′ (50 m × 16 m × 10 m). Ibirapuera Park, São Paulo.
Bottom, a detail of the central group of the same monument.

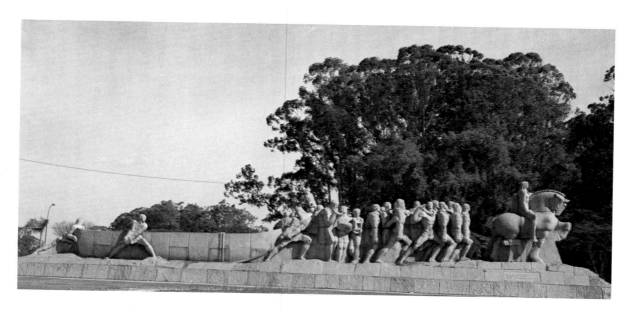

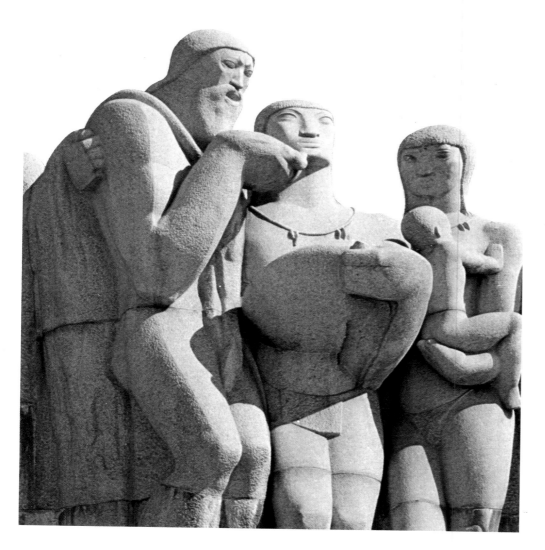

able to wake that sleeping child which was Brazil, resplendent in literature, the arts and thought" (Paulo Mendes de Almeida).

The probable creator of the 1922 initiative was Emiliano Augusto Cavalcanti de Albuquerque e Melo (1897–1976) from Rio, better known as Di Cavalcanti, who as a boy in the house of his uncle, José do Patrocínio, got to know intellectuals and artists such as Olavo Bilac and Puga Garcia. In 1914 the publication by the magazine *Fon-Fon* of one of his drawings sparked off many more contributions by him. Two years later Di Cavalcanti took part in the Salão dos Humoristas organized by Luís Peixoto and Olegário Mariano. After moving to São Paulo, he began working for *O Estado de S. Paulo*, and it was at the Editora do Livro that in 1917 he held his first exhibition, still with symbolist undertones, as a draftsman. From 1918, through visiting the studio of the German painter Elpons, he began to cultivate a watered-down impressionism. In 1921 he published the illustrations for Oscar Wilde's *Ballad of Reading Gaol* and the drawings for *Fantoches da Meia-Noite*, with a text by Ribeiro Couto, which show a strong influence of Aubrey Beardsley. In the same year he held his first exhibition of paintings.

At the Semana de Arte Moderna he presented a dozen of his works with impressionist and symbolist tendencies and expressionist elements. The following year he set off for France as a correspondent for the *Correio da Manhã* and in Paris attended the Académie

Emiliano Augusto Cavalcanti de Albuquerque Melo, known as Di Cavalcanti (1897–1976): *right, The Hill,* 1929; oil on canvas, 14.96″ × 18.50″ (38 cm × 47 cm); Paulo Leão collection; *opposite, Mangue,* 1929; oil on canvas, 20.86″ × 9.84″ (53 cm × 25 cm); Galeria Relevo, Rio de Janeiro.

Ranson for some time, becoming friendly with Jean Cocteau and Blaise Cendrars, the writer Miguel de Unamuno and artists such as Picasso, Braque, Léger and Matisse as well as the composer Eric Satie. After a trip to Italy, during which he discovered "the color of Titian and the theatrical force of Michelangelo," as he himself wrote many years later, he exhibited his works in Brussels, London, Amsterdam, Berlin, Lisbon and Paris.

He returned to Brazil and settled in Rio de Janeiro. In 1929 he produced two panels for the Teatro João Caetano and organized an exhibition of his own works. In 1932 he held another exhibition in São Paulo and between 1935 and 1940 went to live in Paris, returning home after the outbreak of the war. For Di Cavalcanti, the 1940s represent a period of complete artistic maturity, characterized by personal themes: mulatto women, carnivals, Negroes, deserted alleys, tropical landscapes, the interiors of dance halls, still lifes and a few religious scenes. His style reflects many influences—Beardsley, Picasso, the Italian Renaissance, Gauguin, the Mexicans (like Rivera), Delacroix, Matisse and Braque—always interpreted, however, in a personal way (pages 204, 205, 206 and 207).

Vicente do Rego Monteiro (1899–1970), born in Recife of a family of artists, was already in Paris in 1911 with one of his elder sisters and frequented the Académie Julian. Two years later he took part in the Salon des Indépendants. He returned to Brazil in 1917 and between 1919 and 1921 held a series of exhibitions in Recife, Rio de Janeiro and São Paulo. He came into contact with the artists and intellectuals who were organizing the Semana de Arte Moderna, in which he took part. He then returned to Paris and became so much a part of the artistic and cultural life of the French capital that in the 1920s he was one of the most well-known foreign painters due to his active participation in collective exhibitions and numerous ones of his own. Living in contact as he did with Paris's avant-garde art movements, Rego Monteiro teamed up with Ozenfant, Metzinger and Herbin to form the L'Effort Moderne group.

Living partly in France and partly in Brazil, he also became involved in poetry. In 1957 he finally settled in Brazil, giving lessons at the Escola de Belas-Artes in Recife, then at the one in

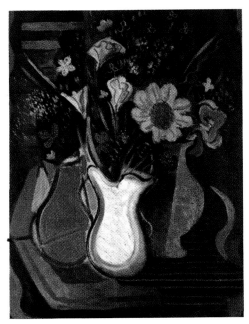

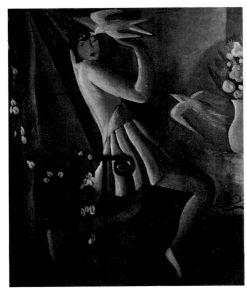

Di Cavalcanti, *Still Life with Flowers.* Oil on canvas, 25.59″ × 19.68″ (65 cm × 50 cm). Museu de Arte Contemporânea, São Paulo.

Di Cavalcanti, *Columbine,* 1922. Oil on canvas, 30.70″ × 25.59″ (78 cm × 65 cm). S. Szamecki Collection.

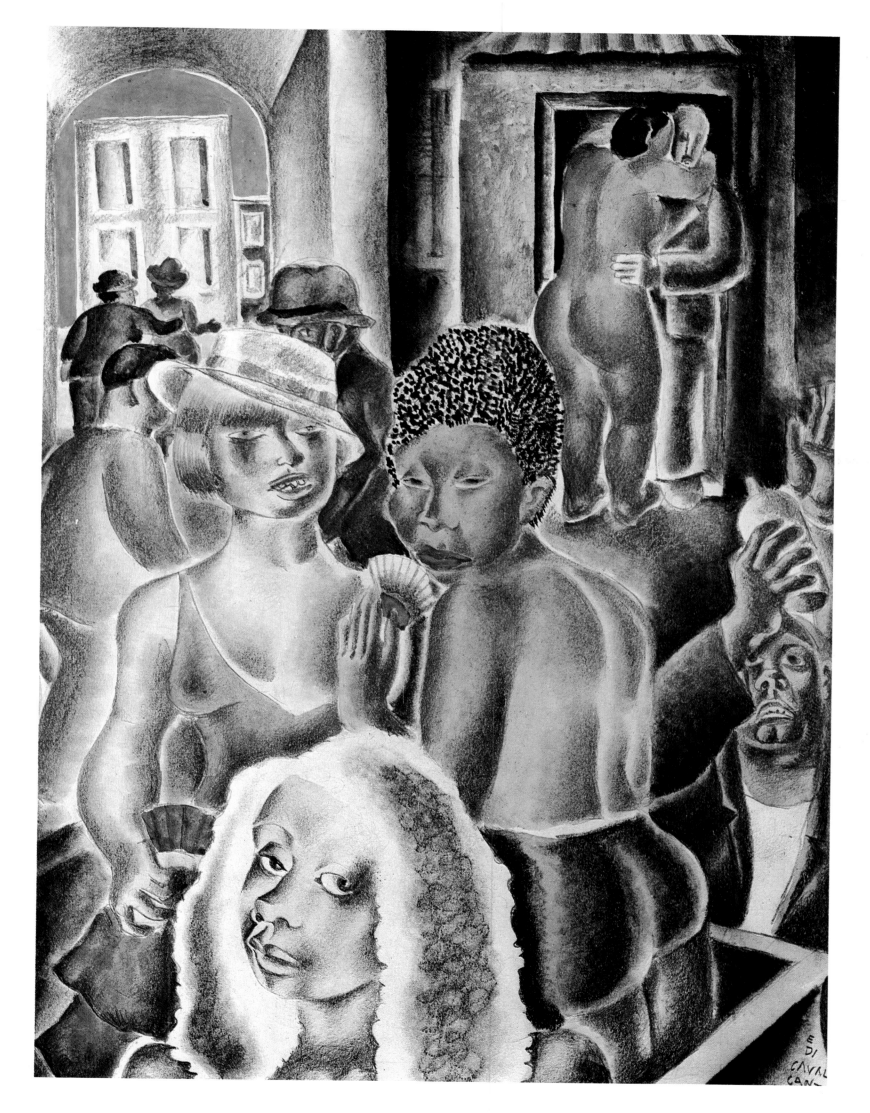

Di Cavalcanti (1897–1976), *Fisherman and Woman*, 1951. Oil on canvas, 44.88" × 63.77" (114 cm × 162 cm). Museu de Arte Contemporânea, São Paulo.

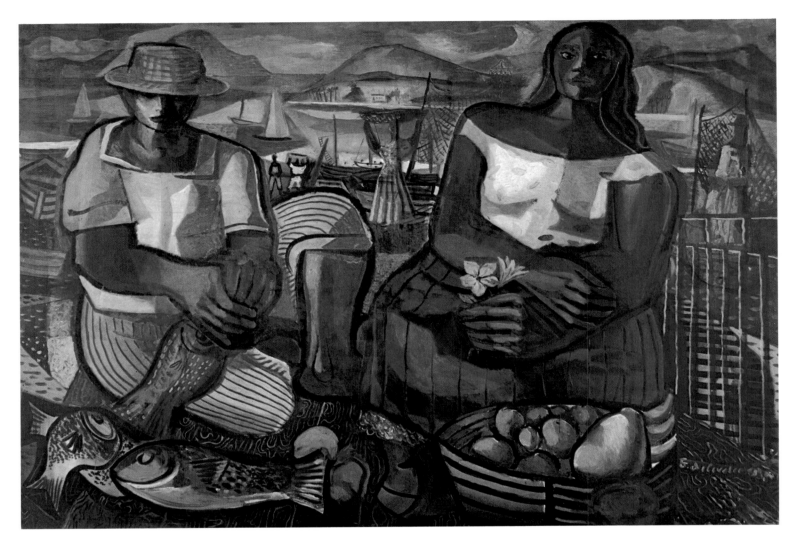

Brasília and again in Recife. Asked by an interviewer to list the determining influences in his paintings, Vicente do Rego Monteiro pointed to "futurism, cubism, Japanese prints, black art, the Parisian school, Brazilian baroque and above all the art of the American Indians on the Island of Marajó." One of his distinctive characteristics, the insistence with which he approaches national themes, places him among the precursors of a modern Latin American tendency. His ideal world moves from the figures of the American pantheon and the Bible to the classics and other great lofty themes, represented by plastic volumes rendered with almost ethereal brushwork (pages 208–209). Vicente do Rego Monteiro was also a sculptor, creating wooden figures similar to those of the cubist, Léger. His influence beame stronger after his death. In fact, in one way or another, some of the best contemporary

artists of Nordeste, including João Câmara and Gilvan Samico, are inspired by him.

John Graz, a painter with decorative tendencies, was born in Switzerland in 1895 and trained in Geneva, Paris and Munich, being influenced at the beginning of his career by a fellow-countryman, Ferdinand Hodler. He came to Brazil in 1920 after his marriage to the painter Regina Gomide, and settled in São Paulo. In December of the same year he exhibited a group of works that attracted the attention of avant-garde artists and writers. In 1922 he took part in the Semana de Arte Moderna with eight paintings. Then, in São Paulo, he created interior decorations, always remaining faithful to a style linked to art deco into which he often introduced Brazilian themes (page 210).

The draftsman and caricaturist, Ignácio da Costa Ferreira, known as

Ferrignac (1892–1958), held his first exhibition in 1915 and from 1917 to 1920 lived in Europe. He produced bookplates and contributed drawings to the magazines *O Pirralho*, *A Cigarra* and *Vida Moderna*, but in 1925, when he was appointed as a police commissioner, he gave up his artistic activities. He only showed one work at the Semana, *Dadaist Landscape*, certainly the first reference in Brazil to the movement founded a few years earlier in Switzerland. *Columbine* (page 210) is his most famous drawing.

Zina Aita (1900–1968) held the first exhibition of her work at a very early age in Belo Horizonte, her home town, and shortly afterwards took part in the 1922 Semana, proposing an impressionist type of style using light shades defined by a design with a symbolist connotation, following the style which was popular at that time (page 211). In 1923 Zina Aita held an exhibition in Rio de Janeiro and

Below, Di Cavalcanti: *Mulatto Woman with a Black Cat*, 1966; oil on canvas, 31.49″ × 45.27″ (80 cm × 115 cm); private collection. *Bottom, Where I Would be Happy*, 1965; oil on canvas, 38.58″ × 51.18″ (98 cm × 130 cm); private collection.

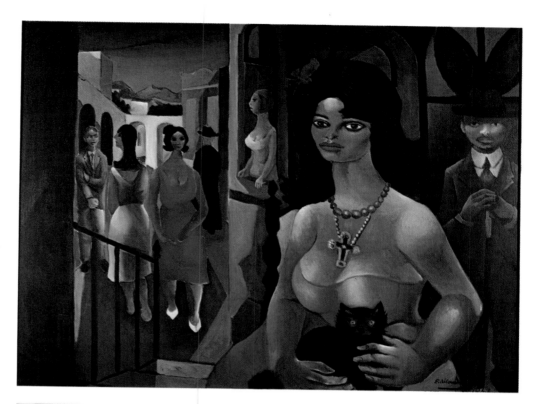

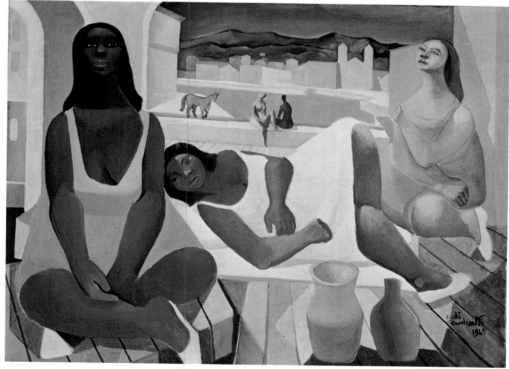

in the following year left for Europe where she settled, abandoning painting for ceramics.

In the twenties a few artists became established in Brazil without whom it would be impossible to present a complete picture of modernism since their work is of fundamental importance, both for its expressive level and the originality of its formal elements. It is no exaggeration to say that among these isolated cases are some of the greatest artists of twentieth-century Brazil, such as Tarsila do Amaral, Antônio Gonçalves Gomide, Celso Antônio de Meneses and Osvaldo Goeldi.

Tarsila do Amaral (1886–1973) was already thirty when she began her artistic activities in 1916, becoming a pupil of the sculptors Zadig and Mantovani. The following year she attended lessons given by Pedro Alexandrino. After a brief stay in the studio of the German painter, Georg Fischer Elpons, in 1920 she went to Paris where for some time she attended the Académie Julian and the studio of Emile Renard, a fashionable portraitist. Some of Tarsila's female figures, painted around 1922, reflect the style of her teacher with their pale colours dominated by blues (page 212).

In 1922 Tarsila took part in an exhibition in Paris and then returned to Brazil where she became involved with the intellectuals of the Grupo Klaxon: Mário de Andrade, Oswald de Andrade, Menotti del Picchia and Sérgio Buarque de Holanda. Shortly afterwards, with the first three and Anita Malfatti, she founded the Grupo dos Cinco, which was short-lived, and in 1923 she returned to Paris.

After deciding to study more seriously, she began to go to the studios of the chief cubist painters and was taught by André Lhote, Fernand Léger and Albert Gleizes. At the same time she struck up friendships with Picasso, De Chirico, Brancusi, Manuel de Falla, Stravinsky, André Breton, Cendrars and John dos Passos. In 1924, during a tour of the town of Minas Gerais in the company of Blaise Cendrars and Oswald de Andrade, who was later to become her husband, Tarsila discovered Brazil and in the years that followed directed her efforts into a stylized representation, set within a solid cubist composition, of the tropical flora, the mestizo and black population and the poor small towns of the interior of the country, using "rustic" colors based on pinks and blues. In 1928 she produced

Vicente do Rego Monteiro (1899–1970),
Pietà, circa 1966. Oil on canvas,
43.30″ × 52.75″ (110 cm × 134 cm). Museu de
Arte Contemporânea, São Paulo.

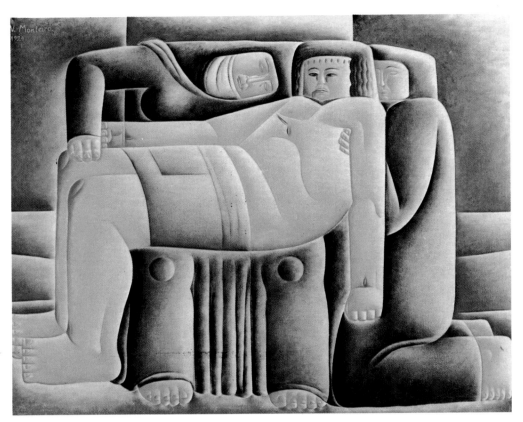

the first work of her so-called anthro-pophagous phrase, characterized by basic tropical landscapes populated by monstrous figures with tiny heads, thin arms and huge legs (page 213), on which Oswald de Andrade formulated an aesthetic theory of which the magazine *Revista de Antropofagia* was the official voice. In 1931 Tarsila visited the Soviet Union and organized an exhibition in Moscow. On her return she painted a series of works treating social themes (*2nd Class*; page 214). In the years that followed she went back to the subjects of previous stages, occasionally with some repetition and sometimes using her "rustic" colors in more lyrical tones (pages 214–215).

Osvaldo Goeldi (1895–1961) from Rio, son of the Swiss scientist Emílio Augusto Goeldi who had been called to Brazil by Dom Pedro II, returned to Berne with his family at the age of six and in 1915 began attending the École Politechnique in Zurich. Two years later when his father died, he abandoned scientific studies to dedicate himself to painting. That same year he held his first exhibition of drawings at a gallery in Berne and it was then that he became acquainted with the work of Alfred Kubin, who had a great influence on the young artist. In 1919 Goeldi returned to Rio de Janeiro where he settled and two years later exhibited his works at the Liceu de Artes e Oficios, winning respect, if not from the critics, from Álvaro Moreira, Di Cavalcanti, Aníbal Machado, Ronald de Carvalho and Manuel Bandeira, who became the artist's friends. In 1924, Geoldi, with Ricardo Bampi from São Paulo, learned the technique of engraving, which was to become his favorite means of expression.

Unanimously recognized in the fifties as one of Brazil's greatest engravers, Goeldi based his entire artistic expression on a careful study of three great artists, Kubin, Gauguin and Munch. Beyond the influence of these masters and expressionism, Goeldi was fundamentally Brazilian, not through his affinity with the artistic past of the country, but for his ability to understand the everyday life of Rio de Janeiro in its most anonymous details—its vagrants, fishermen, alleys and beaches.

Antônio Gonçalves Gomide was born in 1895 in Itapetininga (São Paulo) and moved with his family to Switzerland in 1913. He studied art in Europe, attending courses at the École des Beaux-Arts in Geneva given by Gillard and

Vicente do Rego Monteiro, *The Archer*,
1925. Oil on canvas, 25.59″ × 32.38″
(65 cm × 82 cm). Prefeitura Municipal,
Recife.

Ferdinand Hodler. After a trip to the Iberian Peninsula, he stayed in Paris where he became friends with Picasso and other cubist artists. In Toulon, after 1924, he learned the difficult technique of fresco painting with Marcel Lenori and was one of the first to paint frescoes in Brazil. On his return to Brazil in 1926, after having exhibited his two best cubist works (page 219) at the Salon d'Automne and Salon des Indépendants, the following year he put on an exhibition of his own in São Paulo and did a fresco in the Couto de Barros residence depicting *Primitive Work and Costumes*. Gomide's preference for decorative painting is reflected in his paintings of this period by the ease with which he tackles large surfaces, characterized by a delicate and discreet choice of colors, always remaining faithful to a constructivist system.

After his last trip to Europe in 1928, Gomide settled in São Paulo, gathering around him many young people and joining various groups of artists who were seeking to renew their cultural environment. His contact with them caused his painting, purely European in style, to undergo a profound change. Some of his best works, which date from the thirties, include paintings, cartoons for glass panels and frescoes treating sacred or secular subjects. In the decade that followed he drastically cut down his painting activities to dedicate more time to sculpture, producing works inspired by African and native plastic arts.

José Maria dos Reis Júnior (born in 1903) is better known as a critic and art historian, but from 1923 (the year of his first exhibition in Rio de Janeiro) he was also active in his own right as an artist.

Domingos Viegas de Toledo Piza (1887–1945), like Reis Júnior, produced landscapes with a modernist flavor. He began painting in 1913 under the influence of the impressionists, particularly Monet, Sisley, Pissarro and Gauguin. After his first exhibition in São Paulo in 1915 (when he was accused of being a futurist) he lived for a long time in Paris where he took part in the Salon d'Automne in 1921 and organized an exhibition of his own in 1926. Toledo Piza was considered in his own country, which underwent a renewal of public

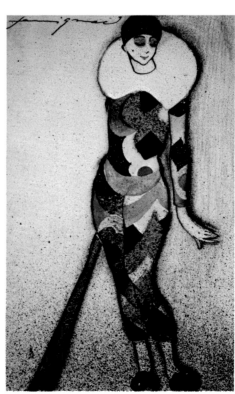

Zina Aita (1900–1968), *Men at Work*, 1922.
Oil on canvas, 8.66″ × 11.41″ (22 cm × 29 cm).
Yan de Almeida Prado Collection, São Paulo.

taste, to be a painter who was out of touch, remaining isolated, even though his limited production shows considerable artistic talent.

Born in 1896 in Caxias, Maranhão, Celso Antônio de Meneses settled in Rio de Janeiro while still young. After having won a scholarship, he studied in Paris under Antoine Bourdelle. From 1926, when he returned to Brazil, to 1930, Celso Antônio lived in São Paulo, building civil and funeral monuments with an expressionist feel. In 1931 he moved to Rio de Janeiro, where he taught for some time at the Escola Nacional de Belas-Artes and later at the Universidade do Distrito Federal. Invited by the Minister of Education, Gustavo Capanema, to work on the new ministry building, designed partly by Le Corbusier, the sculptor designed a series of works such as *Girl Reclining* for the garden and *Motherhood* (currently on Botafogo beach). The *Seated Man*, requested expressly by Le Corbusier, was never produced. A new sculpture, the *Brazilian Worker*, planned for the facade of the Ministry of Labor in Rio de Janeiro, was unveiled in 1946 but had to be taken down shortly afterward due to the protests it aroused, even among Brazilian workers themselves. After this affair the sculptor was disheartened and chose to abandon all artistic activity.

The First Modern Generation

Despite its limitations, the Semana de Arte Moderna of 1922 was the first sign of a desire for renewal in Brazilian culture, and it confirmed the dissatisfaction of many artists and intellectuals. Gradually a new form of expression developed with the establishment of a generation of artists who no longer followed academic rules. All the artists of this first modern generation show the influence of contemporary European art. The choice of subjects such as the Indians, the evaluation of the national tradition and the interpretation of the popular spirit are, in fact, the result of European progressive thought. In the work of these artists, cubist and expressionist elements reveal a synthesis, usually unwitting, of a few important

Zina Aita, *The Gardener*, 1945. Oil, 25.98″ × 18.89″ (66 cm × 48 cm). Osvaldo Ballarin Collection, São Paulo.

Tarsila do Amaral (1886–1973): *left, Urutu*, 1928; oil, 23.62" × 28.34" (60 cm × 72 cm); G. Chateaubriand Collection, Rio; *bottom, Self Portrait*, 1923; oil, 28.74" × 23.62" (73 cm × 60 cm); Museu Nacional de Belas-Artes, Rio; *opposite, Anthropophagy*, 1929; oil, 49.60" × 55.90" (126 cm × 142 cm); J. Nemirovsky Collection, São Paulo.

European artistic movements. Another common trait is a greater interest in technique, which had been relegated to second place during the Semana. This generation included some important figures such as Cândido Portinari, Guignard, Ismael Nery, and Cicero Dias.

The son of Italian immigrants, Cândido Torquato Portinari (1903–1962) studied in Rio de Janeiro at the Escola Nacional de Belas–Artes under Lucílio de Albuquerque, Rodolfo Amoedo and Batista da Costa. With two portraits, one of the poet Olegário Mariano and the other of the art critic and friend Celso Kelly, in 1928 he won a scholarship to travel to Europe, where he stayed for two years studying contemporary movements and the works of the great Renaissance masters. On his return he felt ill at ease in the conservative atmosphere of Rio and in 1933 went back to Brodósqui, his home town, where, in the dining room of his father's house, he painted his first fresco, which was inspired by Fra Angelico's *Flight into Egypt*. In 1935, with his painting *Café*, he got an honorable mention from the Carnegie Foundation (the first modern Brazilian artist to receive a prize abroad) and in the same year was invited to teach mural painting at the Universidade do Distrito Federal in Rio de Janeiro, where Lúcio Costa was teaching (architecture), along with Celso Antônio (sculpture), Andrade Murici and Villa-Lobos (music) and Mário de Andrade (literature), all modernists.

In this highly creative environment, permeated with progressive elements, the artist perfected his fresco technique, which he was to use for some of his most important works. Unfortunately, due to political difficulties and administrative problems, the Universidade do Distrito Federal was closed shortly afterward. From 1936 Portinari was given a few official commissions, such as the decorations for the new Ministry of Education building, now the Culture building. For the large frescoes that he did for this project, Portinari, influenced by the Mexicans Rivera, Orozco and Siqueiros, chose work in different regions of the country as a theme, composing the scenes across great contrasts of masses, deformed figures and light, vivid colors. In 1939, Portinari, still supervising the painting of the Ministry frescoes, which lasted from 1938 to 1945, agreed to paint

three panels for the Brazilian pavilion at the International Fair in New York and in 1942 was called in to decorate the Hispanic Foundation room in the Library of Congress, Washington, D.C.

Deeply struck by the tragedy of the second World War, between 1943 and 1945 the artist produced a dramatic and highly expressionist series of the *Way of the Cross* for the Church of São Francisco (pages 260–261) in the district of Pampulha, Belo Horizonte. Together with the *Way of the Cross* by Batatais, painted in 1935, the Portinari work was ostracized for many years, since its formal aggressiveness scandalized the ecclesiastical authorities, who considered it to be not only disrespectful to the divinity of Christ, but also aesthetically questionable. Around 1944 the *retirantes*, the Nordeste peasants who were forced to emigrate south because of droughts, inspired Portinari to produce a series of paintings that reflect the influence of the metaphysical De Chirico. In 1948, Portinari began a new phase in which he abandoned social criticism in favor of historical remembrance rendered in compositions with an abstract influence.

In the fifties, Portinari's painting seemed to crystallize into an expressive form built upon a personal synthesis of various influences which manifested

Tarsila do Amaral (1886–1973): *below,*
Spring, 1946; oil on canvas, 29.52″ × 39.37″
(75 cm × 100 cm); J. L. Lacerda Soares
Collection, São Paulo; *bottom, 2nd Class,*
1931; oil on canvas, 43.40″ × 59.44″
(110 cm × 151 cm); Fanny Feffer Collection;
right, Port, 1953; oil on canvas,
27.55″ × 39.37″ (70 cm × 100 cm); José
Nemirovsky Collection, São Paulo.

itself above all in the *Cangaceiros* (bandits) series and the children of Brodósqui flying their kites, a reminder of his own childhood spent in poverty. However, in 1956, the impressions gained during a journey to Israel on the occasion of his exhibitions in Tel Aviv and Haifa, caused a new stylistic development in Portinari's work based on the recovery of bold brushwork in a composition enclosed in compact, aggressive forms. In 1962, Portinari died in Rio de Janeiro, a victim of poisoning caused by the paints he was using.

When still an adolescent, Alberto da Veiga Guignard (1896–1962) moved with his family to Europe where he went to the academies of Florence and Munich and twice, in 1923 and 1928, exhibited his own works at the Salon d'Automne in Paris. Referring to himself in the third person, Guignard declared that "from an academic he became a modern painter, after having visited a German modern art exhibition; modernism fascinated him." In actual fact, he was never an academic, since he studied under Groeber and Hengeler, two painters who were linked to expressionism. The modern art exhibition which so fascinated him was probably an exhibition by Kirchner and other members of the Brücke group, although Guignard's style corresponds more, in certain respects, to that of the artists of new German objectivity.

In 1929, Guignard returned to Rio de Janeiro and began to teach at the Fundação Osório and the Universidade do Distrito Federal, at the same time opening a studio in the Jardim Botânico and coming into contact with Cícero Dias and Ismael Nery, who had a certain influence on him. In 1944, invited by the prefect of Belo Horizonte, Juscelino Kubitschek, Guignard moved to the capital of Minas where he set up the Escolinha do Parque, or Escolinha Guignard, which was to train an entire

Osvaldo Goeldi (1895–1961): *below*,
Fisherman, 1970 posthumous edition;
woodcut, 9.05″ × 14.17″ (23 cm × 36 cm); G.
Chateaubriand Collection, Rio de Janeiro;
bottom, Fishermen, 1940; xylograph,
12.20″ × 16.92″ (31 cm × 43 cm); Museu de
Arte Contemporânea, São Paulo; *opposite*,
untitled woodcut.

generation of Minas' artists.

Guignard's style, based essentially on drawing, is expressed above all in his landscapes, with the series of the Jardim Botânico (dating from the beginning of his stay in Rio de Janeiro), the Itatiaia landscapes (between the end of the thirties and beginning of the forties), the Parque Municipal in Belo Horizonte (after 1944), and the landscapes of Lagoa Santa, Sabará, Ouro Prêto (depicted especially on St. John's night) and the surrounding areas (page 218). The artist's production also includes "musical paintings" (abstract compositions inspired by pieces of music), scenes of Brazilian life (page 219), still life paintings and very high quality portraits.

Ismael Nery, from Belém (1900–1934), always considered himself to be a poet and philosopher and saw his painting as an activity of secondary import-

ance. He studied at the Escola Nacional de Belas-Artes in Rio de Janeiro and traveled to Europe between 1920 and 1921, showing at that time an interest only in old French and Italian art. A second stay in Paris in 1927 provided him with the opportunity of meeting Breton and the group of surrealists and to strike up a friendship with Marc Chagall. As distinct from Tarsila, Di Cavalcanti and Rego Monteiro, Nery was not concerned with giving a national flavor to his painting, and he directed his efforts toward the representation of a single theme, the human form, drawing inspiration from both classical art (Titian, Tintoretto, Veronese and Raphael) and his contemporaries such as Chagall, Picasso and Max Ernst. His rather limited production includes about a hundred oil paintings and around a thousand water colors, gouaches and

drawings and is usually separated into three stages: expressionist, between 1922 and 1923 (*Self Portrait Dressed as a Toreador*, 1922, Chaim Hamer Collection, São Paulo; page 220); cubist, from 1924 to 1927 (*Woman with a Bunch of Flowers*, 1925, Alberto Alves Filho Collection, São Paulo; page 221; *Nude*, 1927, P.M. Bardi Collection, São Paulo; page 222); and surrealist, from 1927 until the year of his death (*The Encounter*, 1928, Chaim Hamer Collection, São Paulo; page 222; *The Annunciation*, 1928, Gianni Samaja Collection; page 223). Although the expressionist and cubist stages are artistically the most important and fruitful, the last stage, marked by the influence of Chagall, has greater historical importance since it contributed to the spread of surrealism.

Born in Recife in 1908, Cícero Dias enrolled at the Escola Nacional de Belas-

Alberto da Veiga Guignard (1896–1962),
View of the Mariana Road, 1962. Oil on
canvas, 18.11″ × 21.65″ (46 cm × 55 cm). G.
Chateaubriand Collection, Rio de Janeiro.

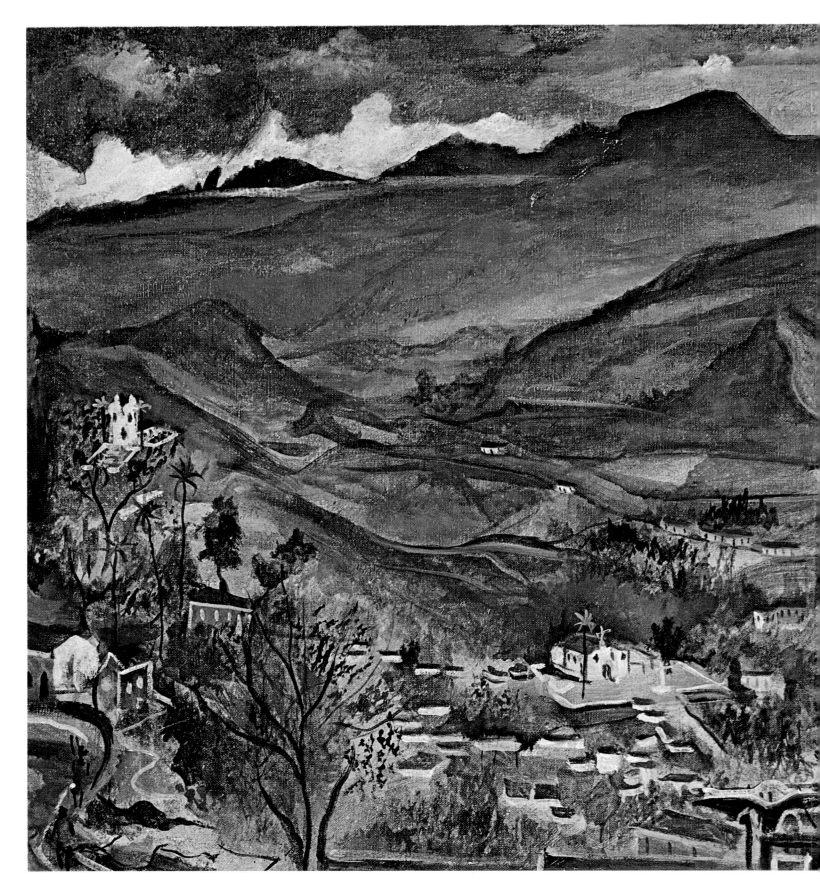

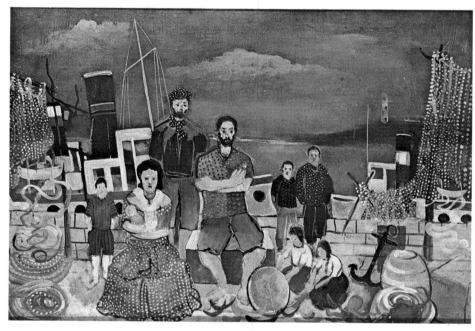

Alberto da Veiga Guignard, *Family in a Minas Landscape*, post 1929. Oil on canvas, 15.74" × 20.47" (40 cm × 52 cm). Enrica Profili Collection, São Paulo.

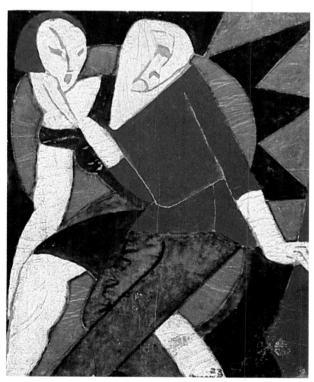

Antônio Gonçalves Gomide (1895–1967), *Figures*, 1923. Combined technique, 10.62" × 8.66" (27 cm × 22 cm). G. Chateaubriand Collection, Rio de Janeiro.

Artes in Rio de Janeiro in 1925 to study architecture, but he was to turn immediately toward painting; in 1927 he put on an exhibition of his own in the capital. The following year he left the academy to work according to his own inspiration, adopting an improvised technique to paint subjects of a rustic surrealism set in his native Nordeste. In 1930 the painter organized the Afro-Brazilian Congress in Recife and in the following year took part in the Salão Revolucionário of Rio de Janeiro, the first national exhibition open to modern artists.

Cícero Dias visited Paris in 1937 and what was to have been a brief stay in the capital of international culture became a permanent residence. In Paris Dias became acquainted with many artists and intellectuals, including Picasso and, later, the surrealists. After the second World War he became interested in abstract art and his 1946 exhibition in Paris revealed a new Cícero Dias totally involved in nonfigurative shapes and colors, although it is still possible to detect recollections of his native country in the choice of colors. During his stay in Brazil in 1948, the artist painted a fresco in Recife which is considered to be the first of an abstract nature in the country. In the last years of his life, Cícero Dias resumed the main theme of his early works, lacking, however, the freshness and originality shown in his youth (pages 224–225).

The sculptor, Bruno Giorgi, was born

Ismael Nery (1900–1934): *below, Eva* (or *Two Friends*), 1925; oil on canvas, 20.07″ × 14.17″ (51 cm × 36 cm); P. M. Bardi Collection, Saõ Paulo; *right, Self Portrait Dressed as a Toreador*, 1922; oil on canvas, 12.59″ × 9.44″ (32 cm × 24 cm); Chaim Hamer Collection, Sào Paulo.
Opposite, Ismael Nery, *Woman with a Bunch of Flowers*, 1925. Oil on paperboard, 24.01″ × 19.68″ (61 cm × 50 cm). Alberto Alves Collection, São Paulo.

mass and a greater number of spaces. In 1959, the *Warriors* for Brasília (page 25) were cast. They are, perhaps, the most well-known work of this phase.

Around 1965 Bruno Giorgi abandoned figures in favor of geometrical shapes made in white Carrara marble, such as the *Meteoro* for the Arches building in Brasília. Ten years later he returned to the human figure with mutilated torsos, often sculpted in pink marble from Estremoz, in northern Portugal, where, in the outskirts the sculptor opened a studio.

Naïf Art

In Brazil, the first to show an interest in *naïf* art were the modernists, who in their retrieval of national art put many particularly original popular votive offerings to good use, considering them to be an expression of collective art. In addition, in 1933 for the first time they acknowledged that the work of a *naïf* painter, Cardosinho, had aesthetic value.

Born in Coimbra, Portugal, José Bernardo Cardoso Júnior (1861–1947), better known as Cardosinho, was just three years old when he came to Brazil

in Mococa, in the state of São Paulo, in 1905, but six years later moved with his family to Italy, settling in Tuscany. Between 1920 and 1922 he studied sculpture in Rome and then in Paris under Aristide Maillol. In 1939 he went back to Brazil and settled in São Paulo, becoming part of the modernist movement. In 1942, perhaps by the good offices of his admirer, Mário de Andrade, he was invited to take part in the decoration of the new Ministry of Education building in Rio de Janeiro for which he completed, four years later, the *Monument to*

Youth. The works which were produced after 1949 show a vaguely cubist type of deformation coexisting with rounded masses, but later Giorgi directed himself toward a greater stylization of the human body. In 1954 the sculptor left again for Europe, where he stayed for two years, and on his return to Rio de Janeiro he produced works with more agitated, twisting forms, such as his *Prometheus* for the Hospital Sul América. The use of bronze dates back to that period. It was a material which allowed Giorgi to create thinner, more vertical figures with less

221

Ismael Nery (1900–1934): *below, Nude,*
1927; oil on canvas, 30.31″ × 22.44″
(77 cm × 57 cm); Pietro Maria Bardi
Collection, São Paulo; *right, The Encounter,*
1928; oil on paperboard, 18.11″ × 21.65″
(46 cm × 55 cm); Chaim Hamer Collection,
São Paulo; *below right, Cubist Nude,* 1927;
water color, 7.87″ × 5.11″ (20 cm × 13 cm);
private collection.

Ismael Nery, *The Annunciation*, 1928. Oil on paperboard, 12.59″ × 15.74″ (32 cm × 40 cm). Gianni Samaja Collection.

with his family. After attending the São João Seminary in Rio, in 1877 he went to Rome to study philosophy but later turned to teaching. Cardosinho, who was the author of numerous, still unpublished literary works, began work as a self-taught painter in 1929 at the age of sixty-eight, drawing inspiration from photographs and engravings that he re-cut and copied with an absolutely free hand, mixing elements of one reproduction with those of another without bothering about proportions, following a practice which is typical of *naïf* art and gives the composition a fantastic, almost oneiric flavour.

Discovered and encouraged by Celso Kelly, Cardosinho found a sincere admirer in Portinari, who managed to put on an exhibition with him at the Palace Hotel, at that time the headquarters of the Associação dos Artistas Brasileiros.

A musician and creator of the samba, Heitor dos Prazeres (1898–1966) from Rio discovered painting in 1937. Encouraged by the critic Carlos Cavalcanti, he became more involved in this new form of artistic expression and in 1942 showed his works for the first time in an exhibition in Belo Horizonte. His paintings show a clear, ingenuous vision of an ideal world, depicting groups of people (always with their faces in profile) taking part in an event: a samba, a popular dance, a serenade, a *macumba* ceremony or working in the fields (page 226).

An innocent vision of the world, expressed with a basic technique that owes almost nothing to the learned pictorial tradition, leads us to include Djanira da Mota e Silva (1914–1979) among the *naïfs*. A descendant of Indians and Viennese immigrants, Djanira married a ship's engineer of the mercantile marines at a very early age and moved to Rio de Janeiro. She was soon widowed, and in order to survive she became a dressmaker and turned her house into a boarding house. During that time she got to know artists who were living in the same area, like Jean-Pierre Chabloz, Milton Dacosta, with whom she studied for some time, and Emeric Marcier, one of her boarders who gave her lessons. In 1942

Cícero Dias (born 1908): *Woman*, 1930; oil, 27.95″ × 23.62″ (71 cm × 60 cm); Pedro Carvalho Collection; *opposite above, Woman on the Beach*, 1944; oil on canvas, 25.59″ × 31.49″ (65 cm × 80 cm); G. Chateaubriand Collection, Rio de Janeiro; *below left, Bathing in the River*, 1931; water color, 25.98″ × 19.68″ (66 cm × 55 cm); G. Chateaubriand Collection, Rio de Janeiro; *below right, Woman Swimming*, 1930; water color, 25.98″ × 19.68″ (66 cm × 50 cm); G. Chateaubriand Collection, Rio de Janeiro.

she exhibited her work for the first time at the Salão Nacional de Belas-Artes where, the following year, she received an honorable mention and, in 1944, a bronze medal. In 1943 she put on her first exhibition at the Associação Brasileira de Imprensa and two years later showed her work in the United States—in New York and Washington, D.C.

Her art can be divided into two periods. The first period depicts scenes of life in Rio and a few apsects of life in the United States picked up during her trip in 1945. The second period of Djanira's activity is more original in its brilliant and pure tones, spread in clearly defined and uniform blocks of background color (page 226), and especially in the subjects, which are drawn from life in the various regions of Brazil, with a special preference for field workers.

Francisco Domingos da Silva, known as Chico da Silva, was born around 1910 in Alto Tejo, in the interior of Acre. He was brought at the age of six to Ceará where, in 1937, he began to paint on walls using pieces of brick, coal and leaves. The Swiss painter, Jean-Pierre Chabloz met him in 1943 and became interested in the young artist, teaching him the *gouache* technique. Chico da Silva then sent his works to numerous exhibitions in both Brazil and Switzerland. The world of Chico da Silva is populated with dragons, snakes, fish, birds and fantastic, brightly colored animals that stand out against an homogenous, monochrome background, recreating the mythological tales passed down by word of mouth within the vast territory that extends from Nordeste to Amazonas.

Terra-cotta was the material used by Vitalino Ferreira dos Santos (1909–1963), called Mestre Vitalino, to model his little figures that told of the life of the peasants in his homeland, Pernambuco. Mestre Vitalino created his style from the popular tradition of the potters of Pernambuco, imbuing his characters with a subtle irony (page 227).

The Núcleo Bernardelli

Although in the thirties Rio de Janeiro continued to be Brazil's most important cultural center, its artistic environment was not influenced in the slightest by the innovative ideas that had led to the 1922 São Paulo Semana de Arte Moderna.

Young artists no longer accepted, how-

Above, Heitor dos Prazeres (1898–1966), *The Mill*, 1951. Oil on canvas, 25.59″ × 31.88″ (65 cm × 81 cm). Museu de Arte Contemporânea, São Paulo.
Right, Djanira da Mota e Silva (1914–1979), *Three Orixas*, 1966. Oil on canvas, 50.77″ × 75.97″ (129 cm × 193 cm). Pinacoteca do Estado, São Paulo. An orixa is a lesser god in African mythology.

Vitalino Ferreira dos Santos, known as Mestre Vitalino (1909–1963), *Retirantes*, before 1953. Painted baked clay. The *retirantes* are peasants from the northern and central areas who emigrate to southern Brazil when there are droughts.

ever, the teachings of the academy staff who still followed, albeit with some variations, the methods established by the French Artistic Mission. Some of these young artists decided to get together and form a group called the Núcleo Bernardelli in 1931, the same year that, for the first time, the annual academy exhibition was opened up to accept contributions from the "modernists." The name of the group, rather contradictory when compared to the aesthetic ideals of its members, was chosen in homage to the Bernardelli brothers, Rodolfo and Henrique, since they, the latter especially, had played a fundamental role in renewing Brazilian art. The first artists to join the group were Ado Malagoli, Edson Mota, João Rescala, Bustamante Sá, José Pancetti, Milton Dacosta, Joaquim Tenreiro, Borges da Costa, Jaime Pereira Ramos,

Martinho de Haro and Bráulio Poiava. Among those who joined at a later stage were Camargo Freire, Takaoka and Tamaki from Japan and the architect and painter Eugênio Proença Sigaud.

The Núcleo did not have teachers in the strict sense of the word, only artists who were already expert and guided the younger ones. In the beginning it worked in conjunction with the Escola Nacional, breaking away only in 1936. When there were no longer rooms available in which to hold lessons and work, the Núcleo began to meet in cafés such as the Gaucho or in shops specializing in artists' materials like Antiga Casa Cavalier. In 1938, due above all to the efforts of Bustamante Sá, the Núcleo was able to establish itself in its own building in Rua São José and elected Quirino Campofiorito as its president. Two years later the group folded, having outlived

the purpose for which it had been formed. The Núcleo Bernardelli represented the moderate wing of Brazilian modernism in the thirties.

The artists who had the greatest influence on the young members of the Núcleo were the Polish landscape painter Bruno Lechowsky (1887–1941), Manuel de Assunção Santiago (born 1897), who was the first in Brazil to produce abstract paintings (dating back to 1916) and later was a landscape painter with a post-impressionist tendency, and finally Quirino Campofiorito (born 1902), who after a long stay in Europe applied himself to subjects such as workers, beach scenes and still life arrangements dominated by a sense of the monumental.

Meeting Bruno Lechowsky in 1934 was of vital importance for José Pancetti (1902–1958), who was self-taught and had begun painting seascapes in 1925

José Pancetti (1902–1958): *left, Funeral of a Little Girl in São João del Rei*, 1945; oil on canvas, 14.96″ × 18.11″ (38 cm × 46 cm); G. Chateaubriand Collection, Rio de Janeiro: *below, Self Portrait*, 1943; oil on canvas, 22.59″ × 21.25″ (65 cm × 54 cm); G. Chateaubriand Collection, Rio de Janeiro. This self portrait belongs to the *Campos do Jordão* series.

while a naval officer. Between 1936, the year of the series painted in the Arsenal da Marinha in Rio de Janeiro, and 1949, the painter produced his best works (pages 228–229): still life paintings that show the influence of Cézanne, self-portraits inspired by those of Van Gogh and, above all, the seascapes of São João del Rei and Itanhaém (1945), Mangaratiba (1946), Cabo Frio and Casimiro de Abreu (1947), Arraial do Cabo (1948) and Campos do Jordão (1949). After settling in Salvador at the end of 1950, the artist suffered initially from the excessive brightness of Bahia and only after 1952 did he again master his painting technique in the landscapes of Monte Serrate, Areia Branca, Farol da Barra, Itapuã, Rio Vermelho and the Abaeté Lagoon (pages 230–231).

Similar to the early landscapes of Pancetti are the works painted by Milton Dacosta (born 1915) while still a young man. In 1933 he took part in the Salão Nacional de Belas-Artes, at the same time attending the meetings of the Núcleo Bernardelli. Around 1940 Dacosta abandoned postimpressionism and worked out a style of his own which shows the influences of Cézanne in the construction of volumes, of Modigliani in the oval faces and long necks of the *Cyclists* and *Bathers* series, of De Chirico in the refined atmosphere of some scenes and of Morandi in the rigid structure of the still life paintings. At the end of the forties, the echo of a postcubist element becomes increasingly apparent and is

José Pancetti (1902–1958): *below,*
Biographical Self Portrait, 1945; oil on
canvas, 25.59″ × 21.65″ (65 cm × 55 cm); G.
Chateaubriand Collection, Rio de Janeiro;
right, Gávea Beach, 1955; oil on canvas,
19.68″ × 31.49″ (50 cm × 80 cm); G.
Chateaubriand Collection, Rio de Janeiro.

based on the use of a color scheme with three or four shades (page 232), faces seen both from the front and in profile at the same time and the gradual reduction of volumes to flat surfaces (the *Heads of Alexander, Towns* and *Castles* series). In the sixties, Dacosta, always working against the official tides, returned to the human figure in the *Venus* series. These were stylized, schematized and reduced to a basic sketch, yet maintaining all the voluptuous beauty of a female body (page 233).

Movements in São Paulo

In São Paulo during the thirties, various movements and artistic groups evolved which were either directly or indirectly linked to the modernism of 1922. Such was the case in Rio de Janeiro where, in 1931, the Núcleo Bernardelli was formed and the artists in the town gathered in groups so as to be able to put up better

opposition to an environment that was intolerant of all that failed to obey the rules of academicism, by now moribund but still influential.

On November 23, 1932 a group of artists and intellectuals met in the house of the architect Gregori Warchavchik to found the Sociedade Pró-Arte Moderna (SPAM). Those present were the landscape painter and architect, Paulo Rossi Osir (of Italian origin), Lasar Segall, John Graz, Vittorio Gobbis (another Italian painter), Wasth Rodrigues, Arnaldo Barbosa, Antônio Gomide, Anita Malfatti, Tarsila do Amaral and Regina Graz Gomide. They were joined at subsequent meetings by, among others, Brecheret, Hugo Adami and Moussia Pinto Alves. In order to raise funds, the group organized, for the 1933 carnival a huge ball in a few rooms decorated by the artists under the supervision of Segall. The rooms were named "Cidade de SPAM" ("SPAM City"). The "Cidade"

had governing bodies, an anthem set to music by Camargo Guarnieri, its own money (the *spamote*) and a newspaper, *A Vida de Spam*, edited by Mário de Andrade, Antônio de Alcântara Machado and Sérgio Milliet.

With the money raised by the ball, on April 28, 1933 the first Exposição de Arte Moderna by SPAM was opened to the public. In addition to the works of SPAM members, it included the originals of great foreign artists belonging to private collections in São Paulo. For the first time works by Picasso, Léger, Brancusi, Dufy, Juan Gris, De Chirico and many others were exhibited in Brazil which until then were known only through reproductions. The success of the exhibition was repeated at the second Exposição de Arte Moderna, held at the end of 1933, in which many artists active in Rio de Janeiro took part—artists such as Portinari, Di Cavalcanti, Cardosinho and Guignard.

José Pancetti (1902–1958): *below, Beach*, oil on canvas, 19.29″ × 28.34″ (49 cm × 72 cm); Maria do Carmo Collection, Rio de Janeiro; *bottom, Itapoã Landscape*, 1953; oil on canvas, 14.96″ × 20.86″ (38 cm × 53 cm); G. Chateaubriand Collection, Rio de Janeiro.

Milton Dacosta (born 1915): *below, Still Life*, 1949; oil on canvas, 28.74″ × 36.22″ (73 cm × 92 cm); Museu de Arte Contemporânea, São Paulo; *bottom left, Figure*, 1949; 31.10″ × 39.75″ (79 cm × 101 cm); Torquato S. Pessoa Collection, São Paulo; *bottom right, Carousel*, 1960; 31.88″ × 39.36″ (81 cm × 100 cm); José Luís M. Lins Collection, Rio de Janeiro.

Another carnival ball, entitled "Expedição às Matas Virgens da Spamolândia" ("Expedition into the Virgin Forests of Spamland") was organised in 1934, again under the supervision of Segall. Among those who helped with the decorations were Anita Malfatti, Rossi Osir, Gastão Worms, Balloni, Arnaldo Barbosa and Jenny Klabin Segall. However, disagreements arose within SPAM which led to the departure of Segall and Warchavchik; without Segall, who had been the real driving force, the group soon broke up.

The day after the founding of SPAM, November 24, 1932 the CAM was born (Clube dos Artistas Modernos) through the initiative of Flávio de Carvalho, Di Cavalcanti, Carlos Prado and Antônio Gomide. Occupying a room in the same building as SPAM, where its founders had their studios, CAM organized avant-garde exhibitions (showing, for example, drawings by children and the mentally handicapped), concerts, debates and conferences, including those by Tarsila do Amaral on proletarian art

Milton Dacosta, *Figure*, 1963. Oil on canvas,
18.11″ × 14.96″ (46 cm × 38 cm). G.
Chateaubriand Collection, Rio de Janeiro.
This painting belongs to the series called
Venus and Little Birds.

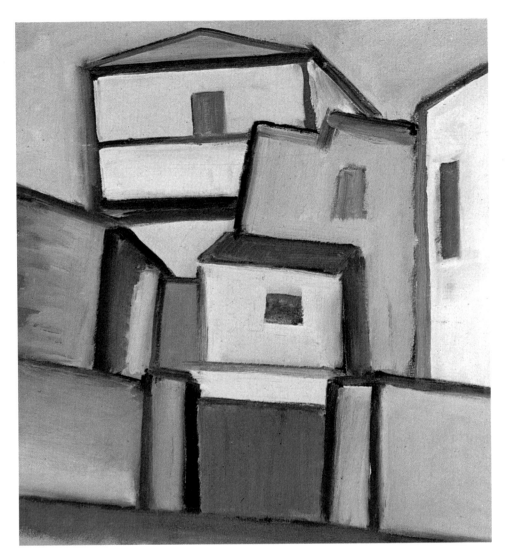

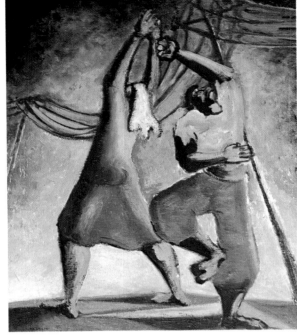

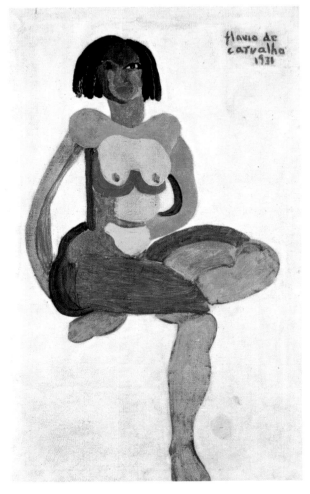

Above, Mário Zanini (1907–1971), *Houses*,
1960. Oil on board, 18.50″ × 24.01″
(47 cm × 61 cm). Museu de Arte
Contemporânea, São Paulo. *Above right*,
Clóvis Graciano (born 1907), *Figures
Dancing*, 1935. Oil on canvas, 21.25″ × 17.71″
(54 cm × 45 cm). A. Samaya Collection.
Right, Flávio de Carvalho (1899–1973),
Preliminary Study for Miss Brazil, 1931.
16.92″ × 11.02″ (43 cm × 28 cm). F. and A.
Leirner Collection, São Paulo.

Fúlvio Pennacchi (born 1905), *On the Beach*,
1972. Acrylic on board, 19.68″ × 27.55″
(50 cm × 70 cm). Galeria Mirante das Artes,
São Paulo.

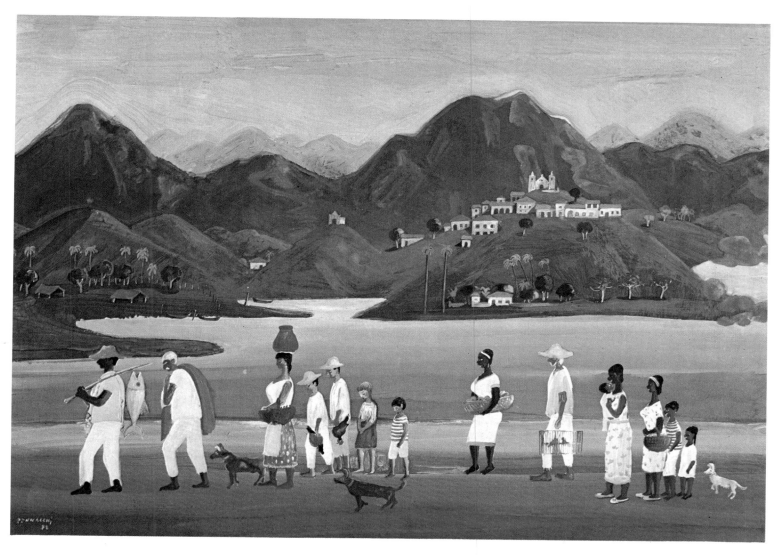

and those by the Mexican painter, Siqueiros. On the ground floor, Flávio de Carvalho set up his "Teatro da Experiência" where he put on the *Bailado do Deus Morto*, a work comprising recitations, songs and dances with actors dressed in aluminium masks and white tunics which flashed spectacularly under the floodlights. After three performances the theater was closed by the police under the accusation of indecent behavior and shortly afterwards CAM met with the same fate.

Flávio de Carvalho from Rio (1899–1973), a pioneer of modern Brazilian architecture and a painter, draftsman and writer, studied in England and was always outstanding for his boldness and originality of style. In his paintings and drawings he remained faithful to lively expressionism and usually portrayed human figures (page 234).

Around the mid-thirties a group of painters began to meet in and around the Praça da Sé in São Paulo. One of them, Francisco Rebolo Gonzales, after having given up his activities as a soccer player, opened a shop in the Santa Helena building, followed shortly afterwards by Mário Zanini. In their spare time they both painted as amateurs and went to evening drawing classes given by Lopes de Leão at the Escola Paulista de Belas-Artes. Here they met Volpi, Graciano and Manuel Martins. Thus the Grupo Santa Helena was formed. It met periodically in the Praça da Sé building to draw and to discuss artistic matters, and it comprised Rebolo Gonzales, Mário Zanini, Fúlvio Pennacchi, Aldo Bonadei, Alfredo Volpi, Humberto Rosa, Clóvis Graciano, Manuel Martins and Alfredo Rullo Rizzotti. A few years later Rebolo Gonzales said, "The Grupo Santa

Helena did not begin as a movement; it was transformed into a movement by the intellectuals. We were just a handful of friends who didn't like academics and wanted true painting that wasn't anecdotal or narrative. Painting for painting's sake."

All, except for Rizzotti, Zanini and Bonadei, were self-taught even though some of them had already taken part in collective exhibitions like the Salão Paulista de Belas-Artes. They sometimes followed the advice of expert artists like Rossi Osir and Vittorio Gobbis, and on Sundays they got together to paint landscapes around São Paulo. They were unknown to the public, received no recognition from the critics and knew nothing of the avant-garde manifestoes promoted by SPAM and CAM between 1932 and 1934. They were all from the working class, sons of immigrants or

Aldo Bonadei (1906–1974), *Landscape with Houses*, 1947. Oil on canvas, 36.22″ × 26.77″ (92 cm × 68 cm). Palácio dos Bandeirantes, São Paulo.

Right, Francisco Rebolo Gonzales (1903–1981), *The Road to Mount Carmel*, 1936. 15.74″ × 19.68″ (40 cm × 50 cm). Chaim Hamer Collection.

immigrants themselves, and they held manual jobs. Volpi, Rebolo and Zanini were house-painters, Rizzotti was a turner, Bonadei an embroiderer, Pennacchi a butcher, Graciano a railwayman and blacksmith, and Manuel Martins was an apprentice goldsmith. Although avant-garde artists considered them to be traditionalists, they did contribute to the development of an artistic expression that paid attention to the purely technical aspects of painting, which were usually neglected by the exponents of more advanced movements.

Francisco Rebolo Gonzales (1903–1981) painted landscapes (page 237), figures and still life paintings, using delicate colors out of preference.

Mário Zanini (1907–1971) painted the outskirts of São Paulo with sincere involvement, sometimes producing still life paintings, scenes from everyday life and compositions that are almost abstract, partly influenced by the work of Cézanne, and that stand out for their intense fauvist colors (page 234).

The descendant of an ancient family of Tuscan artists, Fúlvio Pennacchi (born in Villa Collemandina in 1905) studied at the Lucca academy before emigrating in 1929 to Brazil where he was forced to hold several jobs to survive. He established himself as a painter only after 1962. His paintings, frescoes and ceramics depict both religious subjects inspired by the Italian Renaissance tradition and landscapes and scenes of Brazilian life with a deliberately popular flavor (page 235).

Born in Araras in the state of São Paulo in 1907, Clóvis Graciano was a pupil of Waldemar da Costa from 1935 to 1937 and at the same time attended a drawing course at the Escola Paulista de Belas-Artes. Faithful to an expressionist style, Graciano was later influenced by Portinari, cubism and the Mexican mural painters. He usually depicted people dancing (page 234).

Aldo Bonadei (1906–1974) studied with Pedro Alexandrino, a specialist in still life painting, between 1923 and 1928 and later perfected his studies in Florence from 1930 to 1932 under Felice Carena. Starting from a realist interpretation of still life, Bonadei's painting gradually developed toward abstract layouts, depicting city streets, compositions of bottles, and landscapes that reflect cubism but express a lyrical mood (page 236–237).

Born in Lucca, Italy, in 1896, Alfredo Volpi came to Brazil with his family when he was just over a year old. He began to paint at eighteen but not until 1951 could he dedicate himself to paint-

Alfredo Volpi (born 1896), *Reclining Nude*, 1945. 30.31″ × 57.87″ (77 cm × 147 cm). Artist's collection.

Right, Alfredo Volpi, *Mulatto Woman*, 1943. Oil on canvas, 31.49″ × 25.59″ (80 cm × 65 cm). Antônio Maluf Collection, São Paulo.

ing as a professional. His early paintings, landscapes and interiors combine naturalistic details with others of an expressionist style, but only in the series of seascapes painted around 1939 at Itanhaém does the artist show a definite mastery of styles. A simplification process begun in the forties (pages 338 and 339) led Volpi in the following decade to the series of stylized urban views (1950–1955), concretist works (1955–1960) and finally compositions with strips and flags, usually done in tempera, purely for color effect (pages 240–241).

On May 25, 1937, the first Salão de Maio was opened at the Esplanada Hotel in São Paulo organized by the painter, sculptor and art critic, Quirino da Silva, assisted by Geraldo Ferraz, Paulo Ribeiro de Magalhães, Flávio de Carvalho and Madeleine Roux. Only Brazilian artists or foreign artists living in Brazil took part; they included Lívio Abramo, Tarsila, Brecheret, Flávio de Carvalho, Waldemar da Costa, Guignard, Ernesto de Fiori, Cícero Dias, Gomide,

Portinari, Santa Rosa and Segall.

The second Salão de Maio opened on June 27, 1938, again at the Esplanada Hotel, and as a novelty presented a group of English surrealists and abstract painters, including Ben Nicholson. Among the Brazilian artists were a few members of the Grupo Santa Helena. The exposition was accompanied, as in the previous year, by conferences and debates organized by Geraldo Ferraz, Quirino Campofiorito, Jorge Amado, Graciliano Ramos and other intellectuals.

The third and last Salão de Maio was organized in the Galeria Itá in 1939 by Flávio de Carvalho. About forty artists showed their work, including some famous foreigners such as the American, Alexander Calder, who for the first time introduced his mobiles to the Brazilian public.

Quirino da Silva (born 1902) completed his studies at the Escola Nacional de Belas-Artes, then left Rio, his home town, to settle in São Paulo, where for years he has been busy as an art critic,

which seems to have taken him away from actual creative production. He painted nudes and landscapes (page 242).

Tomás Santa Rosa Júnior (1909–1956) was a painter, engraver and scenographer. *Fishermen* (page 242) is one of his most famous works, but he should also be remembered for his work as an illustrator—various books by Brazilian writers are enriched by his engravings.

One of the chief exhibitors at the Salão de Maio was the Italian, Ernesto De Fiori (1884–1945) who, after studying in Munich under Otto Greiner, at first dedicated himself to painting, adopting a style similar to that of Ferdinand Hodler. In 1911, in Paris, he began to study sculpture and produced his early sculptural works under the influence of Maillol and Degas. In 1914 he moved to Berlin and after the first World War became one of the most sought-after sculptors in the German capital. With Hitler's rise to power in 1934, he fled from Germany to Brazil, settling at first in Rio and then in São Paulo, producing

numerous sculptures and paintings (page 243).

Only artists from the wealthier classes of society showed their works at the Salão de Maio, and the Família Artística Paulista was opposed to this state of affairs. Its members thought that the imposition of avant-garde art should happen gradually, not suddenly, and that "just as the modern lesson must be absorbed and studied, so the lesson of the past cannot be denied or wiped out." In 1937, after the first Salão de Maio, Paulo Rossi Osir, Waldemar da Costa, Vittorio Gobbis, Anita Malfatti, Joaquim Figueira, Hugo Adami and Arthur Krug, with the support of Vicente Mecozzi and Paulo Mendes de Almeida, organized an exhibition to which the exponents of the Grupo Santa Helena were invited. In May 1939, the second exhibition of the Família was opened and Portinari and De Fiori also took part. The third was held in 1940 in Rio de Janeiro, with the support of new artists like Carlos Scliar and Bruno Giorgi.

The most important exponent of the Família Artística Paulista was Waldemar da Costa (born in 1904) who had studied in Portugal and in France. On his return to Brazil his painting was eclectic in style, according to what he had seen in Paris, and was expressed in still life paintings, landscapes and figured subjects dominated by the order of the composition. After an expressionist phase, Waldemar da Costa finally arrived at purely abstract solutions.

The Grupo dos 19

In April 1947 in the União Cultural Brasil-Estados Unidos rooms, a group of young expressionist artists introduced themselves to the public in their first and only collective exhibition. The idea was the brainchild of Maria Eugênia Franco, and Rosa Rosenthal Zuccolotto assisted in its organization while the critic Geraldo Ferraz signed the introduction in the catalogue which showed the name of the exhibitors on its cover: "Grupo dos 19."

The exhibitors were Aldemir Martins, Antônio Augusto Marx, Cláudio Abramo, Lothar Charoux, Enrico Camerini, Eva Lieblich, Flávio Shiró, Huguette Israel, Jorge Mori, Lena (Maria Helena

Left, Alfredo Volpi (born 1896), *Flags and a Pole*, 1965. Tempera, 28.34″ × 57.08″ (72 cm × 145 cm). L. Biezus Collection, São Paulo.
Below, Alfredo Volpi, *Strips*, 1957. Tempera on canvas, 28.74″ × 14.17″ (73 cm × 36 cm). João Marino Collection, São Paulo.

Milliet F. Rodrigues), Luís Andreatini, Marcelo Grassmann, Maria Leontina, Mário Gruber, Otávio Araújo, Odetto Guersoni, Raul Müller Pereira da Costa, Luís Sacilotto and Wanda Godói Moreira. The prizes for painting were awarded to Mário Gruber, Maria Leontina, Aldemir Martins and Flávio Shiró, with Cláudio Abramo mentioned for drawing.

As a movement, the Grupo dos 19 turned out to be an ephemeral one, since the differences between the artists only became more accentuated over the years, but a few of its exponents became important personalities in contemporary Brazilian painting. Lothar Charoux (born in Vienna in 1912) came to Brazil in 1928 and was a pupil of Waldemar da Costa. At the time of the Grupo dos 19 Charoux's painting was figurative and typically expressionist, as shown in his brightly-colored landscapes and still life pieces, but he later adopted a geometrical abstract style which echoed "op" art (optical art). Maria Leontina (born in 1917) from São Paulo was also a pupil of Waldemar da Costa and after the 1947 exhibition began a long process of stylistic development which led her, around 1963, to a plainly nonfigurative, informal style.

A draftsman, engraver, illustrator and painter, Aldemir Martins (born in 1922) from Ceará was struggling, together with other artists in Fortaleza at the beginning of the forties, for the artistic renewal of the state of Ceará. He settled in São

Paulo in 1946 and at the time of the Grupo dos 19 was painting expressionist religious and social subjects alternated with regional themes. The latter eventually prevailed, making Martins one of Brazil's most well-known artists for his bandits, lacemakers, animals and flowers (page 244).

Born in Jaboticabal (São Paulo) in 1924, Odetto Guersoni received a scholarship from the French government in 1948 and learned the techniques of engraving in Paris. Two years later he returned to São Paulo and founded the Oficina de Arte. In the early sixties he developed a new printing process, plastigraphy, which hot-engraves over a chalk, white lead, or oil-based support (with other materials also being used). Guersoni's engravings have gone from expressionism, in the beginning, to a fashionable geometrical abstract style.

Luís Sacilotto (born in 1924), painter, sculptor and designer, was, at the beginning of the fifties, one of the pioneers of concrete art in Brazil, alongside Waldemar da Costa, taking part in all the relevant exhibitions being held in the country.

Engraving, from the woodcut to the aquatint, is the only means of expression

Tomás Santa Rosa Júnior (1909–1956), *Fishermen*, 1943. Oil on canvas, 21.25″ × 24.01″ (54 cm × 61 cm). Museu Nacional de Belas-Artes, Rio de Janeiro.

Left, Quirino da Silva (born 1902), *Landscape*. Oil on board, 11.81″ × 15.74″ (30 cm × 40 cm). Carolina Penteado Silva Telles Collection, São Paulo.

Ernesto De Fiori (1884–1945): *below left*, *Brazilian II*, 1938; plaster, 34.25″ (87 cm); Museu de Arte de São Paulo, São Paulo; *below right*, *Lady*, 1942; oil on canvas,

43.30″ × 35.43″ (110 cm × 90 cm); Antônio Maluf Collection, São Paulo.

adopted by Marcelo Grassmann (born in 1925) to depict his horsemen and fantastic animals which, in a dreamlike atmosphere, portray the fear of humankind in the face of mystery and the supernatural (pages 6 and 245).

Just as unreal is the last phase of Otávio Ferreira de Araújo (born in 1926) who, after having been the assistant of Cândido Portinari in Rio de Janeiro and after a long stay in the Soviet Union (1960–1968), on his return to Brazil

abandoned expressionism for surrealist painting closely linked to fantastic art of all periods, from Bosch to Arcimboldo, from eighteenth-century visionary artists to twentieth-century symbolists and surrealists.

After a stay in Paris from 1949 to 1951, Mário Gruber (born in 1927) was prolifically active as an engraver and teacher in Santos, his home town. From 1947, when he was awarded a prize at the Grupo dos 19 exhibition for his indepen-

dence from European models and his interest in the Brazilian world, he always remained faithful to a form of expressionism that borders on the oneiric and supernatural (page 246).

Originally from Japan, Flávio Shiró (born in Sapporo in 1928) showed his landscapes and still life paintings, characterized by fretful, dramatic drawing, at the 1947 exhibition. Since 1953 he has lived partly in Paris and partly in Brazil. After having gone through

Aldemir Martins (born 1922): *left, Flower,*
1979; 33.46″ × 13.77″ (85 cm × 35 cm); private
collection; *below, Cat,* 1979, 31.88″ × 23.62″
(81 cm × 60 cm); private collection.

Above, Flávio Shiró (born 1928), *Dell's No.
3,* 1978. Gouache on paper, 25.59″ × 23.62″
(65 cm × 60 cm). Artist's collection.

various abstract stages, in recent years he has reached a fantastic, neofigurative style that echoes totemic art and ancestral beings through very violent colors (page 244).

Contemporary Engraving

Brazilian engraving started at the beginning of the nineteenth century due to the work of a series of European artists, mostly lithographers, who worked principally in Rio de Janeiro. Well-known engravings, however, appeared in the twentieth century thanks to pioneers such as Enrique Alvim Correira, Pedro Weingartner, Carlos Oswald, Laser Segall, Osvaldo Goeldi, Raimundo Cela and a few others.

Lívio Abramo (born in 1903) rep-resents the continuation of this phase and has served as a link with younger generations. Influenced, via Segall and Goeldi, by German expressionism at the beginning of his drawing career, he began work as a selftaught engraver in 1926. Lívio Abramo has passed from the drawings and engravings of the dramatic *Workers* and *Spain* series (1933–1938) to a more stylized expression in the *Festa, Rio* and *Macumba* series (1952–1954) and the numerous *Paraguay* series—prints, begun in 1957, which tend to enclose images within a formal framework (page 248).

Maria Bonomi (born in Meina, Italy) is one of Lívio Abramo's outstanding followers. With her teacher and João Luís Chaves, in 1960 she set up the Estúdio da Gravura in São Paulo. She produces abstract works (page 247).

Darel Valença Lins was influenced initially by Goeldi and later developed surrealist themes similar to those of the works of Marcelo Grassmann. A more prosaic vision of existence was given in the forties, however, by the Austrian, Axl von Leskoschek, who illustrated books and magazines and taught engraving to the Polish artist, Fayga Ostrower (born in Lodz in 1920), who from 1935 has turned to abstract art (page 249).

In 1950, Carlos Scliar, Glênio Bianchetti, Danúbio Gonçalves, Glauco Rodrigues and Vasco Prado were among the founders in Porto Alegre of the Clube de Gravura, whose intention was to spread social realism as "art for the people," turning toward subjects that illustrated the costumes and traditions of the *gauchos*, the herdsmen of the prairies

in Rio Grande do Sul. In the same year the German, Karl-Heinz Hansen (1915–1978), better known by his pseudonym Hansen-Bahia, arrived in Bahia, where he published various albums of expressionist-style woodcuts like *Brazil* (1951), *Calvary* (1952), *Flower of São Miguel* (1956), *Tribute to Dürer* (1970; page 249), and trained a great many pupils. He was one of the initiators, together with Mário Cravo and Henrique Bicalho Oswald, of the Bahian school, of which he is one of

the major exponents alongside his pupils Calazans Neto and Emanuel Araújo.

In Nordeste the tradition of popular printing and the example of Goeldi influenced the woodcuts of Newton Cavalcanti (born in 1930) and Gilvan Samico (born in 1928), who are often inspired by local fables and legends.

In 1959 on the occasion of the inauguration of the Ateliê de Gravura of the Museu de Arte Moderna in Rio de Janeiro, the engraver Johnny Fried-

laender was called to Brazil. For four months he held a course on various printing techniques and spread the theories, then currently prevailing, on abstract art. When Friedlaender returned to Europe, directorship of the Ateliê was taken over by Edith Behring (born 1916) who had been a pupil of Leskoschek and, in Paris, of Friedlaender himself and who supported the need for a strict technique as a means to producing perfectly constructed works. Edith Behring was later

Maria Bonomi (born 1935), *Caudal dos Improváveis*, 1976. Woodcut, 98.42″ × 39.37″ (250 cm × 100 cm). Artist's collection.

assisted at the MAM Ateliê by Rossini Perez, who was a pupil of Fayga Ostrower and, after the Friedlaender course, applied himself to abstract art, and by Ana Letícia (born 1929). A pupil of Camargo and Goeldi, Letícia always retained a distant recollection of vegetable forms and animals even in her nonfigurative works. In the sixties, she began a phase characterized by the use of virtuoso methods such as the simultaneous printing of different colors and the use of metal cuttings (page 250).

The MAM Ateliê produced engravers such as Roberto De Lamonica, Isabel Pons, Dora Basílio, Anna Bella Geiger and Marília Rodrigues. Indirectly linked to Edith Behring's school were João Luís Chaves, Sérvulo Esmeraldo and Artur Luís Piza, who had studied in Paris under Johnny Friedlaender. Piza, born in São Paulo in 1928 and now residing in the French capital, has replaced the figurative quality of his early paintings with abstract expressionism in engraving. His works stand out for their poetic and inventive intensity (page 250). Another noteworthy artist is Renina Katz. She was born in Rio de Janeiro and has been living in São Paulo since 1951. Interested above all in engraving, she deals with political and social themes with a lyricism that on occasion borders on the limits of abstract art (page 251).

The Spread of Modernism

São Paulo and Rio de Janeiro were the two centers in which modern art developed in Brazil, but in the forties, the new artistic tendencies began to spread to the other states of the country, gradually asserting themselves over the dominant traditionalist style.

In Rio Grande do Sul, the 1938 creation of the Associação Rio-Grandense de Artes Plásticas Francisco Lisboa by a group of artists which included Carlos Scliar and Edgar Koetz, marked the birth of a new artistic sensitivity which spread from Porto Alegre throughout the entire region. Shortly afterward, in the Instituto de Belas-Artes of the capital of Rio Grande do Sul, a group of teachers and artists was formed and included Vasco Prado, the sculptor, Paulo Flores and Alice Soares. The group adopted the new aesthetic ideals which, however, took root only in the fifties with the founding of the Clube de Gravura de Porto Alegre on the initiative

Right, Glênio Bianchetti (born 1928), *Making Jam*, circa 1952, Woodcut, 8.26″ × 10.23″ (21 cm × 26 cm). Museu de Arte Contemporânea, São Paulo. *Below*, Lívio Abramo (born 1903), *Rhythms and Architecture*, circa 1957. Woodcut, 8.26″ × 11.41″ (21 cm × 29 cm). Museu de Arte Contemporânea, São Paulo. *Opposite: left*, Karl-Heinz Hansen, known as Hansen-Bahia (1915–1978), *Tribute to Dürer*, 1970; engraving, 18.50″ × 14.56″ (47 cm × 37 cm); Museu de Arte Contemporânea, Rio de Janeiro; *right*, Fayga Ostrower (born 1920), *6621*, 1966; xylograph, 22.83″ × 15.74″ (58 cm × 40 cm); Museu de Arte Contemporânea, Rio de Janeiro.

of Glênio Bianchetti, Danúbio Gonçalves, Vasco Prado, Glauco Rodrigues and Carlos Scliar.

Glênio Bianchetti, born in Bagé (Rio Grande do Sul) in 1928, usually depicts the simple life of peasants (page 248) in his figurative and realistic works. Glauco Rodrigues (born in 1909), who initially produced only engravings, later moved on to painting as his chief means of expression. Marked by realism in the early years, his work was later characterized by a critical and at times humorous interpretation of the history of art (page 253). Carlos Scliar, a precocious artist born in 1920, began his career when he was about fifteen years old. In addition to his engravings, his paintings are especially worthy of attention. At first he tried expressionism, and then realism. He finally arrived at colored formal experiments especially in still life paintings, in which he also adopts the collage technique (page 252).

In Ceará modernist ideas began to spread in 1941, with the setting up of the Centro Cultural de Belas-Artes and the organizing of the Primeiro Salão Cearense de Pintura. Antônio Bandeira (page 253), Mário Barata, Clidenor Capibaribe, Barbosa Leite and Zenom Barretto took part in the activities of the center, as did Inimá de Paula from Minas Gerais, who settled in Fortaleza in 1941.

Juscelino Kubitschek, then prefect of Belo Horizonte, introduced modernism to Minas Gerais by inviting the architect Oscar Niemeyer to design the new Pampulha district in 1942. Among the buildings built was the Church of São Francisco, decorated by Portinari (pages 260–261), Burle Marx and Alfredo Ceschiatti. At that time Guignard, a painter, also arrived in the capital of Minas. He was called in by Kubitschek to direct the Escola de Belas-Artes which was to produce Mary Vieira, Lygia Clark and Amílcar de Castro. Again on the initiative of the prefect, a moden art exhibition was opened in 1944, and artists from other states also took part. This caused a scandal but helped to spread the new aesthetic ideals.

The Rumanian painter, Emeric Marcier, settled in Barbacena in 1947 and in his religious paintings, portraits and still life works synthesized the lesson of the avant-garde movements of the early twentieth century, especially that of Cézanne.

José Guimarães was responsible for the organization of the first modern painting exhibition in Salvador in 1932. That exhibition, however, was not followed up until ten years later when the modernists of São Paulo were introduced to the public in an exhibition put on by Manuel Martins in the Biblioteca Estadual. Amongst the exhibitors in 1942 were the extremely young Mário Cravo, Genaro de Carvalho and Carlos Bastos. In the second half of the forties the exhibitions at the Associação Cultural Brasil-Estados Unidos took place and many artists traveled abroad in search of new intellectual stimuli. At the end of 1948 the "Anjo Azul" cabaret, with decorations by Carlos Bastos, was opened and it became a sort of temple (or "den," according to rivals) of the new artistic, poetic and literary trends.

Above left, Ana Letícia (born 1929), untitled engraving, 1972. 19.29″ × 15.35″ (49 cm × 39 cm), Museu de Arte Contemporânea, São Paulo. *Below left*, Artur Luís Piza (born 1928), *Grande Moitié*. Colored burin engraving, 15.74″ × 21.65″ (40 cm × 55 cm). Museu de Arte Contemporânea, São Paulo.

Renina Katz (born 1925): *below, Prisons,*
1978; lithograph, 24.40″ × 16.53″
(62 cm × 42 cm); artist's collection; *bottom
right, Favela,* 1956; xylograph,
24.40″ × 16.53″ (62 cm × 42 cm); Edições Júlio
Pacello.

Above, Carlos Scliar (born 1920), *Still Life with Five Fruits*, 1969. Vinyl and waxed collage on canvas, 21.65″ × 29.52″ (55 cm × 75 cm). Michel Loeb Collection. *Right*, Julio Páride Bernabó, known as Carybé (born 1911), untitled Bahian scene, 1970. Oil.

Left, Antonio Bandeira (1922–1967), *Composition*, 1947. Private collection. *Above*, Glauco Rodrigues (born 1909), *Portrait of Quati-Puru Victorious*, 1977. Artist's collection.

In 1949 the Primeiro Salão Baiano de Belas-Artes was organized and modernists exhibited their works alongside those of traditionalist artists. Between 1949 and 1950 artists from other states who settled in Salvador included Jenner Augusto and Pancetti, in addition to the Argentine, Julio Páride Bernabó, known as Carybé, whose paintings have a central theme of human types and scenes of Bahia rendered with unquestionable technique (page 252).

In the decade that followed, Rubem Valentim, Raimundo de Oliveira, João Garboggini Quaglia, Agnaldo Manuel dos Santos, Calazans Neto, Hélio Oliveira, Emanuel Araújo, Sônia Castro and Fernando Coelho, in addition to Lênio Braga from Pará and the German engraver Hansen-Bahia, finally estab-

lished themselves.

Despite the presence of a few precursors like Hélio Feijó, Lauria, Augusto Rodrigues, Nestor Silva and Percy Lau who in the thirties had created the Grupo dos Independentes, the Sociedade de Arte Moderna in Recife, founded in 1948 by Abelardo da Hora and Hélio Feijó, had to break the ties, which still existed in Pernambuco, with traditional art and teaching. Reynaldo Fonseca, Ladjane and Corbiniano Lins were the main supporters of this break which was represented above all in the establishment of the Ateliê Coletivo. Between 1952 and 1957, the year it closed, the school produced Gilvan Samico, Guita Charifker, José Cláudio, Maria Carmen, Armando Lacerda, Wellington Virgolino, Marius Lauritzen Bern, Ionaldo Caval-

canti, Anchise Azevedo, Adão Pinheiro and Ivan Carneiro. João Câmara, José Barbosa and Ismael Caldas belong to the next generation. Lula Cardoso Aires, Vicente do Rego Monteiro and Francisco Brennand also worked in the town.

In Paraná, the artistic renewal movement began with the setting up of the magazine *Joaquim* and the establishment, in 1948, of the Escola de Música e Belas-Artes, where Poty Lazzaroto was a teacher.

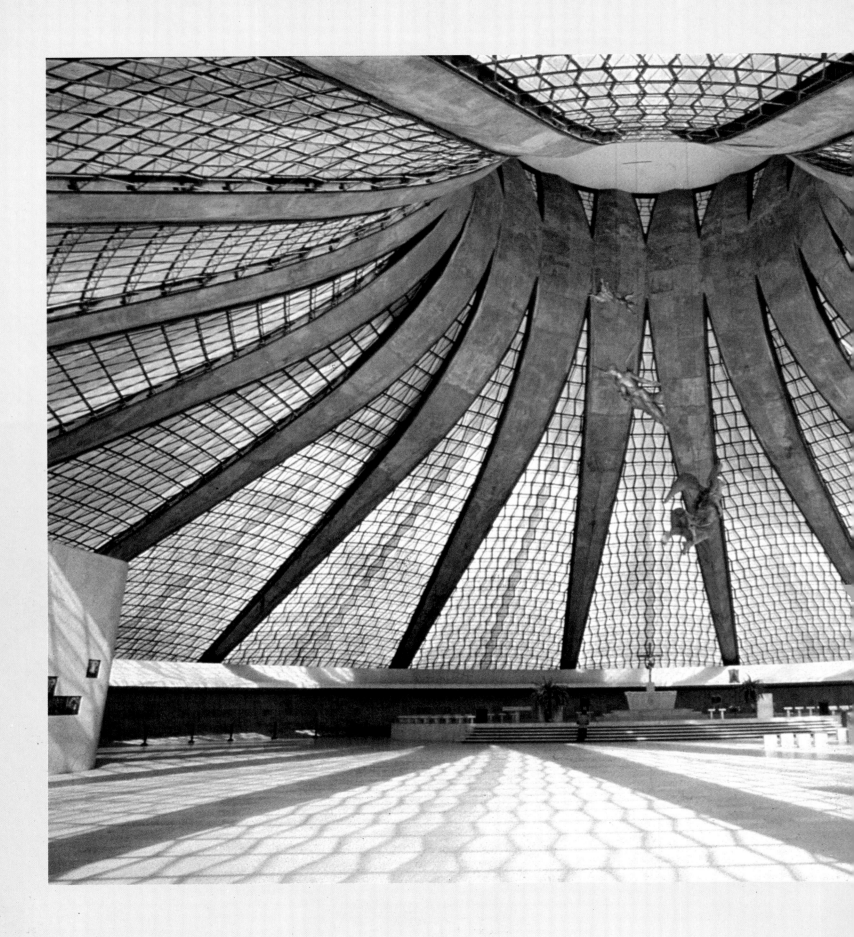

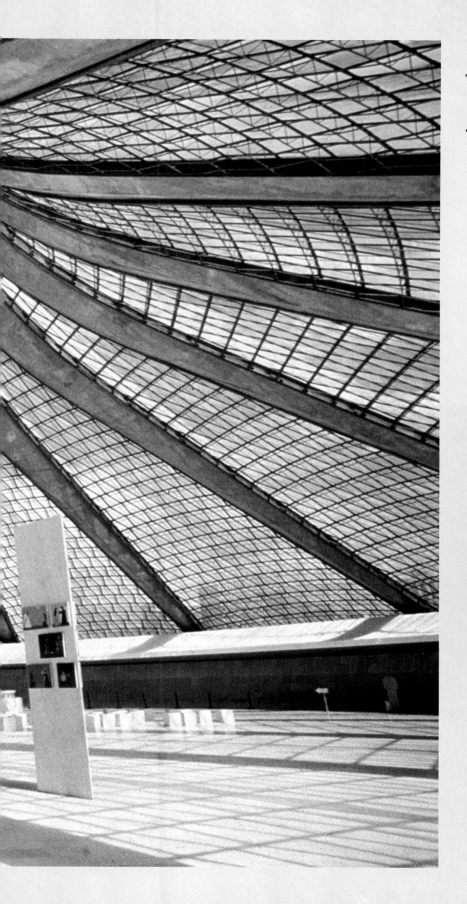

Modern
Architecture

Modern Architecture

As occurred with the other forms of artistic expression, there was confusion between modern trends in European architecture and those in Brazil which were formed in the forties when the Old World, by the second World War, had already assimilated its ideas on structural rationalism.

In Brazil all the new thinking on architecture was assimilated extremely slowly. This was partly due to the lack of independent schools of architecture (the profession of architect was inextricably linked to that of engineer) and the lack of leadership from professionals able to wield a collective influence and establish trends of thought.

The Twenties

The 1922 Semana de Arte Moderna had little influence on the architecture of São Paulo. The architects who took part were not familiar with the modern projects carried out throughout the world on the basis of structural rationalism. The panels exhibited at the Teatro Municipal showed a form of architecture tied to the past, with continuous masonry walls, echoing the styles of Franciscan missions in California. Even Antônio Moya, an architect who took part in the Semana and was to a certain extent considered to be receptive to modern innovations, was still, in 1940, many years later, in favor of eclectic constructions. In Rio de Janeiro, the situation was similar, with a few talented architects operating according to the rules of eclecticism.

But certain events that occurred in the twenties influenced the training of the early and rare supporters of the type of modern architecture practiced in Europe at that time. On October 15, 1925, Rino Levi published an article in *O Estado de São Paulo*, which spoke of the necessity to arrange for town planning since the growth of the cities was at the mercy of the whims of property speculators. About a fortnight later, in the Rio de Janeiro *Correio da Manhã*, the Russian architect, Gregori Warchavchik, who was firmly established in São Paulo, wrote his famous article, "On Modern Architecture," in which he defended the new concepts of the "machine à habiter," showing himself to be well-versed in Le Corbusier's theories. Le Corbusier's visit to Rio in 1929 opened the eyes of a few of the city's young professionals and gave impetus to others who already knew his

work, such as Lúcio Costa, who was later appointed as the director of the Escola Nacional de Belas-Artes. During his very short directorship of the institution, Lúcio Costa introduced basic reforms and, with his charismatic power, greatly influenced the students, giving them implicit encouragement to take important strike action for demands against the obsolete teaching methods.

The Golden Age of Art Déco

The thirties did not bring many examples of rational modernism. The decade was the golden age of art déco architecture, which had acquired a certain amount of popularity and, due to confusion resulting from a lack of information, was popularly called "futur-

ist," a name which had already been given to Warchavchik's "modernist house," on view to the public in the thirties. Art déco was present in São Paulo's early skyscrapers which sprang up after the pioneering Martinelli building (page 256), built in a mixture of styles dreamed up by its owner.

Art déco also inspired the buildings in Goiânia, the new capital of the state of Goiás, planned in 1935 by Atílio Correia Lima. According to a descriptive document attached to the contract signed by the Goiás administration, the architect took advantage of the "effects of perspective" to achieve, while "keeping the right proportions," the monumentality of the "classical principle adopted in Versailles, Karlsruhe and Washington."

In the thirties, the use of reinforced

On the previous pages, the interior of Brasília cathedral, by the architect Oscar Niemeyer (born 1907), built in 1970. Opposite, the Martinelli building, São Paulo, opened in 1929. At the time it was built, this construction (designed by its owner) was the tallest in Latin America. Left and below left, two views of the exterior of the house erected on Santa Cruz road in São Paulo by Gregori Warchavchik (1896–1972) in 1927. The building is considered to be Brazil's first modern house. Below, the present-day Palace of Culture in Rio de Janeiro, planned as the Ministry of Education and Health and designed in 1936–1937 by a team headed by Lúcio Costa (born 1902). It was completed in 1943.

concrete spread and apartment blocks were finally accepted, introducing a collective living arrangement which had until then been rejected by the bourgeoisie. Despite the appearance of this novelty, the projects of those who wanted modern architecture to become established were isolated and personalist. The public at large was totally estranged from arguments concerning aesthetics and the individual exponents of the financial élite at the forefront showed themselves to be insensitive to innovation. Very often, important clients, contractors of large works, tolerated, without much conviction, modernist projects they could neither judge nor appreciate.

The modern architects of that time did not win over the public. Warchavchik, with his newspaper article, his modern house (page 257) and his brief attempt at teaching in Rio de Janeiro, had no followers. Flávio de Carvalho merely shocked people and his work was not taken seriously. The Esther building, the first really modern one in São Paulo, received no greater attention and was practically the only work of its architect, Álvaro Vital Brasil, in the city.

The Great Milestone of Modern Architecture

In Rio de Janeiro, the prospects were not very different from those explained above, as regards the architects' private clientele. As for the style of state ventures, decisions were made according to the opinions of those who were in power. For this reason Brazilian architecture owes a great deal to the fact that, in 1935, the men at the head of the Ministry of Education and Health were enlightened and receptive to innovations. These men were Gustavo Capanema and Rodrigo Melo Franco de Andrade, the future head of the historical and artistic heritage department. In that year a prize-giving competition was held to select the project for the new headquarters of the Ministry.

The prizes were awarded to academic and dull projects, to the detriment of young modernist architects. This time, paternalism worked in an unusual way. With the backing of a group of modern critics, including Mário de Andrade, Capanema paid the prizewinners and placed obstacles in the way of starting on the work. He then sent for Lúcio Costa, one of the rejected modern architects,

Below and right, the Museu de Arte Moderna in Rio de Janeiro, erected in 1954. It is the work of Afonso Eduardo Reidy (1909–1964) who designed the structure of the building so it would not block the view of the Bay of Guanabara.

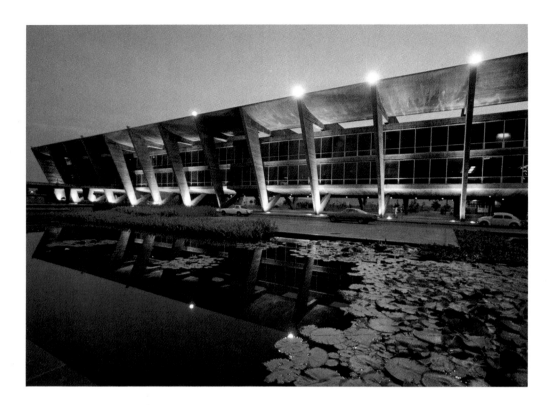

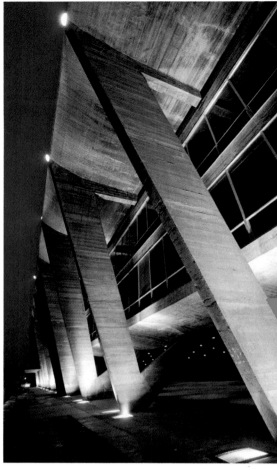

and urged him to produce another project within the scope of the new architectural outlook. Lúcio Costa made one condition: that his unplaced companions should also be called in. Thus a historic group was formed, comprising Lúcio Costa at the head, Carlos Leão, Jorge Moreira and Afonso Eduardo Reidy. They were joined by Oscar Niemeyer and Ernâni Vasconcelos.

In 1936, when the project was ready to be judged, Lúcio Costa suggested that Le Corbusier be called in to express his opinion. The architect accepted the invitation and studied alternative locations and the advantages of the building with the group. In August he gave a series of lectures which sparked off a trend in Rio architecture under the aegis of his functionalist theories. In January 1937 the final project, a variant of the solution proposed by Le Corbusier, was submitted to the ministry. In 1943 the building was completed and constituted the great milestone of modern Brazilian architecture (page 257).

In Search of a National Style

After Gustavo Capanema's historic decision, and thanks to Rio's pioneers who were imbued with the ideas of Le Corbusier (some of them, however, also heedful of the example set by Gropius and Mies Van der Rohe), Brazilian architecture established itself as a national cultural style, conceptually independent from the European models from which it originated. This establishment occurred in a difficult period for European architecture which, due to the second World War, could no longer have a direct and immediate influence. At that time, when iron was scarce, Brazilian experts in reinforced concrete calculation achieved real marvels in economy. All of them began the search for common solutions to problems that until then had only been imagined. Emílio Baumgart, an expert on concrete, and Joaquim Cardoso, an engineer, specializing in concrete and a poet, were of fundamental importance.

With the same proposal of modernist renewal, artists were searching for a Brazilian form of expression in their works which was within the scope of the theories of functionalism. They even revived the old trellises and the traditional *azulejos* to cover facades. In short, anything was used that could serve as a bridge between the authentic past and the modern innovations of reinforced concrete with its *pilotis*, roof gardens and *brise-soleil*.

Various artists took up positions alongside Oscar Niemeyer who, in 1939, replaced Lúcio Costa at the head of the group responsible for the construction of the Ministry building. Those working on special aspects included Roberto Burle Marx, the landscape architect (page 266); Cândido Portinari, who painted large panels including *azulejos*; Bruno Giorgi, the sculptor; and other artists and intellectuals who created an atmosphere of euphoria and pioneering creativity and were all conscious of doing something new and important.

In fact, the first international recognition of the quality of Brazil's new architecture was in 1942 when the New York Museum of Modern Art put on an exhibition of modern Brazilian architecture from which came the book *Brazil Builds*. This work mentions, in addition to the Ministry of Education and Health, the Brazilian Press Association building (1936) by the brothers Milton and Marcelo Roberto, the works of Luís Nunes, responsible for important projects in Nordeste, such as the Olinda water reservoir, and works by Warchavchik, Rino Levi, Henrique Mindlin (page 267) and others.

This publication, however, left out one

Below, a drawing by Le Corbusier (1887–1965) dating from 1936, when the French architect was sent to Rio de Janeiro to examine the Ministry of Education and Health project.

Bottom, the Itália building, designed by the Czechoslovakian exile, Adolf Franz Heep (1902–1978), who came to São Paulo in the late 1940s. The top floor is one of São Paulo's tourist attractions.

of the greatest Rio architects of this generation: Afonso Eduardo Reidy, "the impeccable veteran," as Lúcio Costa called him. Although born in Paris, of a Scottish father, Reidy's architecture was deeply rooted in Brazilian culture. After a brief experience in 1930 as Warchavchik's assistant at the Escola Nacional de Belas-Artes, at that time directed by Lúcio Costa, Reidy dedicated almost his entire career to the construction of public works. In the Rio de Janeiro Prefecture he was head of the Architecture Department, head of the Low-income Housing Section and several times Director of the Town Planning Department. His greatest interest lay in far-reaching programs, almost always intended for the low-income population—a very rare concern in Brazilian architecture. His outstanding works, apart from the Museu de Arte Moderna built in 1954 (page 258), are the local theater in the Marechal Hermes district (1951) and the residential complexes in Gávea (1952) and Pedregulho (1950).

The Pioneers of Modern Architecture in São Paulo

In the forties, architects in São Paulo showed signs of unrest as a collective attitude was forming toward modernity. This coincided with the arrival of good foreign architects who were war refugees, and the setting up of a Faculty of Architecture at São Paulo University and the Mackenzie University.

The chief representatives of this new trend were Rino Levi and Osvaldo Bratke. Rino Levi had studied in Italy, and, once in Brazil, began to design buildings that stood out against the urban landscape. At that time São Paulo was on the point of experiencing a "metropolization" process with no laws or imagination, characterized by a lack of public funds and the indifference of those in government. Levi's professional reliability resulted in plain, ordered and well-thought out buildings, as exemplified by his hospitals. Credit must be given to Bratke for spreading modernism or contemporary rationalism and encouraging its final acceptance by the middle classes and the élite of São Paulo. Bratke became famous when, at the height of the World War, he devised solutions that could do without imports, which were paralyzed at that time.

Among the refugees, Adolf Franz Heep stands out. Born in Czechoslovakia in 1902 he was responsible for the design of the Itália building (page 259), the

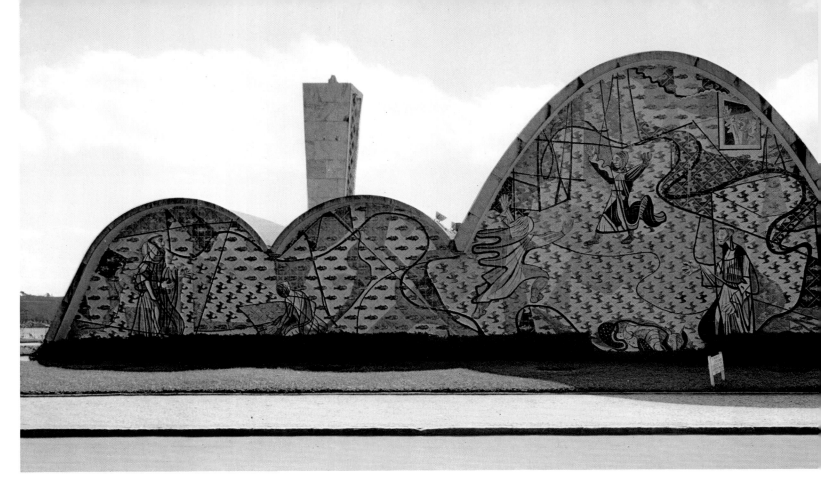

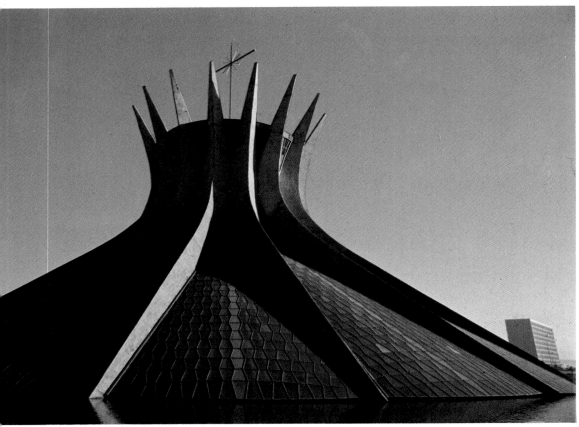

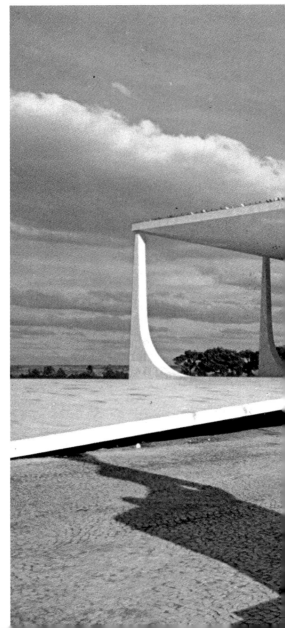

Above, detail of the exterior of Brasília cathedral, built by Oscar Niemeyer in 1970. Sixteen columns support a network of windows. (The interior is shown on pages 254–255).

Right, Brasília's Supreme Federal Court, designed by Niemeyer and completed in 1958. The statue of *Justice* (in the foreground) is by Alfredo Ceschiatti (born 1918).

Church of São Domingos in Perdizes and the building for the *O Estado de São Paulo* newspaper.

The Consecration of Niemeyer

Juscelino Kubitschek, the prefect of Belo Horizonte in the early forties, commissioned Niemeyer to design the famous architectonic complex in Pampulha. It was with this work that Oscar Niemeyer Soares Filho from Rio, who was born in 1907 and graduated in 1934 from the Escola Nacional de Belas-Artes, established himself as an architect, demonstrating all his creative ability. For the first time he compelled reinforced concrete to shape itself into unexpected forms. He departed from the rationalist models which, until then were made captive by an organized tectonic form and were dominated by straight profiles, as if iron and reinforced concrete were not allowed to have curving surfaces which, with certain pleasure, delimit spaces, as Aleijadinho's baroque sculptures managed to do with stone. Niemeyer's innovation made dimensions different and the empty spaces greater and freed the equations of curves from the symmetrical and uniformly distributed orderliness of the old domes and vaults. Freedom prevails with the ease of conquering empty spaces.

The small church of São Francisco (page 260–261) in Pampulha, initially rejected by the clergy, is a milestone. It is the first Brazilian church with a really modern appearance and its spaces are defined by its concrete vaults, a far cry from the prismatic large room of the traditional churches, which had one nave and were so popular in the eclectic period. Portinari's panels, both the

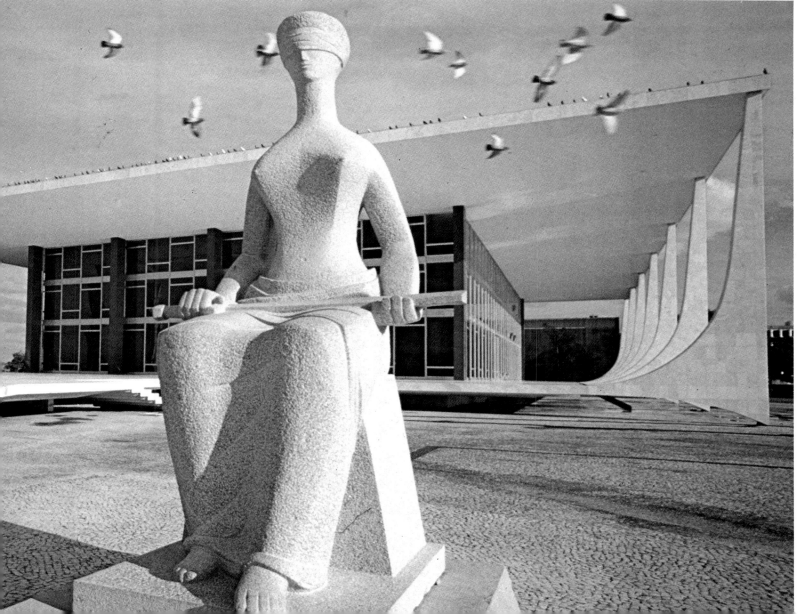

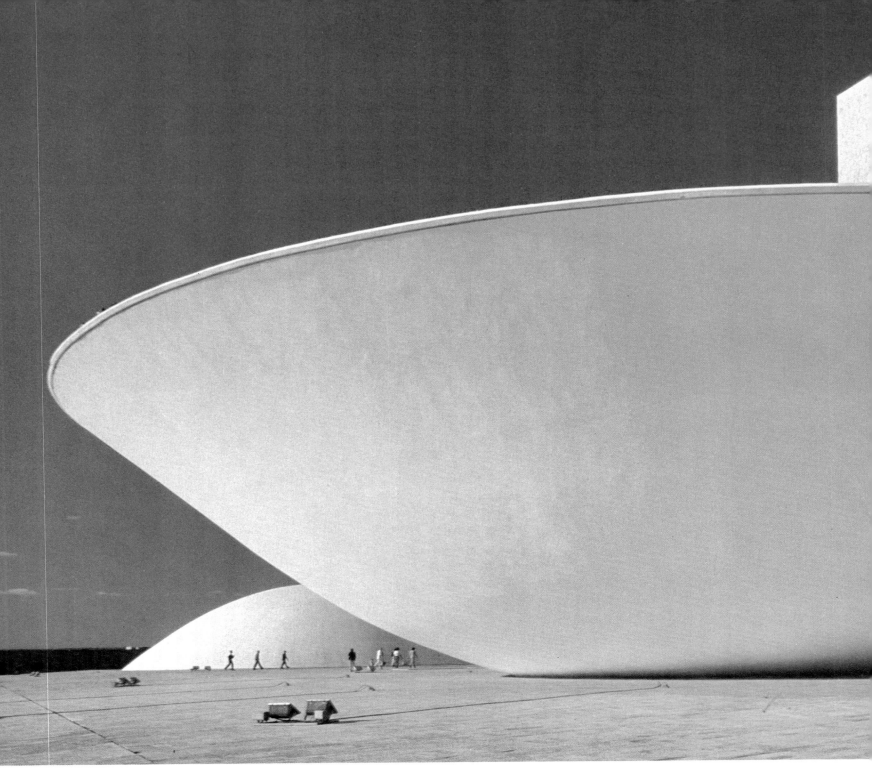

Brasília's National Congress, built in 1958 on a design by the architect Oscar Niemeyer, is made up of three units: the Senate bowl (in the foreground), the two towers containing the Administrative Offices (behind) and the dome of the Chamber of Deputies (in the background).

azulejos and the one in the interior (which eliminates the altarpiece, until then indispensable) are another break with the past, despite the fact the *azulejo* as an external surface was a very old custom along Brazil's coast.

After his works in Pampulha, Niemeyer's career continued to progress, both in the importance of his works and the quality of the projects. Even after so many years, his work still shows great creative ability, a continuous search for solutions. This search is not an indication of dissatisfaction with previous discoveries, but shows a desire fully to explore the plastic possibilities of a material whose use is not restricted to

half a dozen formulas and technical standards.

Many cities in the world were planned as a whole and built according to projects and decisions made by governments, but none emerged, like Brasília, from the determination and ingenuity of just three people: President Juscelino Kubitschek, the town planner Lúcio Costa and the architect Oscar Niemeyer. Obviously, the construction group, headed by Israel Pinheiro also played an important part in carrying out the initiative. The idea of the new capital did not come from Juscelino Kubitschek, but the necessary courage and persistence in reaching the goal did.

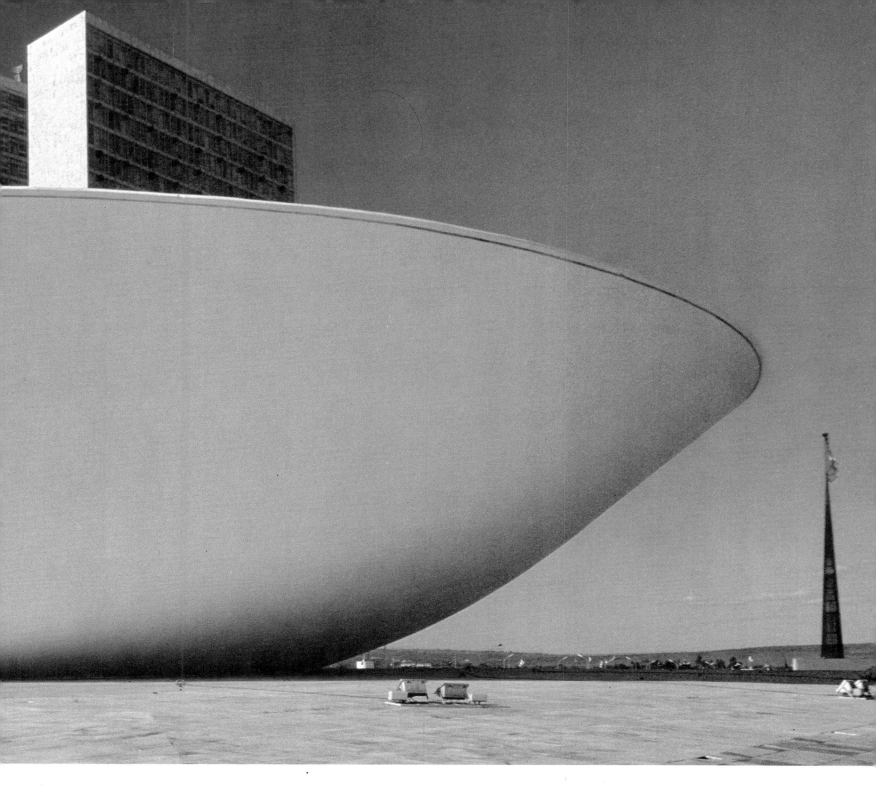

The Creation of Brasília

The plan of Brasília is the personal work of Lúcio Costa, unlike the other competing plans that came from groups with varied disciplines. The plans of all the important buildings are by Oscar Niemeyer, who made decisions and was behind the plans of almost all the other buildings of the first phase, which preceded the 1964 revolution.

Having won a competition that had been published at that time, Lúcio Costa demonstrated his enormous intellectual and artistic ability, justifying his position of leadership from the pioneering times of the Ministry of Education and Health.

As for Oscar Niemeyer, he gave continuity to his highly personal work, already established in the Pampulha project. In addition, the Brasília project gave Niemeyer valuable opportunities to design large architectural complexes on his own. These would usually have been assigned to various architects, resulting in a lack of plastic unity. Brasília is, then, the exclusive accomplishment of a single architect, an architect who has certainly managed to impose an image of modernity even beyond the limits of the planned city and to create symbols of national unity (pages 254–255, 260–261, 262–263). For example the model of the column of the Palace of the Alvorada is

still copied widely today, not only in public buildings, but also in objects and paintings produced and consumed by the people at large, especially in the bodywork of trucks.

Execution of the Project

Once he had risen to power, Juscelino Kubitschek, fulfilling a promise he made during the electoral campaign for the presidency of the republic, created *Novacap*, a body headed by Israel Pinheiro, which began a survey of the chosen site and organized a public competition to select the "pilot plan" of the future capital. When judging the com-

Below, the Faculty of Architecture and Town Planning in São Paulo, opened in 1969, is the work of João Batista Vilanova Artigas (born 1915).
Right, country bus service depot of Jaú (São Paulo), designed by Artigas.
Bottom, the mineral spa in Aguas de Prata (Minas Gerais). Designed in 1970 by João Walter Toscano and completed in 1974.

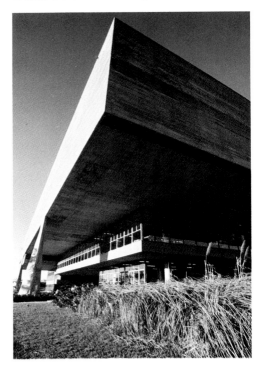

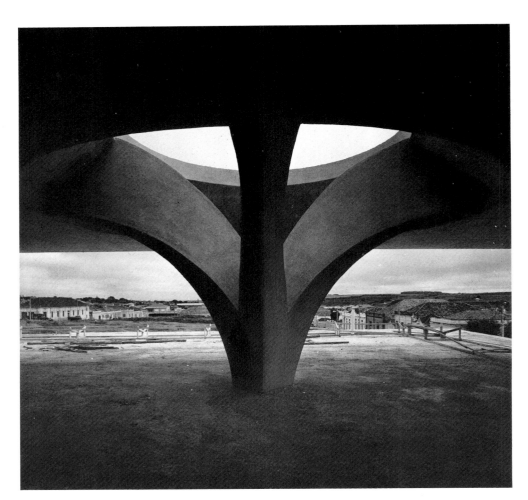

Below, the Tambaú Hotel, situated on Tambaú Beach in João Pessoa (Paraíba), is the work of Sérgio Wladimir Bernardes (born 1919) and was built in the 1970s.

Bottom, the Petrobrás building in the state of Rio de Janeiro is the work of the architect J. M. Gandolfi and has a delicate combination of grandeur and modernity.

Below, the Banco do Brasil in Andaraí (Rio de Janeiro), designed by Maurício Roberto in 1969. *Bottom*, Ponte Pequena metro station, by the architect Marcelo Fragelli.

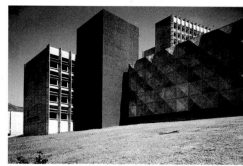

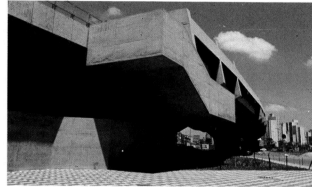

petition, in which various groups of Brazilian architects took part, the commission chose Lúcio Costa's plan.

In the introduction to his famous report, Costa stated that Brasília was to be the beginning of regional planning of a development area and that it was to be "a deliberate act of taking possession, a gesture with the effect of a plough breaking earth, in the mold of the colonial tradition." It was not to be just any modern city, considered as *urbe*, but "a *civitas* in possession of the inherent attributes of a capital" which, among its qualities, was to have a monumentality conscious of its values and meaning. Costa's plan emerged from the first gesture made when taking possession of a place: the marking of two intersecting lines at right angles, that is, "the sign of the cross." From this graphic expression of two intersecting lines, Lúcio Costa worked out all the conditions and arrangements of the urban facilities that he had provided for, in the fluent, imperative style of one who is certain that he holds the correct and only solution. His twenty-three paragraph text is interspersed with small, freehand drawings, which are apparently very spontaneous, but extremely correct and precise in their definitions. Clearly, not everything was carried out as the architect had en-

Below, the monumental State Audit Court building of the town of São Paulo, by the architects Croce, Aflalo and Gasperini. The building covers an area of 95,798.71 feet squared (8,900 m²).

Bottom, the Treasury of the state of Ceará, designed by Gerson Borsoi. The building is in exposed concrete, a medium that is invariably used in modern public buildings. The gardens are by Burle Marx.

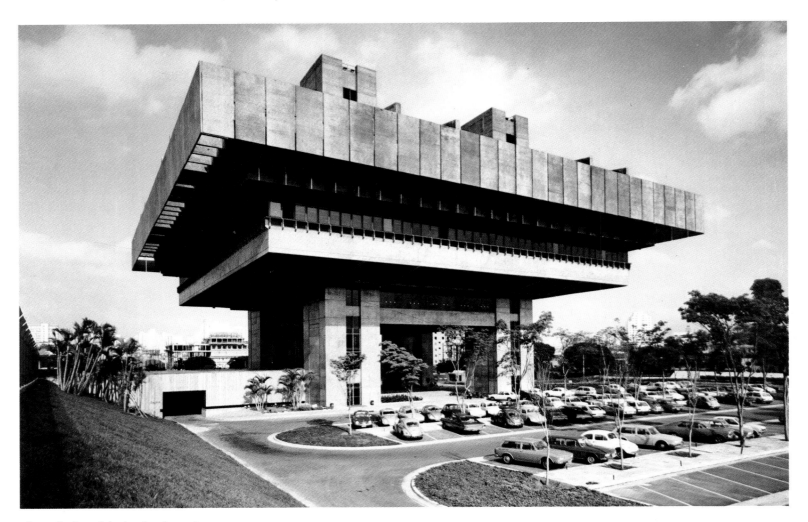

visaged, but his basic thought was expressed in the design of the monumental axis marked by the Square of the Three Powers and the television tower.

Foreseeing the development of the automobile industry, the city was planned along roads punctuated with four-leaved clovers to ease traffic. The architect expressed a certain naivety when he said that in order "to avoid degeneration into *favelas*" in the future city, it was up to the developers "to provide within the proposed scheme, decent and economical accommodation for the entire population." In fact, to Niemeyer's great disgust, the *candango* who built the city was relentlessly expelled into the unplanned "satellite towns," such as the so-called núcleo Bandeirante.

The Triumph of Functionalism

According to the critic Yves Bruand, "it is easy to understand why Le Corbusier's work fell on particularly receptive

Left, Banco do Estado do Rio de Janeiro, designed by Henrique Mindlin (1911–1971). *Bottom*, Forum do Piauí, designed by Gerson Borsoi and made of exposed concrete.

Below, São Paulo's subway station, by Croce, Aflalo and Gasperini. The building is made of glass and cement.

ground: having spread on a large scale in an accessible style, it was not only the best solution of all as regards local material conditions, but it also satisfied Brazilian sensitivity thanks to a combination of rather simplistic Cartesian strictness and visionary enthusiasm of a prophetic nature." The construction of Brasília influenced several generations of architects. The youngsters who were graduating at that time felt, in the face of the monumentality of the project, that they were masters of a profession capable of having a serious effect on the destiny of the nation. Even those who were not in favor of the new capital considered this architectural adventure to be a point of reference.

Always taking Le Corbusier's functionalism as a basis, the group most directly influenced by Niemeyer is characterized by a lasting plasticity of style, a delicacy in the treatment of materials and a lightness in composition, giving rise to a sort of "beautiful" rationalism. These principles, widely spread by Niemeyer, were reflected in almost all the major modern architectural works but flourished above all in Rio de Janeiro. The main followers of this trend are the architects Glauco Campelo (page 268), João Filgueiras Lima and Rui

Ohtake (page 273).

João Filgueiras Lima, closely linked to the designers of Brasília, has built various public works such as the hospital in Taguatinga, a satellite town of Brasília. In the seventies, Filgueiras designed some of the most original constructions of the monumental architectonic complex which makes up the Administrative Center of the state of Bahia (CAB) in Salvador. The architect designed five buildings which actually comprise five long curved platforms on pillars, spaced apart down the hill slopes. The number of floors can vary from one to three, and each building can grow horizontally and vertically due to a special connecting system of prefabricated modules (page 269). Another very creative and economical solution was the elimination of air conditioning by a system of natural ventilation through a central chimney.

CAB was built in just three years at the "Brasília pace," that is, working twenty-four hours a day. The general design, the road system and the arrangement of the gardens were the work of Lúcio Costa and Burle Marx. Both the layout of the roads and the siting of the buildings were dictated strictly by the principle of respect for the landscape and maintenance

The Exhibition Palace, designed by Glauco Campelo, belongs to the Administrative Center of the state of Bahia in Salvador. The center is the work of several architects.

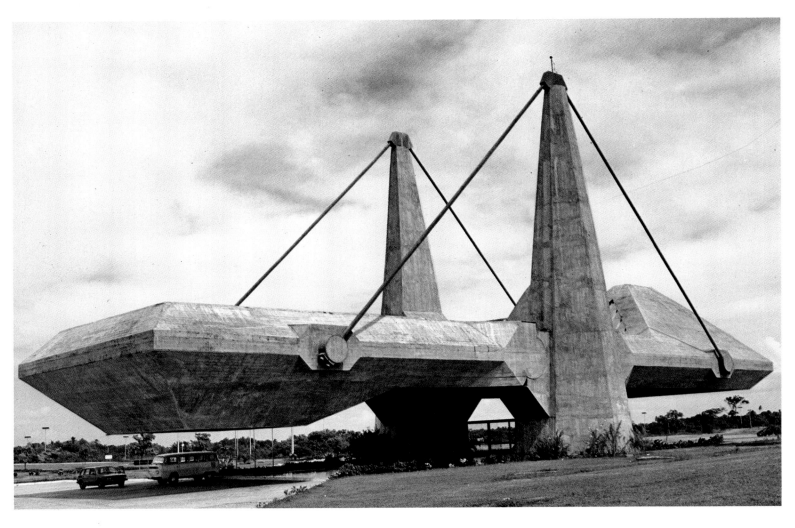

of ecology, preserving the hills, trees, valleys and caves. The flat areas were given over to parking lots since the buildings themselves were built on the slopes.

In order to avoid monotony, there is no architectural uniformity. Each project took into account the specific characteristics of public service, which requires frequent changes. The module system was adopted so that each secretariat could be extended depending on future needs. The Planning Secretariat, for example, comprises one basic building and fifteen modules. In addition, there is a large expanse of land on which more modules can be built if necessary.

Resistance in São Paulo

The triumph of Le Corbusier's principles, seized upon and transformed by Niemeyer's circle, came up against active, although limited, resistance from the architects of São Paulo who were seeking renewal through other channels.

While in the Escola Nacional de Belas-Artes in Rio de Janeiro ideas of plastic rationalism were at their height, some architects in São Paulo sympathized with the organic principles of Frank Lloyd Wright. They rejected architecture based on abstract reason and geometry in favor of natural or psychological functionalism where intuition and inner feelings predominated, and they were therefore totally at odds with rationalist ideas.

The organic school showed apparent modesty, rejecting all things monumental, which were so cherished by the followers of Le Corbusier. Its main aim was simplicity, which tended to become lost in the landscape. The materials used were preferably traditional (stone, wood, brick, tiles) and projects gave greater priority to the interior than to the exterior. More than anything else, organic architecture rejected strict rules:

what was important was the psychological motivation of the people who were to occupy the space. This set of clearly romantic ideas influenced, although only for a short time, the early works of Vilanova Artigas, who was to become the driving force behind São Paulo's architecture. Apart from him, Miguel Forte, Jacob Ruchti and Galeano Ciampaglia designed residences of an intimist style which were in close harmony with nature. Roberto Lacase's residence, designed by Artigas in 1938, is situated on a hilltop and tends to disappear in the greenery that surrounds it. The materials used are extremely simple: bricks for the walls, tiles for the roof, wood for the exposed beams and stone for the rustic flight of steps leading up to the front door.

After 1945, Artigas abandoned organic inspiration and for some time fell in with Le Corbusier's functional rationalism, finally settling on a style which was to be

his hallmark: brutalism. This type of rationalism, which became a true "São Paulo school," basically makes use of a fundamental honesty in architecture which some architects call "truth." The term "brutalism," which was adopted in England in 1954, designates a preference for exposed concrete and for materials without covering. The brutal, antidecorative and, at times, oppressive appearance of these works, according to some architects, are in harmony with the heavy, inelegant face of an industrial, disordered city like São Paulo.

Committed Architecture

In the fifties, Artigas accused Le Corbusier of being an agent of North American imperialism because, in his opinion, the module represented an attack on the decimal metric system and a preference for the archaic units of measurement retained by Anglo-Saxon

Top, the Servico Federal de Processamento de Dados (Federal Department of Data Processing), in Curitiba, Paraná; *above* the Caixa Econômica, São Paulo. Both buildings by the architects Croce, Aflalo and Gasperini, whose style is characterized by a wide use of glass and curvilinear structures.

Below, the Parque Iguatemi building, built by Croce, Aflalo and Gasperini as one of the answers to the private sector's wishes expressed in the seventies, to expand and modernize its buildings.

Below, the Avon Cosmetic building in São Paulo, another creation by Croce, Aflalo and Gasperini who, in this work, used colored filtering plate glass.

Bottom, the office block of the Indústrias Piraquê in Rio de Janeiro by the architect Marcelo Fragelli. Exposed concrete, bricks and the introduction of green spaces are among the building's distinguishing features.

countries. It is practically impossible to separate Artigas's work from his social and political preoccupations. His work always reflects a community interest in integrating everything and breaking down what the architect considers to be the individualism of capitalist society. In working out the project for the Faculty of Architecture and Town Planning of the University of São Paulo (page 264), Artigas could develop his committed theme to the full. "In it," says the critic Yves Bruand, "it is possible to find the ideal of a community way of life, valued so highly by Artigas, with his concern for creating a form of architecture that facilitates human contact, fighting against the tendency of individuals to close themselves up in an ivory tower, but maintaining sufficient flexibility so as not to have unbearable coercion. Without any doubt, never before have architects managed to blend a rigid, regulating external geometry with complete freedom in the arrangement of the interior, seizing on a violent style alternately unleashed and restrained. Here brutalism is total—material and spiritual. It manifests itself both in the systematic use of exposed materials and in the way in which it accentuates the conflicts that

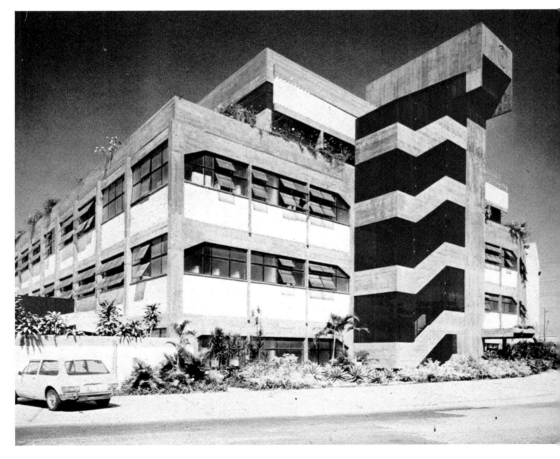

The IBM building in São Paulo is an unusual, daring creation by Croce, Aflalo and Gasperini. *Right*, the exterior, and *bottom*, a view of the interior.

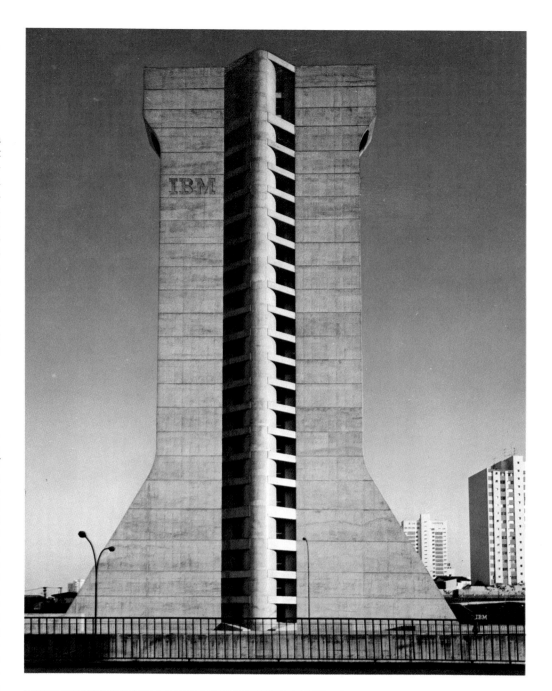

every creative artist must encounter."

For Rino Levi "architecture is not a social art because art is in permanent conflict with society and can be understood only by a minority sensitive to each innovation." However, brutalism seeks not only to discuss but to intervene, through the architect's works, in social questions. "Oscar Niemeyer and I," says Artigas, "have the same preoccupations and are faced with the same problems, but whereas he always makes an effort to resolve the contradictions in a harmonious synthesis, I expose them clearly. In my opinion, the role of an architect is not to compromise; existing struggles must not be covered by an elegant mask, it is our duty to reveal them fearlessly."

Brutalism Wins Through in São Paulo

Artigas's influence was absolutely devastating in São Paulo, stimulating almost all the students in the Faculty of Architecture and Town Planning at the University of São Paulo, where he was the most respected lecturer. Centered around his ideas were the biggest names of São Paulo's architecture: Joaquim Guedes, Paulo Mendes da Rocha, Sérgio Ferro, Rodrigo Lefèvre (page 276), Eduardo de Almeida, Carlos Millan (page 277), Paulo Bastos (page 277), Siegbert Zanettini, João Walter Toscano (page 264) and Ennes Silveira de Mello (page 276). The works of Paulo Mendes da Rocha, for example, burst with brutalism, which constitutes a means of artistic expression associated with a revolutionary program. Gaetano Miani's house, which he designed together with João Eduardo de Gennaro (São Paulo, 1962), is a perfect demonstration of this exposed concrete form of architecture. Everything is solid and hard, with absolutely no concession to an enchanting, restful climate. The facade is a wall similar to that of a prison and even the *brise-soleil* cantilever roof and service stairs, which could brighten up the house, reinforce the feeling of malaise. In the house that he built for himself (page 273), the rooms cannot be isolated or closed: the partitions between them and the veranda do not reach the roof and the doors must stay open to allow light from the side to enter. In this work, which is the final expression of the "impersonal space" defended by Artigas, Paulo Mendes da Rocha enforces his ideal of

Right, the Museu de Arte Moderna in São Paulo, by the architect Lina Bo Bardi (born 1914). The bold construction, in glass and concrete, with a span of 229.65′ (70 m), was opened in 1968. *Center*, three views of the interior of the Rohr building Administrative Department. *Bottom*, facade of the Rohr Industries building, designed by the architects Roberto Loeb and Gabriel Sister.

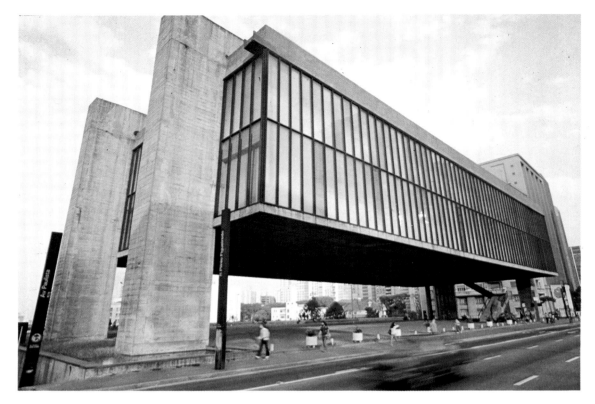

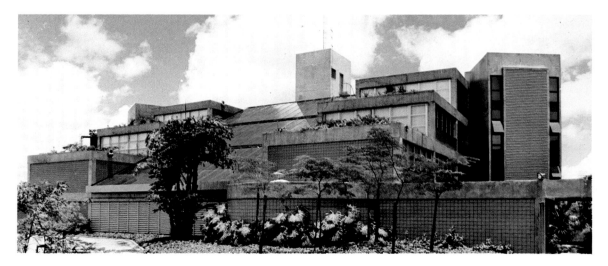

Below, telephone exchange in Campos de Jordão, in the interior of the state of São Paulo, by the architect Rui Ohtake (born 1938).

Center, the CETESB building, erected in São Paulo by the architect Roberto Loeb. *Bottom*, house of the architect Paulo Mendes da Rocha, born in Spain in 1928 and working in São Paulo.

community life. It is practically impossible for whoever lives there to have any privacy. Not even Artigas went so far. In fact, referring to this project he considered it "an act of heroism to live in such surroundings."

Sérgio Ferro also brought brutalism to its extreme consequences. In Bóris Fausto's residence in São Paulo, everything is exposed, including the external pipes and ventilation apertures. The water tank is perched on the roof like an addition bearing no resemblance to the house and the brutality of the concrete is absolute, with no refinements.

More Money than Style

In 1964, Artigas was arrested and Niemeyer forced to leave the country for political reasons. Although their followers upheld the basic proposals of the two great masters with a great deal of vigor and liveliness, in Brazil's universities no new ideas were formed from which alternative trends could spring. In the years that followed, architectural activity of every form was at its most intense. In the seventies, as an immediate repercussion of the "economic miracle," there was a real fever for construction throughout the entire country, in both the public and the private sector, and a whole variety of styles could be seen. Many buildings, the headquarters of multinational companies, were erected as replicas of the parent company in their country of origin whereas exposed concrete, opulent and monumental, typified a series of public works. Some companies, in announcing the proposals for the plans for their new buildings, demanded unusual designs which were extravagant and "personalized" so as to distinguish their buildings from the others. The Avenida Paulista in São Paulo is a living example of this building fever. The road was widened to take more traffic and the most varied commercial buildings were erected along it. They attract one's attention due to their pharaonic and often exotic styles. "Bank architecture" also flourished. Main and branch offices of the large private or state-owned banks, always designed by top level professionals, spread great architectural luxury and sophistication throughout the country. After all, the banking sector was one of the main beneficiaries of the economic growth.

A new middle class, provided with

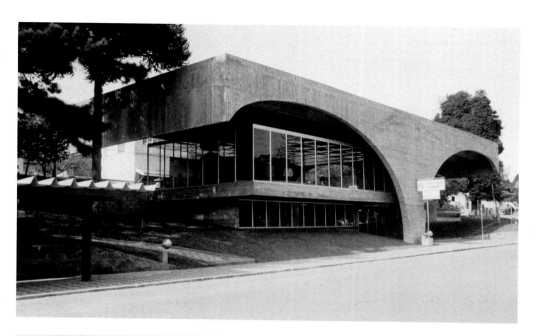

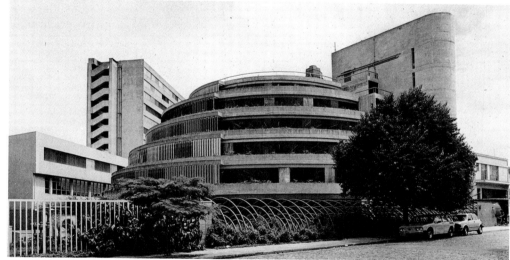

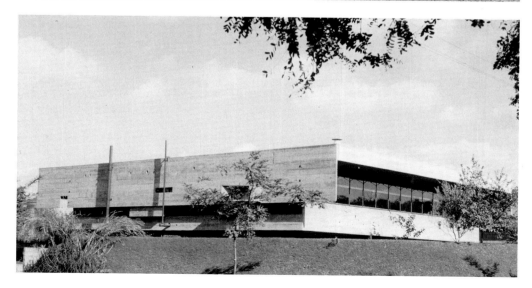

affluence by the "miracle," unleashed
intense property speculation in the large
urban centers. Apartment blocks were
built by the thousands in doubtful styles:
sometimes neoclassical, sometimes Medi-
terranean, but usually indistinct, making
up a strange architectonic collage. This
eclectic "relapse" also occurred in the
residences of the new elegant quarters,
where it is possible to find exposed
concrete and large smoked glass walls in
antiquated projects unsuited to such
materials.

The Independents

Brazilian architects generally remained
estranged from the postmodern disputes
bandied about in the United States and
Europe. Some architects created original
works that were the fruit of independent
investigations. Sérgio Prado, Vítor
Lotufo (page 275) and Walter Ono, for
example, worked on the basis of the
geodesic structures designed by Buck-
minster Fuller. Eduardo Longo, already
tied to the romantic individualism of
the organic school (as exemplified by the
house he designed on the Pernambuco
beach in Guarujá) built a spherical house
for himself in the center of São Paulo city
(page 278). Other architects, such as
Castelo Branco, liberated their creativity
by drawing inspiration from regional
arts. Castelo Branco's house, on a beach
in the state of Piauí, is in the shape of a
Nordeste fishing boat and is built of
taipa, wood, *sapé* and beach pebbles
(pages 279).

Lina Bo Bardi designed the Museu de
Arte in São Paulo (page 272). It is a
concrete and glass structure forming a
huge rectangular box suspended over the
greatest architectural empty space in the
world (229.65' [70 m]). Lina was also the
pioneer in Brazil of an activity known as
"industrial archaeology." She restored a
drum factory in São Paulo dating from
the beginning of the century, transform-
ing it into a gigantic cultural and sports
center for the city (page 277). On a piece
of land measuring 182,986.3 feet squared
(17,000 m²), she has reclaimed 123,784.8
feet squared (11,500 m²) of an area pre-
viously built upon and has maintained in
the new concrete structures which have
been added the industrial appearance of
the complex. The water tank, for ex-
ample, is a 229.65' (70 m) high cylinder
which serves as a landmark in the city,
bringing to mind factory chimneys.

Below, the country house that Vítor Lotufo built for himself in Botucatu in the interior of the state of São Paulo, using the geodesic structure thought out by Buckminster Fuller. *Bottom right*, a view of the interior of the same house.

Left, country house, by the architect Carlos Lemos, in which he has made great use of wood.

Below left and right, the exterior and a view of the interior of the house by Ennes Silveira de Mello, who uses concrete in his projects for residential buildings.

Center right, a view of the upper part of the Bildner residence, designed by Ennes Silveira de Mello.

Center left and bottom, the facade and interior of the vaulted house by Rodrigo Lefèvre. According to the architect, this project was quick and cheap to build.

Carlos Lemos, Zanine Caldas and Severiano Porto, after totally independent research, have created works that seek to integrate traditional techniques with modernism, creating new spatial solutions and taking into consideration the climate and culture of Brazil.

Carlos Lemos, who works in São Paulo, considers himself to be dedicated to naturalistic solutions and makes wide use of demolition material, wood (page 275), natural ventilation and other traditional solutions. In terms of architecture in the strict sense of the word, his work is not, however, a return to the past since it falls into a modern scheme, with the emphasis on integration with nature, to which space gives a new dimension, continuity and perspective (page 274).

In Rio de Janeiro, Zanine Caldas uses unexpected combinations of exposed cement and local wood, of tempered glass and stone for walls in his modern designs (page 274).

Severiano Mario Porto, who works in the state of Amazonas, has opted for an unquestionably ecological style that fits in with the equatorial and almost wild environment in which he creates his works. Porto, who knows the nature of Amazonas in depth, builds his houses with local woods, such as *Itaúba, maracanduba, sucupira,* cedar, *aguano,* laurel, *aritu* and *macacaúba.*

Left, an old factory in São Paulo, restored and converted into a cultural center by the architect Lina Bo Bardi (born 1914): *far left*, pipes; *center left*, meeting place; *bottom left*, direct access area.

Top, the Paineiras do Morumbi Club built in São Paulo by Paulo Bastos on a design by Carlos Millan; *center*, the Club restaurant. *Above*, the snailshell house, an experimental project by Sérgio Prado.

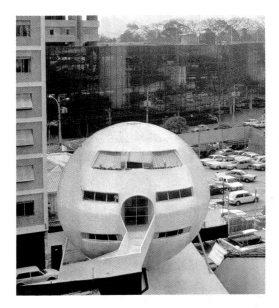

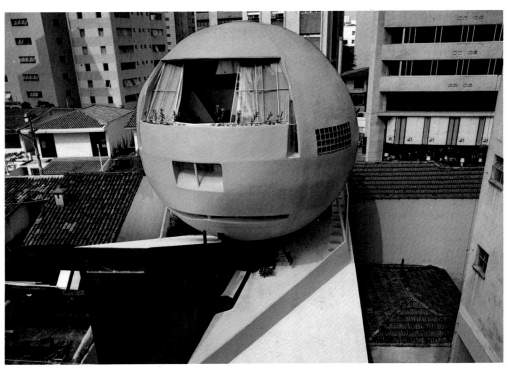

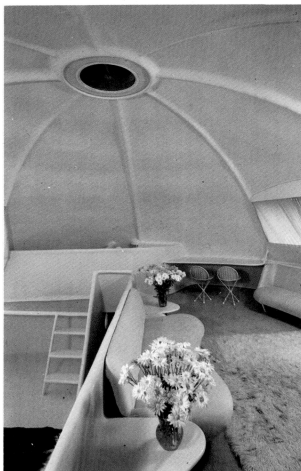

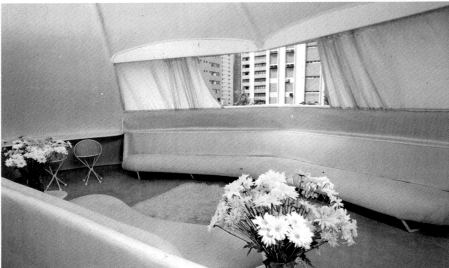

Top left and right, two views of the exterior of the spherical house that Eduardo Longo built for himself with a background of the traditional buildings of São Paulo's built-up area. *Above and center right*, two views of the living room in Eduardo Longo's house; *bottom and right*, the interior staircase and the bathroom of the same house.

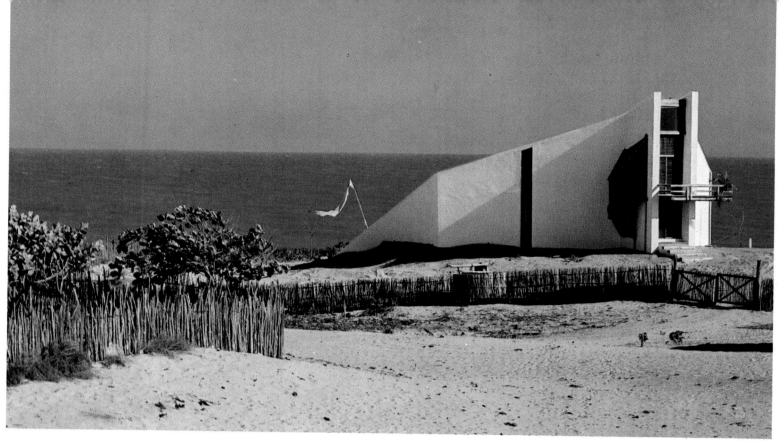

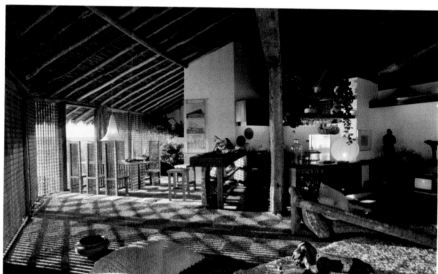

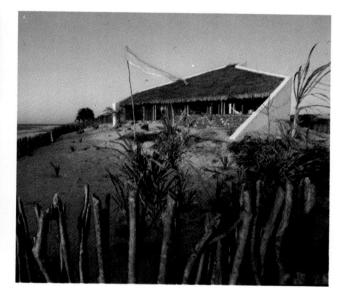

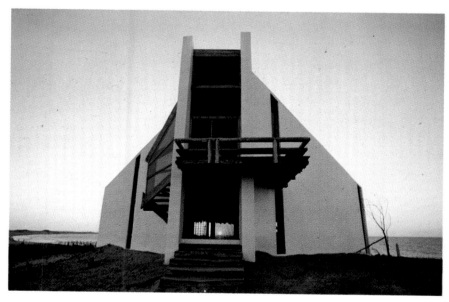

Top, the *taipa* (earth mixed with water) house, inspired by the sailing boats on the Piauí coast and designed by Gerson Castelo Branco; *center left*, room with the living, dining and cooking areas all in one; *center right*, view of the exterior; *left*, exterior with balcony; *above*, the house in the process of being built.

Contemporary
Research

Contemporary Research

From the Figure to Abstraction, from Geometrical Lines to Nonrepresentational Sketches

In the course of the fifties, the third modern generation was working in the sphere of the visual arts, and its activity was characterized by the active participation of the public and very close relations with international artistic circles. It can be said that all the main European trends, at times renamed and partly modified, were represented among Brazilian artists. As a result of the Biennial of São Paulo, which made its debut in 1951, copying the Venice Biennale, and on the initiative of the São Paulo Museu de Arte Moderna, the works of major foreign artists were introduced to the Brazilian public while those of Brazilian artists began to be shown, more and more frequently, at exhibitions in the large international centers. At the same time, numerous art galleries sprang up over the country and Brazil's most important newspapers gave extensive coverage to contemporary art.

Social realism was gradually dying out while abstract art was gaining strength. Abstract art was to culminate in the concretist movement around 1955 and then, from 1959, in nonrepresentational art. Some artists, however, remained faithful to their own personal experience, sometimes combining elements of various trends and only rarely engaging in controversy with fashionable tendencies. This third modern generation, which was taking root at the same time as Brazil's industrial development, also included visual artists and designers who often reached a considerably high artistic level.

The Lone Wolves

Some engravers, who in the fifties moved on to painting, were left in an isolated position. These artists included Darel Valença Lins, Maciej Babinski and Antônio Henrique do Amaral (page 283), the draftsman Ítalo Cencini (page 282) and Fernando Odriozola from Spain, all of whom concentrated on a fantastic or allegorical representation of reality. A surrealistic interpretation of the modern world also characterized the so-called magic realism tendency, begun in 1963 by Wesley Duke Lee (page 284), Maria Cecília, Bernardo Cid, Donato Ferrari, Farnese de Andrade and Gastão Manuel Henrique who, within a realistic image, stressed the magic aspect of everyday elements by means of intuitive and unexpected connections.

On the preceding pages, Tikashi Fukushima (born 1920), *Premier Regard*, 1969. Oil on canvas, 51.18″ × 76.77″ (130 cm × 195 cm). Private collection. *Left*, Ítalo Cencini (born 1925), *Reminiscences*, 1973. 19.29″ × 27.16″ (49 cm × 69 cm). Private collection, São Paulo. *Below*, Antônio Henrique do Amaral (born 1935), *Bananas*, 1970. Oil, 66.92″ × 50.39″ (170 cm × 128 cm). Pinacoteca do Estado, São Paulo.

Right, Waldemar Cordeiro (1925–1973), *Movement*, 1951. Tempera on canvas, 35.43″ × 37.40″ (90 cm × 95 cm). Museu de Arte Contemporânea, São Paulo. Wesley Duke Lee (born 1931): *below left, Comments on Assis Chateaubriand*, 1968; environmental art; G. Chateaubriand Collection, Rio de Janeiro; *below right, The Zone: Life and Death*, 1962; combined technique, 21.65″ × 16.53″ (55 cm × 42 cm); Lydia Chamis Collection, São Paulo.

Sérgio de Camargo (born 1930), untitled sculpture. Panel covered with cylindrical pieces of white-painted wood.

Nonrepresentational Artists

Abstractionism, which took hold in Europe and the United States immediately after the war, also spread at the same time in Brazil through exhibitions organized by the Museu de Arte Moderna in São Paulo and that in Rio de Janeiro, and through the example set by nonfigurative works done in Paris toward 'the end of the forties by Cícero Dias, Antônio Bandeira and Samson Flexor. The early exhibitions at the Biennial of São Paulo were just as much of a determining factor, as were the aesthetic theories based on the outlook of a critic named Mário Pedrosa. The result of these influences was that numerous Brazilian artists came to accept abstractionism, the first being Ivan Serpa, Abraham Palatnik, Almir Mavignier and Mary Vieira.

The São Paulo and Rio Groups

The geometric or constructive tendency took hold in Rio de Janeiro through Palatnik and Serpa (Mavignier and Mary Vieira moved to Europe in the early fifties) and in São Paulo through Waldemar Cordeiro (page 284) and Geraldo de Barros. In 1952, the Grupo Ruptura was formed in São Paulo. Among its members were Lothar Charoux, Waldemar Cordeiro, Geraldo de Barros, Kazmer Fejer, Leopold Haar, Luís Sacilotto and Anatol Wladislaw. In the same year in Rio de Janeiro, Ivan Serpa, Décio Vieira, Aloísio Carvão, João José da Costa, Lygia Pape, César and Hélio Oiticica created the Grupo Frente.

In the *Manifesto* published on the occasion of the 1952 exposition at the Museu de Arte Moderna in São Paulo, the Grupo Ruptura artists declared themselves to be against all forms of naturalism, including the "false" expressionist and surrealist forms, and against "hedonistic nonrepresentationalism," stating that they preferred "all experiences that are inclined to renew the essential values of visual art (space-time, motion and matter)." They also refuted intuition, proclaiming that art is a type of knowledge which can be deduced from concepts and is above mere opinion. Both the Grupo Ruptura and the Grupo Frente declared themselves to be against not only art forms that were simply the reproduction or recreation of nature, but

Above, José Roberto Aguilar (born 1941), *1st Division Soccer Team*, 1966. Oil on canvas, 44.88″ × 57.48″ (114 cm × 146 cm). Museu de Arte Contemporânea, São Paulo. *Left*, Manabu Mabe (born 1924), untitled oil, 1958.

Tomie Ohtake (born 1938), *Composition*,
1974. Oil on canvas, 64.96″ × 64.96″
(165 cm × 165 cm). Artist's collection.

Above, Carlos Alberto Fajardo (born 1941), *Three Hours/Different People/In Santos/Out of the House*, 1977. Acrylic on canvas, 78.74″ × 137.7″ (200 cm × 350 cm). Artist's collection. *Right*, Antônio Peticov, *Mitocôndrio*, 1977. 39.37″ × 47.24″ (100 cm × 120 cm). Luiza Strina Gallery, São Paulo.

also against lyrical, expressionist and romantic abstractionism which was beginning to spread through Brazil. The Grupo Ruptura organized only one exhibition (in 1952) whereas the Grupo Frente, after its first exhibition in 1953, also presented its work to the public in 1955 and 1956, the year it folded. As distinct from the artists in São Paulo, the Grupo Frente was not strictly orthodox in that, toward the end, it welcomed artists who had little or nothing to do with geometric abstractionism such as Elisa Martins da Silveira and Vincent Iberson, who was involved with lyrical abstractionism.

The National Modern Art Exhibition

The first national modern art exhibition was held in February 1953 in the Quitandinha Hotel in Petrópolis. Twenty-three artists with various tendencies took part. These included Antônio Bandeira, Fayga Ostrower, Ivan

Luis Paulo Baravelli (born 1942), *The Island*,
1973. Acrylic on canvas, 31.49″ × 31.49″
(80 cm × 80 cm). Luiza Strina Gallery, São
Paulo.

Serpa, Aloísio Carvão, Palatnik, Lygia Clark, Lygia Pape and Décio Vieira. Geometric abstraction predominated but signs of the future tendency, concrete art, were already perceptible. Abstract art was even influencing traditionally representational artists like Portinari and Pancetti, while Milton Dacosta and Rubem Valentim were moving toward abstractionism without abandoning natural forms and colors completely.

Concrete Art

In December 1956, the first national exhibition of concrete art was organized in the Museu de Arte Moderna, São Paulo, with artists and writers from Rio and São Paulo taking part. After being transferred to the Museu de Arte Moderna in Rio de Janeiro at the beginning of 1957, the exhibition was accompanied by a series of conferences and debates given by critics, artists and poets like Mário Pedrosa, Alfredo Volpi, Décio Pignatari, Ferreira Gullar, Wal-

demar Cordeiro, Oliveira Bastos and Alexandre Wollner. The concretists put on other exhibitions in Ceará in 1957 and at the Museu de Arte Moderna of Rio in 1960. After the first exhibition, however, a few differences of opinion arose between the São Paulo group and the Rio group, which brought about the break between Ferreira Gullar, one of the main thinkers behind Rio's concrete art, and the São Paulo artists headed by Décio Pignatari and Augusto and Haroldo de Campos. The São Paulo group claimed that form should be autonomous to the detriment of expression and any symbolic intention, whereas the Rio group still held the traditional concept of art as expression to be partly valid. These differences caused neoconcretism to be born, bringing together Ferreira Gullar, Reinaldo Jardim, Theon Spanudis, Lygia Clark, Lygia Pape, Franz Josef Weissmann and Amílcar de Castro. The first national exhibition of neoconcrete art took place at Rio de Janeiro's Museu de Arte Moderna in 1959. The following year, the

Palácio da Cultura organized a second exhibition and the third was held in 1961 in the Museu de Arte Moderna in São Paulo. A few artists from São Paulo, such as Theon Spanudis, Willys de Castro and Hércules Barsotti, also joined the Rio group. Artists like Antônio Maluf, Judith Lauand and Maurício Nogueira Lima remained tied to the strict approach of the São Paulo group. Sensing the influence of the concrete and neoconcrete movements, some artists such as Ubi Bava, Sérgio de Camargo (page 285), Yutaka Toyota, Rubem Valentim, Arcangello Ianelli, Abelardo Zaluar and Dionísio Del Santo developed a similar style, even though they belonged to neither of the two groups.

Nonrepresentational Abstractionism

Both concretism and neoconcretism petered out within a few years. From 1959, when it made its triumphant appearance at the fifth Biennial of São Paulo, non-

Opposite, Rubens Gerchman (born 1942), *Air. Left*, Fábio Magalhães (born 1940), *The Painter's Sleep*, 1965. Enamel paint, 36.61″ × 25.59″ (93 cm × 65 cm). Artist's collection. *Below*, Carlos Vergara (born 1941), *Without Inscription*, 1967. Plasticized ink on wood, 47.24″ × 47.24″ (120 cm × 120 cm). G. Chateaubriand Collection, Rio de Janeiro.

representational art became the dominating aesthetic tendency, offering new stimuli to the current nongeometric style which, since the late forties, had gone hand in hand with the development of Brazilian abstract art. Many figurative artists also joined the new movement.

More artistic coherence was shown by the artists of the Japanese-Brazilian group: Manabu Mabe (page 11 and 286), Tomie Ohtake (page 287), Tikashi Fukushima (pages 280–281) Kazuo Wakabayashi, Iberê Camargo, Iolanda Kohalyi, Laszlo Meitner, Felícia Leirner, Fayga Ostrower, Wega Nery, Frans Krajcberg (page 292), Loio Pérsio and Benjamim Silva.

New Centers and New Perspectives

During the fifties, in addition to São Paulo and Rio de Janeiro, other centers took part in the process of artistic renewal, including Belo Horizonte, Porto Alegre, Salvador, Recife, Manaus and two cities in the interior of the state of São Paulo, Campinas and Ribeirão Preto, preceding the movements of the second half of the sixties in Santos, Campo Grande in Mato Grosso, Pelotas in Rio Grande do Sul and Blumenau in the state of Santa Catarina.

The great variety of tendencies that characterize the last twenty years and the continual development of the younger artists, makes it impossible to express a final critical opinion, but we should mention Fábio Magalhães's work done from memory and aimed at canceling out real time (page 291), Carlos Vergara's hyperrealist experience (page 291), Luís Paulo Baravelli's clear vocation for painting (page 289) and that of Carlos Alberto Fajardo (page 288). Among the themes of the younger artists, those deserving mention are Nelson Leirner's neodadaism (page 292), Rubens Gerchman's pop art (page 290) and that of Cláudio Tozzi (page 292), Antônio Peticov's incursions into fantasy (page 288) and finally José Roberto Aguilar's magic approach to reality (page 286). The latter has also experimented with video art.

Above, Cláudio Tozzi (born 1944), *Gate of the Tinsmith's Workshop. Above right*, Nelson Leirner (born 1932), *Adoration*, 1966. Combined technique, 80.70″ × 64.96″ (205 cm × 165 cm). Museu de Arte, Sào Paulo. *Right*, Frans Krajcberg (born 1921), *Flowering*, 1968. Sculpture.

Biographies of the Artists

Chronology

Index

Biographies of the Artists

Abramo, Lívio (Araraquara, São Paulo, 1903). Engraver, draftsman and painter. He began work as an engraver in the thirties, treating human and social themes, influenced by European expressionism which he abandoned in favor of a technique that is more refined and has greater formal purity. The *Festa* series of engravings is one of his best works.

Aguilar, José Roberto (São Paulo, São Paulo, 1941). Painter and engraver. His early paintings are tied to fantastic realism. City life, sexuality, revolutions and the plurality of symbols are the themes he treats. One of his most outstanding works is the large mural painting of the Emurb, in São Paulo.

Aita, Zina (Belo Horizonte, Minas Gerais, 1900–Naples, Italy, 1968). Painter and potter, she took part in the 1922 Semana de Arte Moderna. In 1924 she went to live in Naples where she set up a ceramics factory.

Aleijadinho (Antonio Francisco Lisboa) (Ouro Prêto, Minas Gerais, 1730/38–1814). Architect, sculptor, carver and decorator. The outstanding works of his production, which constitutes the climax of baroque in Minas Gerais, are the episodes of the *Passion* and the statues of the *Prophets* created for the Sanctuary of the Bom Jesus de Matosinhos in Congonhas do Campo and the Franciscan churches of Ouro Prêto and São João del Rei. The style of his architectural works includes baroque and rococo and in his sculptures it is possible to detect expressionist elements. At the age of forty-seven he was struck by an illness which deformed his body (the nickname Aleijadinho in fact means "Little Cripple"). He is considered to be Brazil's greatest artist.

Almeida Júnior, José Ferraz de (Itu, São Paulo, 1850–Piracicaba, São Paulo, 1899). Painter. From 1876 to 1882 he studied in Paris where he was influenced by romanticism, realism and pre-impressionism. He depicted Brazilian types and costumes in works such as *Peasant's Head* and *Shredding Tobacco*. In Europe he painted, among other things, *The Model's Rest*. He also painted landscapes and historical and religious subjects.

Amaral, Antônio Henrique Abreu (São Paulo, São Paulo, 1935). He is a painter and engraver and in his album *Mine and His* has brought together woodcuts inspired by symbols taken from everyday life. In his tropical phase he painted huge bananas.

Américo de Figueiredo e Melo, Pedro (Areia, Paraíba, 1843–Florence, Italy, 1905). An academic painter, he studied in Rio de Janeiro and Paris where he also delved into the fields of science and literature. His enormous historical canvases, the *Battle of Avaí* and the *Proclamation of the Ipiranga*, were painted in Florence by order of the Brazilian government. He also painted biblical subjects and portraits. His style is magniloquent and closed to any innovation.

Amoedo, Rodolfo (Salvador, Bahia, 1857–Rio de Janeiro, 1941). Painter. In 1879, he won a trip to Europe and stayed there for eight years. His style is academic, inspired by classicism and strictly formal. His works *Christ at Capernaum*, *Marabá* and *Ultimo Tamoio* were painted during his stay in Paris.

Araújo, José Soares de (Braga, Portugal, ?–Diamantina, Minas Gerais, 1799). Painter. He created the ceilings in the churches of Nossa Senhora do Carmo, Nossa Senhora do Rosario and São Francisco in Diamantina and the Church of Santana in Inhaí, in the same region. His works were planned according to baroque rules of perspective.

Artigas, João Batista Vilanova (Curitiba, Paraná, 1915). An architect who works in São Paulo, and one of the founders of the Faculty of Architecture and Town Planning, whose building he designed. Several of his projects have been awarded prizes.

Ataíde, Manuel da Costa (Mariana, Minas Gerais, 1762–1830). A painter who used both oil and tempera, on canvas or board, showing skillful brushwork and a preference for blues. Although he drew inspiration from engravings in European missals, he gave his characters popular faces with lively expressions. The *Glorification of the Virgin*, on the nave ceiling of the Franciscan church in Ouro Prêto, is the masterpiece of Ataíde, who is considered to be Minas Gerais' greatest baroque painter.

Aurélio de Figueiredo e Melo, Francisco (Areia, Paraíba, 1856–Rio de Janeiro, Rio de Janeiro, 1916). A painter and sculptor who studied with Pedro Américo, his brother. He painted genre paintings, portraits and landscapes. *The Last Ball on Fiscal Island* is generally held to be his most famous work.

Bandeira, Antônio (Fortaleza, Ceará, 1922–Paris, France, 1967). A painter who belonged to the Ceará avant-garde group. In 1945 he exhibited his works in

Rio de Janeiro and later moved to Paris after winning a scholarship from the French government. He was influenced by the painters Camille Bryen and Wols and applied himself to abstractionism. He returned to Brazil in 1950 and stayed there until 1954 when he went back to Paris for good. He is one of the most important names in the Parisian school of nonrepresentational art.

Baravelli, Luís Paulo (São Paulo, São Paulo, 1942). A painter and draftsman who in his large panels uses various materials in his search for a new form of expression.

Barbosa, Dario Vilares (Campinas, São Paulo, 1880–Paris, France, 1952). A painter who dedicated himself to landscape, historical and genre painting and was the twin brother of Mário Vilares Barbosa. He was a pupil of Oscar Pereira da Silva.

Bardi, Lina Bo (Rome, Italy, 1914). An architect, she designed the Museu de Arte in São Paulo, the town in which she also converted an old factory into a cultural center. After moving to Salvador, she set up the Museu de Arte Popular da Bahia there.

Bates, Richard (England, 1775–1856). An amateur draftsman and painter who settled in Rio de Janeiro as a trader in 1808, later returning to his country around the mid-1800s. He painted town scenes in water color.

Bento, Antônio Garcia (Campos, Rio de Janeiro, 1897–Rio de Janeiro, Rio de Janeiro, 1929). A seascape artist who was stimulated by the impressionists' use of light and who specialized in the spatula technique.

Bernardes, Sérgio Wladimir (Rio de Janeiro, Rio de Janeiro, 1919). An architect who has searched for a new use for construction materials. His most outstanding projects are the Rio de Janeiro Flower Market and the Fortaleza government building.

Bernardo de São Bento, Friar (Braga, Portugal, 1624–Rio de Janeiro, Rio de Janeiro, 1693). A Benedictine architect who, from 1669, was responsible for the construction of the São Bento monastery in Rio de Janeiro.

Bianchetti, Glênio (Bagé, Rio Grande do Sul, 1928). A painter and engraver and one of the founders of the Clube de Gravura in Porto Alegre (1950). He is a figurative expressionist who is in-

clined to an almost abstract form of simplification.

Bicho, Galdino Guttmann (Petrópolis, Rio de Janeiro, 1888–Rio de Janeiro, Rio de Janeiro, 1955). A painter of nudes, portraits and landscapes who, at the beginning of his career adopted the divisionist technique, through which he has produced his best works.

Bonadei, Aldo (São Paulo, São Paulo, 1906–1974). A painter who studied under Pedro Alexandrino and perfected his style in Italy. On his return to Brazil in 1932, he joined the Grupo Santa Helena and the Família Artística Paulista. He painted landscapes and still life works with a composition made up of cubist elements.

Bonomi, Maria (Meina, Italy, 1935). An engraver who settled in São Paulo where in 1960, with Lívio Abramo, she founded the Estúdio da Gravura (Engravers' Studio). In addition to woodcuts, she is involved with scene-painting and designing theatrical costumes.

Brasil, Álvaro Vital (São Paulo, São Paulo, 1909). An architect who trained in Rio de Janeiro and in 1935 designed the Esther building, considered to be São Paulo's first modern construction.

Brecheret, Vítor (São Paulo, São Paulo, 1984–1955). A sculptor who began his studies in the Liceu de Artes e Ofícios in São Paulo and perfected his style in Rome. In 1919, he returned to his home town where he set up his studio in the empty rooms of the Trades building where he was discovered by the modernists. He took part in the 1922 Semana de Arte Moderna, although at the time he was in Paris on a scholarship awarded to him by the São Paulo government (1912–1930). He was a founding member of the Sociedade Pró-Arte Moderna. One of his most famous works is the *Monument to the Bandeiras* (1936–1953) in São Paulo, the model of which was exhibited in 1920. In his last phase he became involved with indigenous art. His style is linear and bare and borders on abstractionism.

Briggs, Frederico Guilherme (Rio de Janeiro, Rio de Janeiro, nineteenth century). An influential painter and lithographer who painted views of Rio de Janeiro, caricature albums and costume scenes.

Brito, Francisco Xavier de (Portugal, ?–Ouro Prêto, Minas Gerias, 1751). A

sculptor who initially worked with Manuel de Brito on the carvings in the Church of São Francisco da Penitência in Rio de Janeiro. He moved to Ouro Prêto and produced the carvings for the mother church of Nossa Senhora do Pilar. The "Brito style" was to influence Aleijadinho's carving, as can be seen in the cluster of cherubs on the portal of São Francisco de Assis in São João del Rei.

Brito, Manuel de (Portugal, ?–eighteenth century). A carver who came to Brazil in 1726 and worked with Francisco Xavier de Brito on the carvings in São Francisco da Penitência, Rio de Janeiro.

Camargo, Sérgio de (Rio de Janeiro, Rio de Janeiro, 1930). Sculptor. His outstanding works are the white reliefs sculpted in marble and the panels covered with cylindrical pieces of wood, painted all one color.

Carneiro, Francisco Xavier (Mariana, Minas Gerais, 1765–1840). A painter who was a pupil of Ataíde and painted a few of the statues from the *Passion* groups sculpted by Aleijadinho. The nave ceiling of the Church of São Francisco de Assis, Mariana, is attributed to him.

Carvalho, Flávio de Resende (Barra Mansa, Rio de Janeiro, 1899–Valinhos, São Paulo, 1973). A draftsman, painter, architect and sculptor who was active in São Paulo. He studied engineering and art in England and was a polemical innovator as shown in his theatrical experiments (*The Ballet of the Dead God*, a choreographic symphony by his friend, Camargo Guarnieri, performed against striking scenery). In the thirties, he headed avant-garde groups such as the Clube dos Artistas Modernos and the Salão de Maio. He painted portraits and female nudes in a decisively expressionist style and in surrealist environments. His drawings reveal his lively, vigorous pen work: the *Tragic Series* captured the last moment of his mother's life and represents the climax of his works. His plan for the São Paulo government building (1927) is a pioneering expression within the field of modern Brazilian architecture.

Carybé (Héctor Julio Páride Bernabó) (Lanus, Argentina, 1911). A figurative painter who has settled in the state of Bahia and captured scenes of everyday life of the people with a graphic stylization which at times borders on abstractionism.

Cavaleiro, Henrique (Rio de Janeiro, Rio de Janeiro, 1892–1975). He became a painter at the beginning of the divisionist phase and moved toward cubism. He also adopted fauvist and expressionist elements. In his last phase, he painted figurative pictures in vivid, powerful colors.

Cencini, Ítalo (São Paulo, São Paulo, 1925). A draftsman whose constant theme is the female nude. He has also produced works in water color and oil.

Ceschiatti, Alfredo (Belo Horizonte, Minas Gerais, 1918). A figurative sculptor who creates bare and, at the same time, monumental statues. His most important works are in Brasília: *The Bathers*, in the pool of the Alvorada Palace, *Justice*, in front of the Supreme Federal Court, and *Angel*, in the cathedral.

Clarac, Charles-Othon-Frédéric-Jean-Baptiste, count of (Paris, France, 1777–1847). A draftsman who in 1816 spent a few months in the interior of the state of Rio de Janeiro. His work, *Brazilian Forest*, dates back to that period. It can be considered to be one of the most faithful representations of tropical nature.

Codina, Joaquim José (eighteenth century). Draftsman. Together with José Joaquim Freire, he illustrated the book *Viagem Filosófica* by the naturalist Alexandre Rodrigues Ferreira, describing aspects of Amazonas.

Conceição, Friar Domingos da (Matosinhos, Portugal, circa 1643–Rio de Janeiro, Rio de Janeiro, 1718). A sculptor who was active in Rio de Janeiro, where he created the drawings for all the carvings in the church of the Benedictine monastery, as well as a series of images and a few portals. He sculpted the *Dead Christ* and *Christ Crucified* statues for the Olinda monastery.

Cordeiro, Waldemar (Rome, Italy, 1925–São Paulo, São Paulo, 1973). A painter and designer who lived in São Paulo from 1948. He is considered to be the forerunner of concrete art in Brazil. He carried out the first art research by means of a computer in 1968. *Movement* (1951) is his most important work.

Correia, Henrique Alvim (Rio de Janeiro, Rio de Janeiro, 1876–Brussels, Belgium, 1910). A painter, draftsman and engraver who, in 1892, settled in Europe. He was anti-academic and pro-

duced military scenes, nudes and land-scapes. The illustrations he produced for the Belgian edition of *The War of the Worlds*, by H. G. Wells, are considered to be his masterpiece.

Costa, Artur Timóteo da (Rio de Janeiro, Rio de Janeiro, 1882–1923). A painter of portraits and landscapes. His works are outstanding for their vigorous brushwork and the impressionist bright-ness of their colors. He won a trip to Europe with his painting *Before the Allelujah*. He died in a mental hospital.

Costa, Lúcio (Toulon, France, 1902). An architect, town planner and scholar who initially upheld the neocolonial style, defending architecture with a national flavor (1926/1927). He was one of the pioneers of modern architecture in Brazil and, from 1936, directed the rev-olutionary project of the former Ministry of Education and Heath building (now the Palace of Culture) built in Rio de Janeiro, following a design to which Le Corbusier made a few alterations. In 1957 he won the competition for the pilot plan of Brasília, a milestone in con-temporary town planning. His interest in Brazil's past led him to publish works such as *O Aleijadinho e a Arquitetura Tradicional*, *Arquitetura Jesuítica no Brasil*, *Notas sobre a Evolução do Mobiliário Brasileiro*.

Costa, Manuel Inácio da (?, 1763–Salvador, Bahia, 1857). A baroque sculp-tor who was active in the Bahia area and is considered to be the most outstanding sculptor of his day. The various works that are attributed to him include the statue *Christ at the Column*.

Dacosta, Milton (Niterói, Rio de Janeiro, 1915). A painter and engraver who was a member of the Núcleo Bernardelli. His work goes through a series of stages, both figurative and abstract. In the beginning he painted impressionist-style landscapes, then he moved on to simple and geometrical cubist forms (*Head*). In the fifties he went through a geometrical abstract phase, coming back to figures with the *Venus and Little Birds* series.

Dall'Ara, Gustavo (Venice, Italy, 1865–Rio de Janeiro, Rio de Janeiro, 1923). A painter and caricaturist who settled in Rio de Janeiro in 1889. He painted landscapes and figures and documented the appearance of the town.

Debret, Jean-Baptiste (Paris, France, 1768–1848). A draftsman, painter and teacher who was a member of the French Artistic Mission which arrived in Brazil in 1816 with the task of setting up the Academia Imperial de Belas-Artes. Debret remained in Brazil for fifteen years, during which time he was ex-tremely active as a teacher. He painted portraits of the imperial family and promoted the first salon of fine arts. On his return to France, he wrote and illustrated his three-volume *Pictorial and Historical Journey in Brazil* (1834–1839), a work that documented the nature, inhabitants and society of Rio de Janeiro at the beginning of the nineteenth cen-tury. Despite his strict neoclassical train-ing, his drawings are lively and realistic.

De Fiori, Ernesto (Rome, Italy, 1884–São Paulo, São Paulo, 1945). A European-trained sculptor and painter who settled in São Paulo in 1936. He exhibited his works at the Salões de Maio and the exhibition organized by the Família Artistica Paulista. He painted figures, landscapes and seascapes.

Dias, Cícero (Recife, Pernambuco, 1908). A painter and draftsman who settled in Rio de Janeiro in 1925. He became involved with avant-garde artists and put on the first exhibition of his own in 1927. In the thirties, he settled per-manently in Paris and came into contact with the surrealists. From 1945, he became involved in abstract art and mural painting. In his recent works he has returned to figures, painting scenes from his childhood.

Dias, Francisco (Alenquer, Portugal, 1538–Rio de Janeiro, Rio de Janeiro, 1633). A Jesuit architect and master builder who in 1577 was sent by the Society of Jesus to work in Brazil. He designed the college of the Church of Nossa Senhora da Graça in Olinda and the Jesuit college and church in Rio de Janeiro.

Di Cavalcanti (Emiliano Cavalcanti de Albuquerque e Melo) (Rio de Janeiro, Rio de Janeiro, 1897–1976). A painter and caricaturist who made his debut in 1917 with his own exhibition of caricatures in São Paulo, where he was one of the instigators of the 1922 Semana de Arte Moderna. He spent a long time in Paris and established close ties with the great artists of the day, being influ-enced mostly by expressionism, cubism and surrealism. His work is outstanding for its Brazilian themes, expressed in exuberant, sensual scenes and characters and focusing on the female (chiefly mul-atto) figure. *Five Young Girls from Guaratinguetá* (1930) is one of his most famous paintings.

Djanira da Mota e Silva (Avaré, São Paulo, 1914–Rio de Janeiro, Rio de Janeiro, 1979). A self-taught painter and draftsman who began to paint when she was taken into a sanatorium in São José dos Campos. She was discovered by Emeric Marcier and exhibited her work for the first time at the Salão Nacional de Belas-Artes in 1942. Her work comprises landscapes and popular scenes treated with an almost naive lyricism.

Dutra, Miguelzinho (Itu, São Paulo, 1810–Piracicaba, São Paulo, 1875). A painter and writer (whose full name was Miguel Arcanjo Benício da Assunção Dutra) who, between 1835 and 1855, painted numerous water colors portraying popular figures, churches, farms and landscapes. He painted the portrait of Friar Jesuino do Monte Carmelo with whom he worked on decorating the churches of São Paulo. He also wrote treatises on art.

Eckhout, Albert (Groningen, Holland, circa 1610–1655). He painted figures and still life works and came to Brazil on the invitation of Maurice of Nassau in 1637, remaining there until 1644. The *Dance of the Tapuias*, which is considered to be his masterpiece, is kept in the National Museum of Denmark with eight life-size portraits of the inhabitants of the country and twelve still life paintings with tropical fruits. Between 1687 and 1730, the Gobelin tapestries were made, based on his pictures and produced in two series: *Anciennes Indes* and *Nouvelles Indes*.

Ender, Thomas (Vienna, Austria, 1793–1875). A draftsman and painter who studied at the Academy of Fine Arts in Vienna. He arrived in Brazil in 1817. He traveled around the states of Rio de Janeiro, São Paulo and Minas Gerais, using water colors to paint the landscape and costumes of the province. His works provide accurate and sensitive documentation of Brazil.

Fajardo, Carlos Alberto (São Paulo, São Paulo, 1941). A painter, draftsman and architect who, in 1970, formed the Escola Brazil, together with Nasser, Baravelli and Resende. His figurative works are created with various materials and techniques.

Ferrignac (Ignácio da Costa Ferreira) (Rio Claro, São Paulo, 1892–São Paulo, São Paulo, 1958). A draftsman and caricaturist. He took part in the 1922 Semana de Arte Moderna, abandoning his artistic activities immediately afterwards. *Columbine* is his most famous work.

Florence, Hercule (Nice, France, 1804–Campinas, São Paulo, 1879). A draftsman, painter, photographer and lithographer. In 1825, he accompanied the Langsdorff expedition, creating documentary works on nature and local inhabitants. He has recently been recognized as one of the pioneers of photography.

Freire, José Joaquim (Portugal, eighteenth century). A draftsman who joined the scientific expedition of Alexandre Rodrigues Ferreira into Amazonas (from 1783 to 1792). With Joaquim José Codina, he illustrated the *Viagem Filosófica*.

Fukushima, Tikashi (Fukushima, Japan, 1920). A painter who came to Brazil in 1940 and was active in São Paulo. Initially he was a figurative artist but later he opted for nonrepresentational abstractionism.

Gerchman, Rubens (Rio de Janeiro, Rio de Janeiro, 1942). An avant-garde painter, draftsman and sculptor who, concerned about the social content of his work, has turned to urban folklore. He is among those responsible for introducing "pop art" to Brazil.

Giorgi, Bruno (Mococa, São Paulo, 1905). A sculptor who studied in Rome and Paris. At first he settled in São Paulo (1939), where he joined the Grupo Santa Helena. In 1943 he moved to Rio de Janeiro. His outstanding monumental sculptures are *Monument to Youth*, *The Warriors* and *Shooting Star*. His style has developed by abandoning the figure for the abstract form.

Goeldi, Osvaldo (Rio de Janeiro, Rio de Janeiro, 1895–1961). An engraver and draftsman who studied in Switzerland. He returned to Rio de Janeiro in 1919. In 1930 he published his album *Ten Woodcuts* and illustrated various books, always seeking to convey the mood of the text. He was influenced by expressionism and depicted urban landscapes in excellent woodcuts.

Gomide, Antônio Gonçalves (Itapetininga, São Paulo, 1895–Ubatuba, São Paulo, 1967). Painter, draftsman and sculptor. He studied in Geneva and Paris and was influenced by the masters of cubism. In 1926, he returned to São Paulo where he took part in all the modernist exhibitions. He was one of the pioneers of mural painting in Brazil. *Portrait of Vera Azevedo* (1929) and the water color *Cubist Composition* (1932) are among his most important works.

Gotuzzo, Leopoldo (Pelotas, Rio Grande do Sul, 1887). A painter who studied in Italy. He painted nudes, still life works and portrayed regional types.

Graciano, Clóvis (Araras, São Paulo, 1907). A figurative painter and draftsman who joined the Grupo Santa Helena and was one of the organizers and exhibitors of the first Salão da Família Artística Paulista. His figures follow the dictates of cubism in the organization of space. He has dedicated himself to mural painting, in which he has excelled, and to the illustration of literary works.

Grassmann, Marcelo (São Simão, São Paulo, 1925). An engraver, draftsman and painter who at first applied himself to sculpture. He perfected his style in Vienna and his outstanding works are his engravings, which border on the fantastic, and in which he creates knights, suits of armor, monsters and devils in an archaic manner.

Graz, John (Switzerland, 1895). A painter and decorative artist who settled in São Paulo in 1920. He exhibited his paintings at the 1922 Semana de Arte Moderna and specialized in interior art déco style decoration, assisting in the work on Gregori Warchavchick's modernist house (1930).

Gruber Correia, Mário (Santos, São Paulo, 1927). A painter, engraver and draftsman who received a prize at the Grupo dos 19 exhibition (1947). He can be considered to be Latin America's pioneer in fantastic realism. His little creatures, puppets and masked characters are produced using a refined technique.

Guignard, Alberto da Veiga (Nova Friburgo, Rio de Janeiro, 1896–Belo Horizonte, Minas Gerais, 1962). A painter and draftsman who studied in Europe. In 1929 he settled in Rio de Janeiro and in 1944 founded the Escola de Arte in Belo Horizonte, where for nineteen years he gave lessons. He later retired to Ouro Prêto. With an almost ingenuous lyricism he depicted Brazilian types and landscapes, especially those of the historical towns of Minas Gerais.

Guillobel, Joaquim Cândido (Lisbon, Portugal, 1787–Rio de Janeiro, Rio de Janeiro, 1859). A draftsman who came to Brazil in 1811, he was also a soldier and architect. From 1914 he began to paint tiny water colors depicting scenes and figures from Rio's society of the period that are of considerable documentary value.

Hansen-Bahia (Karl-Heinz Hansen) (Hamburg, Germany, 1915–São Paulo, São Paulo, 1978). He was an engraver and dedicated himself above all to xylography. He depicted the streets and inhabitants of the Bahia area.

Heep, Adolf Franz (Fachbach, Czechoslovakia, 1902–Paris, France, 1978). An architect who studied in Germany. At the end of the forties he settled in São Paulo where, in addition to various other works, he designed the Itália building and the Church of São Domingos.

Joaquim, Leandro (Rio de Janeiro, circa 1738–circa 1798). A painter and stage designer who was active in Rio de Janeiro. Among other works, six oval panels are attributed to him. These were painted for a pavilion of the Passeio Público (public park) and are considered to be the finest examples of eighteenth-century Rio painting. It appears that he worked as a stage designer at the Teatro de Manuel Luís.

Katz, Renina (Rio de Janeiro, Rio de Janeiro, 1925). An engraver, draftsman and painter who has been active in São Paulo since 1951. Involved mainly in engraving, she treats the essence of reality in a lyrical mood.

Krajcberg, Frans (Kozienice, Poland, 1921). A painter, sculptor and engraver who arrived in Brazil in 1948. At first he was a figurative artist and then, in the fifties, he moved into an abstract phase. Since the sixties, in his works he has used elements taken straight from nature such as stones, leaves, roots and so forth.

Landi, Antonio Giuseppe (Bologna, Italy, 1708–Belém, Pará, 1790). An architect who was engaged by the Crown as a military engineer and was in Belém in 1753. He is considered to be the pioneer of neoclassical architecture in Brazil. The Church of São João Batista (1767), in Belém, is considered to be his masterpiece.

Landseer, Charles (London, England, 1799–1879). A painter and draftsman who stayed in Rio de Janeiro from 1825 to 1827. During this period he produced about three hundred drawings and water colors depicting people, customs and landscapes, which were only discovered in 1924.

Lee, Wesley Duke (São Paulo, São Paulo, 1931). A painter, draftsman and engraver active in São Paulo. In 1963 he organized the "magic realism" avant-garde movement and Brazil's first

"happening." His works are characterized by their narrative force, combining objective realism and mystical fantasy.

Leirner, Nelson (São Paulo, São Paulo, 1932). A painter and draftsman of São Paulo's avant-garde. He is concerned with provoking a reaction to his various proposals and has appeared in various "happenings." His *Stuffed Pig* (1967) created a sensation at the Salão de Brasília.

Letícia Quadros, Ana (Teresópolis, Rio de Janeiro, 1929). An engraver who is active in Rio de Janeiro. She has concentrated on engraving on metal, particularly on the dry-point process and relief work. She began with representational art and moved on to non-representational abstractionism. In the seventies she returned to representational art.

Lisboa, Manuel Francisco (Jesus de Odivelas, Portugal, ?–Ouro Prêto, Minas Gerais, 1767). A master builder who was active in Minas Gerais. He worked on the construction of the mother church of Nossa Senhora da Conceição and the governors' palace in Ouro Prêto. He was Aleijadinho's father.

Lopes, Silvestre de Almeida (eighteenth century). A painter who was active in Minas Gerais and worked in Diamantina, where he painted the sacristy ceiling of the Church of São Francisco de Assis (1795). His greatest work is considered to be the apse ceiling for the Bom Jesus de Matosinhos in Serro (a church which should not be confused with the sanctuary of the same name in Congonhas do Campo).

Mabe, Manabu (Kumamoto, Japan, 1924). A self-taught painter who came with his family to Brazil in 1934 and settled in Lins, in the interior of the state of São Paulo, where he worked on a coffee plantation. Since the mid-fifties he has produced figurative paintings, especially landscapes and still life works, and of late has become interested in non-representational abstract art. He has also turned his attention to upholstering.

Magalhães, Fábio Luis Pereira de (São Paulo, São Paulo, 1942). A draftsman and painter who is active in São Paulo. He does pencil drawings of men and symbols, expressing the dramatic side of existence.

Malfatti, Anita (São Paulo, São Paulo, 1896–1964). A painter who was active in São Paulo and studied in Germany and the United States. Her controversial exhibition of 1917 was one of the main events that, within the field of plastic arts, preceded the 1922 Semana de Arte Moderna. Her exhibition provoked harsh criticism from the writer Monteiro Lobato and caused a group of intellectuals and modernist artists to gather around her and to finally organize the 1922 Semana de Arte Moderna. After 1917 Malfatti's paintings lost their vigor. Her outstanding works are: *The Pale Man, The Russian Student* and *The Idiot.*

Martins, Aldemir (Ingazeira, Ceará, 1922). A draftsman, painter and engraver and one of the founders of the Sociedade Cearense de Artes Plásticas. In 1946 he moved to São Paulo. He has dedicated himself to themes connected with the world of Nordeste (forest bandits, tenant farmers and peasants forced to emigrate to the south because of drought). He later moved on to painting cats, fish, goats, cocks and the flowers and fruits of Brazil. His works are characterized by varied and busy brushwork.

Meireles de Lima, Vítor (Florianópolis, Santa Catarina, 1832–Rio de Janeiro, Rio de Janeiro, 1903). He painted historical episodes and landscapes, in addition to biblical scenes and portraits. In 1847 he moved to Rio de Janeiro and five years later won a trip to Europe, where he painted the *First Mass in Brazil* (1861), one of his most important works. Using a revolving cylinder, in 1888 he exhibited the series of *Panoramas* of Rio de Janeiro in Brussels.

Meneses, Luís da Cunha de (Eighteenth century). An architect who drew up the plan for the Courthouse and Prison buildings in Ouro Prêto (now the Museu da Inconfidência) and Gioás Velho, in Goiás.

Mesquita, Francisco Frias de (Portugal, 1587–1645). The official chief architect of the colony, he came to Nordeste in 1635 by appointment of the Crown. The Fortaleza dos Reis Magos in Natal is his most important work. He built various fortifications and drew up a plan for the town of São Luis do Maranhão.

Mindlin, Henrique Ephin (São Paulo, São Paulo, 1911–Rio de Janeiro, Rio de Janeiro, 1971). An architect who was at first active in São Paulo, moving to Rio de Janeiro in 1944. In the thirties he took part in the movement to renew Brazil's architecture. One of his works was the design for the Banco do Estado da Guanabara building in Rio de Janeiro (1963–1965). He is the author of the

book *Modern Architecture in Brazil* (1956), well-known in the United States, England, France, Holland and Germany. In the sixties he worked in Portugal.

Monte Carmelo, Friar Jesuíno do (Santos, São Paulo, 1764–Itu, São Paulo, 1819). A painter and architect known in the secular world as Jesuíno Francisco de Paula Gusmão. In Itu he decorated the mother church (together with José Patricio da Silva Manso), planned the Church of the Patrocínio and painted the apse ceiling of the Church of Nossa Senhora do Carmo. He also worked in São Paulo. Among the works that he painted in this town, the pictures for the Church of the Tertiary Order of the Carmelites are outstanding.

Monteiro, Vicente do Rego (Recife, Pernambuco, 1899–1970). A painter, draftsman and sculptor who studied and lived in both Brazil and Europe where he struck up relationships with the avant-garde artists of Paris. In 1922 he showed ten of his paintings at the Semana de Arte Moderna in São Paulo. Derived from cubism and influenced by pre-Columbian art, his paintings treat mainly national and biblical themes. His drawings are vigorous and schematic with planes that give a feeling of volume.

Mota, Agostinho José da (Rio de Janeiro, Rio de Janeiro, 1821–1878). A painter who was a member of the French Mission and, in addition to still lifes, also painted landscapes. His outstanding works are *Melon and Pineapple* and *Baron Capanema's Farm*.

Müller, Augusto (Baden, Germany, 1815–Rio de Janeiro, Rio de Janeiro, ?). He painted landscapes, historical episodes and portraits after settling in Rio de Janeiro in his early childhood. He was one of the French Mission's most talented artists. His outstanding works are the portraits of *Grandjean de Montigny* and *Manuel Correia dos Santos, the Boatswain of a Sumaca* (the sumaca is a small two-masted boat used in Latin America).

Muzzi, João Francisco (Italy, eighteenth century). A painter who was active in Rio de Janeiro and excelled as a scene-painter firstly at the Casa da Ópera and then at the Teatro de Manuel Luís. His two canvases, *The Fire* and *The Reconstruction of the Retreat of Nossa Senhora do Parto* (1789) are valuable historical and artistic documents which show in detail the furniture, dress and means of transport at the end of the eighteenth century in Rio de Janeiro.

Nery, Ismael (Belém, Pará, 1900–Rio de Janeiro, Rio de Janeiro, 1934). A painter and draftsman who is considered to be the forerunner of surrealism in Brazil. When just a baby he settled in Rio de Janeiro with his family. He later went on two long trips around Europe. His early works reveal a link with expressionism. A cubist period then followed (to which the famous "blue phase" belongs) and from 1927 Nery's painting became surrealist. His works are inspired by themes of love and poetry, focusing on the human figure (often his wife, Adalgisa), while the environment or landscape are treated in isolation. His *Self Portrait* (1927) is one of his most famous works.

Niemeyer Soares Filho, Oscar (Rio de Janeiro, Rio de Janeiro, 1907). An architect who was a member of the group that designed the Ministry of Education and Health Building (1936/37). One of his most important works is the Pampulha architectural complex (1942–1944) in Belo Horizonte, to which the Church of São Francisco belongs. The curving form of this church, very different from rationalist models, establishes a demarcation in modern Brazilian architecture. Other outstanding projects are the government buildings in Brasília. He has also designed buildings and urban complexes in various foreign countries.

Ohtake, Rui (São Paulo, São Paulo, 1938). An architect active in São Paulo where he designed various private houses and state schools. One of his most outstanding works is the Parque Ecológico do Tietê. He is a supporter of "beautiful" rationalism.

Ohtake, Tomie (Kyoto, Japan, 1913). A painter also involved with engraving. She has been active in São Paulo since 1936. Large monochromatic areas characterize her nonrepresentational abstract works.

Ostrower, Fayga (Lodz, Poland, 1920). An engraver and draftsman who is active in Rio de Janeiro. She came to Brazil in 1934 and at first treated social themes in a phase during which she was influenced by expressionism. She later opted for nonrepresentational abstractionism. She has worked above all on engraving on metal.

Pallière, Armand Julien (Bordeaux, France, 1784–1862). A painter, draftsman and engraver who lived in Brazil from 1817 to 1830. On the invitation of Dom Joào, he painted scenes and landscapes of the states of Rio de Janeiro, São

Paulo and Minas Gerais. He is considered to be the pioneer of lithography in Brazil.

Pancetti, José (Campinas, São Paulo, 1902–Rio de Janeiro, Rio de Janeiro, 1958). A painter whose first works date back to 1925. He was self-taught until 1932, when he joined the Núcleo Bernardelli and accepted the trends set by Bruno Lechowsky. He painted very fine seascapes and in his canvases depicted the coasts of Rio de Janeiro, São Paulo and Bahia. He also painted landscapes of Campos do Jordão, Campinas and São João del Rei, in addition to self-portraits, portraits and still life paintings.

Parreiras, Antônio Diego da Silva (Niterói, Rio de Janeiro, 1869–Rio de Janeiro, Rio de Janeiro, 1937). A landscape painter who also painted historical subjects and female nudes. Pale colors characterize his landscapes, of which *Sertanejas* (1896), painted in Teresópolis, stands in a class of its own.

Pennacchi, Fúlvio (Villa Collemandina, Italy, 1905). A painter, potter and draftsman who in 1929 settled in São Paulo where he joined the Grupo Santa Helena and the Família Artística Paulista. He painted genre and religious scenes, excelling in the field of mural painting.

Peyroton, Charles (France, nineteenth century). An architect who worked in the Teatro Municipal of Rio de Janeiro, the Teatro Amazonas of Manaus and in the town of Belo Horizonte, which was then being built.

Piedade, Friar Agostinho da (Portugal, ?–Salvador, Bahia, 1661). A Benedictine sculptor who was active in Salvador. Between about 1625 and 1642, he produced terra-cotta sculptures. His statues reflect a certain stiffness reminiscent of Renaissance works. Among his works, we should mention the reliquary busts of *St. Lucy*. The famous image of *St. Peter Repentant*, in the Church of Nossa Senhora do Monte Serrate in Salvador, is also attributed to him.

Pilar, Friar Ricardo do (Cologne, Germany, 1630/40–Rio de Janeiro, Rio de Janeiro, 1702). A Benedictine painter who came to Rio de Janeiro some time between 1660 and 1670. Among other works, he produced *Christ of the Martyrs*, considered to be his masterpiece, and fourteen panels on the life of St. Benedict. His paintings show the influence of the old Germanic and Flemish schools.

Piza, Artur Luís (São Paulo, São Paulo, 1928). An engraver and painter who has been active in Paris since 1953. He has replaced the lyrical representationalism of his early paintings with the abstract expressionism of engraving on metal. He also produced some mosaic collages with pieces of painted cardboard.

Portinari, Cândido Torquato (Brodósqui, São Paulo, 1903–Rio de Janeiro, Rio de Janeiro, 1962). Painter and draftsman. The son of Italian emigrants, he began to paint at a very early age, working on restoring the decorations of the church in his home town. In 1918 he moved to Rio de Janeiro and attended the Escola Nacional de Belas-Artes. In 1928 he won a trip to Europe where he lived for two years. After he had returned to Brazil and settled in Brodósqui, in 1933 he made his first experiment in mural painting, copying Fra Angelico's *Flight into Egypt* in the dining room of his father's house. In 1935 he got an honorable mention from the Carnegie Foundation in the United States for his painting *Café*, done the year before. He was influenced by Mexican mural painters and in 1937 began to work out the panels for the Ministry of Education building, completed in 1945. In the forties he became interested in expressionism of a social nature (the outstanding works of this period are *Dead Child* and *Funeral in the Net*, 1945). In the same decade he produced *The Way of the Cross* for the Church of Pampulha (Belo Horizonte) and painted various paintings inspired by the children of Brodósqui. From 1948 he created a series of historical works such as *First Mass in Brazil* (1948), *Tiradentes* (1949), and *War and Peace* (1957). In the fifties he was inspired by the *cangaceiros* (forest bandits). In addition to regional and historical subjects he painted religious scenes and portraits.

Post, Frans Janszoon (Haarlem, Holland, 1612–1680). A painter who came to Brazil in the retinue of Maurice of Nassau in 1637. He stayed in Brazil until 1644 and faithfully painted the landscape of Pernambuco. In his works the sky occupies the major part of the picture and clusters of trees are placed at the corners. *Brazilian Panorama* (1652) is one of his most famous paintings. The outstanding canvases among those that he painted in Brazil are *The Island of Itamaracá* (1637) and the *Oxen Cart* (1638). In addition to landscapes, Post also painted views of ports and fortifications, a few of which were used to illustrate Barlaeus's book *Rerum per Octennium in Brasilia*.

Prazeres, Heitor dos (Rio de Janeiro, Rio de Janeiro, 1898–1966). A primitive self-taught painter who began his career in 1937, depicting scenes of samba dancing, *macumba* ceremonies and agricultural work.

Rebolo Gonzales, Francisco (São Paulo, São Paulo, 1903–1981). A self-taught painter who was a member of the Família Artística Paulista. Most of his paintings depicted the landscape of São Paulo, laying emphasis on the countryside and suburbs, painted in predominately light shades.

Reidy, Afonso Eduardo (Paris, France, 1909–Rio de Janeiro, Rio de Janeiro, 1964). An architect who, in addition to other works, designed the Pedregulho residential complex (1950) and the Museu de Arte Moderna, both in Rio de Janeiro.

Ribeiro, Gabriel (?–Salvador, Bahia, 1719). A Portuguese-trained architect who was active in the Bahia region. The Church of the Tertiary Order of São Francisco in Salvador (1703) is undoubtedly his masterpiece.

Roberto, Marcelo (Rio de Janeiro, Rio de Janeiro, 1908–1964). An architect who was active in Rio de Janeiro and, with his brother Mílton, in addition to other works, drew up the plan for the Brazilian Press Association building (1936), introducing the *brise-soleil* technique with reinforced concrete to Brazil.

Roberto, Maurício (Rio de Janeiro, Rio de Janeiro, 1921). An architect who has worked with his brothers, Marcelo and Mílton, on various important projects (which bear the name M.M.M. Roberto), the most outstanding being the headquarters of the Brazilian League Against Tuberculosis.

Roberto, Mílton (Petrópolis, Rio de Janeiro, 1914–Rio de Janeiro, Rio de Janeiro, 1953). An architect who, with his brother Marcelo, designed various works including the passenger terminal at Santos Dumont Airport in Rio de Janeiro.

Rocha, Joaquim Gonçalves da (Sabará, Minas Gerais, 1755–?). A painter who was active in Minas Gerais and, between 1812 and 1813, painted the nave ceiling of the Church of Nossa Senhora do Carmo in Sabará.

Rocha, Paulo Mendes da (Vitória, Spain, 1928). An architect who was active in São Paulo. One of his most outstanding works is the USP Science and Arts Faculty Building in the university quarter.

Rodrigues, Glauco Otávio Castilho (Bagé, Rio Grande do Sul, 1929). A painter and graphic artist who was one of the founders of the Clube de Gravura de Porto Alegre (1950). After a phase of using a predominance of abstract graphic elements, he moved on to representational art, adopting native themes and mocking aspects of urban life.

Rugendas, Johann-Moritz (Augsburg, Germany, 1802–Weilheim, Germany, 1858). A draftsman and painter who arrived in Brazil in 1821 as a draftsman with the scientific expedition of the baron of Langsdorff, which he was unable to join. He therefore traveled around various regions in Brazil, depicting landscapes, human types and costumes in his drawings and water colors. Ten years after his return to Europe in 1825, he published *Pictorial Journey through Brazil*, a book which was illustrated with a hundred of Engelmann's lithographs. He also painted portraits in oil, the most noteworthy being the ones of *Pedro II* and *Dona Januária*.

Santa Rosa Júnior, Tomás (Paraíba, 1909–New Delhi, India, 1956). A painter and engraver who settled in Rio de Janeiro in the thirties. He took part in the first Salão de Maio. One of his outstanding paintings is *Fishermen* (1943). He became well-known as an engraver for having illustrated the books of Graciliano Ramos, José Lins do Rego and other Brazilian writers.

Sant'Olalla, Francisco García (Málaga, Spain, 1870–Rio de Janeiro, Rio de Janeiro, 1895). A painter of landscapes and historical subjects who arrived in Brazil shortly before he died.

Santos, Friar Francisco dos (?–circa 1650). An architect who designed the Franciscan monasteries of Olinda (1585) and João Pessoa (1590). In Salvador, where he lived from 1590 to 1596, he painted the retables of the Church of São Francisco, which were later destroyed by the Dutch.

Santos, José Pereira dos (Brazil, eighteenth century). An architect who was active in Minas Gerais. In Mariana, he designed the courthouse and prison building (1762) and the churches of São Francisco de Assis (1762) and Nossa Senhora do Rosário (1752). He assisted in the construction of the Carmelite church of Ouro Prêto.

São João, Friar Macário de (Spain, ?–Brazil, 1676). A Benedictine architect who was active in Salvador, where he arrived in 1648. He introduced late sixteenth-century Italian Renaissance ideals and is best remembered for having designed the monastery of São Bento. He is also thought to be responsible for the plans of the Santa Casa, the convent of Santa Theresa and the facade of the town hall.

Scliar, Carlos (Santa Maria, Rio Grande do Sul, 1920). A painter, draftsman and engraver who joined the Família Artística Paulista in 1940. Between 1944 and 1945, he fought in Italy as a member of the Brazilian expeditionary force, producing a series of drawings on the war. Between 1947 and 1950, he lived in Paris where he produced works with an expressionist tendency. On his return to Brazil, he helped set up the Clube de Gravura de Porto Alegre (1950). His work mainly consists of landscapes and still life paintings. His most outstanding engravings are the *Estância* series, begun in 1953. (An *estância* is a farm on which cattle are reared).

Segall, Lasar (Vilna, Lithuania, 1891–São Paulo, São Paulo, 1957). A painter, engraver and sculptor who studied in Berlin where he became attached to the *Freie Sezession* movement, the forerunner of expressionism. He came to Brazil in 1912 and the following year organized the first modern art exhibition in São Paulo. When he returned to Europe in 1914 during the first World War, he was interned in a concentration camp as a Russian citizen. In 1923 he returned to Brazil and settled in São Paulo where he helped to create the SPAM (Sociedade Paulista Pró-Arte Moderna) in 1933. His work is derived from expressionism and has human suffering as its main theme: the dramatic aspects of war, persecution and also of prostitution. Between 1935 and 1948 he painted the series of Campos de Jordão landscapes, the *Portraits of Lucy* and a few of his epic paintings such as *Pogrom, Refugee Boat* and *Concentration Camp*. In this same period he also produced the engravings for the album *Mangue* (1944).

Sepúlveda, João de Deus (Pernambuco, eighteenth century). The most important painter of eighteenth century Pernambuco. His masterpiece is the nave ceiling of the Church of São Pedro dos Clérigos, in Recife. He is thought to have painted the *Battle of the Guararapes* panels, kept in the Church of Nossa Senhora da Conceição dos Militares, in Recife.

Shiró, Flávio (Sapporo, Japan, 1928). A painter who came to Brazil as a child. In 1947 he joined the Grupo dos 19, exhibiting landscapes and still life paintings. In 1953, having settled in Paris, he began painting large pictures in which he depicts forms reminiscent of totems and ancestral creatures.

Silva, Bernardo Pires da (eighteenth century). A painter who was active in Minas Gerais. Between 1773 and 1775 he painted the apse ceiling of the Sanctuary of the Bom Jesus de Matosinhos, in Congonhas do Campo.

Silva, Quirino da (Rio de Janeiro, Rio de Janeiro, 1902). A painter and sculptor who was the chief advocate of the Salão de Maio, organized in São Paulo in 1937. His paintings include nudes and landscapes. He has also made a name for himself as an art critic.

Sousa, Manuel Rebelo e (Braga, Portugal, ?–Ouro Prêto, Minas Gerais, 1775). A painter who was active in Minas Gerais. His masterpiece is the apse ceiling of Mariana cathedral, painted in 1760.

Tarsila do Amaral (Capivari, São Paulo, 1886–São Paulo, São Paulo, 1973). A painter who began to study in 1917 under Pedro Alexandrino. In 1920 she went to France. After returning to Brazil, in 1922 she joined the intellectuals of the Grupo Klaxon who had taken part in the Semana de Arte Moderna, and formed the Grupo dos Cinco with Anita Malfatti, Menotti del Picchia, Mário de Andrade and Oswald de Andrade. The following year, she returned to Paris and came into contact with a few exponents of the cubist movement. Her work is divided into three important phases: Pau-brasil, anthropophagous and social. *E.F.C.B.* of 1924 is the most representative of the Pau-brasil phase, which was characterized by the constant use of blue and pink and geometrical stylization. The anthropophagous phase has *Abaporu* (1928) as its most distinctive work and enormous, deformed figures rendered in earthy colors as its typical elements. The social phase includes works such as *Workmen* and *2nd Class*, inspired by a trip she made to Russia in 1931. Her final works are a reorganization of the elements that shaped the previous phases.

Taunay, Adrien-Aimé (Paris, France, 1803–Vila Bela de Mato Grosso, Mato Grosso, 1828). A painter and draftsman who came to Brazil in 1816 as part of the French Artistic Mission with his father,

Nicolas-Antoine Taunay. In 1824, he accompanied the Langsdorff mission as an artist. He met his death during the expedition, drowning in the Guaporé river.

Taunay, Nicolas-Antoine (Paris, France, 1755–1830). A painter who came to Brazil in 1816 with the French Artistic Mission. In 1821, he returned to Paris since he disagreed with the governing body of the academy. During his stay in Brazil he painted landscapes, biblical and historical subjects and childrens' portraits which made him the most important painter of the French Mission. *Boy Seated on a Chair, Portrait of Janneton, Portrait of Félix-Emile* and *The Main Square in Rio de Janeiro in 1816*, are some of his best works.

Tozzi, Cláudio (São Paulo, São Paulo, 1944). A painter and draftsman who initially produced collages and engravings, making critical use of comic strip stories. In a later phase he has created three-dimensional multiples and carried out research into optical effects.

Valentim da Fonseca e Silva (Serro Frio, Minas Gerais, circa 1750–Rio de Janeiro, Rio de Janeiro, 1813). A sculptor, carver and architect, known as Master Valentim, who was active in Rio de Janeiro. He produced carvings in various churches in Rio de Janeiro, the most outstanding being those done for the Church of Santa Cruz dos Militares, almost completely destroyed by fire, and those for the apse of the Church of São Francisco de Paula. His statues, already bearing the stamp of neoclassicism, are the climax of eighteenth-century Rio de Janeiro sculpture; his *St. Matthew* and *St. John* are fine examples, and indeed he may be considered Brazil's greatest sculptor after Aleijadinho. As an architect, between 1785 and 1795, he designed various public fountains but his real masterpiece is the Passeio Público (public park).

Veiga Vale, José Joaquim da (Pirenópolis, Goiás, 1806–Goiás, Goiás, 1874). A sculptor who created religious images, remaining within the concepts accepted in the eighteenth century. One of his most famous works is the *Holy Trinity*, the mecca for Goiás's pilgrims, in Barro Preto.

Vergara, Carlos (Santa Maria, Rio Grande do Sul, 1941). A painter who supports new art forms, using materials that range from acrylic to cardboard and working from a surrealist and critical standpoint as regards Brazilian reality.

Visconti, Eliseu D'Angelo (Giffoni Valle Piana di Salerno, Italy, 1866–Rio de Janeiro, Rio de Janeiro, 1944). A painter who came to Brazil when not even a year old and returned to Europe in 1892, as a result of a trip he won. In Paris he was a pupil of Grasset and came into contact with art nouveau. From this time until 1918, the year in which he settled in Rio de Janeiro, he alternated his activities between Brazil and France. He was one of Brazil's greatest masters of color, and he painted figures, genre scenes and landscapes. At first he felt the influence of symbolism and impressionism, as is clearly visible in works such as *Youth* (1898) and *Motherhood* (1906). After a transition phase, marked by accentuated realism (1909–1912), he became an impressionist (1913–1919) and then returned to realism (1920–1930), finally opting for impressionism in his last phase (1931–1944). His most creative period runs from 1913 to 1919, when he created some of his most lyrical works and produced the paintings for the Teatro Municipal in Rio de Janeiro, considered to be his divisionist masterpiece. He also tried other applied arts of the art nouveau type and can be considered a pioneer in the field of Brazilian design.

Vitalino Ferreira dos Santos (Caruaru, Pernambuco, 1909–1963). A self-taught sculptor who since early childhood made models of popular types and animals of Nordeste out of clay. He was discovered by the painter and art teacher, Augusto Rodrigues. Until 1953 he painted his figurines, with their rounded shape and amusing appearance. From that year onward, he no longer coloured his statuettes but left them at the raw terracotta stage.

Volpi, Alfredo (Lucca, Italy, 1896). A self-taught painter who came to Brazil as a small child. Before being able to dedicate himself totally to painting, he was a carpenter, carver and housepainter. In the thirties he helped set up the Grupo Santa Helena and joined the Família Artística Paulista. In this period he "discovered" Itanhaém (a coastal town south of Santos), where he painted an important series of seascapes. In 1950, he visited Europe where he became acquainted with the work of Giotto and the major early Italian artists who were to influence him later on in his career. After this trip, he produced a series of stylized urban views, some concretist works, culminating in his most important works (flags, poles, strips and color schemes) which tended toward geometrical abstract art.

Warchavchik, Gregori (Odessa, USSR, 1896–São Paulo, São Paulo, 1972). An architect who was active in São Paulo, where he arrived in 1923. In 1925, he published two articles in defence of rationalism. In 1927, he designed his first modernist house in Santa Cruz Road, São Paulo. He then produced groups of low-income houses in the Moóca district, São Paulo. In 1930, he put his modernist house on view to the public. It was built in Pacaembu, São Paulo and decorated with works by Tarsila do Amaral, Segall, John Graz and other exponents of modernism. In 1931, he was invited by Lúcio Costa, who had become the director of the Escola Nacional de Belas-Artes, to examine the reform in teaching as applied to architecture. In the same year, together with Lúcio Costa, he built low-income houses in Gamboa.

Weingartner, Pedro (Porto Alegre, Rio Grande do Sul, 1853–1929). A painter who served his apprenticeship in Germany and France. He was involved mostly with genre scenes. He also painted portraits, landscapes and scenes with a classical theme.

Zanini, Mário (São Paulo, São Paulo, 1907–1971). A painter and engraver who joined the Grupo Santa Helena and the Família Artística Paulista. He is considered to be the São Paulo landscape painter par excellence.

Chronology

1500—Discovery of Brazil by the Portuguese navigator, Pedro Álvares Cabral.

1501—First reconnaissance expedition along Brazil's coastline.

1503—Amerigo Vespucci, a Florentine navigator in the service of the king of Portugal, establishes the first settlement in Arraial do Cabo (in today's state of Rio de Janeiro).

1504—First French attacks on the Brazilian coast.

1510—Diogo Álvares establishes a settlement in the Bahia area.

1519 (circa) João Braga establishes a settlement in Rio de Janeiro.

1526—Recife emerges as a trading post, thanks to the Portuguese.

1529—The French arrive in Pernambuco.

1530—The first colonizing expedition sets out from Portugal with Martim Affonso de Sousa at its head. Igaraçu, in Pernambuco, is founded.

1531—Martim Affonso de Sousa erects an outpost in Rio de Janeiro.

1532—The founding of São Vicente (in today's state of São Paulo) by Martim Affonso de Sousa.

1534—The king of Portugal, Dom João III, creates the system of hereditary captaincies.

1536—Brás Cubas founds Santos, in the captaincy of São Paulo.

1537—Duarte Coelho founds Olinda in Pernambuco.

1540—Founding of the Church of the Savior, the mother church of Olinda (Pernambuco).

1548—Dom João III takes away the captaincies' administrative independence and creates a general government, placing Tomé de Souza at its head.

1549—Tomé de Souza arrives in Bahia with the master builder Luís Dias and various Jesuits. Salvador is founded.

1553—Duarte da Costa takes over general government. João Ramalho founds Santo André da Borda do Campo (in the state of São Paulo).

1554—The Jesuits found the college of São Paulo.

1555—The French settle in the Bay of Guanabara, creating "Antarctic France."

1557—Mem de Sá becomes governor general.

1560 (circa) The sculptor João Gonçalves Viana creates the first religious images.

1565—Estácio de Sá founds São Sebastião do Rio de Janeiro. This is the origin of the present-day town of Rio de Janeiro.

1565 (circa) Founding of the Jesuit village of Reritiba, today's Anchieta.

1567—The French are chased out of the Bay of Guanabara.

1572—Mem de Sá dies and the Crown divides Brazil into two realms, with centers in Salvador and Rio de Janeiro.

1577—General government is restored with Lourenço da Veiga at its head.

1580—The construction of the Church of Nossa Senhora da Graça in Olinda (Pernambuco) begins, on a design by Francisco Dias.

1585—The construction of the monastery of São Francisco and the Church of Nossa Senhora das Neves, in Olinda, is begun on a design by Friar Francisco dos Santos.

1588—Work begins on building the Carmelite church in Olinda.

1590—Friar Francisco dos Santos designs the monastery of Santo Antônio in João Pessoa, Paraíba.

1599—Natal, in Rio Grande do Norte, is founded.

1604–1672 Construction of Salvador cathedral on a design by Francisco Dias.

1610—Founding of Fortaleza (Ceará). In the territory belonging to today's Rio Grande do Sul, the Jesuit missions are set up.

1612—The French found São Luis in Maranhão.

1614—On a former construction, dating back to 1598, Francisco Frias builds the Fortaleza dos Reis Magos, in Natal (Rio Grande do Norte).

1615—The French are expelled from Maranhão.

1616—Francisco Caldeira Castelo Branco founds Belém (Pará).

1617—Francisco Frias draws up the first plan for the monastery of São Bento, in Rio de Janeiro.

1620—Friar Agostinho da Piedade arrives in Brazil.

1623—Work begins on building the Forte de São Marcelo in Salvador, on a design by Francisco Frias.

1624–1625 The Dutch arrive in Bahia.

1630—The Dutch invade Pernambuco.

1633—Work begins on building the monastery of São Bento in Rio de Janeiro.

1637—Maurice of Nassau, governor of Dutch Brazil, arrives in Recife, with Frans Post, Albert Eckhout and other artists in his retinue.

1648—Founding of Paranaguá (Paraná). First battle of the Guararapes Mountains.

1649—Second battle of the Guararapes Mountains.

1654—Expulsion of the Dutch.

1660—Founding of Parati (Rio de Janeiro).

1668—Founding of Curitiba, today the capital of the state of Paraná.

1669—Founding of the São José fortress which was to become Manaus (Amazonas).

1676—Founding of the bishopric of Rio de Janeiro.

1682—The *bandeirantes* (armed expeditions whose task it was to explore forests, discover mines and capture slaves) advance into Goiás. The Companhia de Comércio do Maranhão is founded.

1685—Construction of the Church of Nossa Senhora do Carmo, Recife.

1686—Work begins on building the Franciscan convent in Salvador.

1693—Antônio Rodrigues de Arzão discovers gold in Minas Gerais.

1695—The Capela Dourada is completed. It belongs to the Franciscan monastery of Santo Antônio in Recife and was designed by Antônio Fernandes de Matos.

1701—Work begins on building the convent of Santo Antônio and the Chapel of the Tertiary Order of São Francisco in Salvador.

1709—The captaincy of São Paulo and Minas Gerais is created.

1720—The captaincy of Minas Gerais is made independent of that of São Paulo.

1725—Gold is discovered in Goiás.

1726—Manuel de Brito arrives in Brazil and begins work on the Church of São Francisco da Penitência, in Rio de Janeiro.

1727—Cuiabá (Mato Grosso) is founded.

1729—Diamond mines are discovered in Serro Frio (Minas Gerais).

1735—Francisco Xavier de Brito begins work on the decoration of the Church of São Francisco da Penitência, Rio de Janeiro.

1747—Francisco Xavier de Brito begins work on the decoration of the Church of Nossa Senhora do Pilar in Ouro Prêto.

1750—Portugal and Spain sign the Madrid Treaty, on the basis of which Portugal's frontiers are extended in Latin America.

1735—The Italian architect, Antonio Giuseppe Landi, comes to work in Belém.

1759—The Jesuits are expelled from Brazil.

1763—The center of colonial administration is transferred to Rio de Janeiro.

1766—Aleijadinho designs the Church of São Francisco de Assis, in Ouro

Prêto. Manuel Francisco Lisboa, Aleijadinho's father, draws up the first plan for Ouro Prêto's Carmelite church which, four years later, his son was to alter.

1774—Aleijadinho designs the Church of São Francisco de Assis, in São João del Rei (Minas Gerais).

1781—The *Battle of the Guararapes* panel is painted. It is attributed to João de Deus Sepúlveda.

1783—Inauguration of the Passeio Público of Rio de Janeiro, designed by Master Valentim.

1783–1792 Joaquim José Codina and José Joaquim Freire produce drawings to illustrate Alexandre Rodrigues Ferreira's *Viagem Filosófica.*

1784—Construction of the Casa dos Contos in Ouro Prêto (Minas Gerais), whose design is attributed to Antônio Pereira de Sousa Calheiros. The courthouse and prison building in Ouro Prêto is designed by Luís da Cunha de Meneses.·

1789—*Inconfidência Mineira* (Mining Treason). An attempt at an insurrection in Minas Gerais, led by Joaquim José da Silva Xavier, called Tiradentes. A few writers, including Cláudio Manuel da Costa, joined this movement.

1792—Dom João VI becomes prince regent of Portugal. Tiradentes is executed.

1795—Silvestre de Almeida Lopes paints the sacristy ceiling of São Francisco de Assis, in Diamantina (Minas Gerais).

1796–1798 Aleijadinho sculpts the figures of the *Passion* of Christ, for the Sanctuary of the Senhor Bom Jesus de Matosinhos, in Congonhas do Campo (Minas Gerais).

1799—Manuel da Costa Ataíde works on the apse of the Church of São Francisco de Assis in Ouro Prêto (Minas Gerais).

1800—Manuel de Oliveira is appointed the director of the Aula Público de Desenho e Figura, just created in Rio de Janeiro.

1800–1805 Aleijadinho sculpts the *Prophet* statues for the Sanctuary of the Bom Jesus de Matosinhos.

1800–1809 Ataíde paints the nave ceiling of the Church of São Francisco, in Ouro Prêto.

1808—The royal family and the Portuguese Court arrive in Brazil. Brazilian ports open to the ships of friendly nations. The *Gazeta do Rio de Janeiro* begins to circulate. This was a newspaper printed by the printing works brought over from Portugal by the Court.

1812—Joaquim Gonçalves da Rocha paints the nave ceiling of the Church of Nossa Senhora do Carmo, in Sabará (Minas Gerais).

1815—Brazil becomes a kingdom united with Portugal and Algarve.

1816—The French Artistic Mission arrives in Brazil. Grandjean de Montigny makes plans for the Academia de Belas-Artes in Rio de Janeiro.

1817—The Austrian painter, Thomas Ender, arrives in Brazil with the expedition of the scientists, Spix and Martius.

1821—The Portuguese Court returns to Portugal. Johann-Moritz Rugendas arrives in Brazil as a member of Langsdorff's scientific mission.

1826—Opening of the Academia Imperial and Escola de Belas-Artes.

1828—Ataíde paints the *Last Supper*, a canvas now kept in the Seminário do Caraça (Minas Gerais).

1829—Jean-Baptiste Debret organizes the first public art exhibition in Brazil, wich takes place in Rio de Janeiro. ·

1831—Dom Pedro I abdicates, withdrawing to Europe. He is succeeded by his six-year-old son, Dom Pedro II.

1835—Rugendas publishes his *Pictorial Journey through Brazil.*

1840—After coming of age, Dom Pedro II is appointed emperor of Brazil.

1845—Dom Pedro II organizes the prize of a trip to Europe for artists.

1846–1849 Frederico Guilherme Briggs publishes the album *Souvenir of Brazil.*

1864–1849 War against Paraguay.

1875—Vítor Meireles begins to paint the *Battle of the Guararapes* which he was to complete in 1879.

1882—The Manaus Municipal Market is built (Amazonas).

1888—Abolition of slavery.

1889—Proclamation of the republic.

1896—The Teatro Amazonas in Manaus is opened.

1897—Founding of Belo Horizonte, a town which was to become the capital of Minas Gerais, replacing Ouro Prêto.

1898—Almeida Júnior paints *Importune*.

1905–1908 Visconti paints the backdrop scene and ceiling of the Teatro Municipal in Rio de Janeiro.

1910—Pedro Weingartner exhibits his painting *La Faiseuse d'Anges* (painted in 1908) in São Paulo.

1913—Lasar Segall exhibits his paintings in São Paulo: the first modern art exhibition in Brazil.

1917—In April, Brazil breaks off diplomatic relations with Germany and in October joins the fray, taking part in the World War alongside the Allies. In December Anita Malfatti exhibits 53 of her works, which are met with a hostile reception, opening the floodgates to a sea of discussion.

1920—Vítor Brecheret presents his model for the *Monument to the Bandeiras*, which he created between 1936 and 1953.

1922—The Semana de Arte Moderna is organized in São Paulo. The *Klaxon* is created, a magazine popularizing modernism.

1924—Brecheret exhibits his *Perfume Bearer* in Paris.

1925—Vicente do Rego Monteiro paints *The Archer*.

1927—Construction of the house in Santa Cruz road, São Paulo, which was the work of the architect Warchavchik and was considered to be the first example of modern architecture in Brazil. In the same year Lasar Segall paints *Banana Plantation*.

1928—Tarsila do Amaral paints *Abaporu* and *Urutu* (paintings from her anthropophagous stage).

1929—The French architect, Le Corbusier, arrives in Brazil. His visit opens the eyes of a few young professionals and gives impetus to those, such as Lúcio Costa and Gregori Warchavchik, who are already familiar with his work.

1930—President Washington Luíz is deposed and the liberal Getúlio Vargas seizes power becoming provisional president until he is elected in 1934.

1931—The Núcleo Bernardelli is formed in Rio de Janeiro by a group of artists who have rejected academicism, and their first modern art exhibition is organized.

1932—An insurrection by the constitutionalists in São Paulo.

1933—Founding of the Sociedade Pró-Arte Moderna (SPAM) and the setting up of the Clube dos Artistas Modernos (CAM)—both in São Paulo.

1934—Cândido Portinari's painting, *Café*, is awarded a prize in the United States.

1936—Brecheret begins his *Monument to the Bandeiras*. A group of architects, led by Lúcio Costa, begins the project for the Ministry of Education and Health building to be built in Rio de Janeiro. The Esther building, in São Paulo, is completed.

1937—President Getúlio Vargas dissolves the congress and the parties and sets up a dictatorship. The two main events in the art world are the first exhibition by the Família Artística Paulista and the first Salão de Maio in São Paulo.

1937–1949 Annual exhibitions by the Sindicato de Artistas Plásticos of São Paulo.

1938—Creation of the Associação Rio-Grandense de Artes Plásticas Francisco Lisboa.

1941—Creation of the Centro Cultural de Belas-Artes, in Ceará.

1942—Brazil joins the Allies in the second World War.

1942–1944 The Pampulha complex in Belo Horizonte, Minas Gerais, is built on a design by Oscar Niemeyer.

1943–1945 Cândido Portinari creates the panel of the *Way of the Cross* for the Church of São Francisco in Pampulha, Belo Horizonte.

1944—The first modern art exhibitions in Minas Gerais and Bahia.

1945—Getúlio Vargas is overthrown and general Enrico Gaspar Dutra rises to power.

1947—Creation of the Museu de Arte de São Paulo. Grupo dos 19 exhibition.

1948—Creation of the Museu de Arte Moderna in São Paulo. The Recife Sociedade de Arte Moderna is set up.

1949—Opening of the Museu de Arte Moderna of São Paulo with an exhibition entitled "From Representational Art to Abstract Art."

1950—The architect, Afonso Eduardo Reidy, draws up a plan for the Museu de Arte Moderna of Rio de Janeiro. The Clube de Gravura de Porto Alegre is set up.

1951—The Grupo Ruptura (concrete art) is formed in São Paulo and the first Biennial Exhibition is organized.

1952—The Grupo Frente (concrete art) is formed in Rio de Janeiro.

1952–1957 Activity by the Ateliê Coletivo, formed in Recife.

1953—The second Biennial of São Paulo.

1954—Getúlio Vargas, who had been re-elected four years previously with a large majority, bitterly disappointed by being reduced to the opposition, commits suicide.

1955—The third Biennial of São Paulo.

1956—After the brief presidency of João Café Filho, Juscelino Kubitschek takes over the government. Work begins on the construction of Brasília according to the design of Lúcio Costa.

1956–1957 Pancetti paints landscapes in Itapuã and Abaeté, in Salvador.

1957—Fourth Biennial of São Paulo.

1957–1958 The new São Paulo Museu de Arte building is built, on a design by Lina Bo Bardi.

1959—Fifth Biennial of São Paulo. The first neoconcrete art exhibition is organized in Rio de Janeiro. The sculptor Bruno Giorgi creates *The Warriors* for the Square of the Three Powers in Brasília.

1960—On April 21 Brasília is inaugurated. In the same year Lívio Abramo and Maria Bonomi set up the Estúdio da Gravura in São Paulo. Carlos Scliar moves from social realism to hedonistic painting.

1961—In August the president of the republic, Janio Quadros, (Kubitschek's successor) resigns. He is replaced by the vice president, João Goulart. In September the sixth Biennial of São Paulo is held.

1962—The painter and sculptor, Frans Krajcberg, begins to use elements taken straight from nature in his works.

1963—Milton Dacosta paints *Figura*, a canvas that belongs to the *Venus and Little Birds* series. São Paulo's seventh Biennial takes place and the Museu de Arte Contemporânea da Universidade de São Paulo is set up, thanks to the contribution from the Museu de Arte Moderna. Also in São Paulo, a collective exhibition by the Associação de Artes Visuais Novas Tendências is held, and the first "happening" is performed in the João Sebastião Bar, organized by the painter, Wesley Duke Lee.

1964—The March 31st Revolution: a military uprising forces President Goulart into exile. In April the military junta, which has taken over the government, appoints President Castelo Branco.

1965—The eighth Biennial of São Paulo. In Rio the first Salão Esso de Artistas Jovens, hosted by the Museu de Arte Moderna, is held. Works by José Roberto Aguilar and Rubens Gerchman are shown. Also in the Museu de Arte Moderna of Rio de Janeiro, the "Opinião" exhibition is organized.

1966—The first Biennial of Plastic Arts is held in Salvador (Bahia). The painter Nelson Leirner creates the *Adoration*.

1967—The ninth Biennial of São Paulo. In Rio de Janeiro, in the Museu de Arte Moderna, works by artists supporting the "new Brazilian objectivity" movement are exhibited.

1968—The painter Antônio Henrique Amaral makes a name for himself with *Bananas*. The new Museu de Arte Building, by Lina Bo Bardi, is opened in São Paulo.

1969—Glauco Rodrigues starts off the *Terra Brasilis* phase. The Faculty of Architecture and Town Planning is opened in São Paulo. This building is considered to be Artigas's masterpiece.

1970—Oscar Niemayer builds Brasília cathedral.

1974—The president of the republic, Ernesto Geisel, launches a plan for national development.

1979—João Baptista Figueiredo becomes president of the republic.

Index of Names

Picture sources

The abbreviations a, b, c, l, r refer to the position of the illustration on the page (above, below, center, left, right).

Abril Press: 28r, 30bl, 30br, 41 42 54–55, 60, 82, 98l, 99l, 102, 113, 120, 166, 167, 173b, 175al, 175b, 178a, 196, 198, 199, 200a, 200bl, 201, 204a, 205, 207, 208–209, 212, 214, 215, 220r, 222br, 235, 237, 245, 248b, 252b, 254–255, 262b, 280–281, 286b, 292. Akademie der Bildenden Künste, Vienna: 92bl, 159a, 159b. Alipio S. Júnior/Abril: 227. Odair C. de Almeida: 109. Antônio de Andrade/Abril: 257al. José Antônio: 282. P. M. Bardi: 256bl, 256br, 257al, 257b. Biblioteca Nacional, Rio de Janeiro: 46r, 82–83, 84–85, 85r, 152, 153, 162, 163. Jorge Butseum: 48, 52, 86l, 86r, 87, 90a, 90b, 91a, 91c, 91b, 176, 182ar, 188l, 189, 190l, 192, 193. Tadeau Fessel: 160, 161. Rômulo Fialdini: 6–7, 12, 36, 38a, 39a, 39b, 40–41, 43b, 45, 92a, 93b, 94a, 95, 97, 98r, 99r, 182al, 200br, 202, 204bl, 206, 208, 210, 211, 213, 216b, 217, 218a, 220l, 223, 226a, 231a, 232al, 232bl, 234, 236–237, 238, 239, 240–241, 242a, 243, 244, 246, 247, 248a, 249, 250, 252a, 253l, 284a, 284br, 286a, 287, 288, 289, 291a. Fundação R. O. Castro Maya, Rio de Janeiro: 154al, 154b, 156b, 157a. Luís Garrido: 53l. IPHAN (São Paulo): 105. Milton Kato: 29, 110–111. José Reinaldo Lutti: 263l. Sérgio Matulevicius: 43a, 88, 89, 89b, 150b, 155l. Pedro Manuel: 145r. National Museum of Denmark: 44a, 44bl, 44br. J. C. Morares: 241. Marcos Alves Morato: 115, 118, 121. Museu Antônio Parreiras, Niterói (Rio de Janeiro): 179. Museu Nacional de Belas-Artes, Rio de Janeiro: 180al, 180bl, 181b, 191. Museu Paulista, São Paulo: 155ar, 155br. Carlos Namba/Abril: 258b, 284bl. Lew Parrella: 281, 30al, 30ar, 32, 33, 34l, 34ar, 34br, 35, 46l, 47, 49, 50l, 51, 56l, 56r, 56b, 57, 58l, 58r, 59, 61, 63, 64, 65, 66l, 66r, 67, 68–69, 69, 70, 71al, 71bl, 71r, 72–73, 73r, 74a, 74b, 75, 76–77a, 76b, 77b, 78–79a, 78b, 79b, 80–81, 100, 101, 102–103, 104–105, 106, 107, 108, 112, 114, 116, 116–117, 119, 122–123, 124, 125, 126, 127, 128–129, 130, 131, 132, 133, 134, 135, 136–137, 138, 139, 140, 141, 142, 143, 144–145, 145l, 145b, 146l, 146r, 147, 168, 169, 170, 171, 172, 173al, 174, 175ac, 175ar, 180–181ac, 188r, 197, 226b, 258–259, 260–261, 283. Philips do Brasil: 92br, 93a. Pinacoteca do Estado, São Paulo: 177. Gilson Ribeiro: 96, 148, 149, 150al, 150ar, 151, 154ar, 156a, 157b, 158, 164, 165, 178b, 183, 186a, 190r, 204br, 224–225, 232br, 242b, 291b. Luís Roberto: 251. Paolo Mendes da Rocha: 263ar, 263br. Norma Rodrigues: 253r. Paolo Schoeuenstuhl: 212a, 216a, 218b, 218–219, 225, 228–229, 229, 230, 230–231, 231b, 233. Milton S. Shirata: 186b. Raul Victor: 203. João Walter Toscano: 262a. Darcy Trigo/Abril Press: 50l, 50r. David Zingg: 173ar.